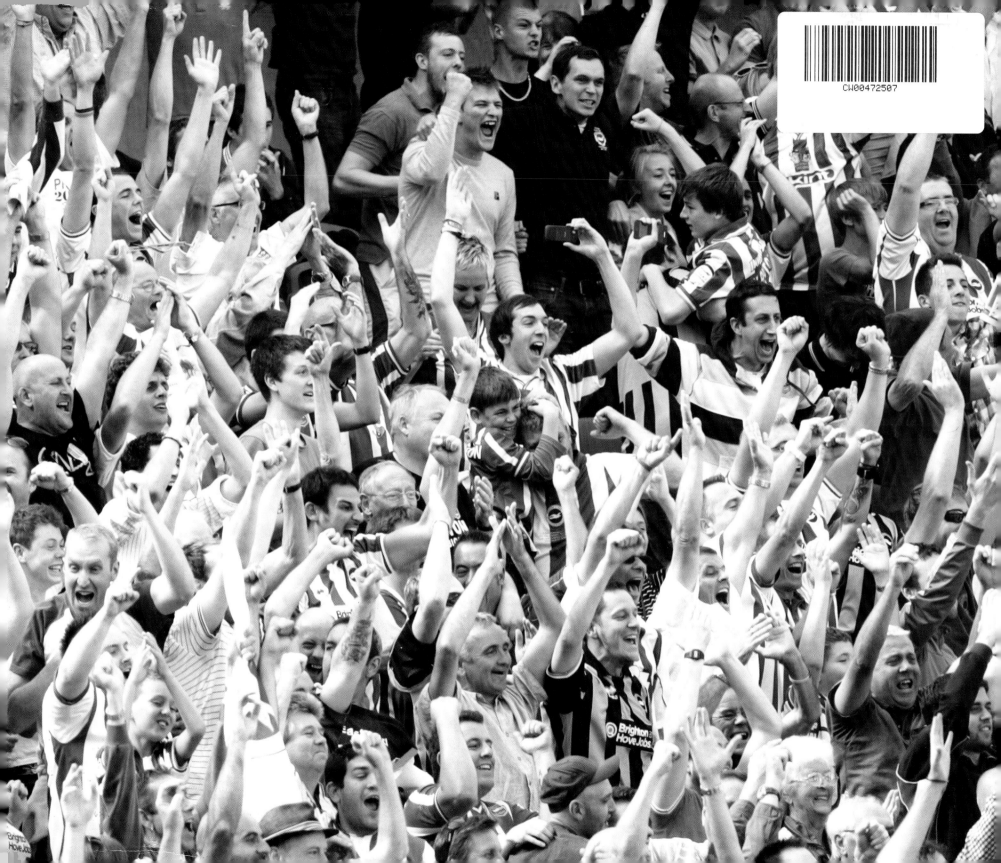

Dear Alan

Many, many congratulations
on your 65th birthday!

Love always

Paul & Sue
xx

HAPPY 65th ALAN
Hope you ENJOY!
Love Cathy & Derek
x x

Dear Alan,

Retirement Now Then!!
 Don't think so!

Congratulations.

Much Love Always,
 Karen
 x.

First published in 2012 by Step Beach Press Limited

28 Osbourne Villas
Hove BN3 2RE
United Kingdom

ISBN: 978-1-908779-04-5

Design by Digital Mimic
Covershot by Paul Hazlewood

Photography by Paul Hazlewood and Bennett Dean
Printed and bound in Europe
Manufacturing managed by Jellyfish Print Solutions

Acknowledgements

Tony Bloom, Chairman for providing us not only with a state of the art new arena to watch our football but also with helping Gus Poyet construct a team worthy of competing at this level, and then taking our already breathtaking stadium and improving it further.

Martin Perry, Director who never rests. No sooner had the gates opened for the first game, he was embroiled in paperwork and plans not only for further enhancements to the stadium, but also to a new training ground.

Derek Chapman, Director who was a driving force in ensuring the publication of *Stadium Yes!* Supposedly retired (several times over!), Derek quickly became consumed with extra seats, levels and concourse areas, working so hard to ensure everything would be in place and timescales would once again be met with development works.

And finally, very special thanks to every last one of you who waved blue and white flags on that opening day, and created an atmosphere other clubs can only envy. When so many new stadia seem quiet and soulless, ours was awake, alive and pulsing with energy from the first kick to the very last.

A percentage of the profits from this book are being donated to Albion in the Community, showing our continued support for such a worthwhile cause, not only here in Sussex, but much, much further afield. We are proud to support a charity with such innovative projects and initiatives that inspire, educate and motivate so many.

Tony Bloom

This book is a photographic celebration of Brighton & Hove Albion's first full year at the American Express Community Stadium.

It's poignantly titled, as for that first season many of us were genuinely Living the Dream watching our beloved Seagulls in a stadium which for so many years had remained a dream. Now, as both a club and a team we have fully settled into life at the Amex and the club has evolved enormously in the past 12 months. The enjoyment and buzz of coming to a home game at the Amex is the same now as it was at the start of last season.

Of course, that first game was extra special. The unbelievable atmosphere and vibe of the whole occasion culminating in Will Buckley's late, late winner against Doncaster set the tone for an historic first season at our new home. It will forever be etched in my memory – the moment when triumph overcame all the adversities our club has had to overcome. We flirted with the play-offs, but coming into the division from League One, and getting used to our new surroundings, we can be proud of our team's top-ten finish as we established ourselves in the Championship. We also enjoyed some success in both cup competitions including two superb victories at the Amex against Premiership clubs Sunderland and Newcastle.

Even in our defeat against Burnley just before Christmas, many fans left the Amex with a feeling of real pride, as we played most of the match with nine men and almost pulled off an incredible result. Depleted and desperate to break a tough run of winter results, we entertained then-top-of-the-table Southampton after New Year. Despite seemingly having more players in the treatment room than available for selection, a youthful side put on a great performance to put one over our south-coast rivals with a 3-0 win which sparked a fine run of form in the New Year.

I am sure you will find some of your own special memories in the pictures within these pages. They have been brilliantly captured through the lenses of our club photographers Paul Hazlewood and Bennett Dean, who spent the season running up and down the touchlines to record these iconic images from our inaugural season at the Amex. In addition to those images of what happened out on the pitch, Paul and Bennett have also documented a series of moments away from the public gaze. These give access to the players and staff on a day-to-day basis and provide a fascinating insight into life at the Albion and show what goes on behind the scenes at the Amex.

It all adds up to a superb photographic record of one of the most important seasons in the history of Brighton & Hove Albion, and a stunning book which I am sure you will enjoy turning to again and again to relive that phenomenal first season at the Amex.

Tony Bloom, Brighton & Hove Albion Chairman
September 2012

Martin Perry

I can still remember standing up in front of a group of fans in 1996 at a meeting held near George Street in Hove, and promising that our new stadium would have a WOW factor. In those days it must have seemed a long way off – almost an impossible dream – with the battles to save the club still to be won. Little did we know how long it would take, and what we would have to go through, but in our first season at the Amex we have certainly delivered on that promise. The Amex has wowed all of us!

Driving over the Downs from Woodingdean and seeing it nestling in the valley, coming round the curve of the A27 as it comes into view, from whichever angle you catch a glimpse of the graceful curves and sweeping arches it takes your breath away. It is an exciting building which promises thrills and spills and delivers the roller coaster ride of the beautiful game. But even stunning buildings like the Amex on their own are just concrete and steel. It is the supporters and people who use it, that breathe life into it and create the exciting atmosphere that we are all enjoying so much and now look forward to each week with such eager anticipation.

And what an atmosphere! Who will ever forget, Doncaster Rovers – the flags!, Sunderland, Newcastle, Liverpool, Burnley? Each of those games far exceeding our wildest expectations, the highs and lows of the season, the noise, the nail biting finishes, the excitement and the sheer exhilaration of being amongst fans both home and away savouring the experience. Is it any wonder that supporters can't wait for their next Amex fix? What's more, the experience isn't confined to match days. Norman Cook turned the whole arena into a massive night club, the senses pounded with the beat of the music and a spectacular light show. I will carry with me the gasp from 20,000 people as the lasers were suddenly switched on and everyone saw the light patterns above their heads framed by the curves of the stadium – below the roof line of course!

The building is now being used up to seven days a week and has hosted conferences, dinners, award ceremonies, weddings, acrobats and singers. All of them creating new and memorable experiences that will live long in the memory. When I show people around the stadium I always start by taking them to the West Stand upper concourse and out onto the top tier. As they walk out through into the stadium bowl, look down at the pitch and then take in the sheer scale of the building, the reaction is always the same – a sharp intake of breath, a brief silence while they take it in and then an audible gasp – Oh Wow! It never fails!

I am so proud of what we have achieved together: something quite unique in stadium design which is being recognised both nationally and internationally. We have Premier League clubs telling us we are breaking the mould and copying what we are doing. We are now market leaders which is where we want to stay.

And the future is equally bright – we are expanding the stadium and then embarking on the construction of a state of the art training ground. We are so lucky; together, we owe so much to our Chairman Tony Bloom who has made it all possible. Thank you, Tony and thank you to all of the supporters who believed in us and supported us. Because of all of you we can return to our seats each week and look at the awesome sight before us – Oh Wow!

Martin Perry, Brighton & Hove Albion Executive Director
September 2012

Derek Chapman

So here we are one year into our dream, and I still get emotional just before kick-off when the video clip shows the stadium coming into view over the poppy field. Don't you? The 6th August 2011 wasn't the end of our dream; it was just a very important date along the way to greater times ahead. I still wander around the stadium thinking to myself – is this really ours? Is this the home of Brighton & Hove Albion?

So the highlights of the first year for me: of course the first game, Doncaster at home – very poignant as it was the same opposition as the last ever game at the Goldstone some 14 years previously. Two very late goals by Will Buckley – who writes our scripts? Burnley, Southampton, but to be honest, every minute of every match and a couple of hours before and after are all highlights for me. The matchday experience of watching our beloved Brighton & Hove Albion Football Club playing at our home, the American Express Community Stadium.

The stadium has become a great source of civic pride for the city of Brighton and Hove and the county of Sussex. I wonder how many of the people who were against the stadium have attended matches and functions there. And who will ever forget the two nights in June that our very own Fatboy Slim served up for us? Thanks for everything, Norman, you are an Amex legend!

I hope that we have learnt from our mistakes (hopefully there were only a few). We may never be able to clear the car parks in five minutes at the end of the game, or serve every single person over the half-time period, but tell me what stadium in the world can? The biggest mistake I made was to doubt John Baine when he told me that we should put real ale in the ground as it would sell thousands of pints. I thought we would sell a few hundred pints a game at best, just to keep the campaign for real ale guys happy. How wrong could I be! Over 12,000 pints a game are sold so please accept my apologies, John.

So what for the future? Well, with Tony and Gus in charge the only way can be up on the pitch. With regards to the stadium, we managed to complete the upper East and South end corners in time for the 2012/13 season, which takes the capacity to well over 27,000 with over 22,000 being season tickets – the 10th highest of all the English leagues! Who says we're not a big club? The extra boxes and lounges in the South Stand will be completed by Christmas 2012 and the North end corners by March 2013 giving us a capacity of 30,500. Of course, it's not just the Albion fans that love the Amex. Ask the away supporters and the majority will tell you it's the best away experience they have ever had. The awards that we have received include the Best New Stadium in the World award when we were up against stadiums from the USA, Poland (Euro 2012 stadiums) and Juventus.

So my message to Albion fans is to enjoy the Amex. You all deserve it as you all helped in our battle to get permission to build it, which turned all our dreams into a reality!

Derek Chapman, Brighton & Hove Albion Director
September 2012

Paul Hazlewood

The song suddenly had a relevance that took my breath away. "Everywhere was blue and white, and everyone was singing".

An undulating sea of blue and white flags, a crescendo of noise, smiles, laughter and tears of joy, thousands of faces full of emotion. I was lucky enough, no... privileged to be able to witness the spectacle of a key moment in our club's history as we finally came home. My vantage point for this assault on the senses of colour and sound was the pitch, a perspective I am lucky enough to have shared with the players. It is something that will stay with me for the rest of my days, and I am certain in decades to come I will remember the moment as if it were yesterday. Nothing could prepare me for the overwhelming sense of pride, belonging and justice. Like many of you I fought the fight for over 15 years, never giving up hope, supporting every idea I could to raise awareness of the plight of our club, then the battle to return home, referendums, and of course all the subsequent planning meetings and applications.

As club photographer and fan, never have I found it more difficult to detach myself from one role in order to perform the other. Amidst this charged atmosphere, it was my responsibility to freeze and record this moment for future generations to come, so they will be able to understand the significance of the 6th August 2011. I don't mind admitting, my work that day was carried out through eyes filled with tears. During our pre-match planning session I had decided to set up a remote camera in the North Stand, and left it capturing images for around five hours. The intention was to create a time lapse of the occasion. By chance, this camera also froze the moment Will Buckley's historic winner crossed the line, from an altogether unique perspective. I know many of you have this image hanging on a wall at home, but knowing it was created almost by chance somehow makes it that little bit extra special for me.

Throughout this first landmark season the stadium and people working in it have put Brighton firmly on the map. Part of my job involves covering away games. Everywhere the media team travels we are greeted positively. Club media, photographers and journalists have nothing but praise for the facilities and also the friendliness of staff and supporters. We have moved in one short year from everyone feeling sorry for us and the conditions we work in, to a position where our peers wish to emulate what we do, where we are setting new and ground breaking standards. In our treatment of away fans we have excelled. Away team action photographs shown on flat screen TVs, concourse lighting to match team colours, padded seating, guest beers imported from their locality, and 'Welcome' signage including both clubs' badges - all examples of how we treat everyone as we would wish to be treated ourselves.

All of this would not have been possible without the vision, dedication and commitment of the three gentlemen providing forewords in this book. It's not just the stadium they promised they would deliver, but the immense positive impact on our local community, and our standing in professional football. They have created a legacy very few could emulate. What started out as a fight for a new stadium has become far, far more. Like all of you I feel indebted to them. This first season at the Amex was under the stewardship of Gus Poyet delivered on the pitch, but off it well, I will finish with a Martin Perry buzzword... WOW!

Paul Hazlewood, Brighton & Hove Albion Photographer
September 2012

Bennett Dean

I can't believe that it's more than a year since we've been living in our new home. Nor can I believe how long it took us to get here. Is it really more than 15 years? Somehow, I always knew it would happen, even when common sense and sensible reasoning strongly suggested otherwise. Even after all the turmoil of the final season at the Goldstone and our peripatetic existence since then via Gillingham and Withdean.

The images from that period are mainly in my head and in the heads of fellow fans and friends. In those days I didn't take my camera to matches and there certainly wasn't the plethora of digital media resources to help capture the vital historical events at our football club that there are today. Now, it seems impossible not to record every moment and every sound. So many fans seem to be at it, using the cameras on their mobile phones to record precious moments. Despite this, it is still possible to miss and overlook things, especially those daily events and tasks that we take for granted, things we do on autopilot such as match-day rituals.

This book I think captures many of those moments. I caught some of them, but without doubt it is Paul Hazlewood whose photographic vision and zeal recognised the majority of them. It provides further insight into and greater illumination upon the events that marked our debut season at our new home. It was the season when the spectacle of thousands of blue and white flags on a day in August overwhelmed me; the season when the roar of 'Good Old Sussex By the Sea', bellowed by men (and women and children] of Sussex and beyond, reverberated through the magnificent construction we call 'home'. The season when berserk celebrations greeted Will Buckley's sublime opening-day winner against Doncaster Rovers. What a start! It was only one game, but it felt like we had been at Falmer, in the Amex, for years. What a way to begin living the dream! What a privilege to have been there.

Bennett Dean, Brighton & Hove Albion Photographer
September 2012

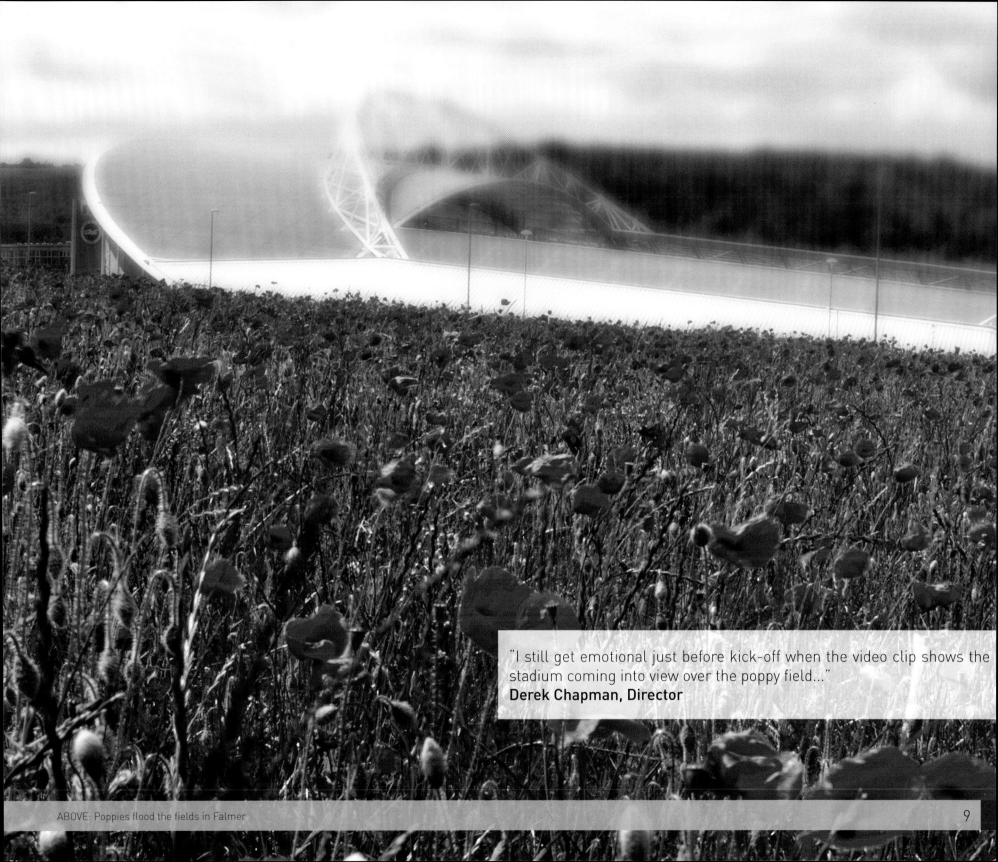

"I still get emotional just before kick-off when the video clip shows the stadium coming into view over the poppy field..."
Derek Chapman, Director

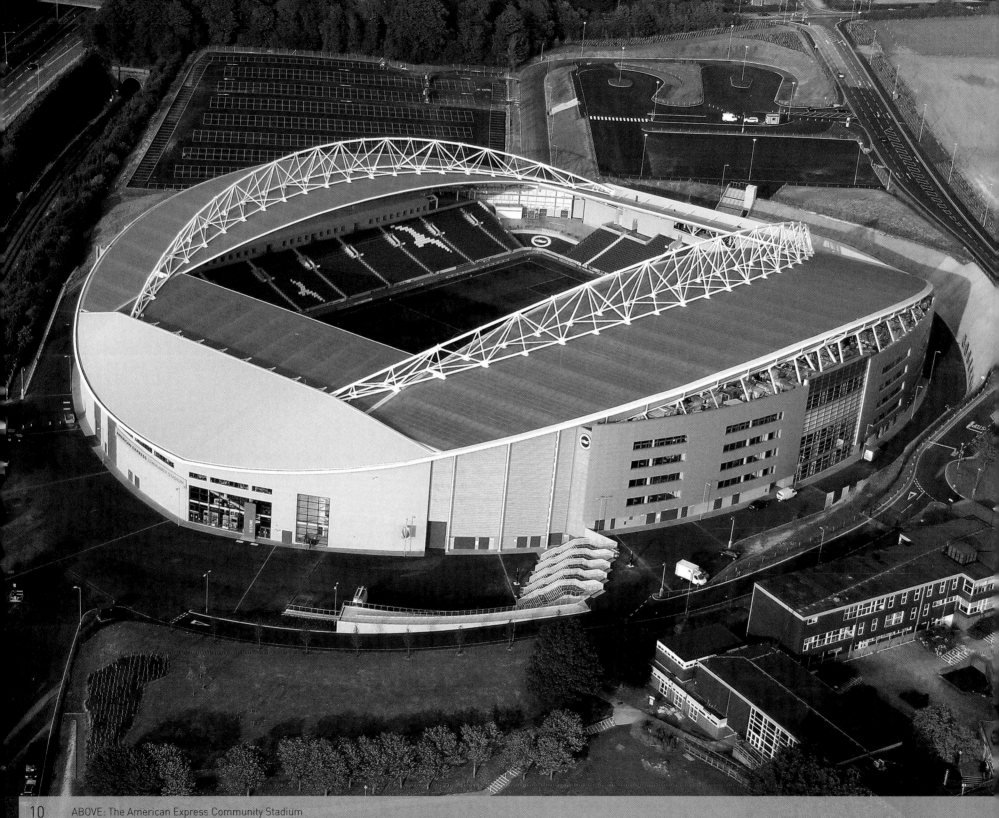

ABOVE: The American Express Community Stadium

HOME

Verb: Return by instinct to one's territory after leaving it.
Noun: The place where one lives permanently.

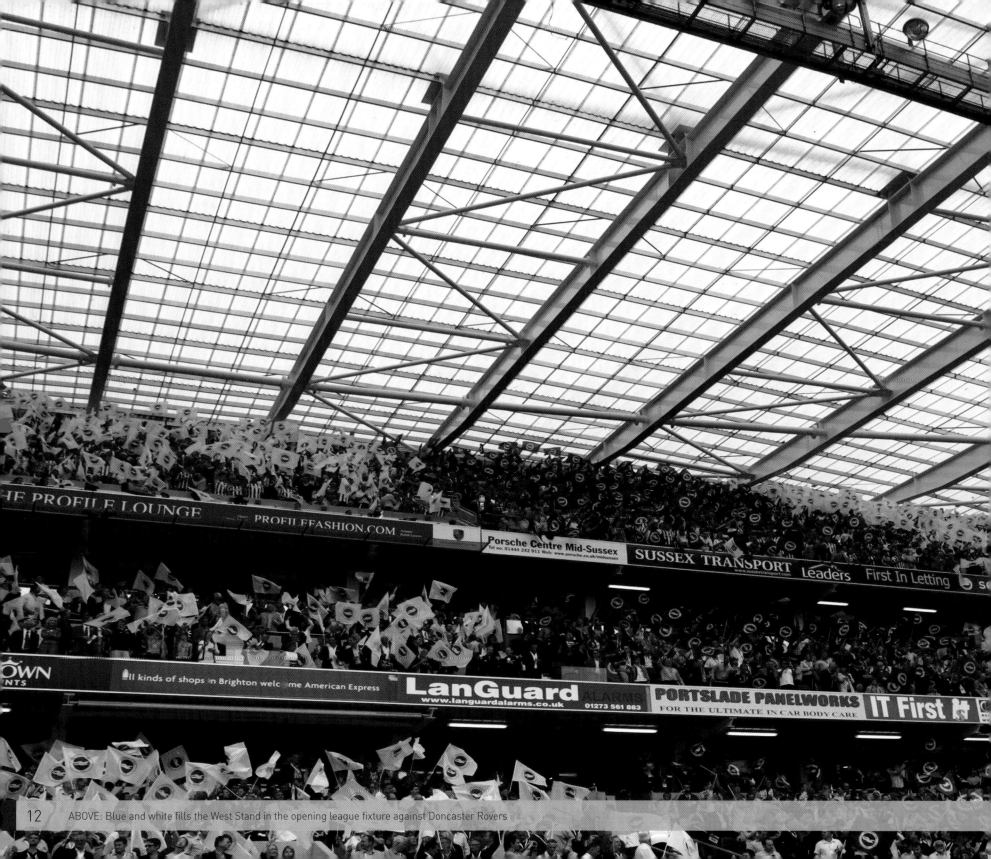

ABOVE: Blue and white fills the West Stand in the opening league fixture against Doncaster Rovers

14 YEARS

"This is my 50th season of supporting the Albion, and I can't think of anything in the previous 49 seasons to match the 10 minutes prior to kick-off against Doncaster when 20,000 fans waved their flags and sang in unison, it was awe-inspiring. What a magical day."
Steve Kennedy, Albion Fan

"For so many reasons in over three decades of watching this great club of ours that was the single most exciting, entertaining and emotional Albion match by a long, long way. I was at times speechless and almost in shock at the complete perfection of the afternoon. I am still stunned and will treasure the memories of being able to take my two young sons to this game forever. Brilliant, simply brilliant."
Gavin Krute, Albion Fan

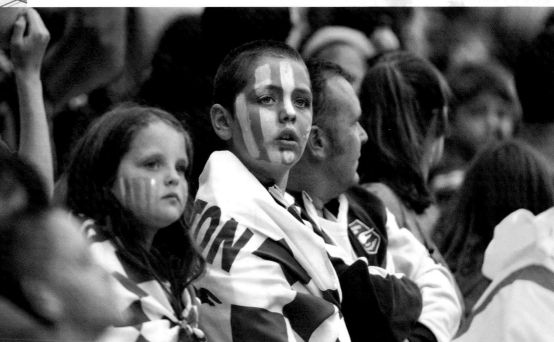

ABOVE: A permanent home was a new experience for many

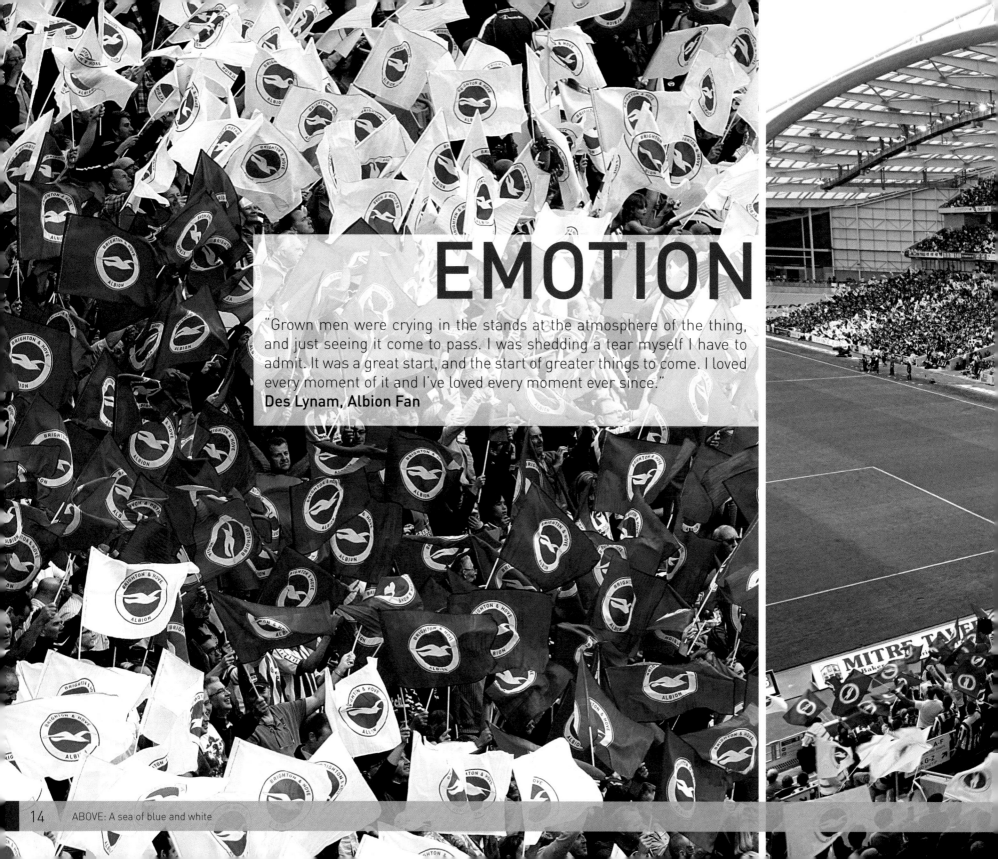

EMOTION

"Grown men were crying in the stands at the atmosphere of the thing, and just seeing it come to pass. I was shedding a tear myself I have to admit. It was a great start, and the start of greater things to come. I loved every moment of it and I've loved every moment ever since."
Des Lynam, Albion Fan

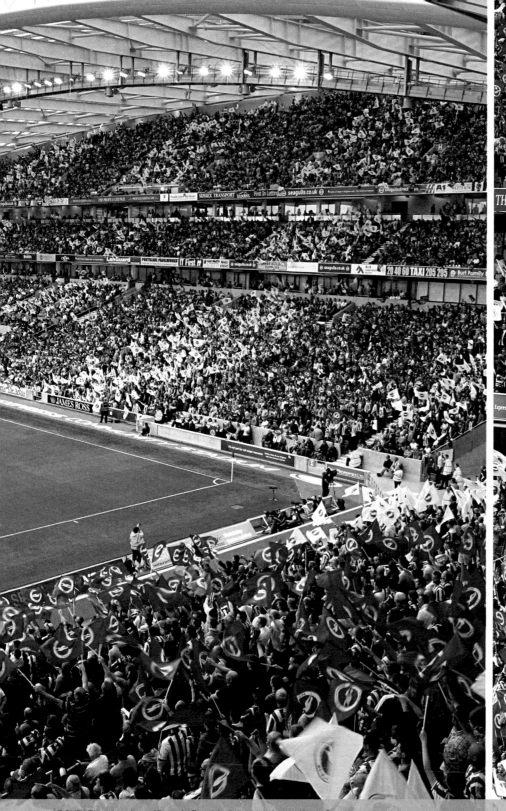

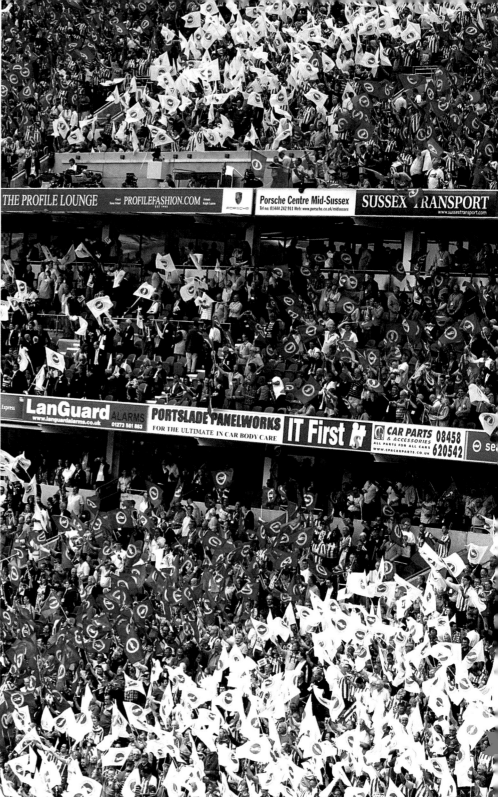

ABOVE: The view from 'Perry's Perch' of the North and West Stands

ABOVE: An iconic and unforgettable way to set off the club's future

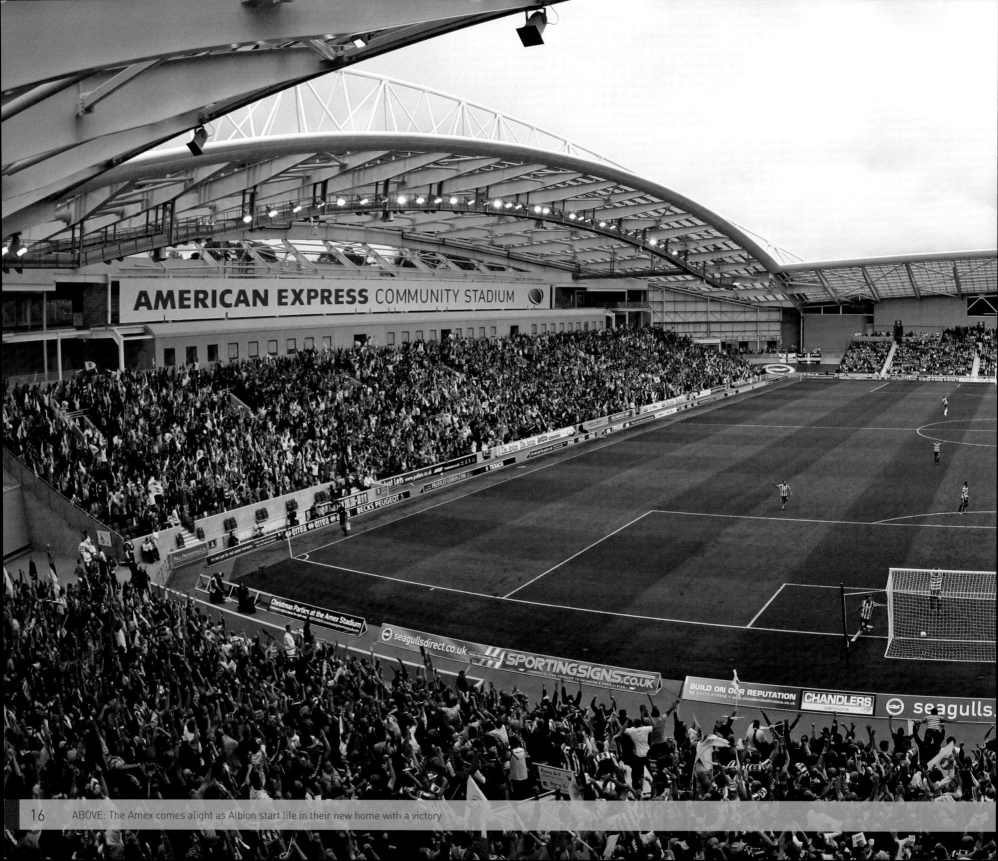

ABOVE: The Amex comes alight as Albion start life in their new home with a victory

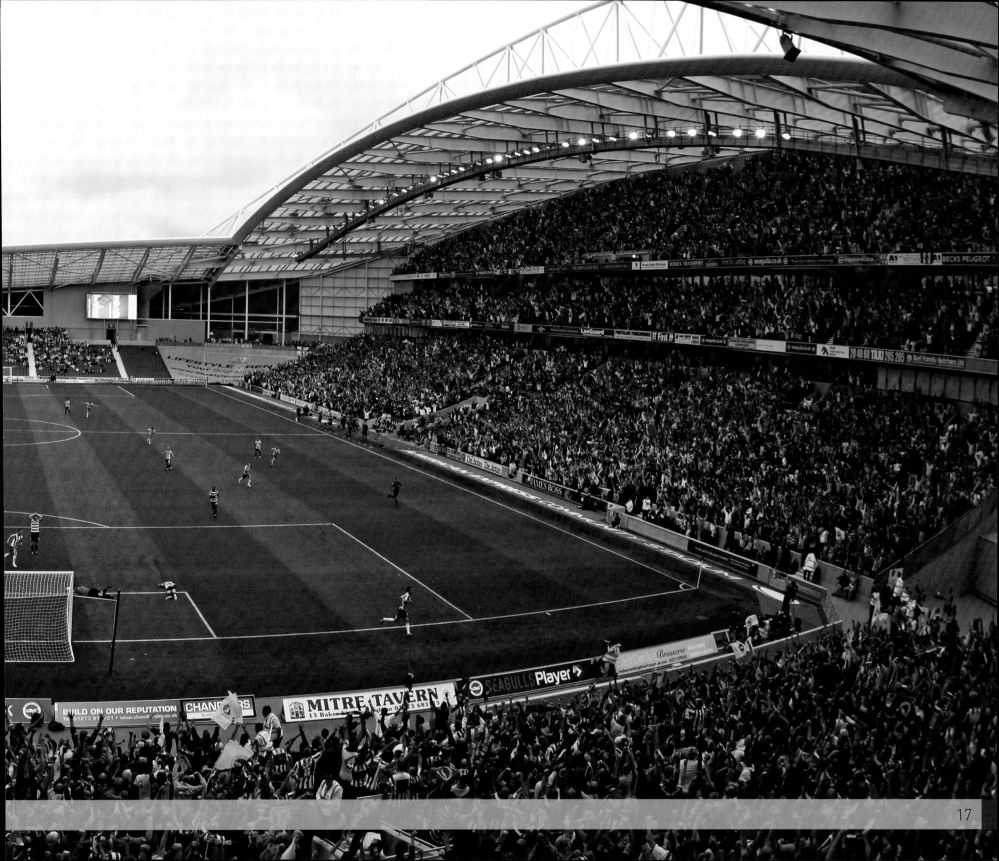

MATCH WINNER

"I was running up and down the side of the pitch, looking at the bench and wanting the gaffer to call me. It's all a bit of a blur to be honest, I think he just said 'Try and get us back in the game'. Having been watching the game for the first hour I just couldn't wait to get on that pitch. When you're a sub you dream of coming on and making an impact like that, but to do it on my league debut for the club in the opening game of the season here at the Amex was just an amazing feeling."
Will Buckley, Midfielder

"The way that Bucka took that opportunity in his first game for us after such a big transfer fee, I remember thinking he's already paid us back! We needed to start well, and we needed to make the Amex a special place. Many people may think winning four or five nil would be better. No. Those emotions at the end of the game and what happened in the dressing room after made us feel like we are at home, which was more important than anything."
Gus Poyet, Manager

"I think all of our fans and the whole city can be proud of that occasion. I don't think any of us could have imagined in our dreams, what an atmosphere we all created that day. The whole emotion of the occasion was unbelievable. To go one-nil down was obviously a disappointment, but to come back and equalise in the 83rd minute was brilliant. The last minute winner will be forever etched in my memory, and Will Buckley will be forever remembered by all Brighton fans for what he did that day."
Tony Bloom, Chairman

ABOVE/ TOP: In the 98th minute, Will Buckley beats the offside trap and slots past Gary Woods in front of the North Stand

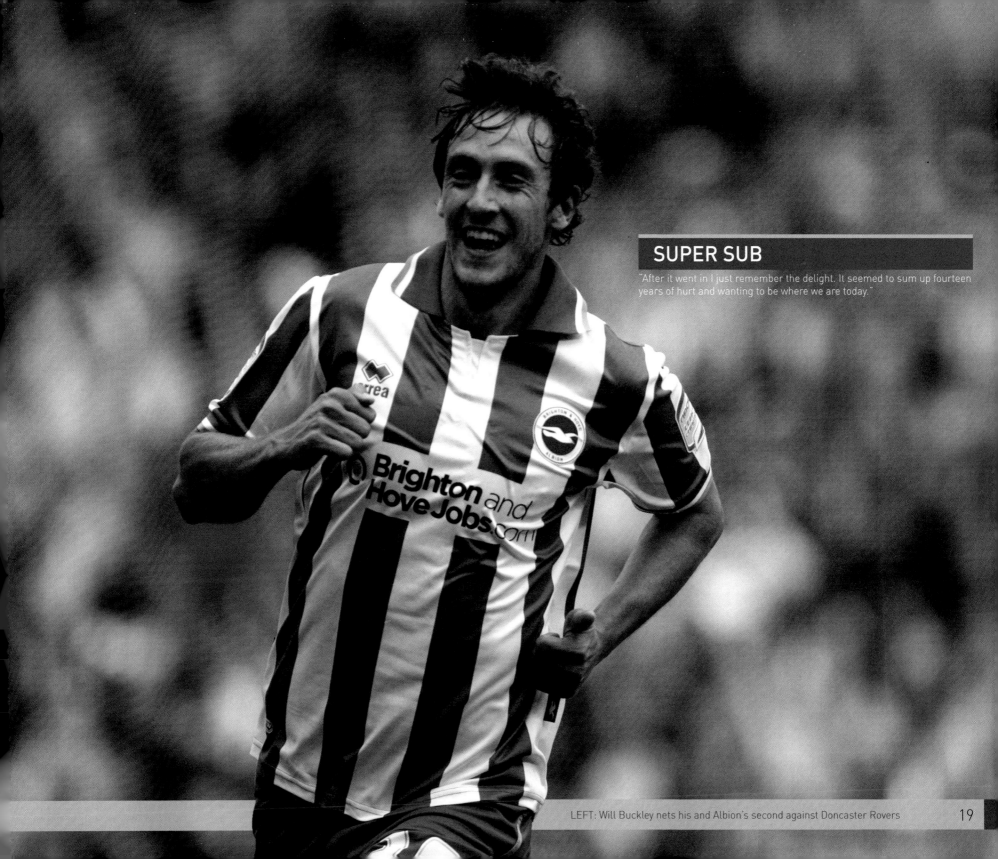

SUPER SUB

"After it went in I just remember the delight. It seemed to sum up fourteen years of hurt and wanting to be where we are today."

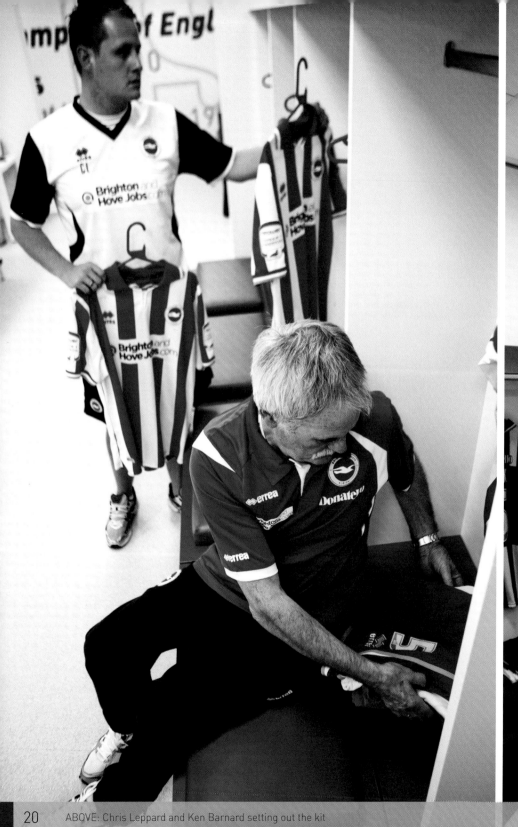

ABOVE: Chris Leppard and Ken Barnard setting out the kit

The home dressing room has 20 padded seats. The away dressing room has none.

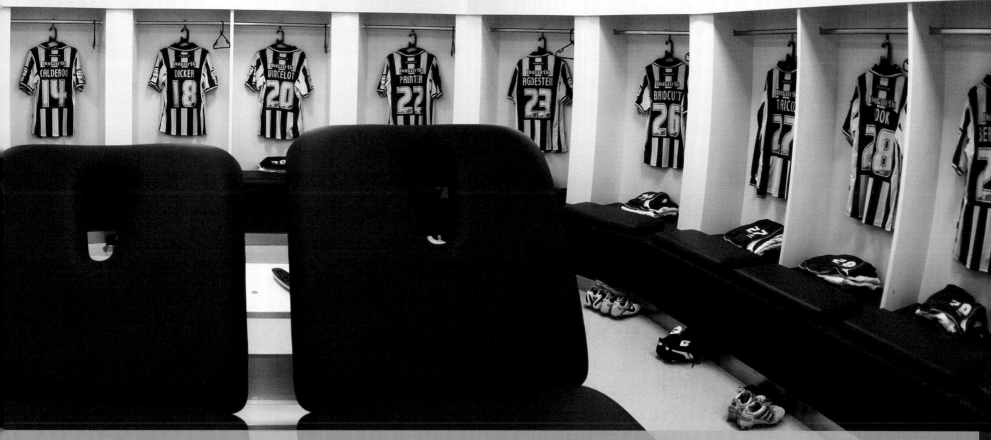

ABOVE: Home team dressing room ready for action

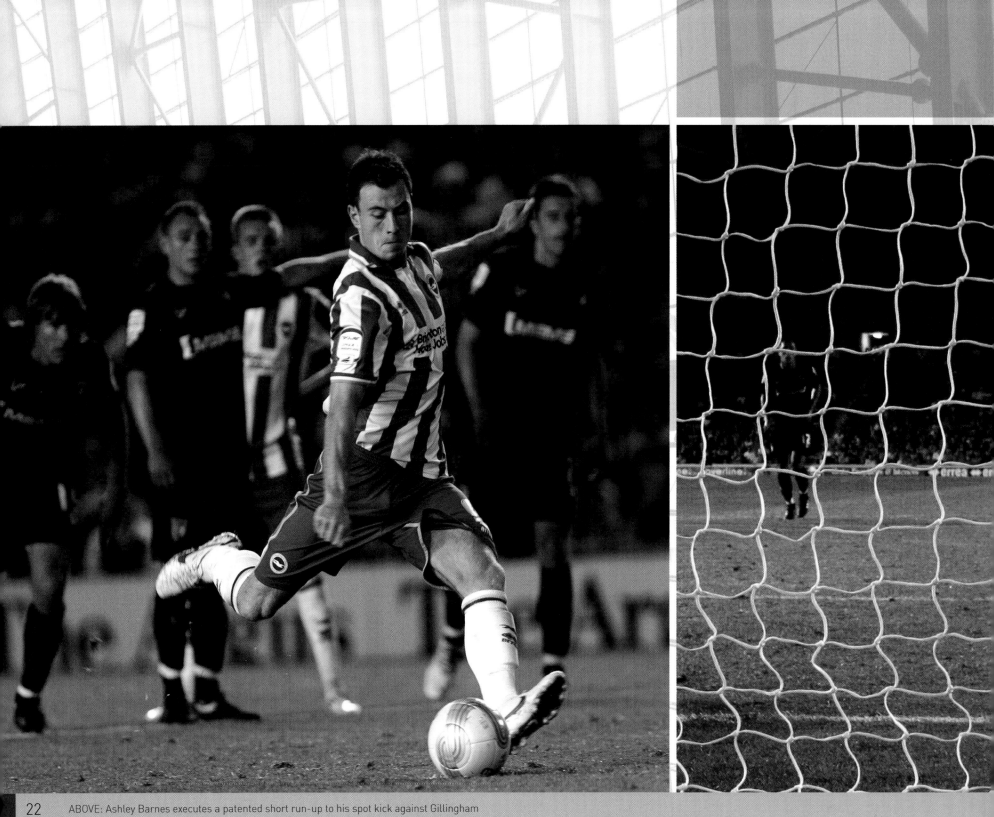

ABOVE: Ashley Barnes executes a patented short run-up to his spot kick against Gillingham

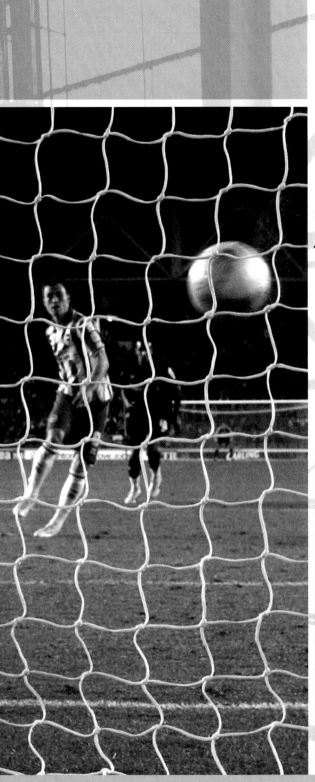

PERFECT SYMMETRY

"You couldn't write this script. After the most poignant opening league fixture, the very next game and we find ourselves pitted in the League Cup against former temporary landlords Gillingham! Brighton was a homeless club after the sale and demolition of the Goldstone Ground, and forced to ground-share at The Priestfield during the 'wilderness years' before coming home to the Withdean. I was one of around 2,000 fans who regularly made the tedious 82 mile journey for every 'home' game. I hated that journey, I hated calling Gillingham 'home', I hated how our club's primary aim was simply survival. It was fitting that they would be our first cup opponents, and it felt extremely good to welcome Paul Scally and his staff to our impressive new home, and then beat them!"

Paul Hazlewood, Club Photographer

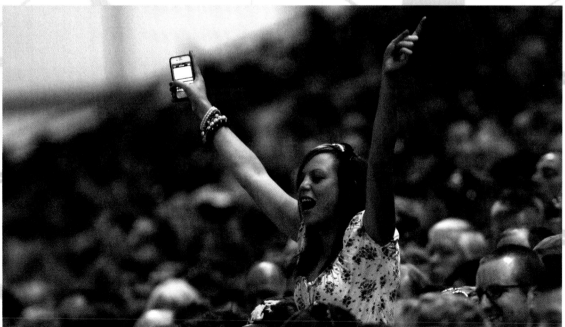

ABOVE: Ashley Barnes slots home his first of the season

ABOVE: Albion fans see their club progress to round two of the League Cup

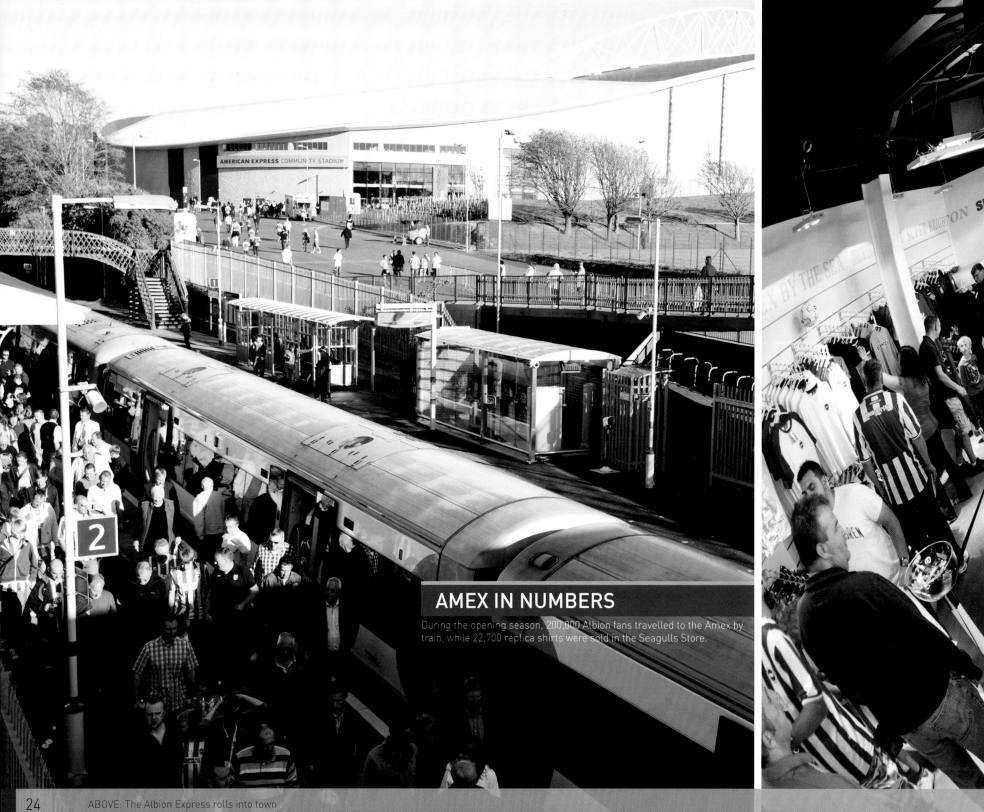

AMEX IN NUMBERS

During the opening season, 200,000 Albion fans travelled to the Amex by train, while 22,700 replica shirts were sold in the Seagulls Store.

ABOVE: The Albion Express rolls into town

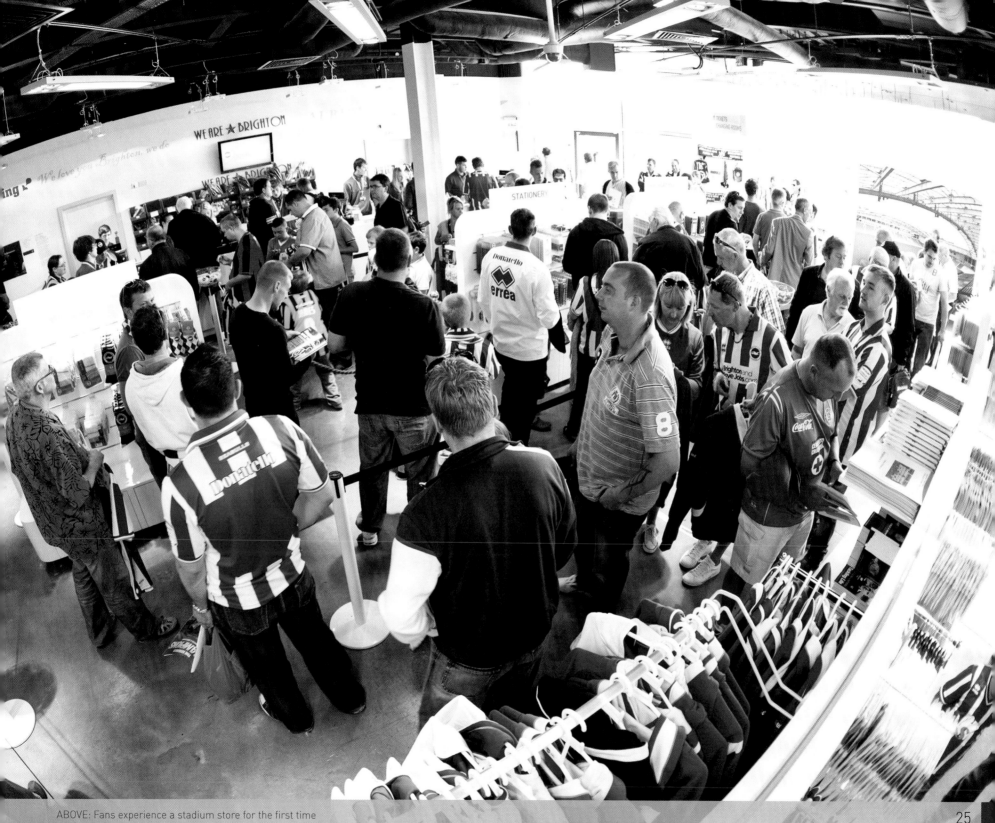

ABOVE: Fans experience a stadium store for the first time

ON THE ROAD

"The first time you go away from home in a new division it can be ver hard for you. I think Portsmouth was one of those games where w knew we could play but we had to fight as well as play, and we showe that we could compete. At the time they were one of the biggest team in the league, and those sort of games were key for us."
Liam Bridcutt, Midfielder

"They thought they could bully us. They thought it was okay for ther to push us around but we all stood up to them and we came awa on top. We play football but we have also shown we can do the dirt work."
Craig Noone, Midfielder

"We were playing against a good Portsmouth side but we kept playin football, we kept our identity as a football club and we showed grea strength."
Gus Poyet

ABOVE: The squad warm up at Fratton Park

ABOVE: Craig Mackail-Smith begins his tally for the Seagulls

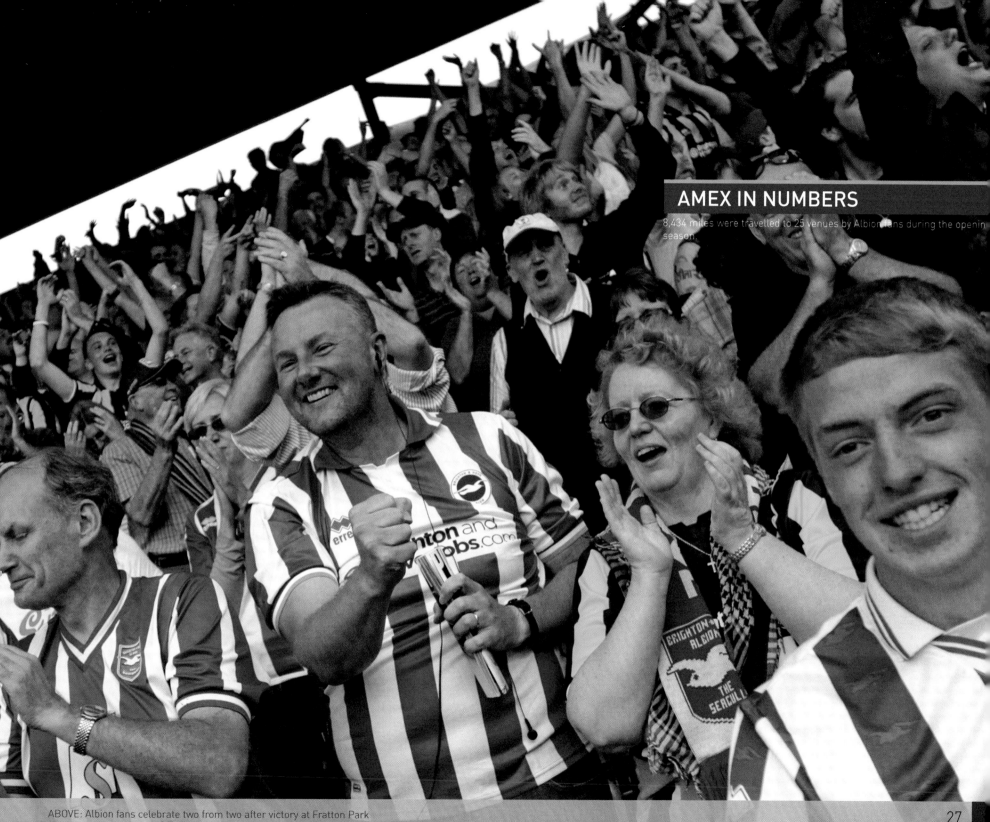

AMEX IN NUMBERS

8,434 miles were travelled to 25 venues by Albion fans during the openin season.

ABOVE: Albion fans celebrate two from two after victory at Fratton Park

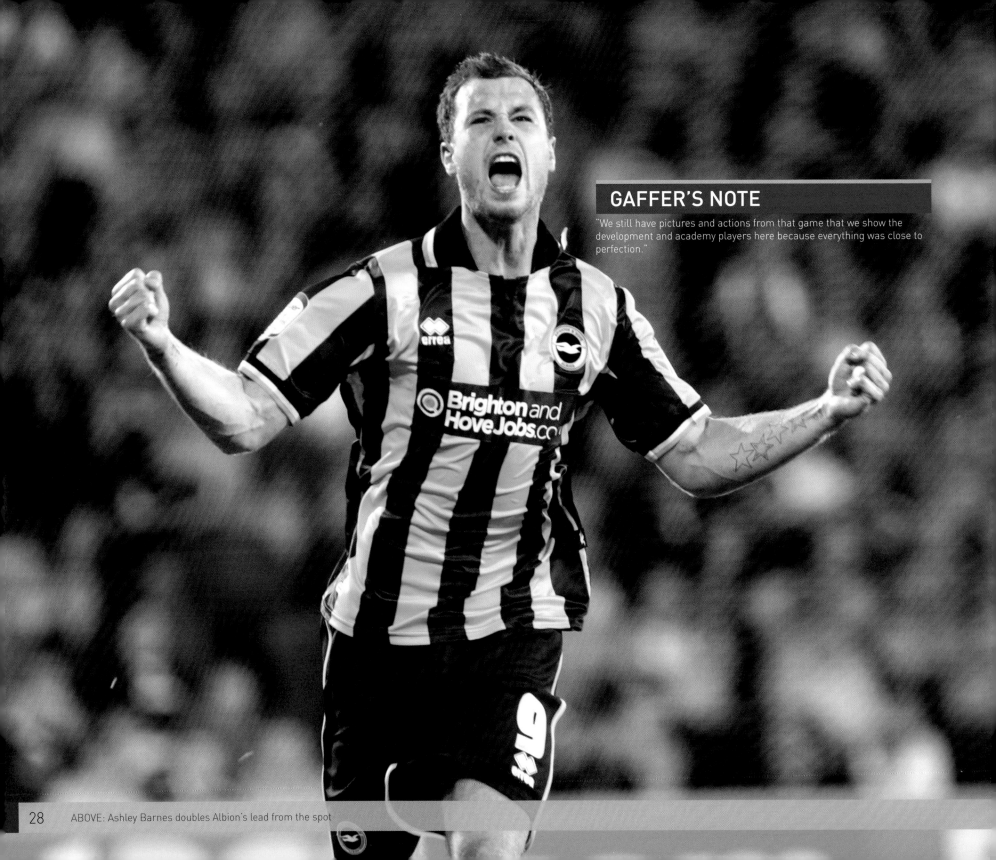

"We still have pictures and actions from that game that we show the development and academy players here because everything was close to perfection."

ABOVE: Ashley Barnes doubles Albion's lead from the spot

OUR FOOTBALL

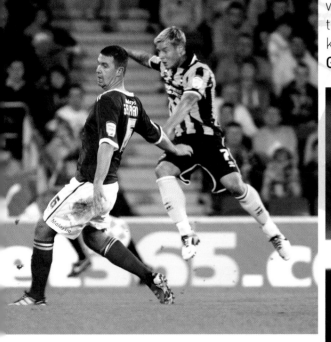

"I think Cardiff was our best game away from home without any doubt this season. We were probably similar to the previous year, even Cardiff were very surprised. They were not expecting a newly promoted team to come away from home and control the game the way we did. There were too many questions beforehand: can they play the same way as they did in League 1, can they control the game, can they pass it? And we proved, yes, it was possible. Not only in the opening games but in the first month or two as well. The way we defended, the way we were organised, how we kept the ball, when to attack, when to hold it, when to score. So the feeling at that moment was 'Well, here we go, no? Who knows what is going to happen this year..."

Gus Poyet

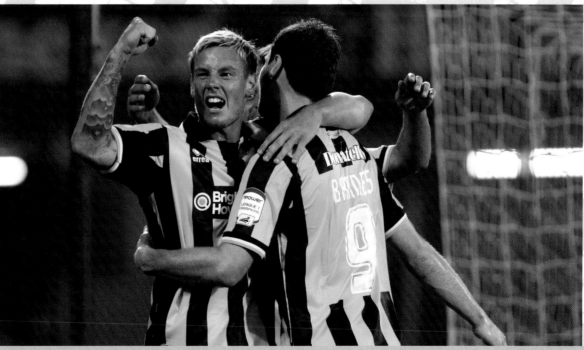

ABOVE/ RIGHT: Will Hoskins celebrates as he nets Albion's third of the evening, capping an impressive victory against the Bluebirds

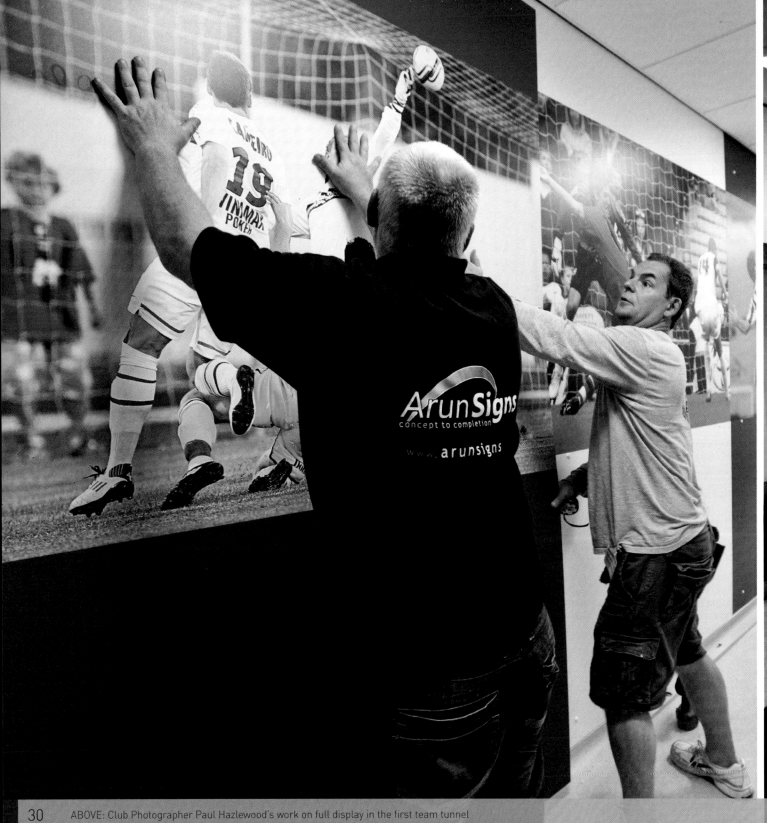

ABOVE: Club Photographer Paul Hazlewood's work on full display in the first team tunnel

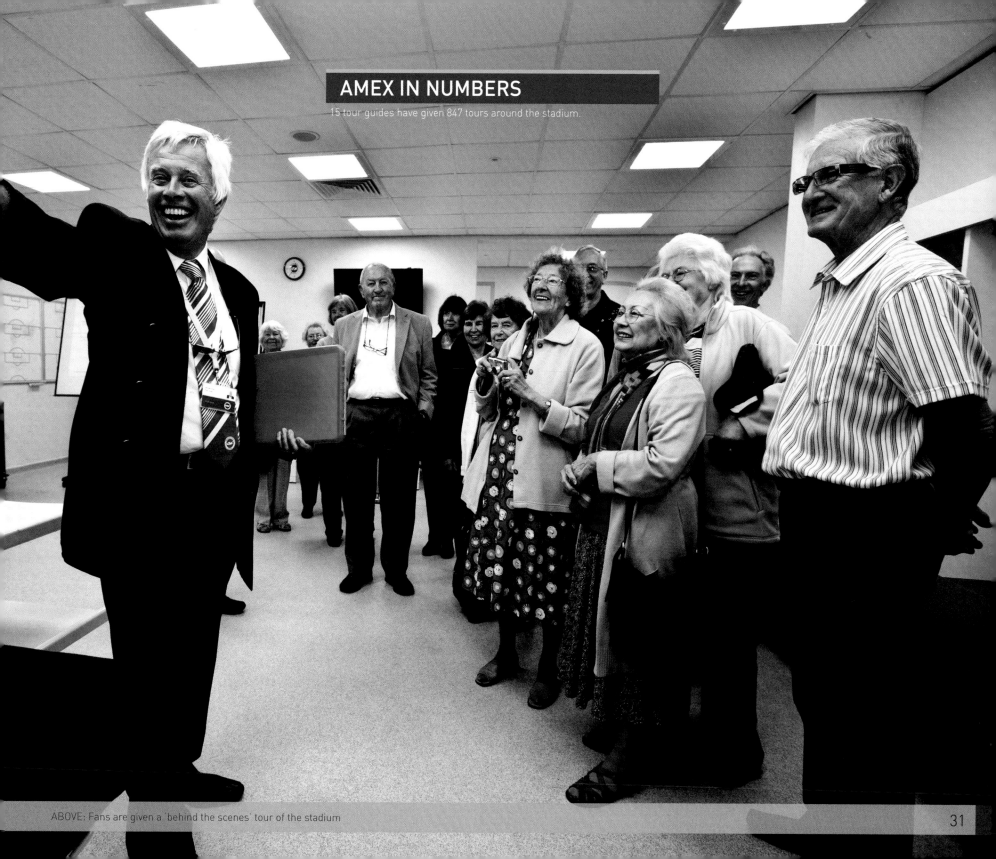

AMEX IN NUMBERS

15 tour guides have given 847 tours around the stadium.

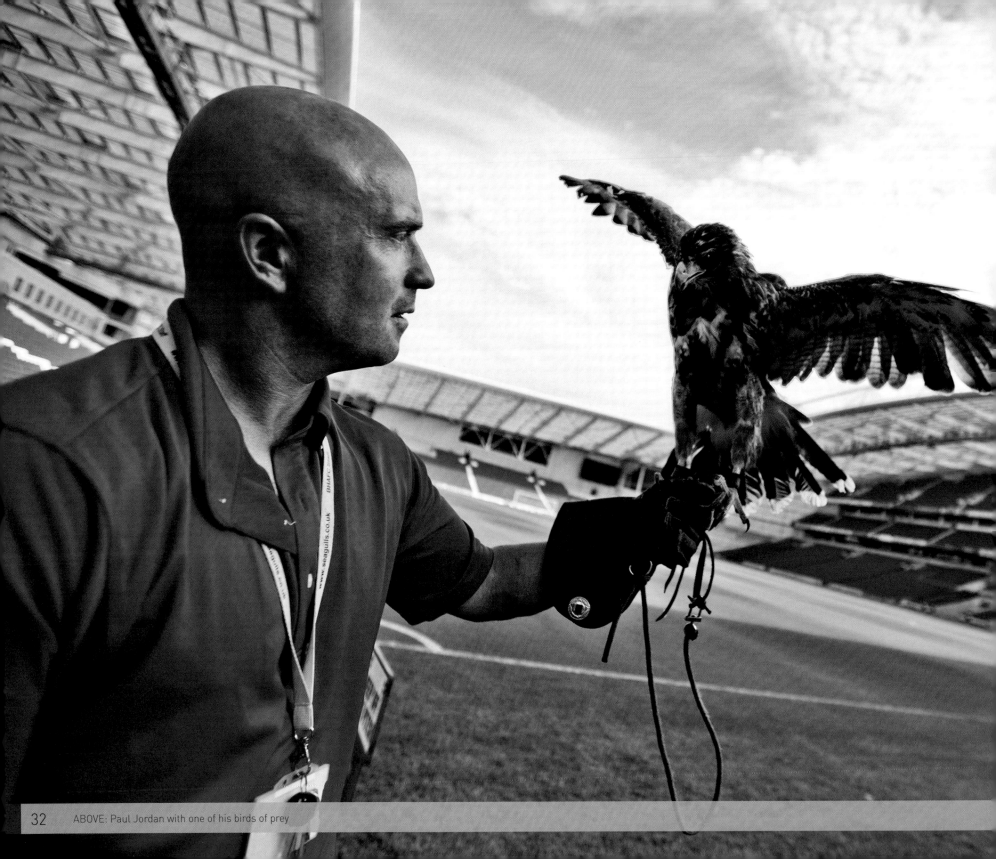

ABOVE: Paul Jordan with one of his birds of prey

THE BIRDMAN

"As a member of the Stadium Maintenance team, some of my spare time is spent keeping and training birds of prey. The club use my service as a humane way of keeping pigeons and seagulls from nesting beneath the arches of the stadium roof. On one occasion, a bird was released outside the stadium. Thinking that a supporting beam beneath Dick's Bar might be a good spot to take refuge, the majestic creature headed straight for it. Fans in the bar were given quite a shock when the 5lb hawk suddenly crashed into the window! Thankfully nothing but his pride was damaged, but I've only released him in the stadium bowl since that day."

Paul Jordan, Stadium Maintenance

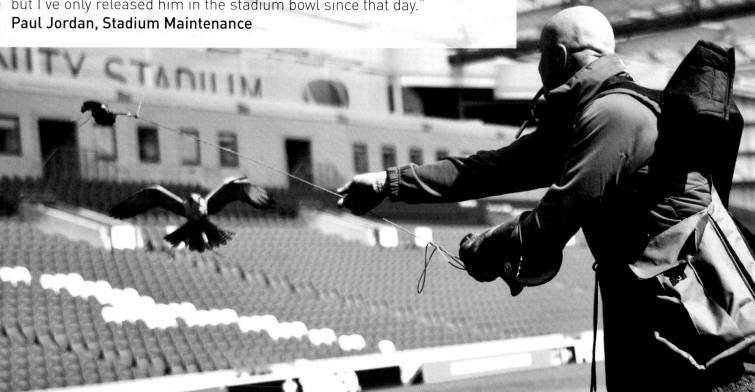

ABOVE: Paul Jordan releases the bird inside the stadium bowl

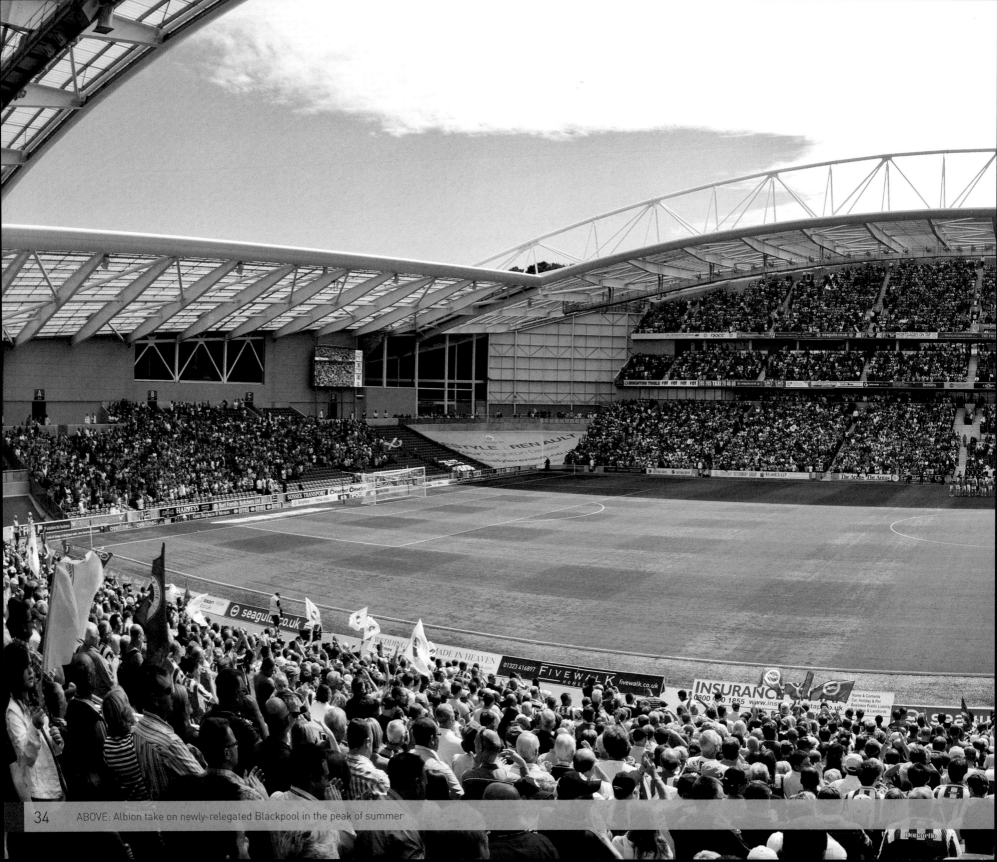

ABOVE: Albion take on newly-relegated Blackpool in the peak of summer

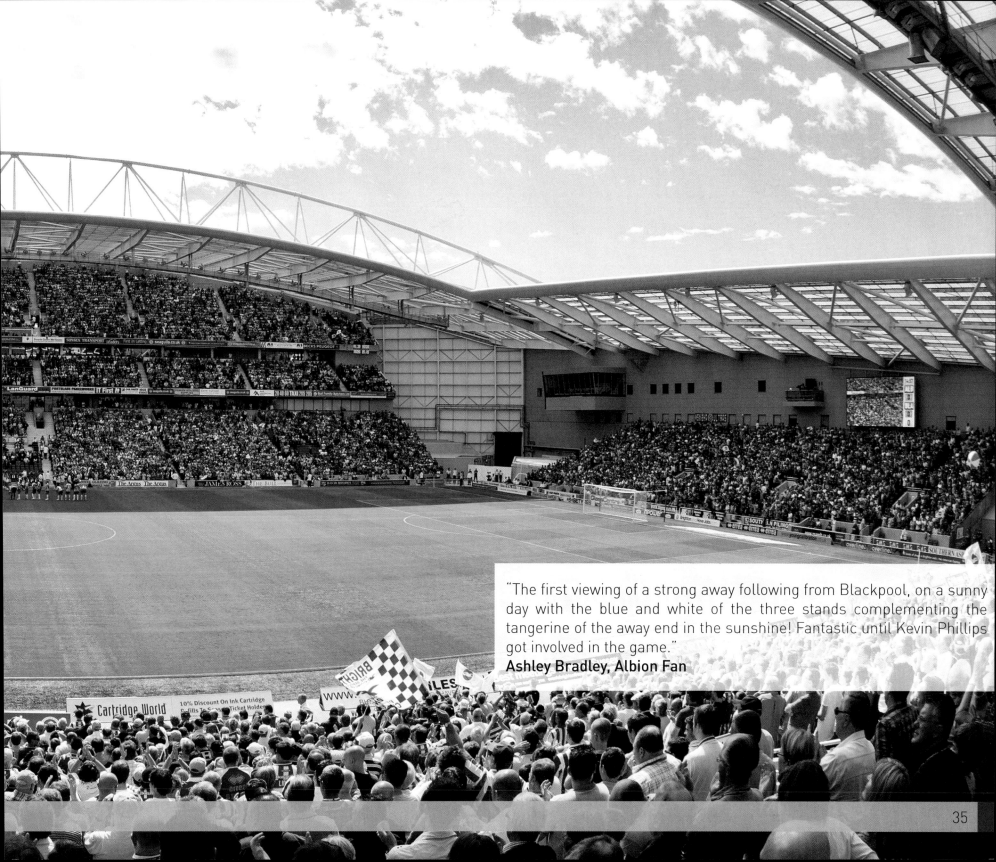

"The first viewing of a strong away following from Blackpool, on a sunny day with the blue and white of the three stands complementing the tangerine of the away end in the sunshine! Fantastic until Kevin Phillips got involved in the game."
Ashley Bradley, Albion Fan

THE SETBACK

"I'm really pleased how far we've all come as a squad and also myself, because on a personal level I'm happy with the contribution I made. It just shows the progress we've made to be disappointed with a point against a team that's just dropped out of the Premiership."
Craig Noone

"We tried to play our own game and we were not phased by the opposition. Having said this, that day was the confirmation we have some rules and some basics we need to do all the time, and if you don't do them you pay the price, and we paid the price with Kevin Phillips in two simple actions. Normally, we would do better."
Gus Poyet

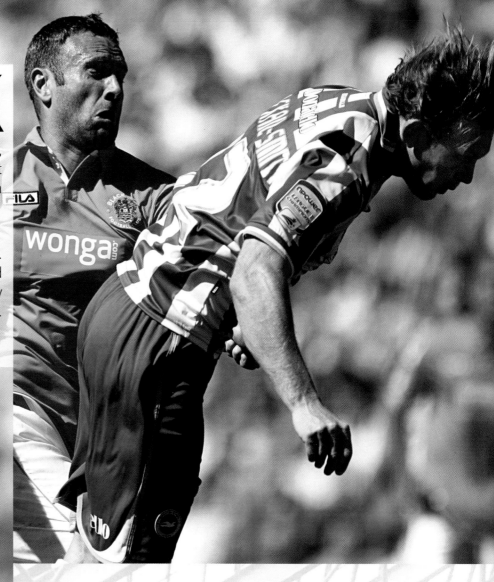

ABOVE: Gus Poyet looks on ecstatically as the Seagulls take the lead ABOVE: Craig Noone's superbly weighted cross finds Albion's centre-forward

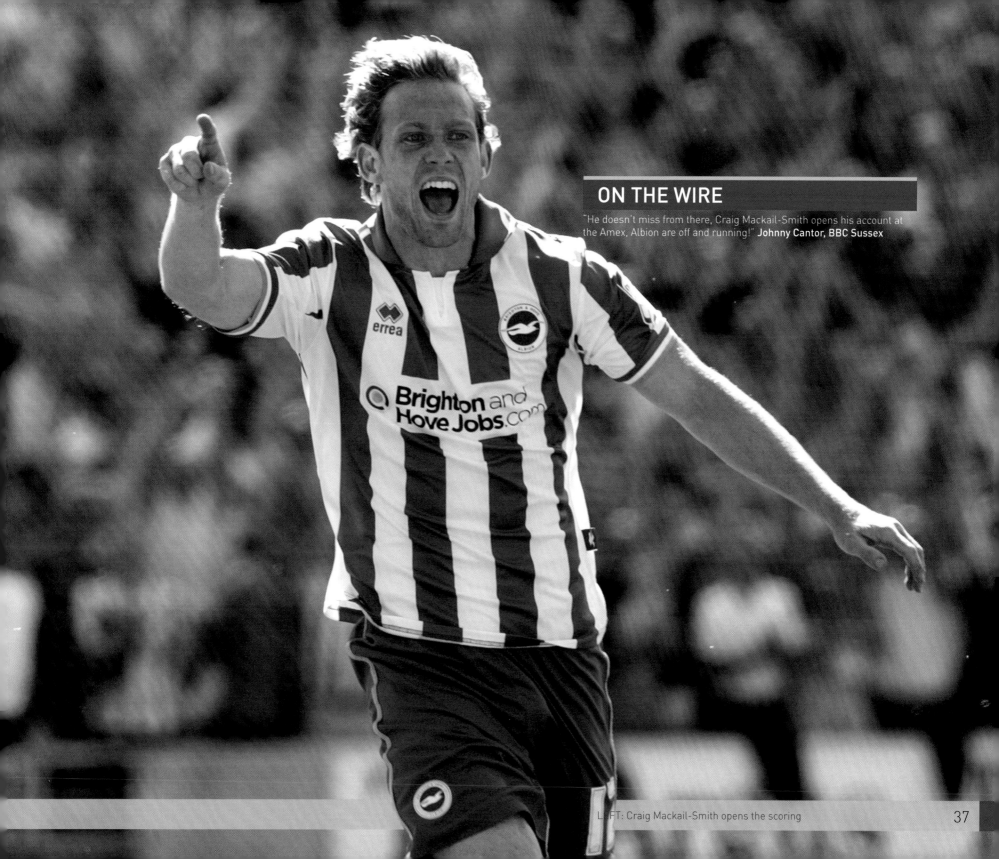

ON THE WIRE

"He doesn't miss from there, Craig Mackail-Smith opens his account at the Amex, Albion are off and running!" **Johnny Cantor, BBC Sussex**

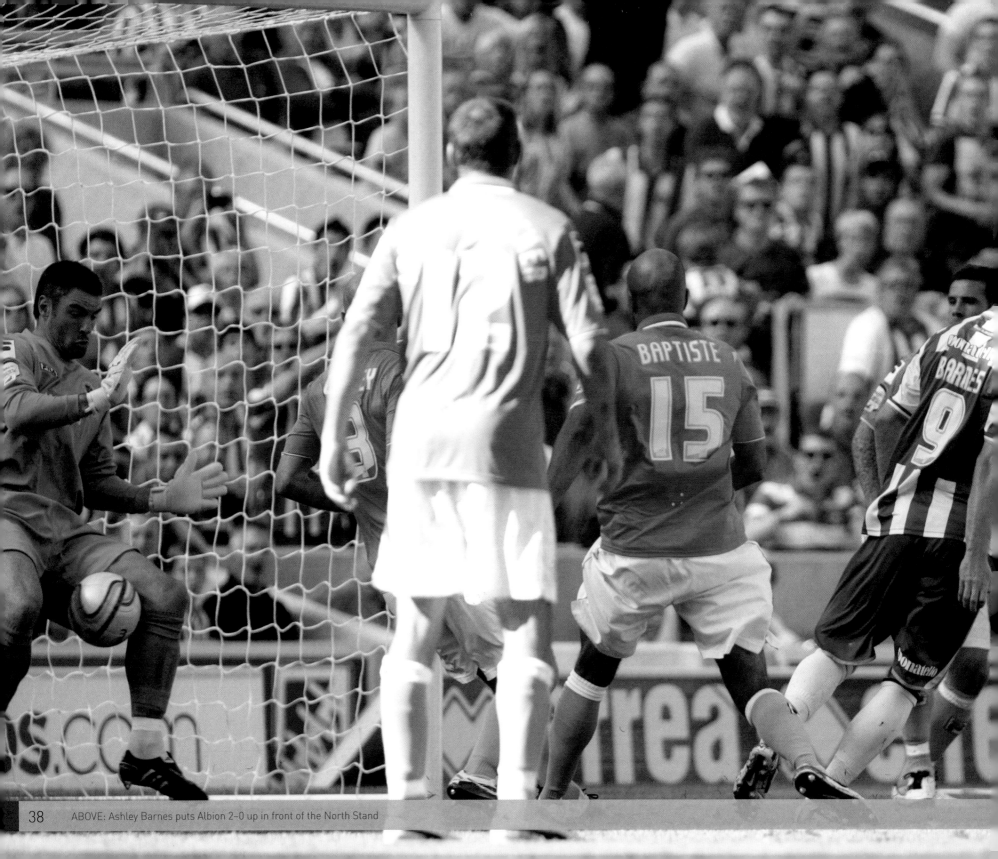

ABOVE: Ashley Barnes puts Albion 2–0 up in front of the North Stand

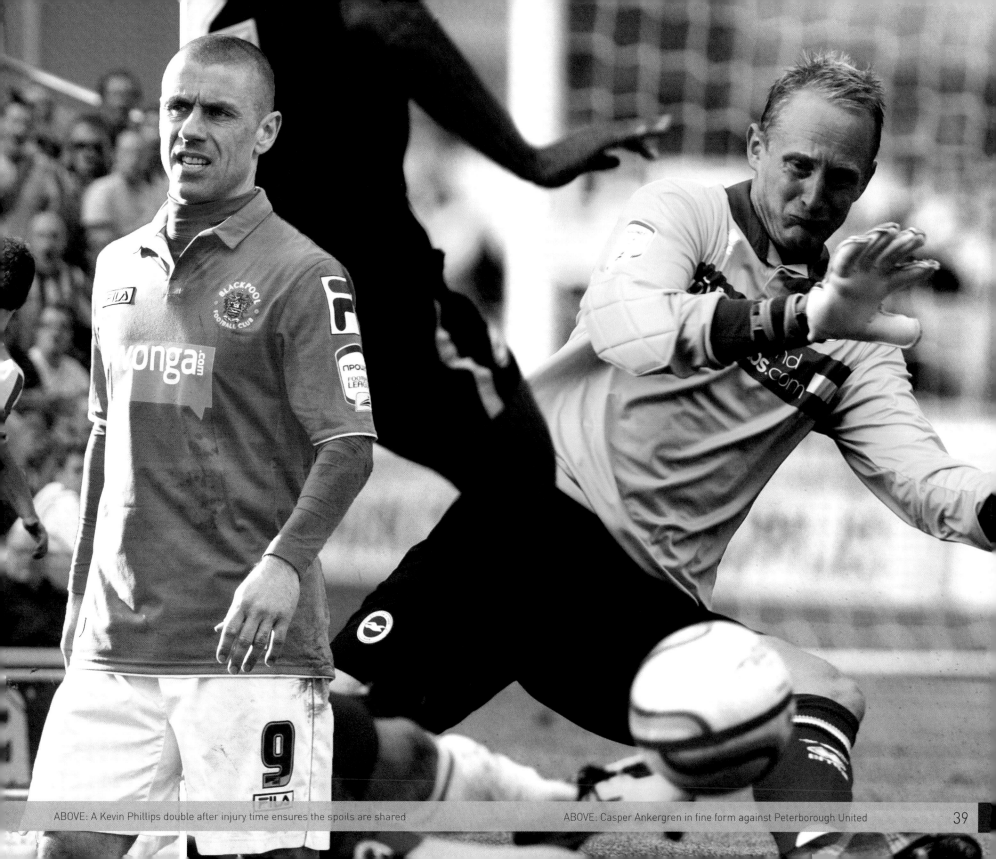

ABOVE: A Kevin Phillips double after injury time ensures the spoils are shared

ABOVE: Casper Ankergren in fine form against Peterborough United

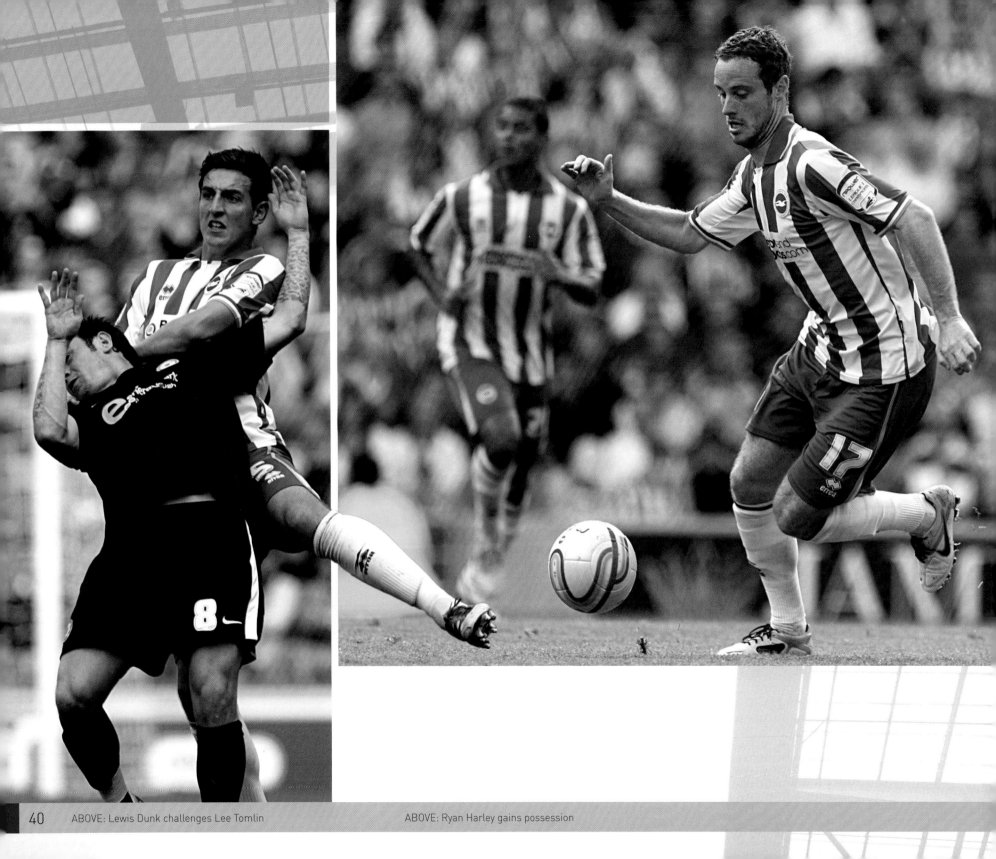

ABOVE: Lewis Dunk challenges Lee Tomlin

ABOVE: Ryan Harley gains possession

LEAGUE LEADERS

"Sometimes after maybe two or three games you can find yourself up there, but after a month's worth of results to be sitting top? I think it was nice, I think it was confirmation it was possible if we kept a high standard in terms of performances, and after that we needed to maintain it. People always say all over the world that it's difficult but not *that* difficult to get to the top, the difficulty is maintaining yourself up there, and that was the key. Then people start to talk about momentum, being a new team, surprise, adrenaline or whatever it is. But we were there."
Gus Poyet

"It was great to get into that position early on. I don't know how many of us felt that we necessarily had the strength to stay there, but it was great to get off on that footing. If you start on the other side, very poorly, it can be difficult to recover."
Tony Bloom

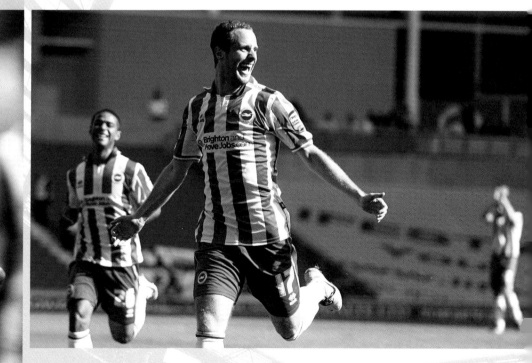

ABOVE: Craig Noone opens the scoring against Peterborough

ABOVE: Ryan Harley doubles Albion's lead from 35 yards

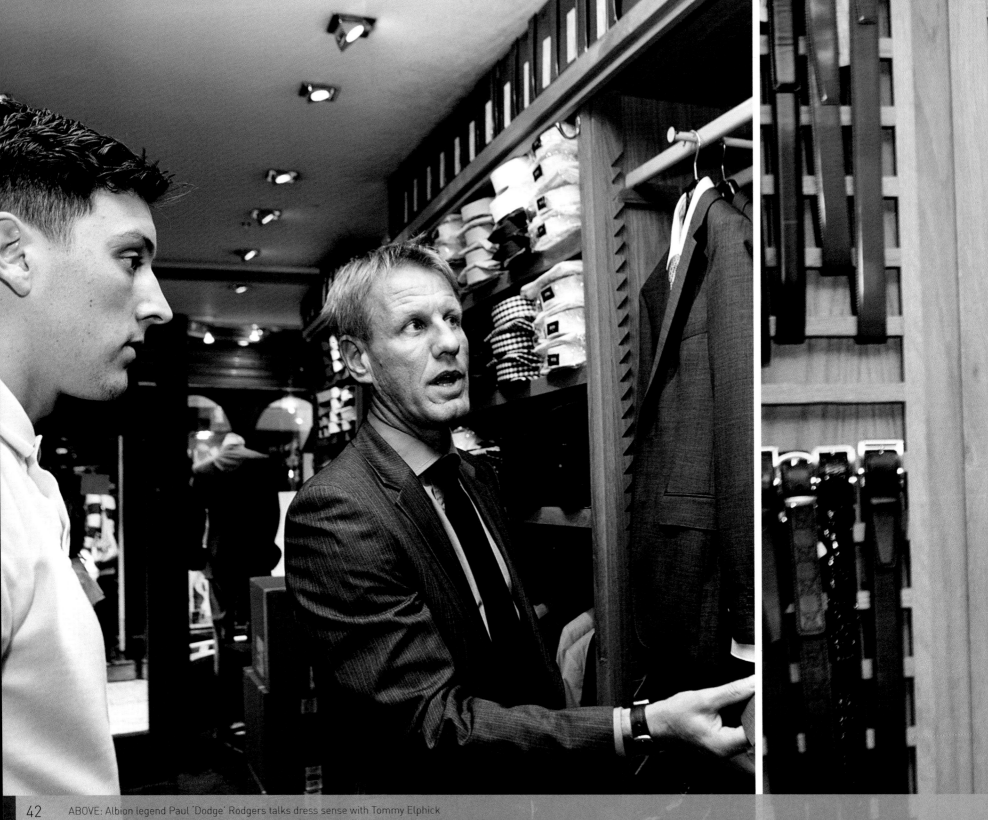

ABOVE: Albion legend Paul 'Dodge' Rodgers talks dress sense with Tommy Elphick

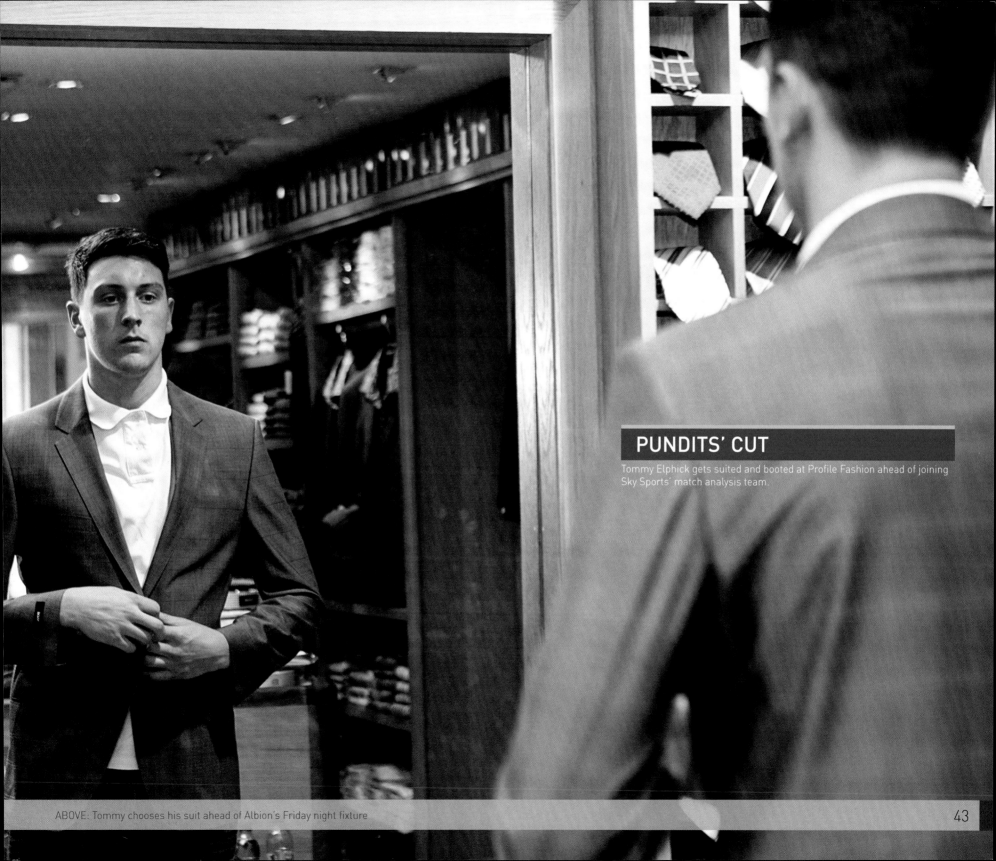

PUNDITS' CUT

Tommy Elphick gets suited and booted at Profile Fashion ahead of joining Sky Sports' match analysis team.

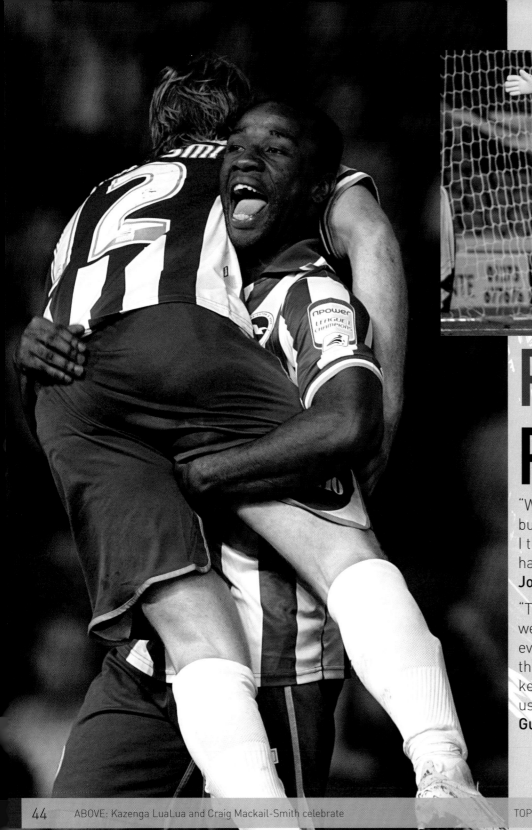

PREMIER PEDIGREE

"We'd been to Aston Villa, we'd been to Stoke in the last couple of year but this was a little bit different because they *came* to the new stadium I think I suppose, a reflection of the first season was that such big team had come."
Johnny Cantor, Commentator

"The feeling in the dressing room was one of happiness, but we kne we needed to keep things calm. We'd had a dream start and every wee everything was getting bigger and better. At the same time we couldr think we were better than we were and lose our rhythm. We needed keep our identity and keep playing consistently, because that's what wir us matches."
Gus Poyet

ABOVE: Kazenga LuaLua and Craig Mackail-Smith celebrate TOP: Craig Mackail-Smith beats Keiren Westwood in injury time

CHAIRMAN SAYS

"We were superb, because they are a mid-table, at least, Premiership team and we comfortably won. It really set us up for the beginning of the season and showed that we weren't afraid of anyone."

ABOVE:Romain Vincelot challenges Wes Brown and Anton Ferdinand

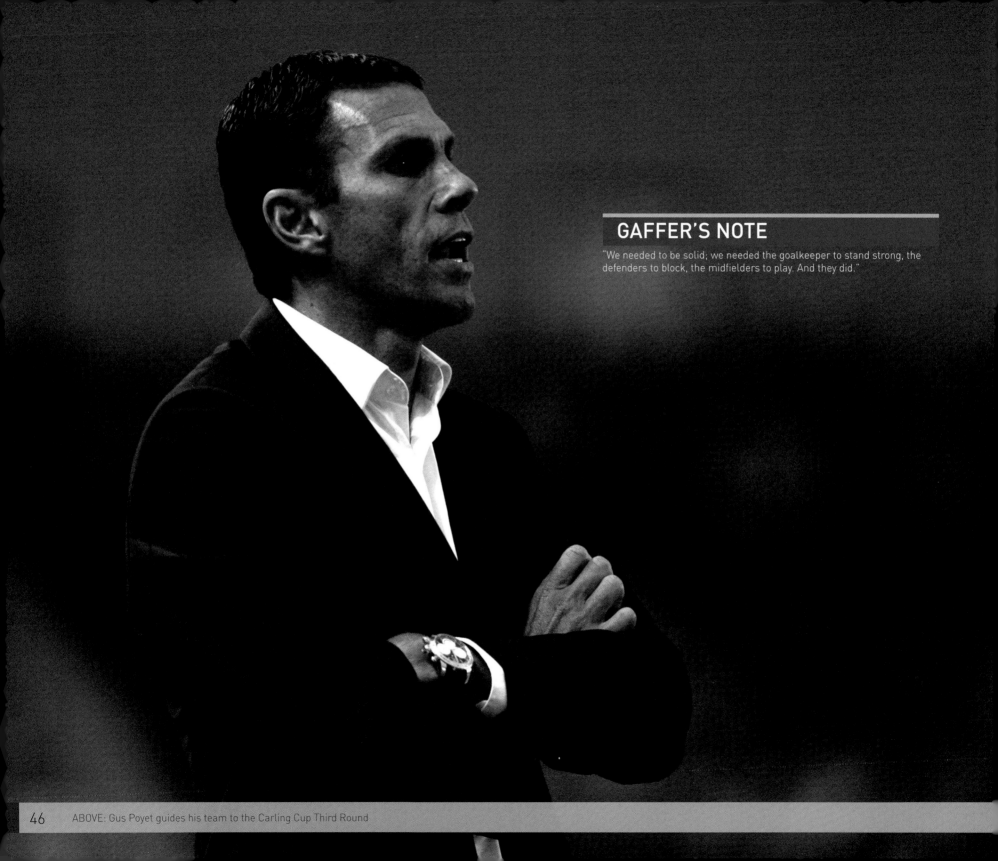

GAFFER'S NOTE

"We needed to be solid; we needed the goalkeeper to stand strong, the defenders to block, the midfielders to play. And they did."

ABOVE: Gus Poyet guides his team to the Carling Cup Third Round

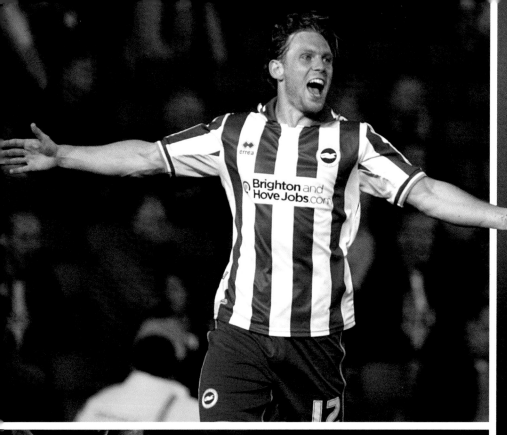

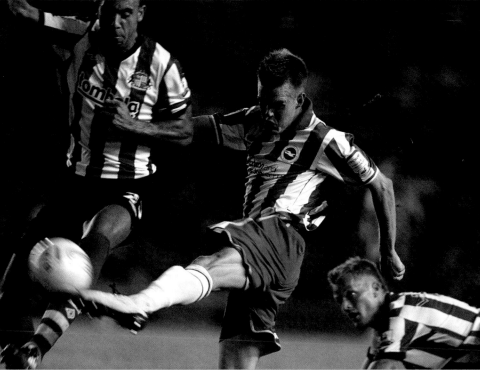

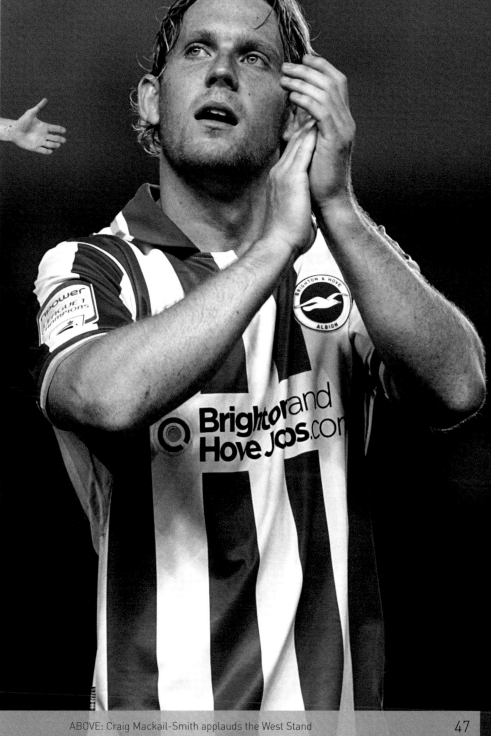

ABOVE: Iñigo Calderón translates for Vicente's first press conference

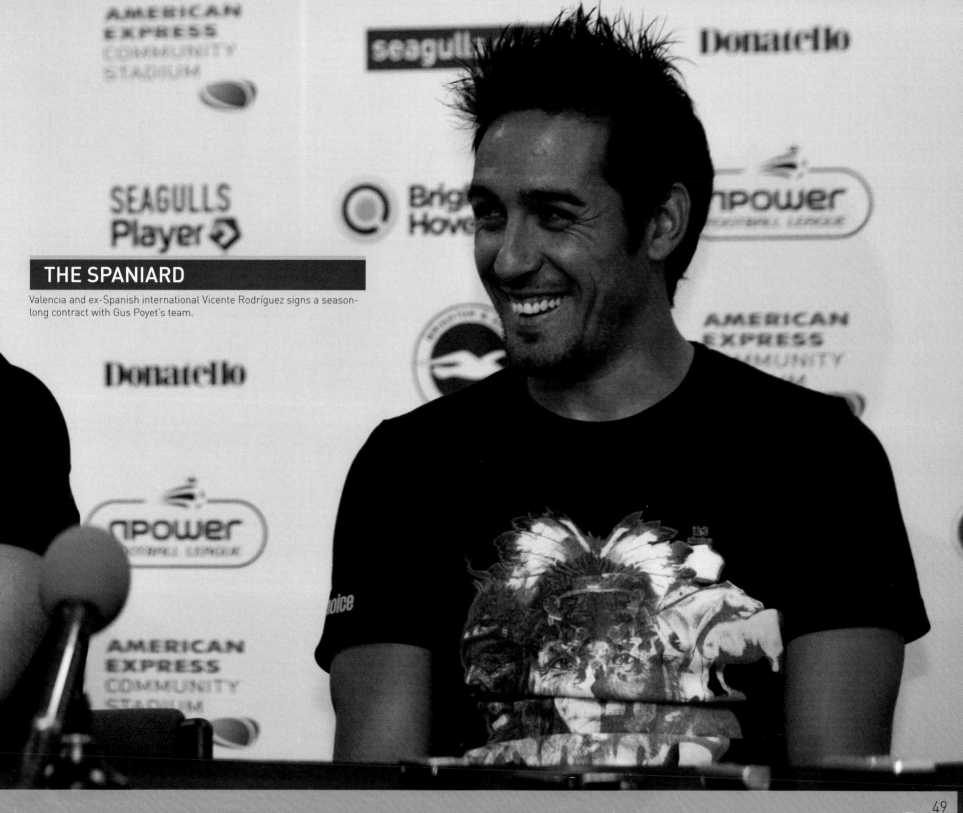

THE SPANIARD

Valencia and ex-Spanish international Vicente Rodríguez signs a season-long contract with Gus Poyet's team.

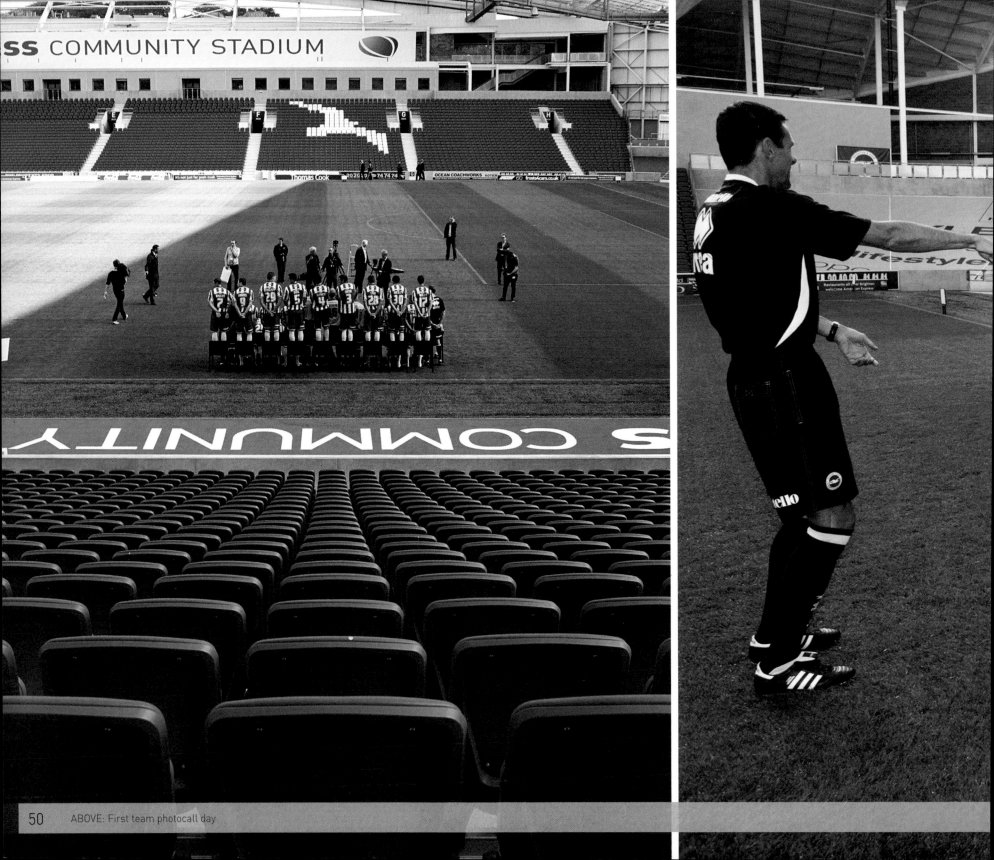

ABOVE: First team photocall day

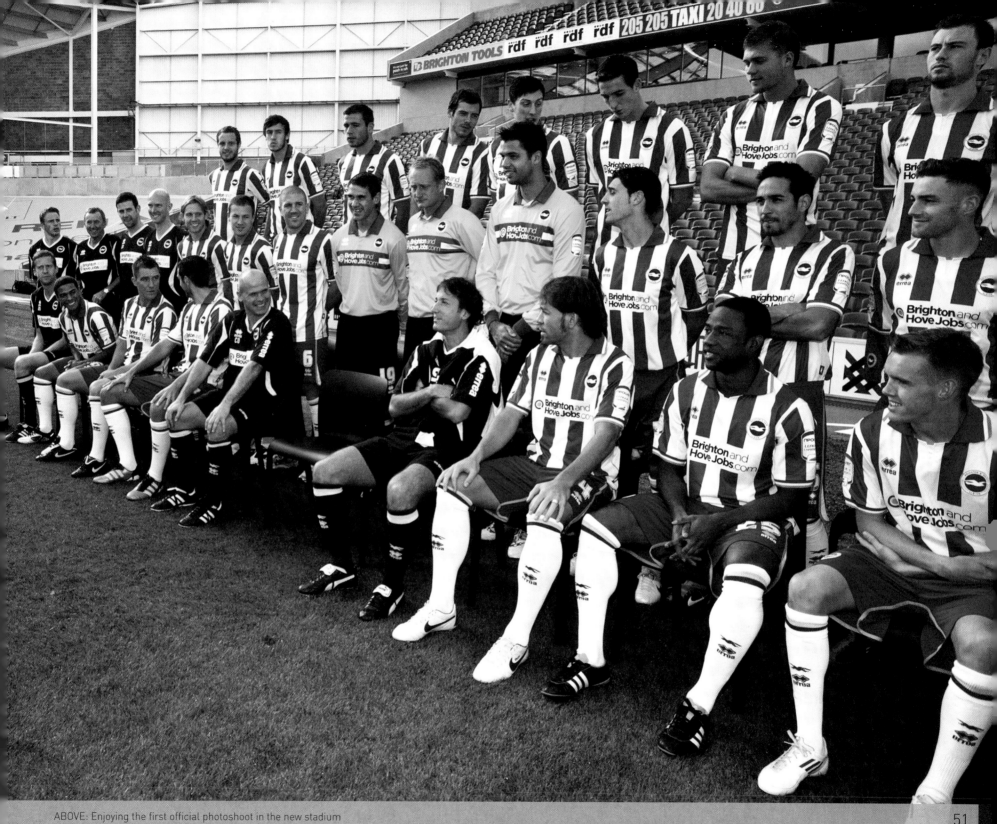

ABOVE: Enjoying the first official photoshoot in the new stadium

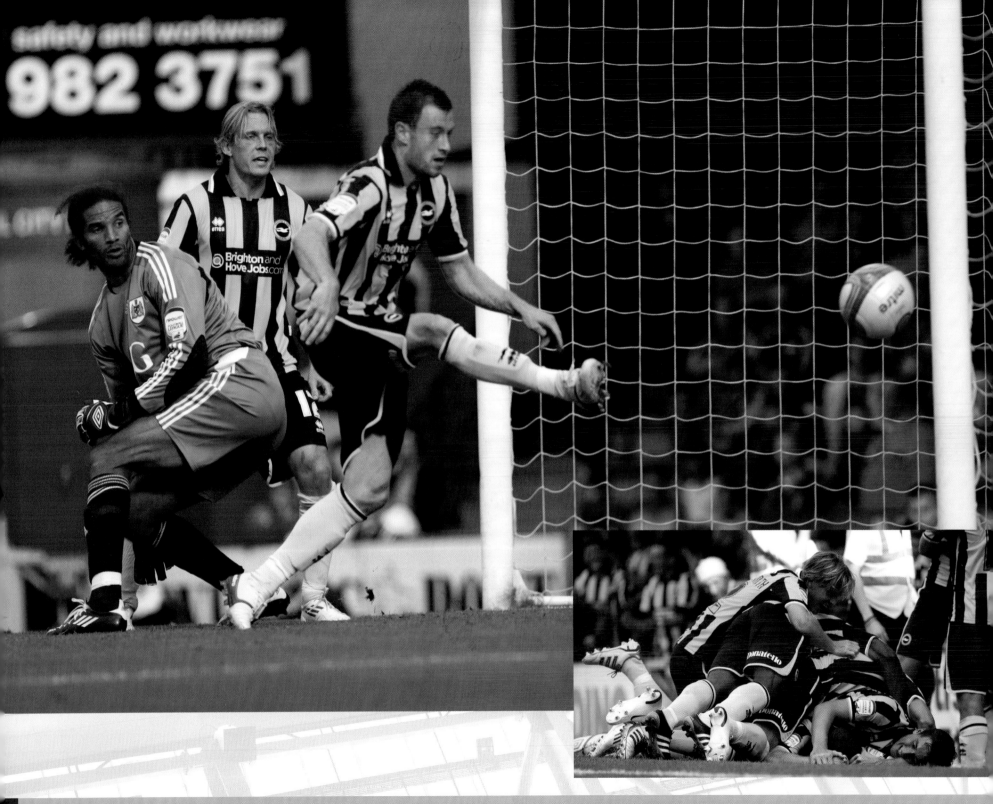

ABOVE: Ashley Barnes finds the net from less than a yard

ABOVE: Players celebrate victory at Ashton Gate

MOMENTUM

"We started playing our football in the first minute and tried to keep playing right until the end. We never stopped playing and we never stopped moving the ball on the ground, which is pleasing."
Gus Poyet

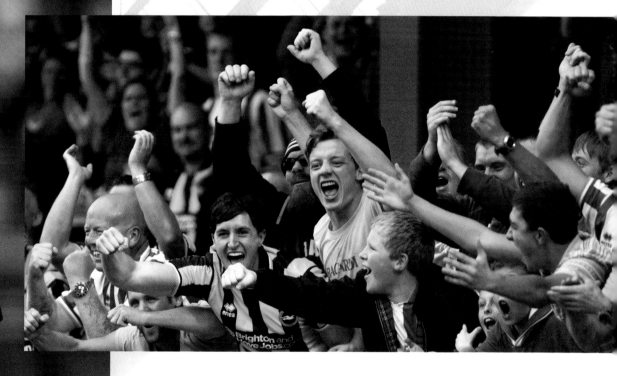

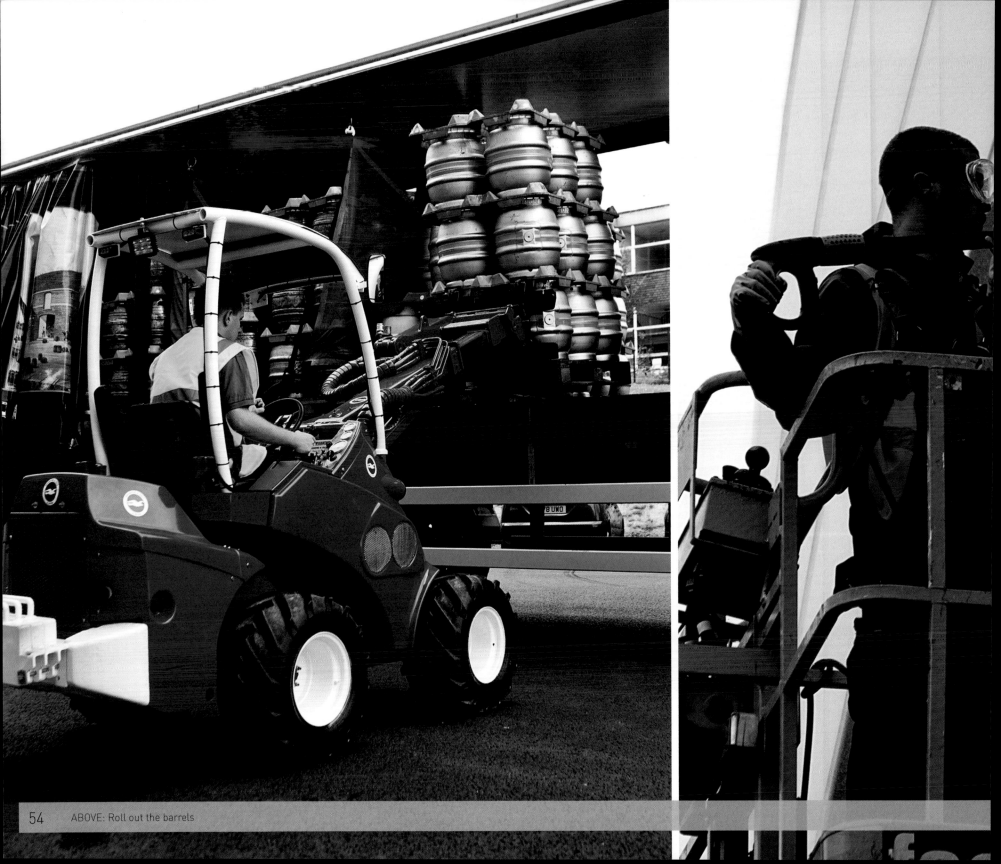

ABOVE: Roll out the barrels

AMEX IN NUMBERS

39,148 man hours of cleaning were undertaken, during which time 717 windows were regularly cleaned.

ABOVE: The front of the West Stand is cleaned

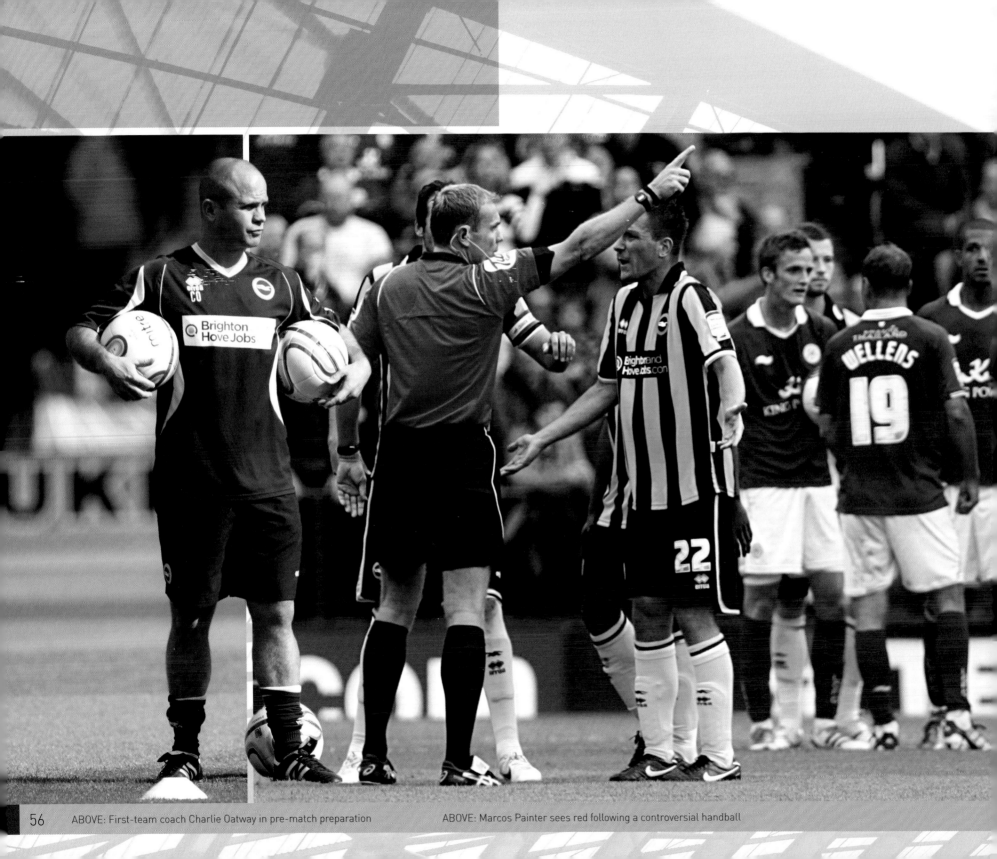

ABOVE: First-team coach Charlie Oatway in pre-match preparation ABOVE: Marcos Painter sees red following a controversial handball

FIRST BLOOD

"It's still a result that we analyse because it was a one-nil, it was close and we had two unbelievable chances, especially one, with Macca, where any other day it would have gone in. But we were a good team, and we felt we could successfully compete despite the fact that Leicester were one of the top teams in the division. We were very close to getting something from the game so afterwards we were still thinking 'we can have a great season here'. I don't think we realised what was coming after..."
Gus Poyet

ABOVE: Gus Poyet and Leicester City manager Sven Goran Eriksson

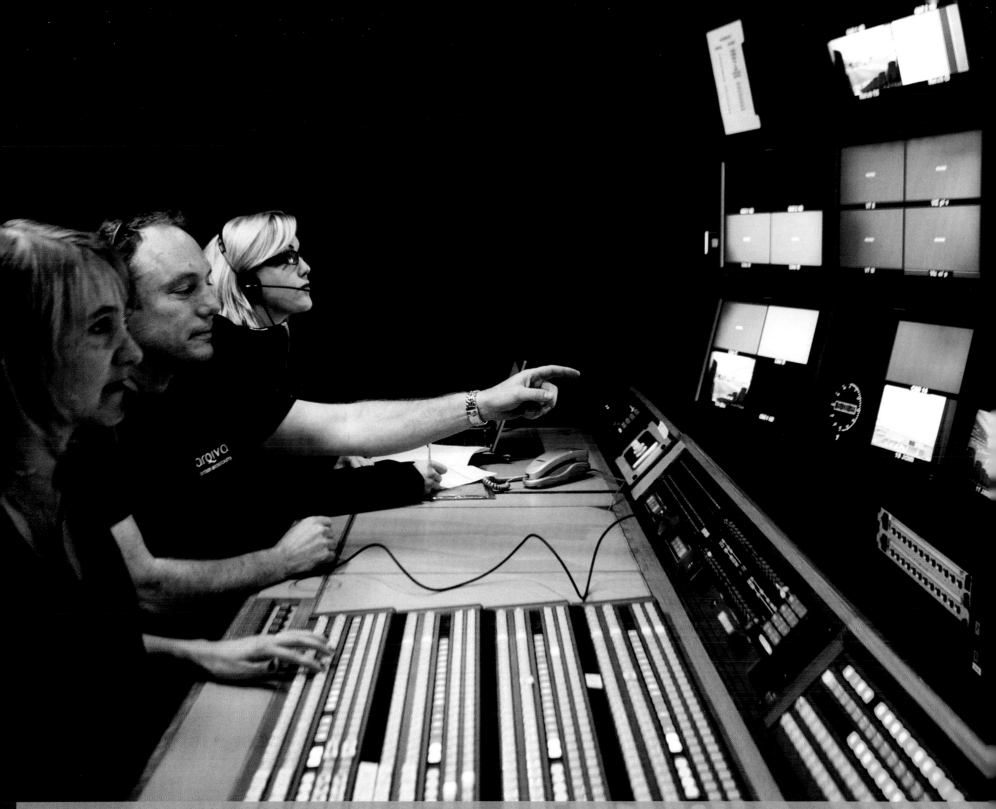

ABOVE: Crunch-time inside Arquiva's broadcast truck.

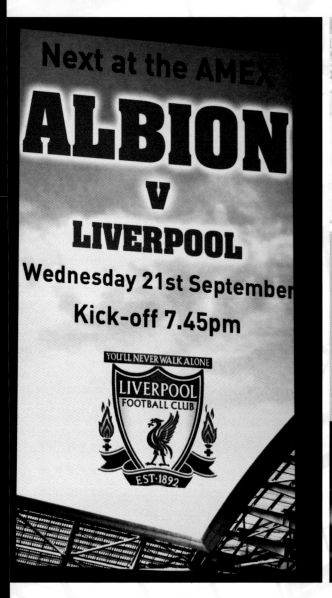

Next at the AMEX

ALBION

V

LIVERPOOL

Wednesday 21st September

Kick-off 7.45pm

YOU'LL NEVER WALK ALONE

LIVERPOOL
FOOTBALL CLUB

EST·1892

THE SETUP

"During the first season at the Amex, no fewer than 7 games were televised using between 18 and 26 cameras dotted about the pitch. On each occasion, the OB trucks roll into the Gatehouse car park 24 hours before to start the arduous process of laying cable and checking signals for all the feeds. For the game at hand we don't have to operate an in-house broadcast because we simply take a feed of their output. Hence, on a day like this we can just sit back and enjoy the football!"

Kris Hawes, Seagulls TV

HALF MARATHON

Nearly 13 kilometres of cabling is used every time a major broadcaster comes to the Amex.

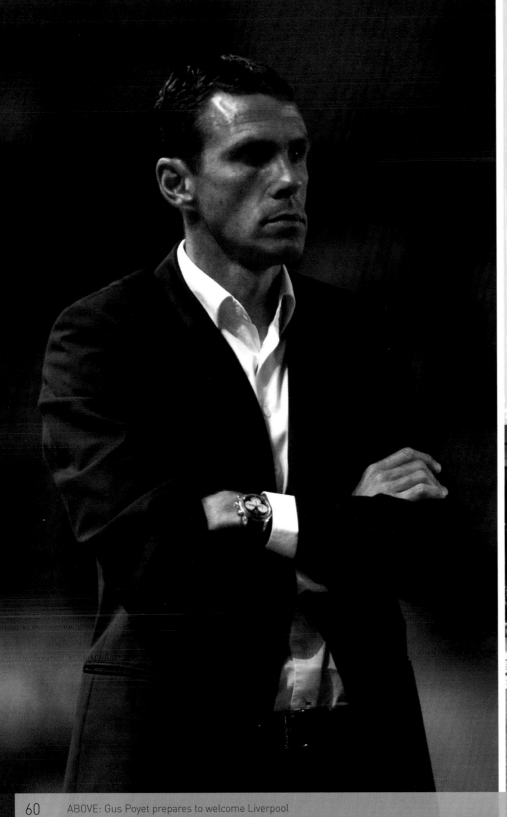

THE REDS

"It was amazing to be in the tunnel area there, seeing players that you'd normally only ever see on TV walking right past you. So that was a lot of fun and Kenny Dalglish was there, 'King Kenny' if you want to call him that. He was in his usual curmudgeonly way because, of course, he had a job to do. Gerrard was there as well, having been injured for so long. It was a shame though, I thought we should have won it."

Richard Reynolds, Pitch Presenter

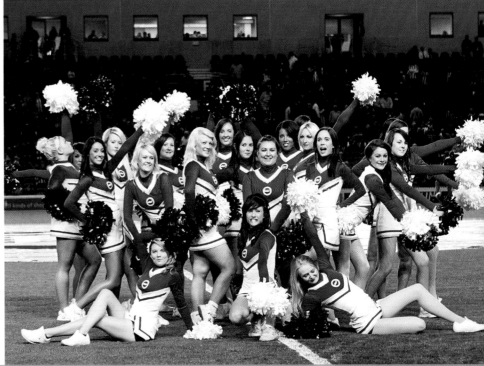

ABOVE: Gus Poyet prepares to welcome Liverpool

ABOVE: Gully's Girls perform a pre-match routine

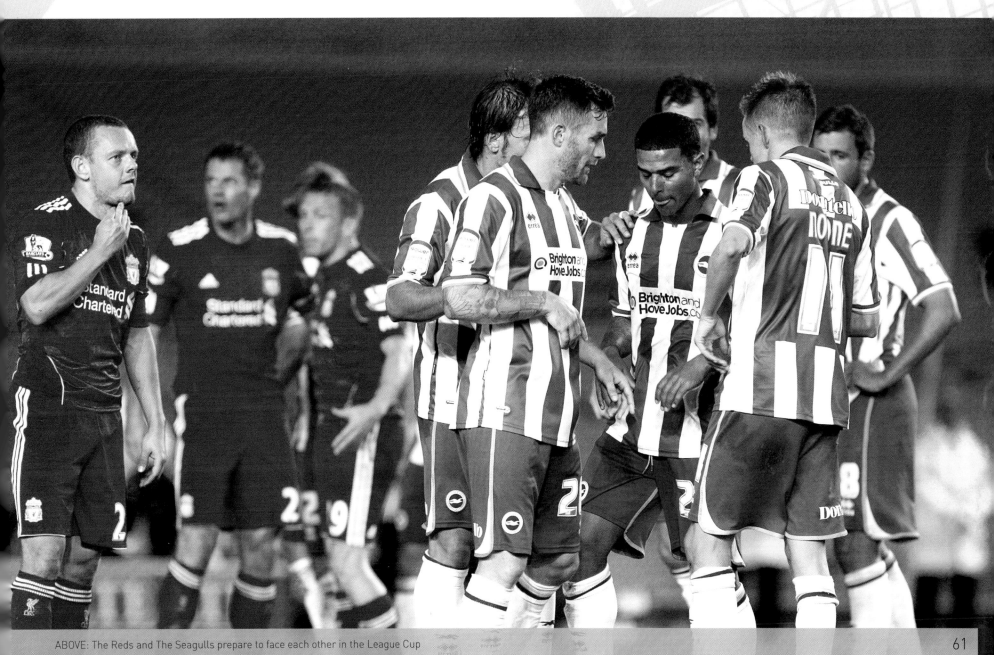

ABOVE: The Reds and The Seagulls prepare to face each other in the League Cup

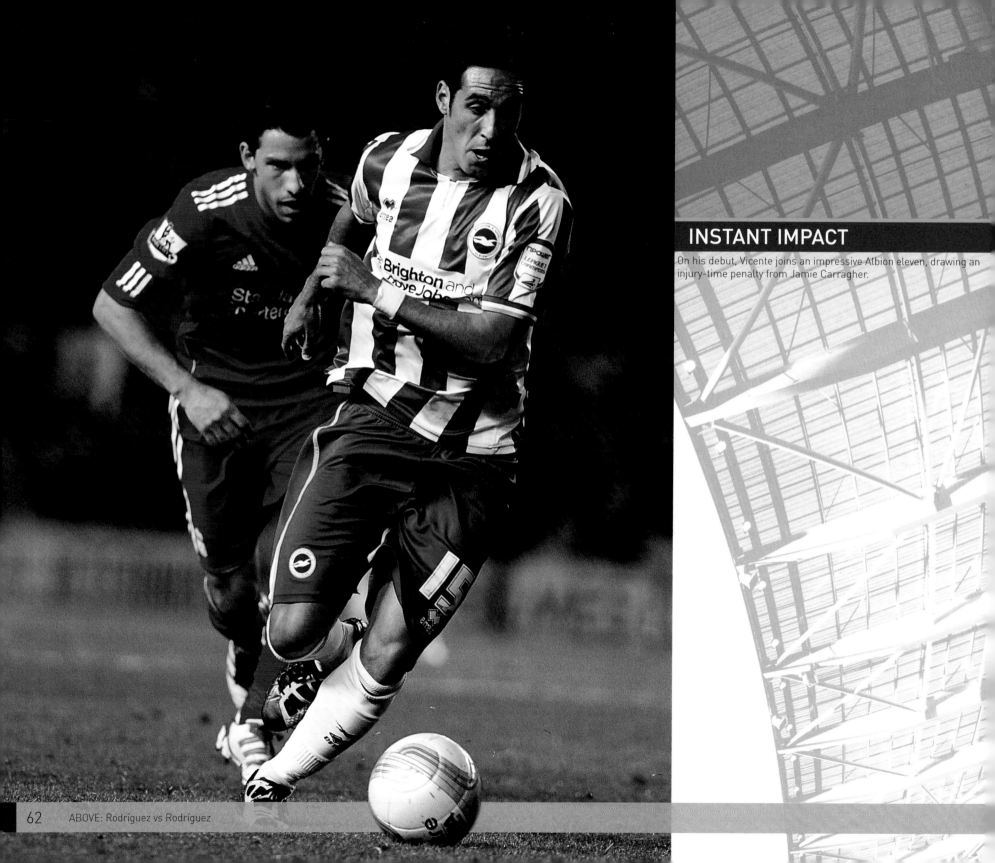

INSTANT IMPACT

On his debut, Vicente joins an impressive Albion eleven, drawing an injury-time penalty from Jamie Carragher.

ABOVE: Rodríguez vs Rodríguez

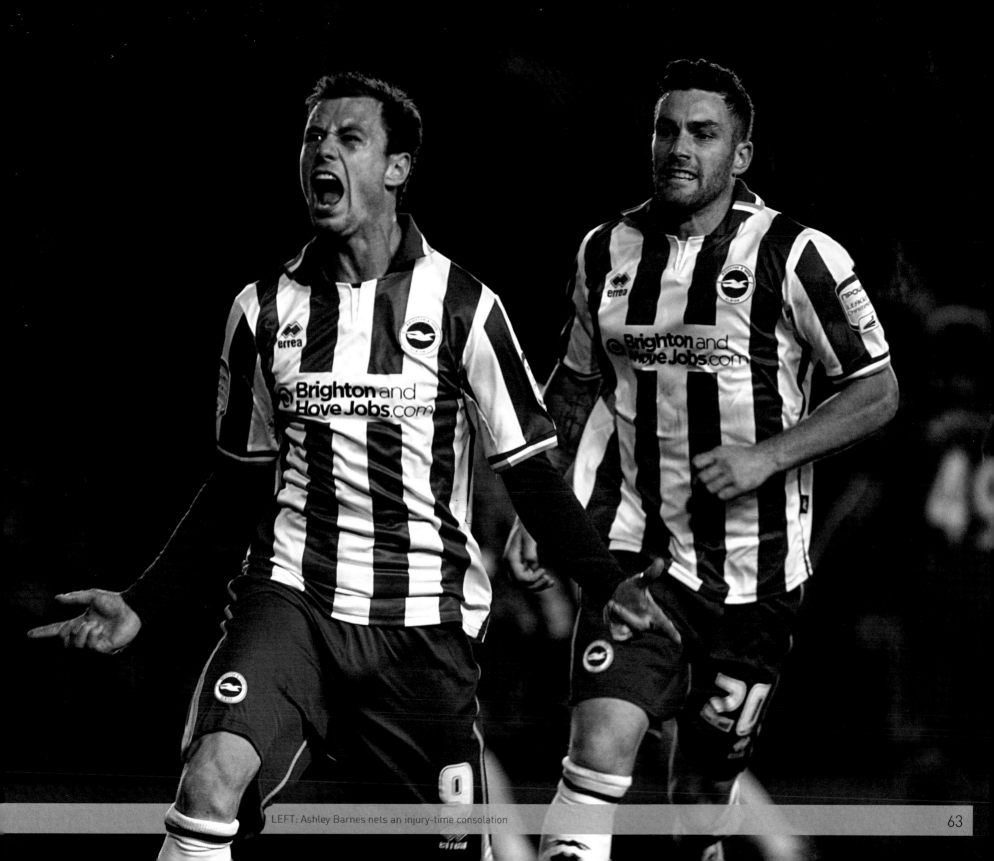

48 HOURS

"I remember choosing to play Wednesday and Friday. It was a decision we had to make without purely thinking about the performance. It was an opportunity of a big impact financially and sometimes you cannot say no. I think between Liverpool and Leeds, it was the moment, it was the timing. We put Brighton in the head of football fans all over the world. Those two games were watched all over, and the reaction from people everywhere was spectacular."
Gus Poyet

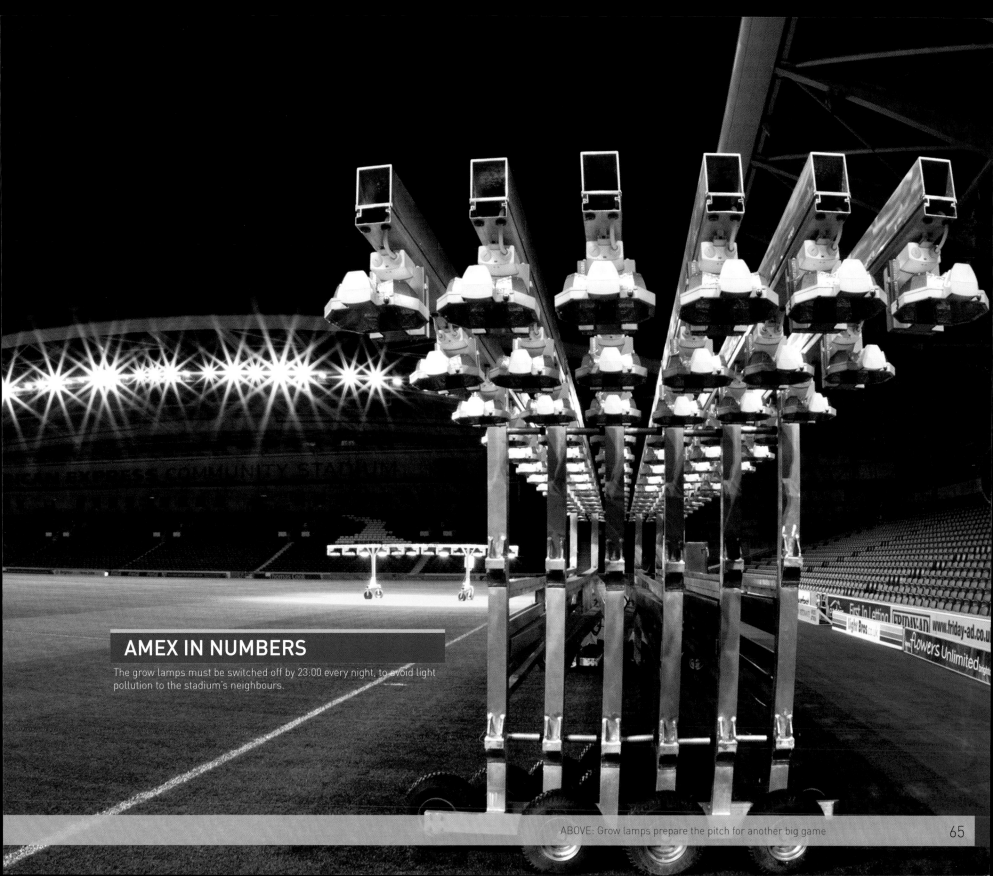

AMEX IN NUMBERS

The grow lamps must be switched off by 23:00 every night, to avoid light pollution to the stadium's neighbours.

FINDING FORM

"We gave ourselves a mountain to climb in that game; 2–0 down at home at half-time and probably looked dead and buried. But in fairness to the fans and the lads we got it back to 3–2, and the atmosphere when we scored that third goal was frightening."
Gary Dicker, Midfielder

"In the first half we were flat all the way. It was like we gave everything against Liverpool and had nothing left against Leeds. We say sometimes one difference is to be playing football or just being on the pitch and I think we were just there. Then, something was said at half-time, of course, but at the end of the day it's up to the players to react, and the momentum and the crowd, and the goals! And everything went in the other way, I mean it was spectacular."
Gus Poyet

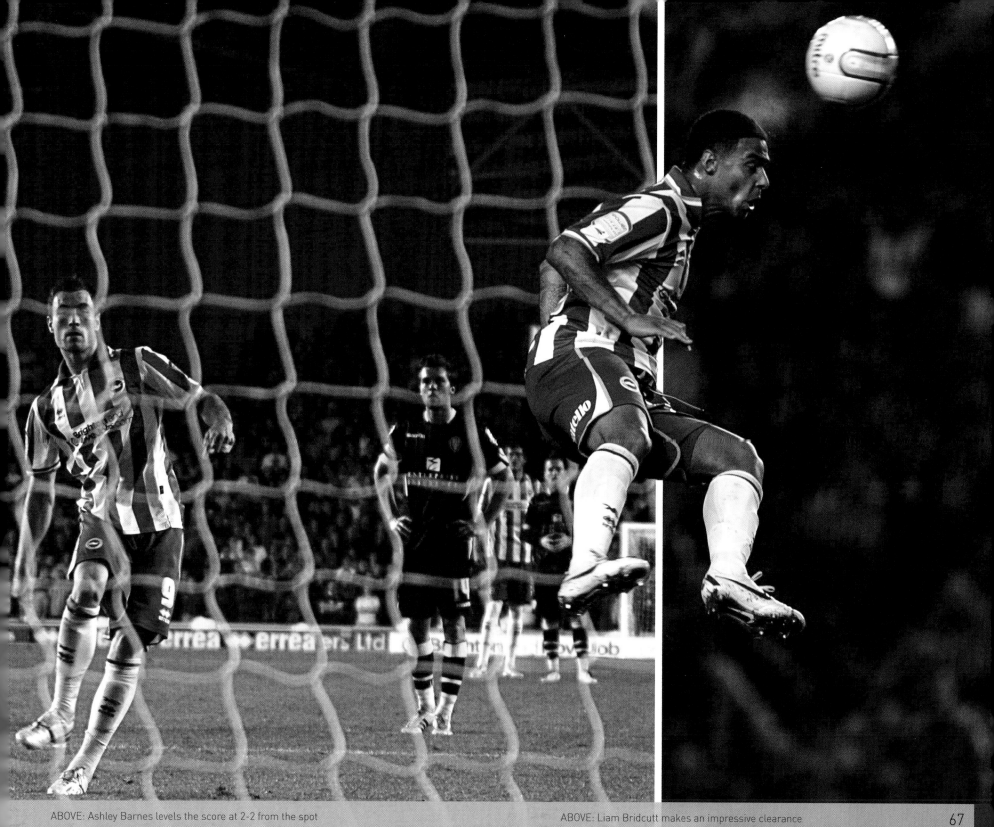

ABOVE: Ashley Barnes levels the score at 2-2 from the spot

ABOVE: Liam Bridcutt makes an impressive clearance

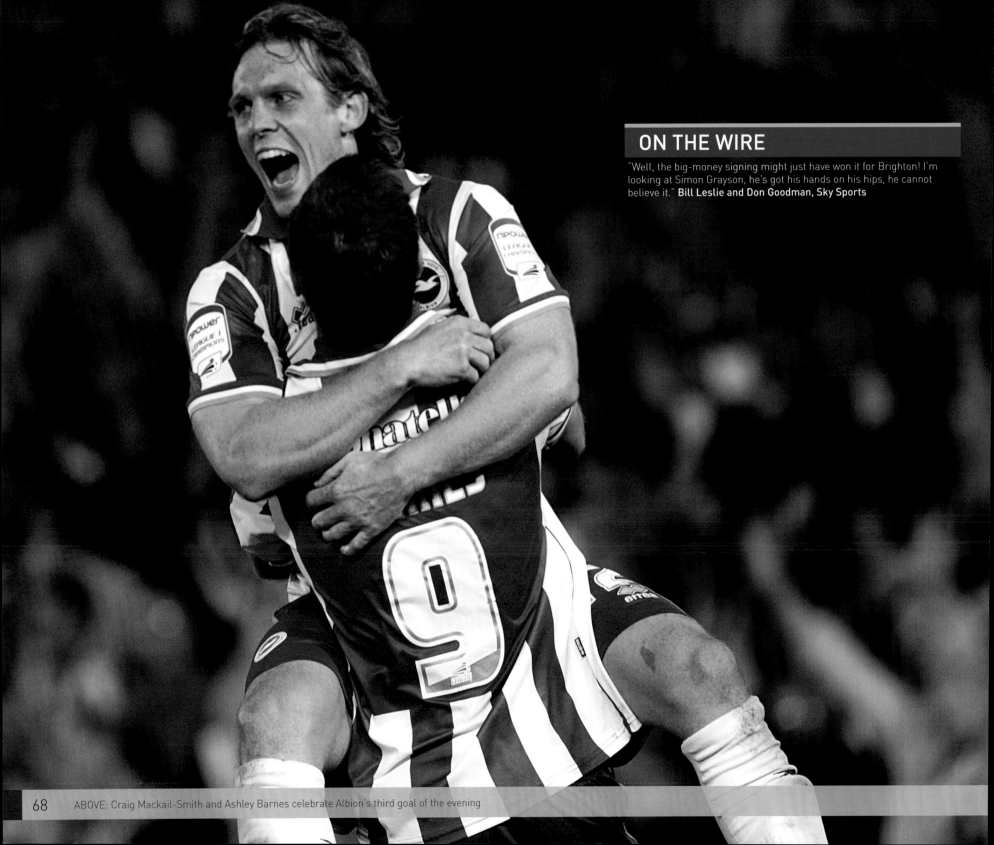

"Well, the big-money signing might just have won it for Brighton! I'm looking at Simon Grayson, he's got his hands on his hips, he cannot believe it." **Bill Leslie and Don Goodman, Sky Sports**

ABOVE: Craig Mackail-Smith and Ashley Barnes celebrate Albion's third goal of the evening

EQUAL AND OPPOSITE

"Albion, I think, showed that strength to come back after a disappointing start. Belief was a big part of the first season; they had belief that they could come from behind and score at any moment. But, they did have a level of susceptibility late on, Blackpool exposed it as well..."
Johnny Cantor

"I think those two games in isolation – this is my analysis and my debrief – they really had an impact on the momentum of the season. Until then, we were a very good team, and after those two games we had a real dip in form, in performances, in reactions and in character that we couldn't cope with. We paid the price, and we learnt a lot from that spell."
Gus Poyet

ABOVE: Young Albion fans sing their hearts out

ABOVE: Leeds United manager Simon Grayson watches his side rescue a point

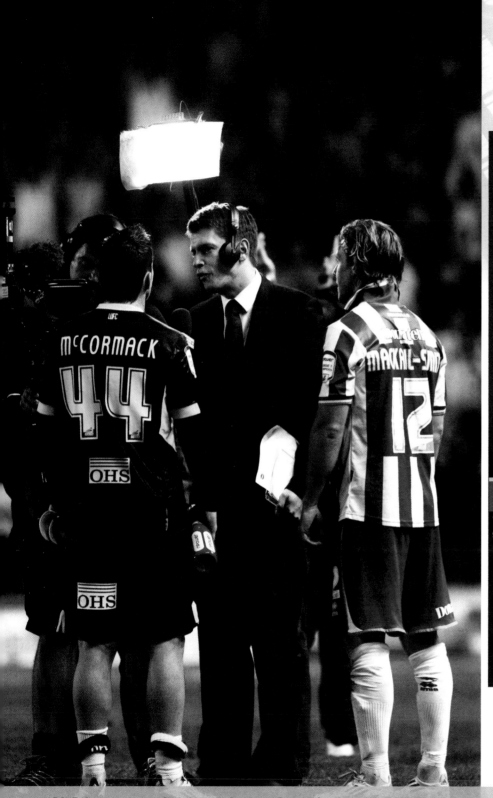

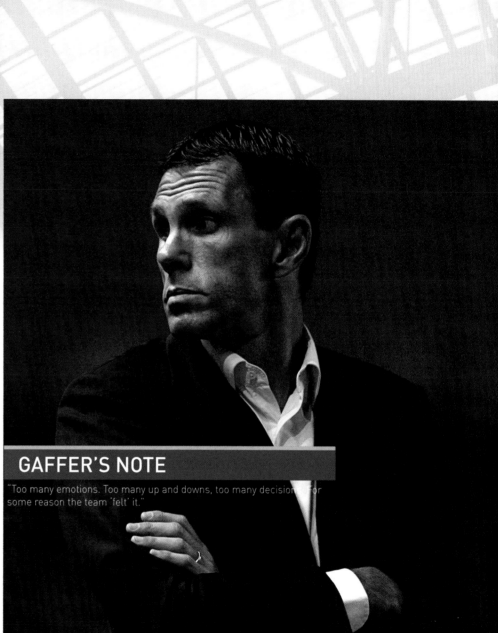

GAFFER'S NOTE

"Too many emotions. Too many up and downs, too many decisions. For some reason the team 'felt' it."

ABOVE: Albion's first team squad stroll the pitch prior to an evening kick-off

ABOVE/ ABOVE RIGHT: Training at the Amex and at the training ground

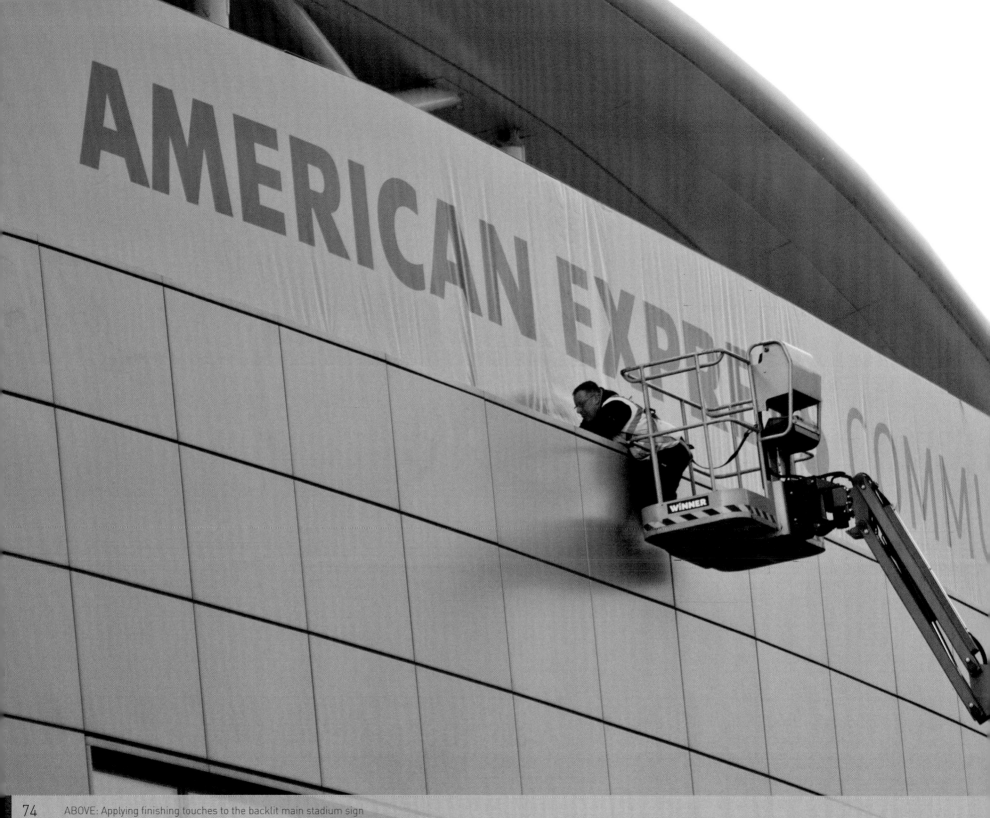

ABOVE: Applying finishing touches to the backlit main stadium sign

SIGNAGE

"All signage throughout the stadium was a challenge, one which we were elated to overcome, but none more-so than the primary-identity stadium-name signs. Each unit was more than 90ft long and 6ft tall and curved to follow the stadium shape as well as standing proud of the wall so as to appear 'floating'. They were, in essence, a stretched canvas over a frame and it took six guys and two cherry pickers to fit them. It was like stretching a canvas around a corner but the result is stunning and certainly ensures that visitors know that they have arrived."

Neil Keeley, Graffiti Design

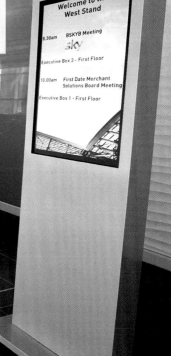

ABOVE: The West Stand reception

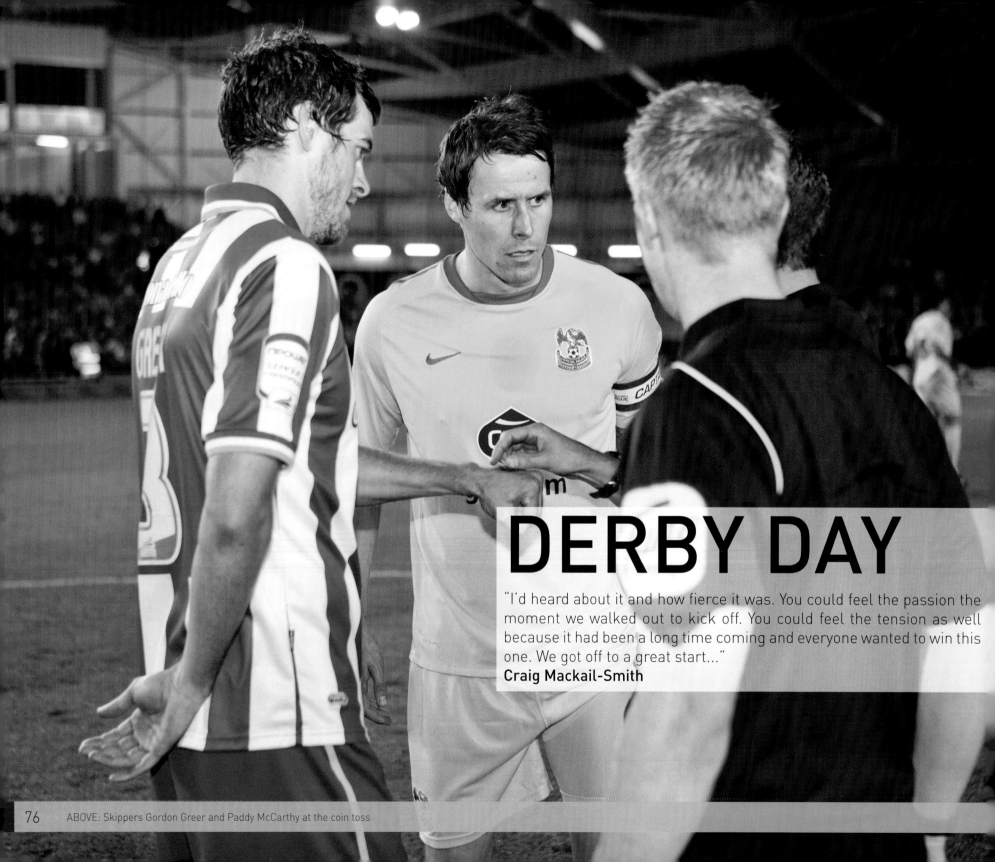

DERBY DAY

"I'd heard about it and how fierce it was. You could feel the passion the moment we walked out to kick off. You could feel the tension as well because it had been a long time coming and everyone wanted to win this one. We got off to a great start..."
Craig Mackail-Smith

ABOVE: Skippers Gordon Greer and Paddy McCarthy at the coin toss

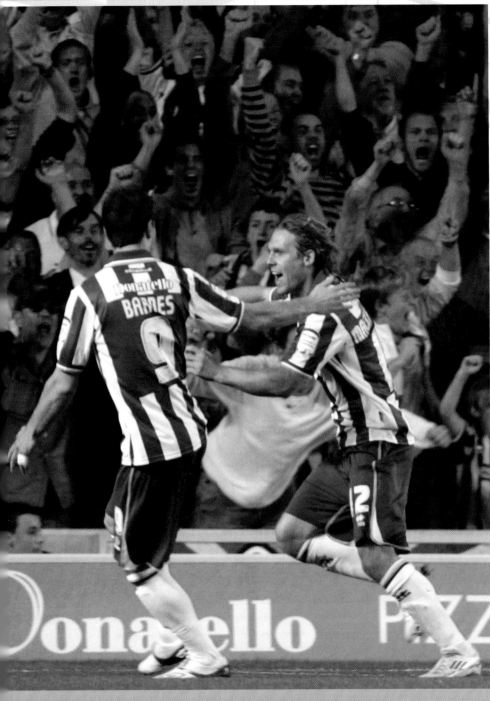

ABOVE: Craig Mackail-Smith breaks the deadlock after only six minutes

ABOVE: Paul Jordan makes repairs in the aftermath

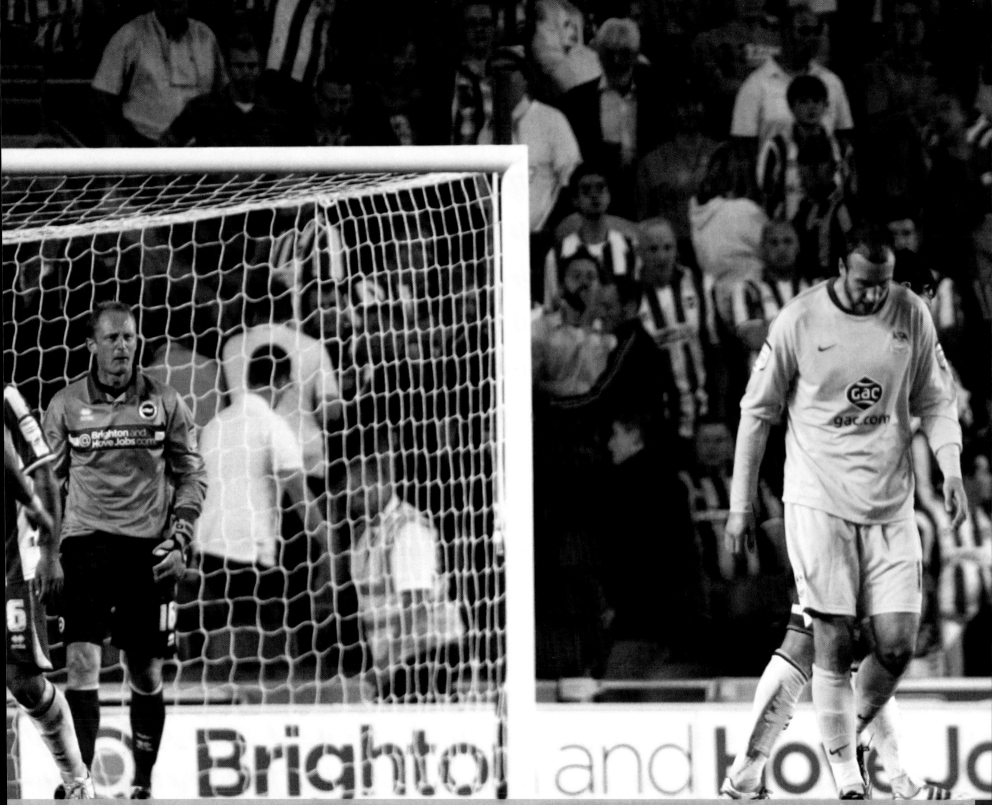

ABOVE: Glenn Murray stoically celebrates, as he rounds off a 3-1 victory for Crystal Palace in front of the North Stand

LOSING GRIP

"Everyone hits a bad patch and hopefully that was ours. The Championship is one of the toughest leagues in the country at the moment and anyone on their day can beat anyone. We hit that patch and it became a tough few months for us, but we showed great character and determination to try and get back out the other side."
Liam Bridcutt

"We were experiencing the start of a bit of loss in confidence, loss in belief in ourselves maybe, and that carried on for ten or so games. I think it was a series of little things that go against you, things that weren't quite falling for us. But these things happen in football."
Craig Mackail-Smith

ABOVE: Vicente shoots his big screen 'walk-on' TOP: Vicente begins an impressive run resulting in him opening the scoring at Portman Road

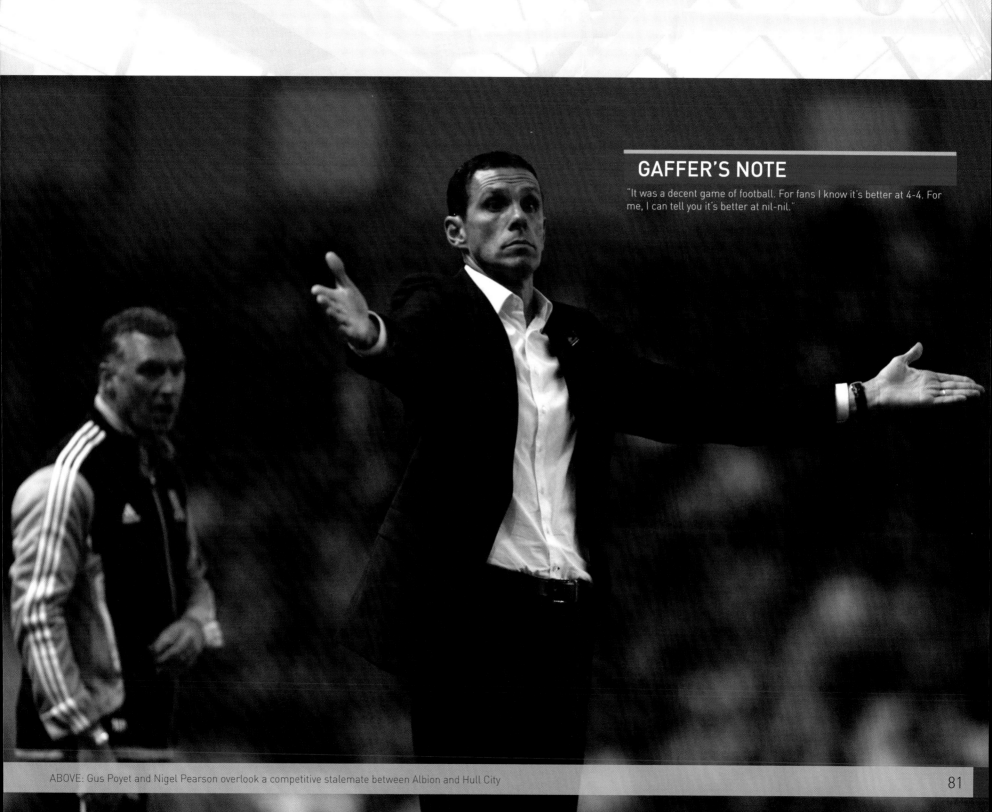

"It was a decent game of football. For fans I know it's better at 4-4. For me, I can tell you it's better at nil-nil."

ABOVE: Gus Poyet and Nigel Pearson overlook a competitive stalemate between Albion and Hull City

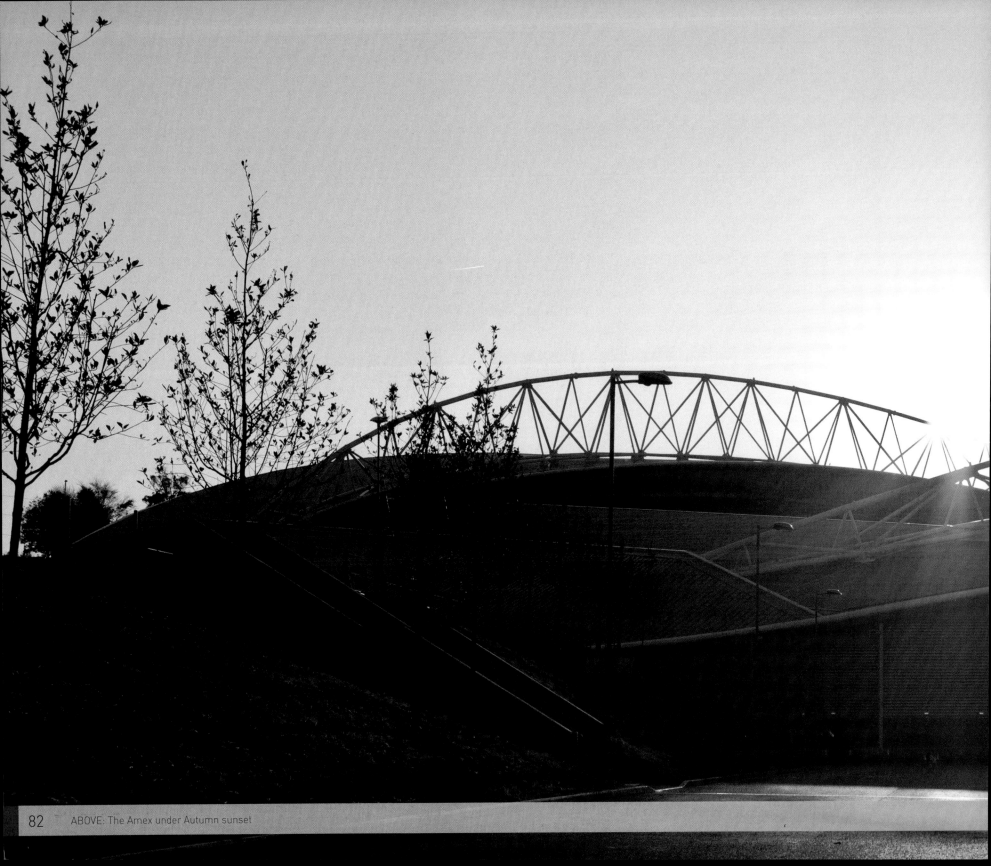

ABOVE: The Amex under Autumn sunset

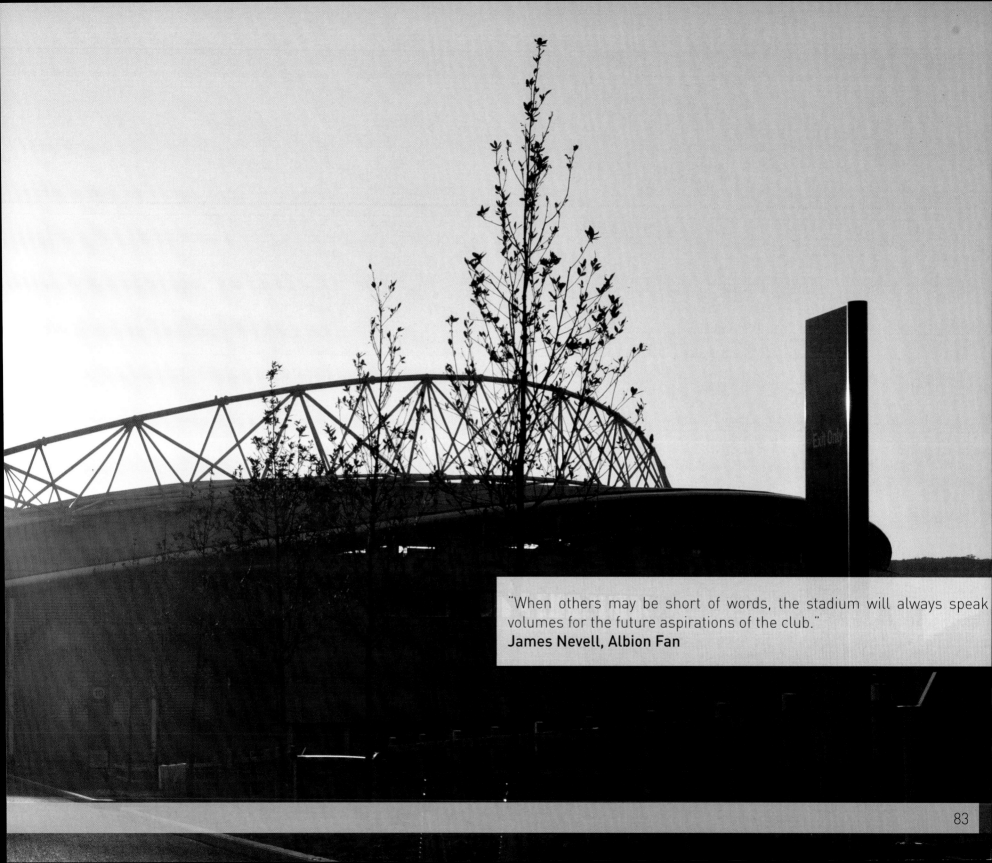

"When others may be short of words, the stadium will always speak volumes for the future aspirations of the club."
James Nevell, Albion Fan

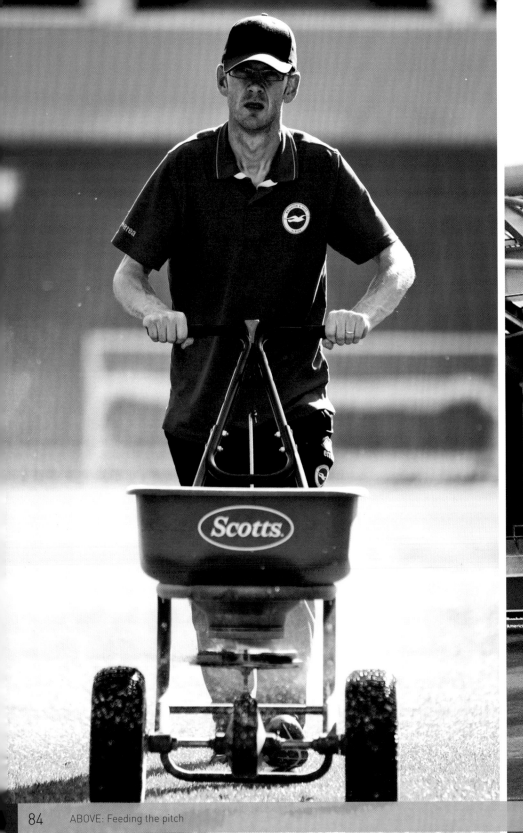

ABOVE: Feeding the pitch

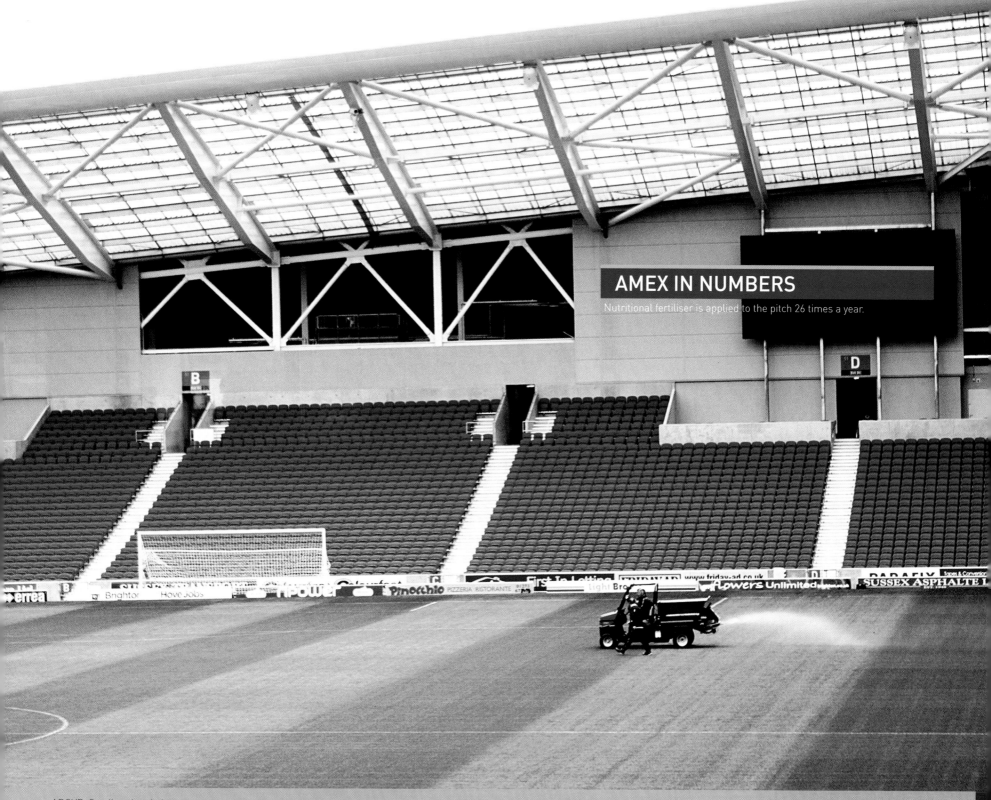

AMEX IN NUMBERS

Nutritional fertiliser is applied to the pitch 26 times a year.

ABOVE: Seeding the pitch

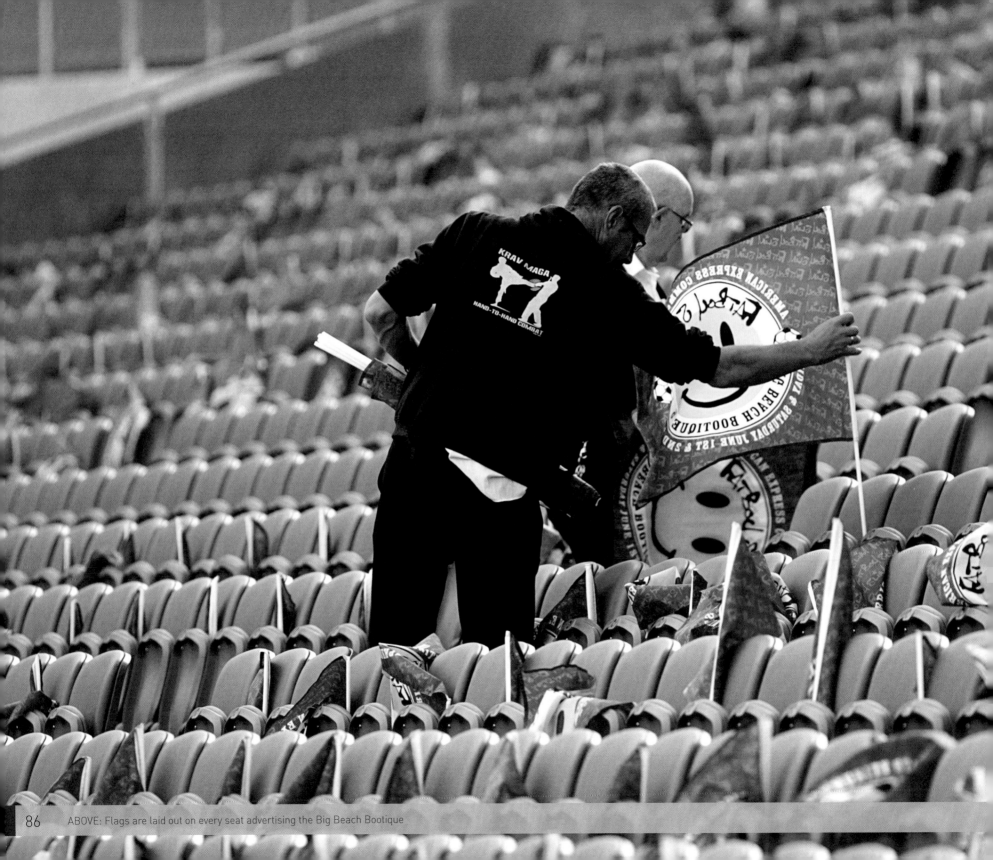

ABOVE: Flags are laid out on every seat advertising the Big Beach Bootique

FATBOY SLIM

"I'm very, very proud. Dick Knight promised me a few years back that I could do the opening show, and Tony Bloom has managed to make it come true. Of course, everyone knows I'm an Albion fan and this is the only place I wanted to play. It's been ten years since the first one, this is number five, and I think we've outgrown the beach now. Ten years ago when I first thought 'I'll do a gig for my Brighton people' I couldn't have imagined it would have grown so huge, but it's just great doing a gig in your home with your hometown support. It's going to be fantastic, hopefully it'll be the event of the year for Brighton and possibly even the event of my life for me. Let's hope the weather picks up by then!"

Norman Cook, Albion Fan

ABOVE: Fatboy Slim is interviewed pitchside by Richard Reynolds

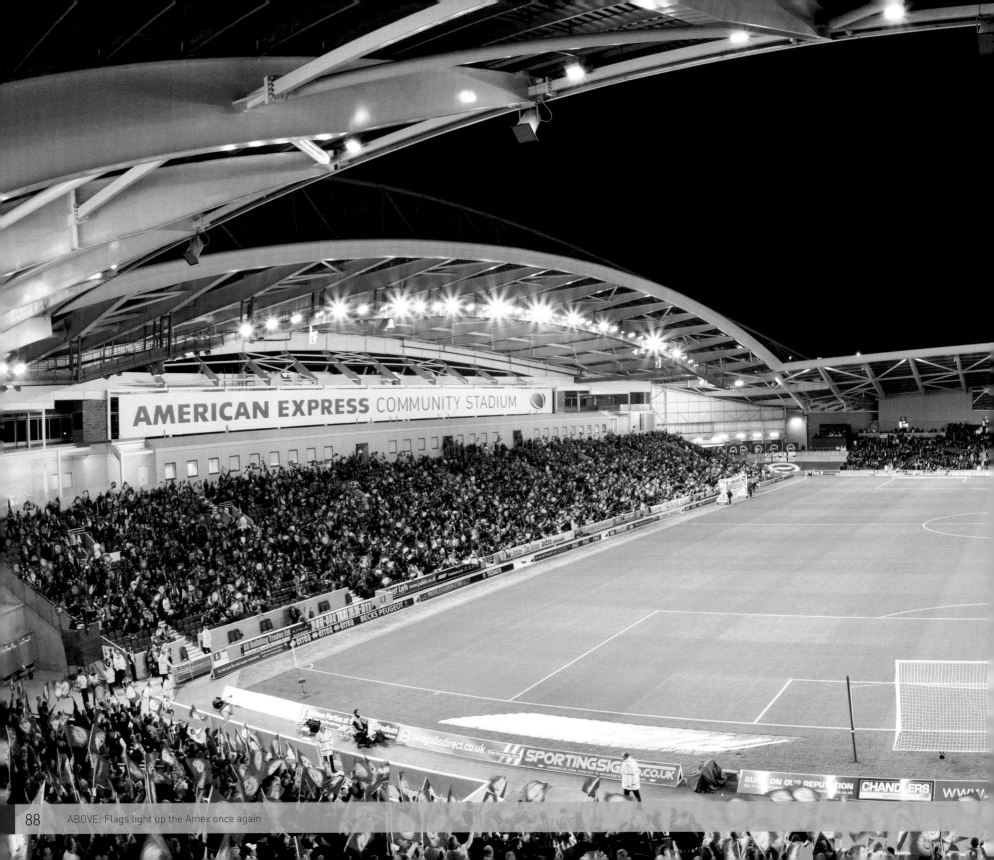

ABOVE: Flags light up the Amex once again

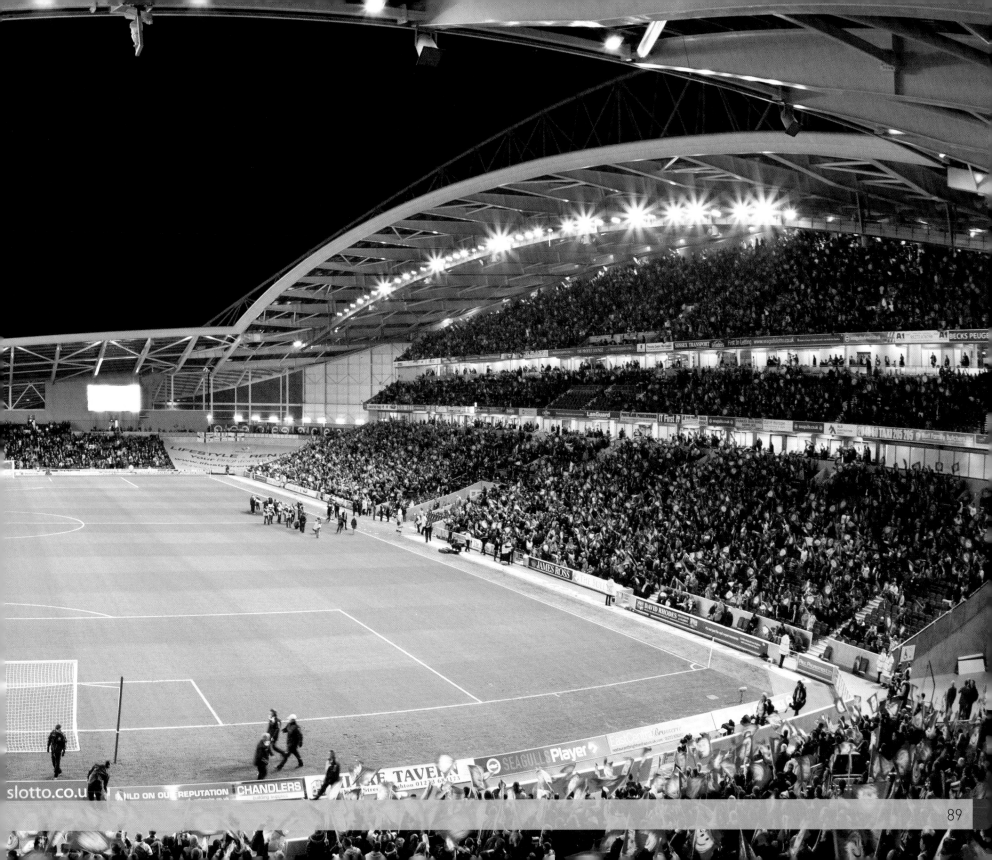

LOAN WATCH

"We are back as a Brighton team in possession and we are back a[s a] Brighton team dominating the game against a Premier League clu[b] because West Ham are without doubt a Premier League quality club."
Gus Poyet

"No one blames anyone. We go up as a team, we go down as a team and [we] stay behind each other. It was a mistake by ourselves that cost us a g[oal] and the game in the end because that's what happens against Prem[ier] League players. From then on we just said: we can be up there, this is w[hat] we've got to do, and play like that and we will be up there."
Will Buckley

LEFT: Gonzalo Jara Reyes impresses on his debut but Albion fail to find the net

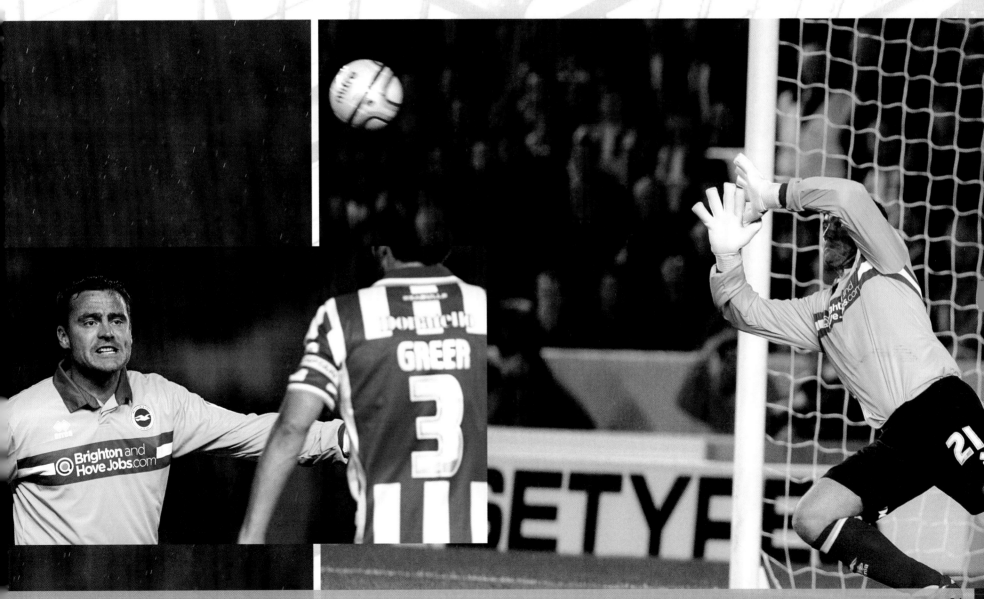

ABOVE: Steve Harper communicating with Gordon Greer

ABOVE: Steve Harper is beaten by Kevin Nolan

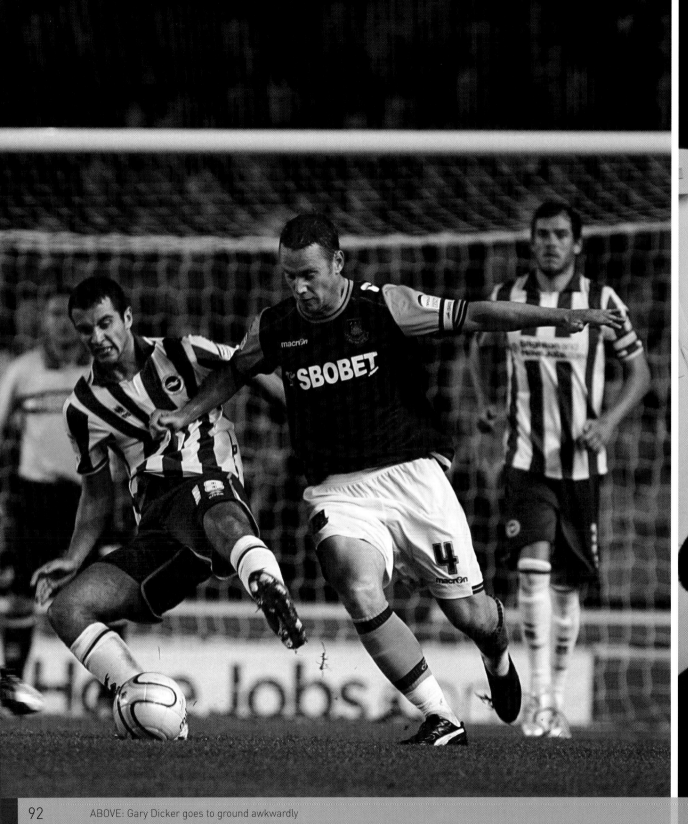

ABOVE: Gary Dicker goes to ground awkwardly

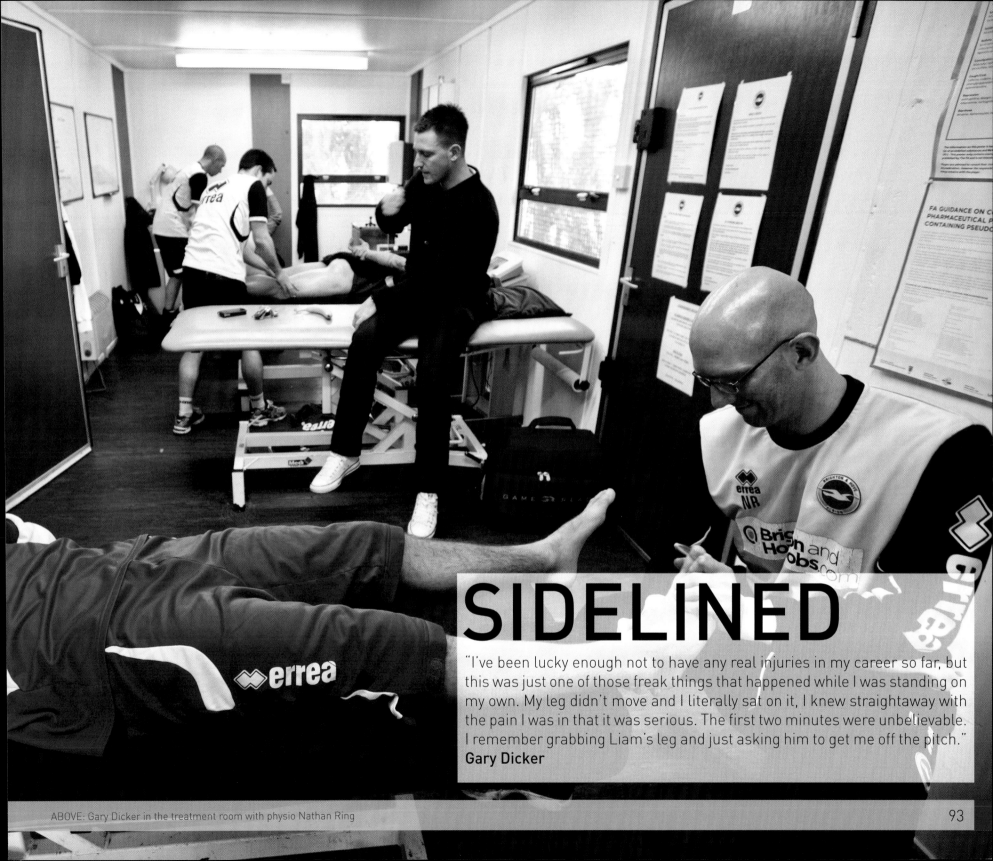

SIDELINED

"I've been lucky enough not to have any real injuries in my career so far, but this was just one of those freak things that happened while I was standing on my own. My leg didn't move and I literally sat on it, I knew straightaway with the pain I was in that it was serious. The first two minutes were unbelievable. I remember grabbing Liam's leg and just asking him to get me off the pitch."
Gary Dicker

ABOVE: Steve Harper and Craig Noone relax in the players' lounge

ABOVE: Dinner is prepared for the first team

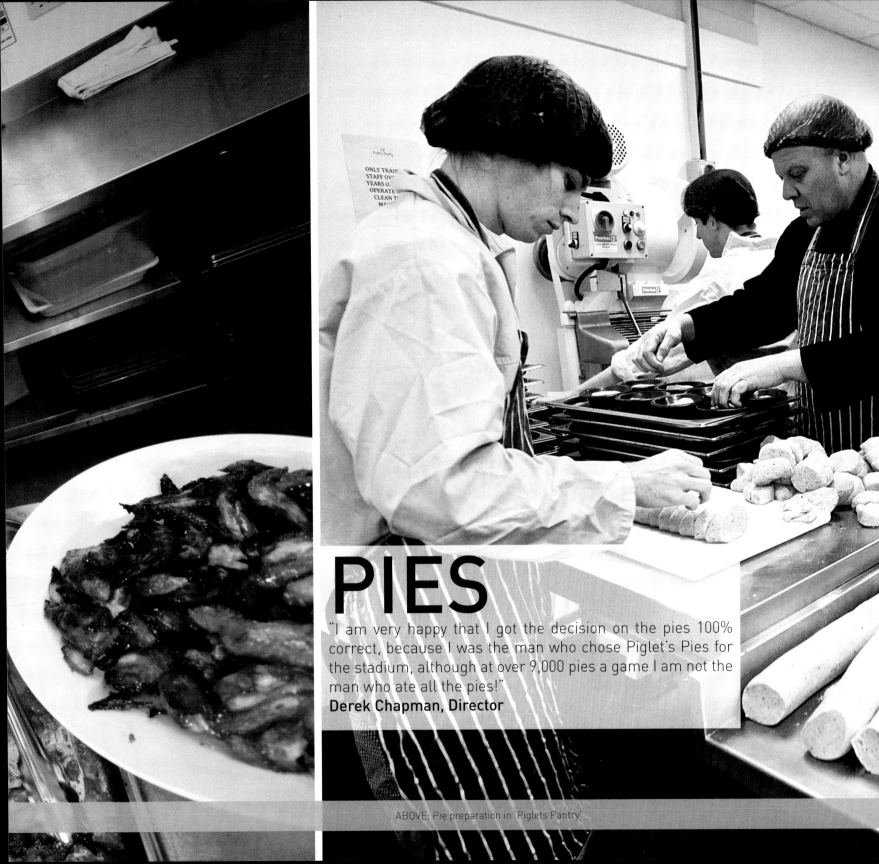

PIES

"I am very happy that I got the decision on the pies 100% correct, because I was the man who chose Piglet's Pies for the stadium, although at over 9,000 pies a game I am not the man who ate all the pies!"
Derek Chapman, Director

ABOVE: Pie preparation in 'Piglets Pantry'

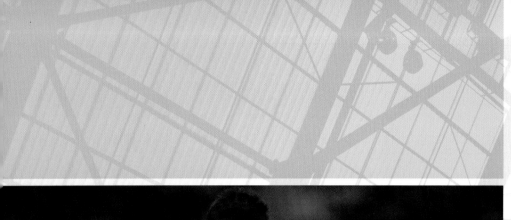

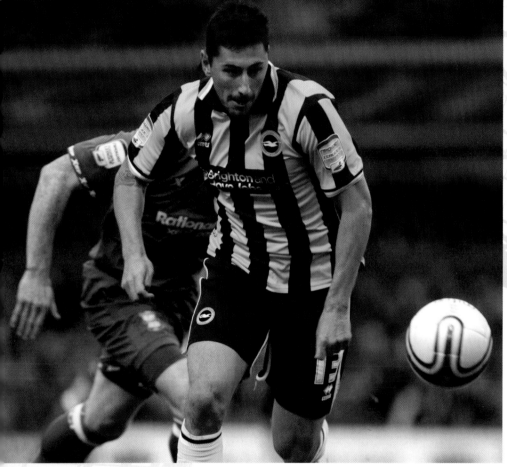

NARROW MARGINS

"Nothing changed in terms of our play. We just carried on the same way telling ourselves we're going to get out of it if we keep playing the way the gaffer wants us to play, and the way we've all been taught since coming here. We knew a win would come, eventually, but when you go through runs like that it's confidence that keeps you going."

Will Buckley

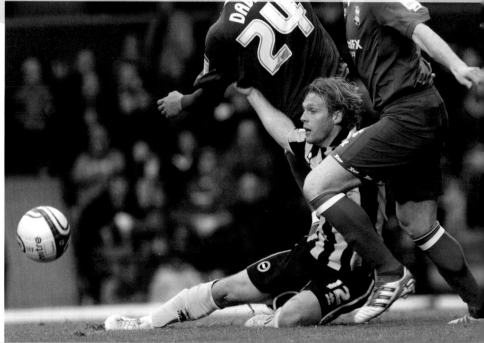

TOP: Billy Paynter makes his debut at St Andrew's ABOVE: Craig Mackail-Smith battles for possession

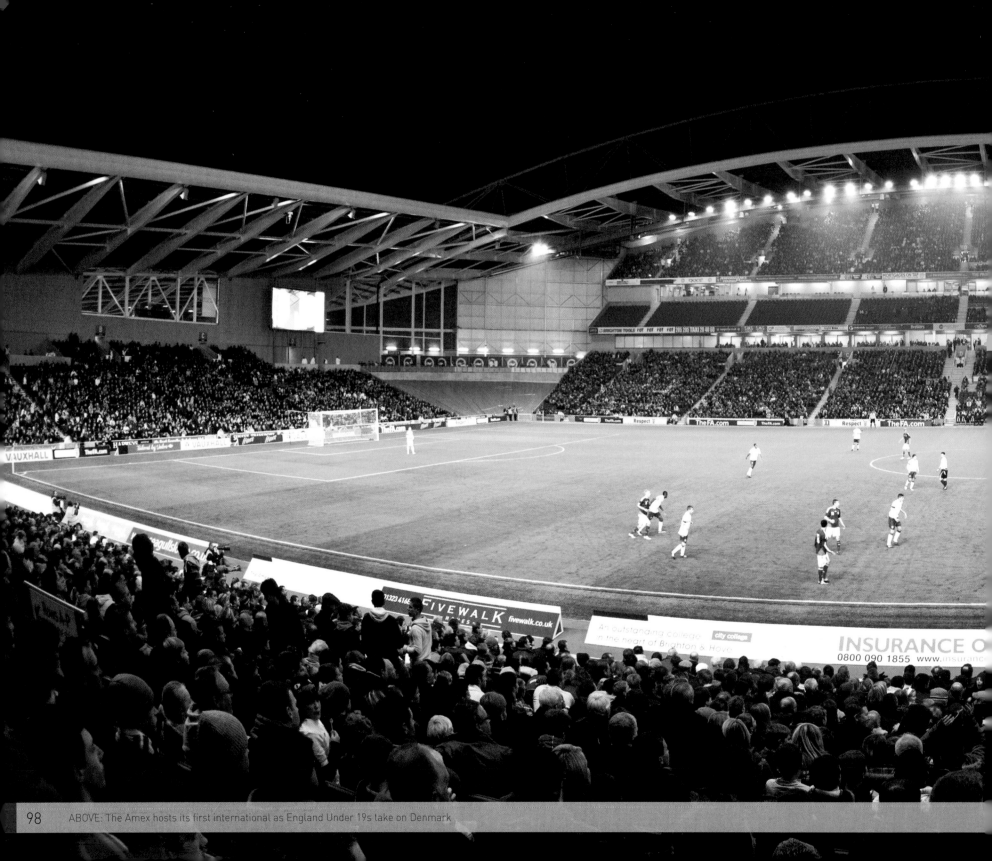

ABOVE: The Amex hosts its first international as England Under 19s take on Denmark

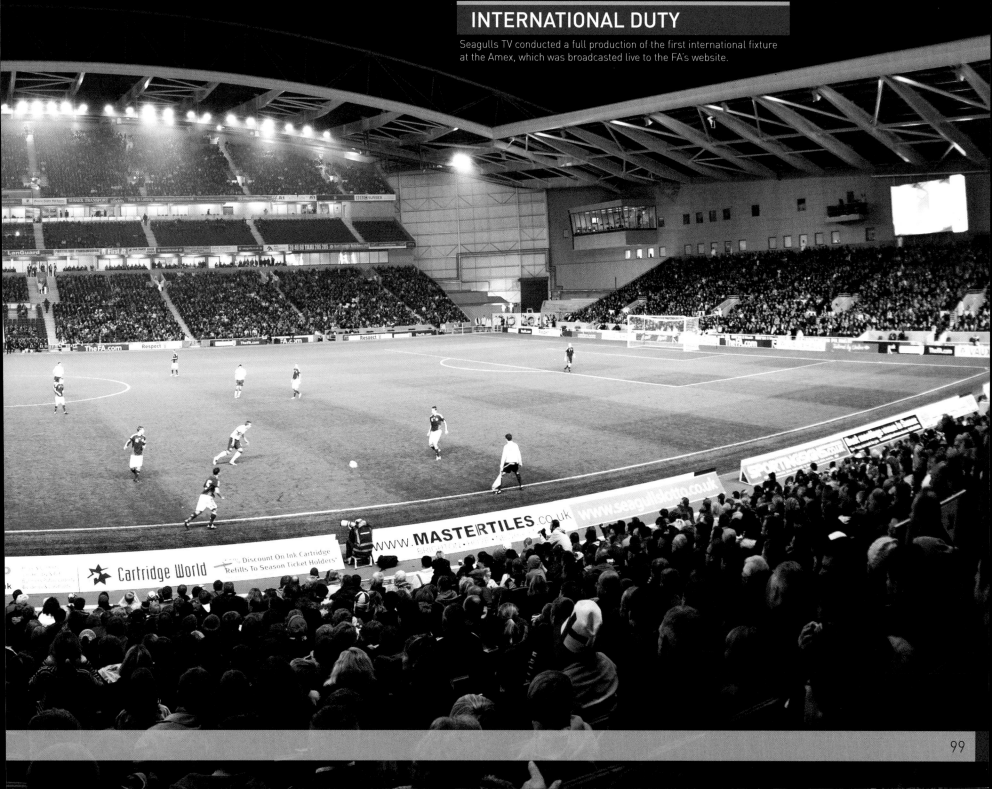

INTERNATIONAL DUTY

Seagulls TV conducted a full production of the first international fixture at the Amex, which was broadcasted live to the FA's website.

BREAKING THE DEADLOCK

"He celebrated well to be honest, I don't think he's scored that many but it was a great finish! That was a tight game, I was watching from the bench and Barnsley were playing some good football but getting that breakthrough from the captain really kicked us on. I think that's all we needed, we needed a win because from the start of the season we couldn't lose, and then we couldn't win. To stop the losing run was great; to do it at home was even better."

Will Buckley

"When you're a defender and you're always playing from the back, you need to run for every ball, fight for every ball and on top of that, I ask him to play. Gordon hasn't scored for us and he doesn't score very often, so I said if GG scores we're going to definitely win, we cannot lose!"

Gus Poyet

ABOVE TOP/ BOTTOM: Gordon Greer breaks Albion's goalless run at home to Barnsley

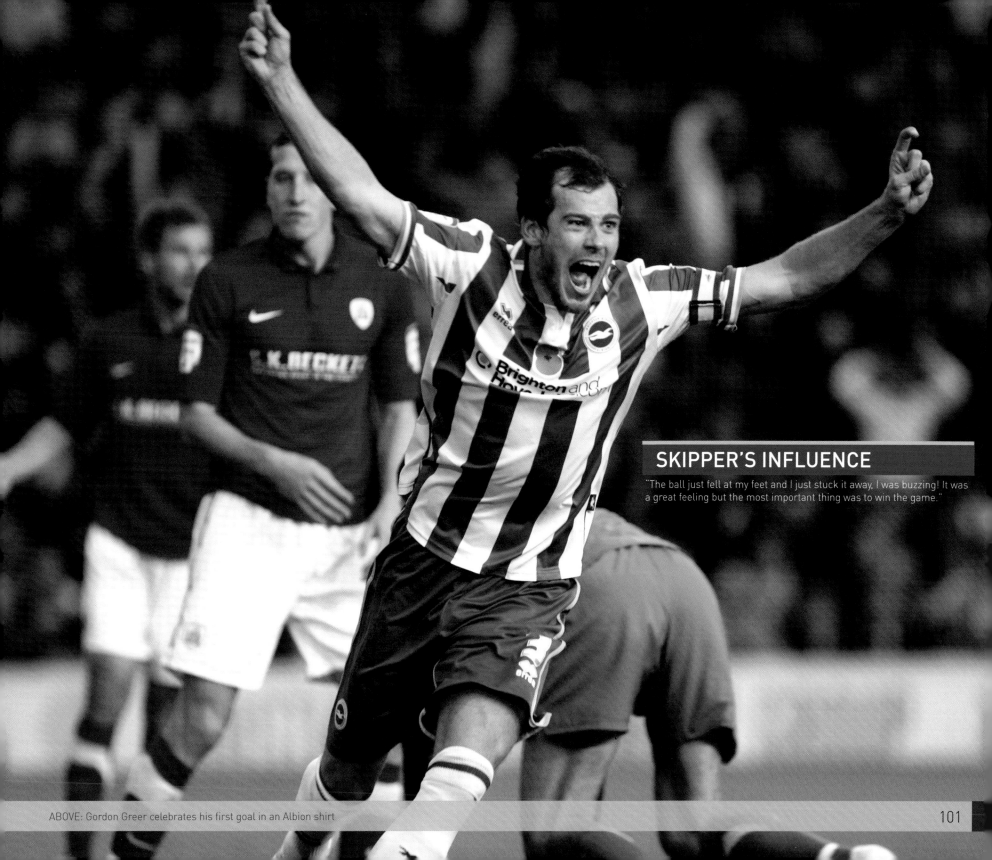

SKIPPER'S INFLUENCE

"The ball just fell at my feet and I just stuck it away, I was buzzing! It was a great feeling but the most important thing was to win the game."

ABOVE: Gordon Greer celebrates his first goal in an Albion shirt

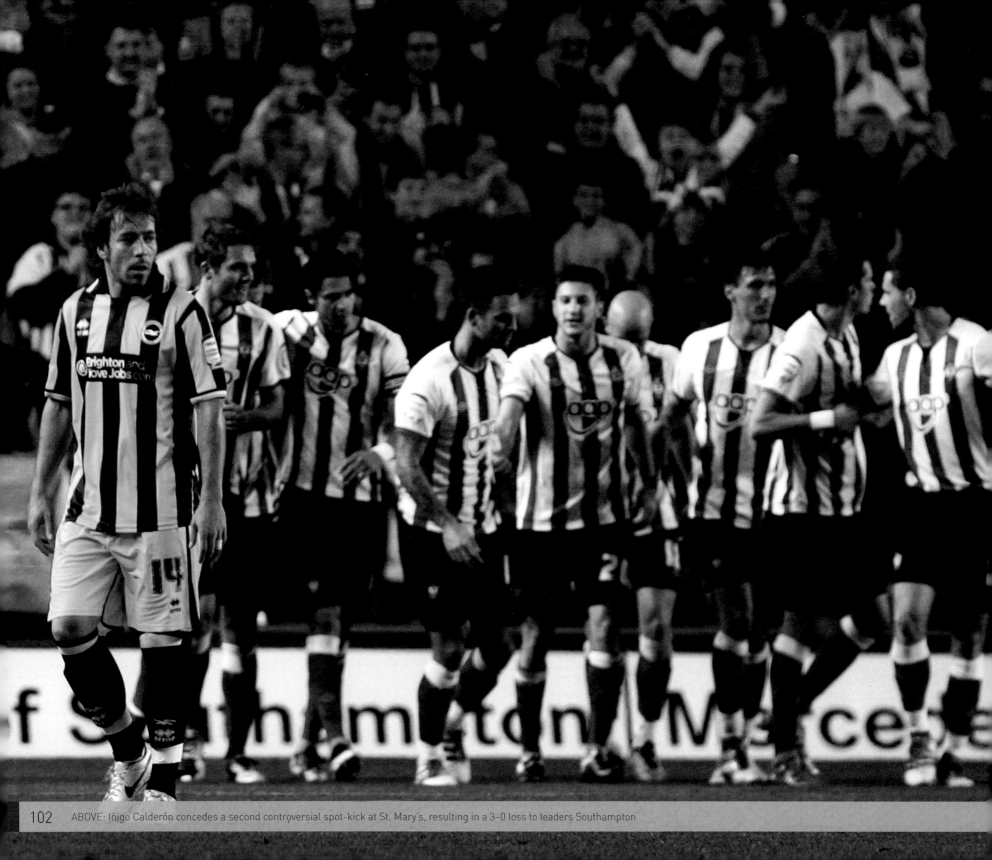

ABOVE: Iñigo Calderón concedes a second controversial spot-kick at St. Mary's, resulting in a 3–0 loss to leaders Southampton

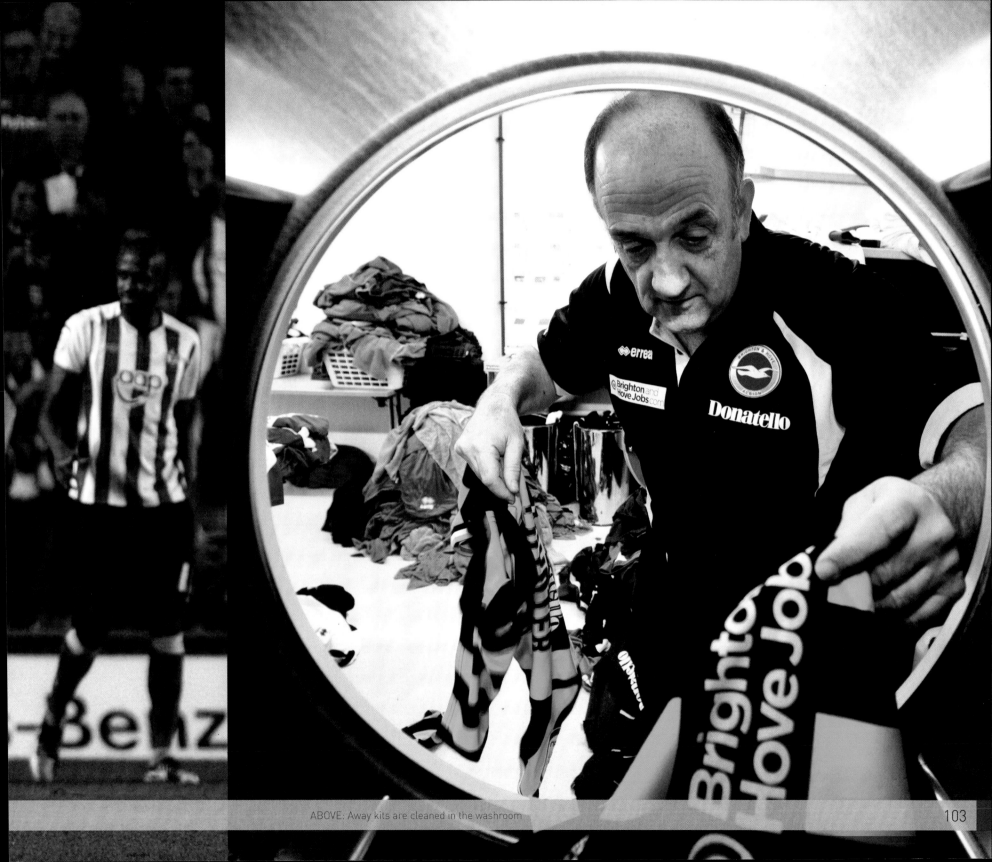

ABOVE: Away kits are cleaned in the washroom

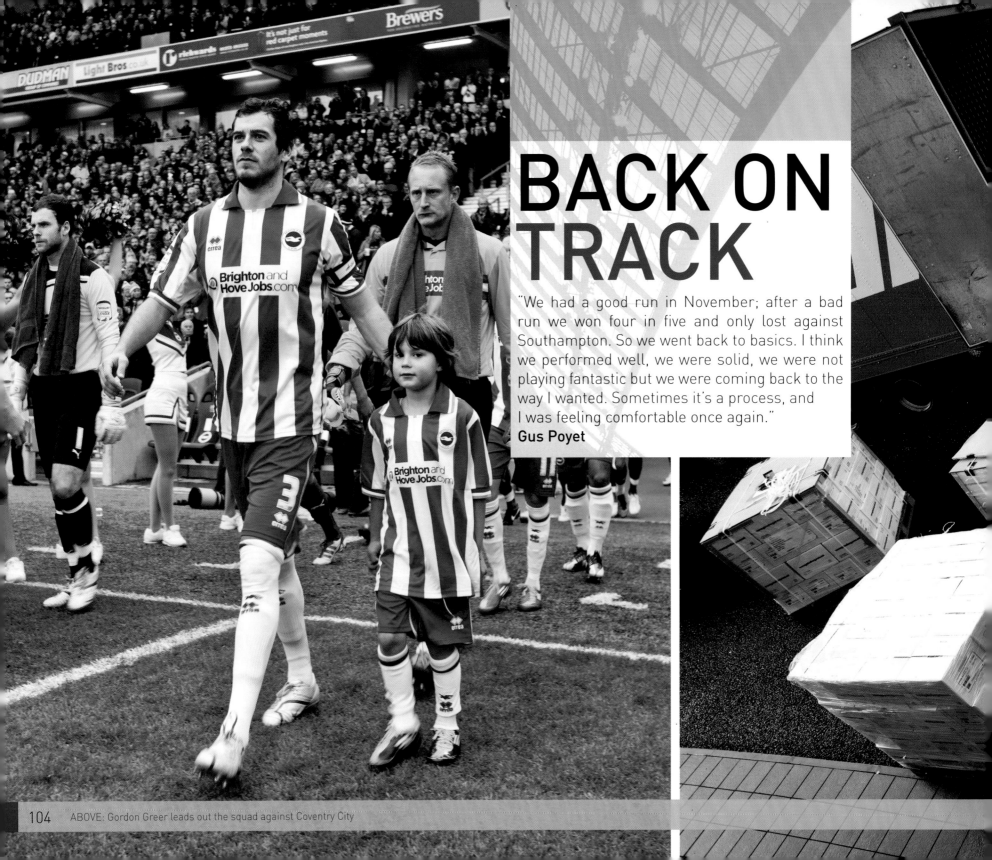

BACK ON TRACK

"We had a good run in November; after a bad run we won four in five and only lost against Southampton. So we went back to basics. I think we performed well, we were solid, we were not playing fantastic but we were coming back to the way I wanted. Sometimes it's a process, and I was feeling comfortable once again."

Gus Poyet

ABOVE: Gordon Greer leads out the squad against Coventry City

ABOVE: The first batch of *Stadium Yes!* arrives

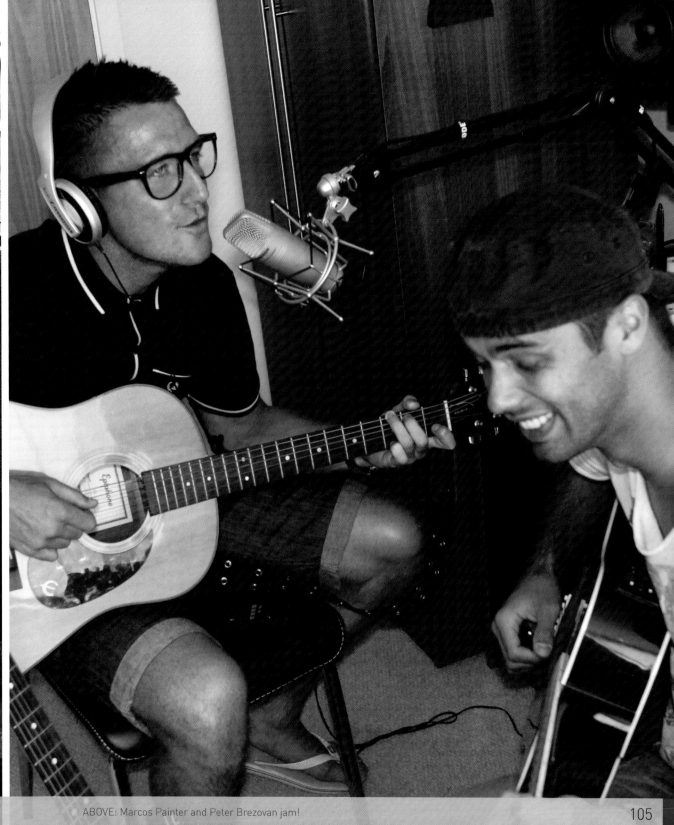

ABOVE: Marcos Painter and Peter Brezovan jam!

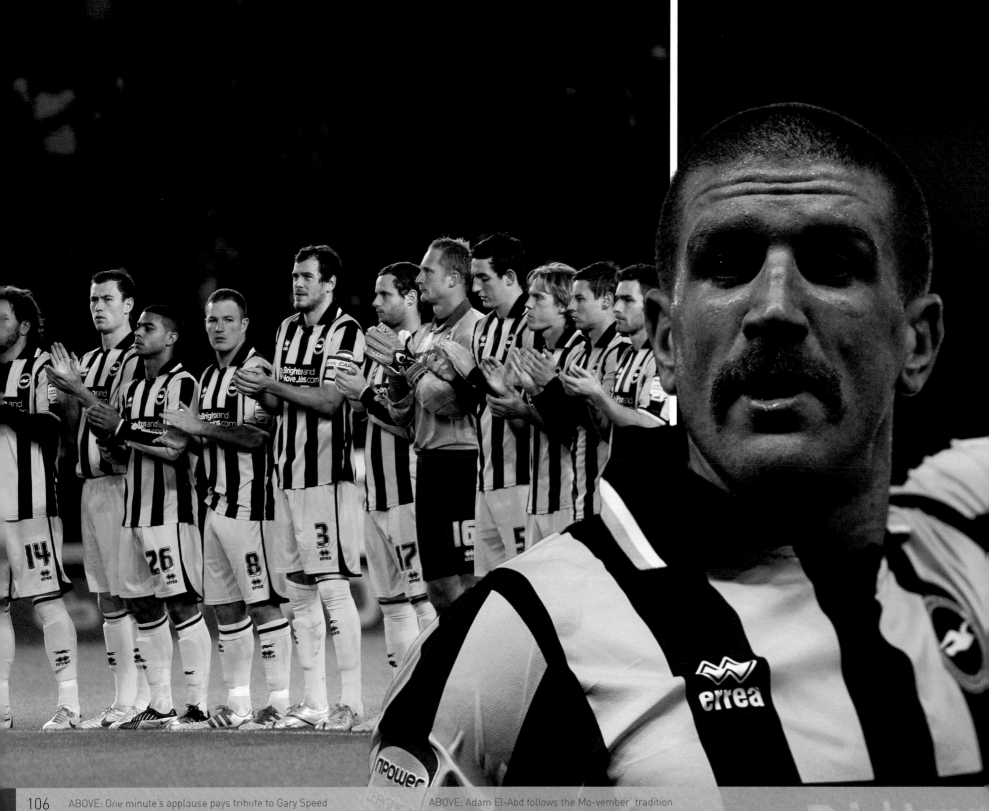

ABOVE: One minute's applause pays tribute to Gary Speed ABOVE: Adam El-Abd follows the 'Mo-vember' tradition

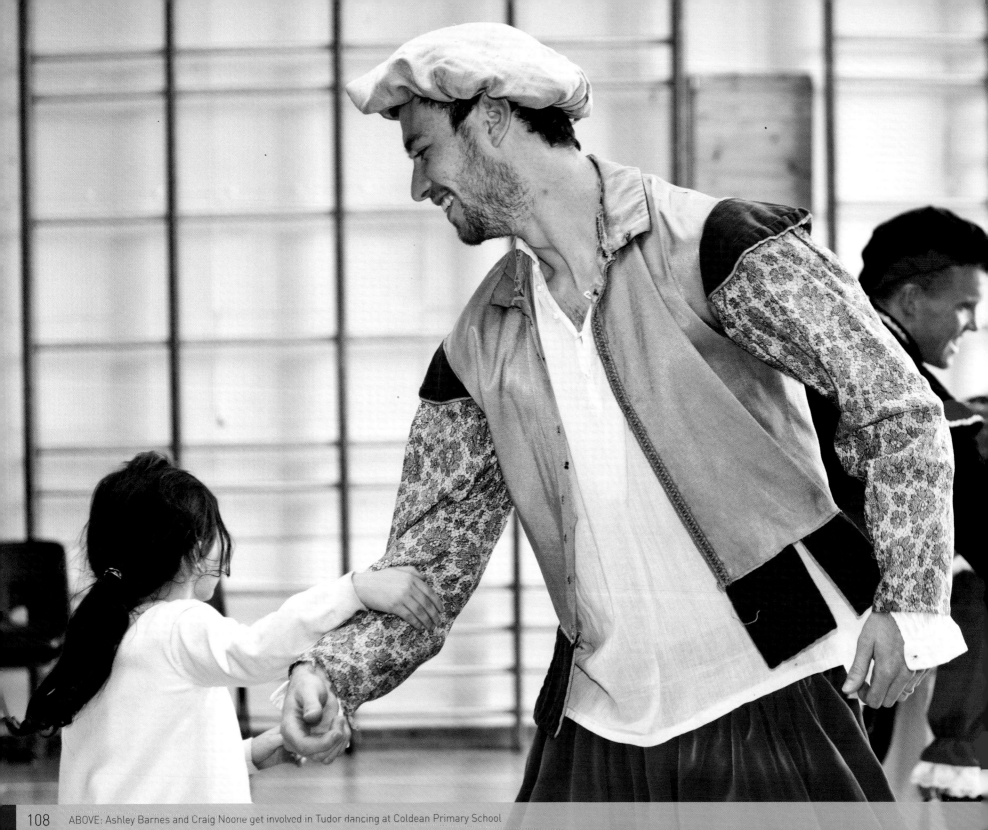

ABOVE: Ashley Barnes and Craig Noorie get involved in Tudor dancing at Coldean Primary School

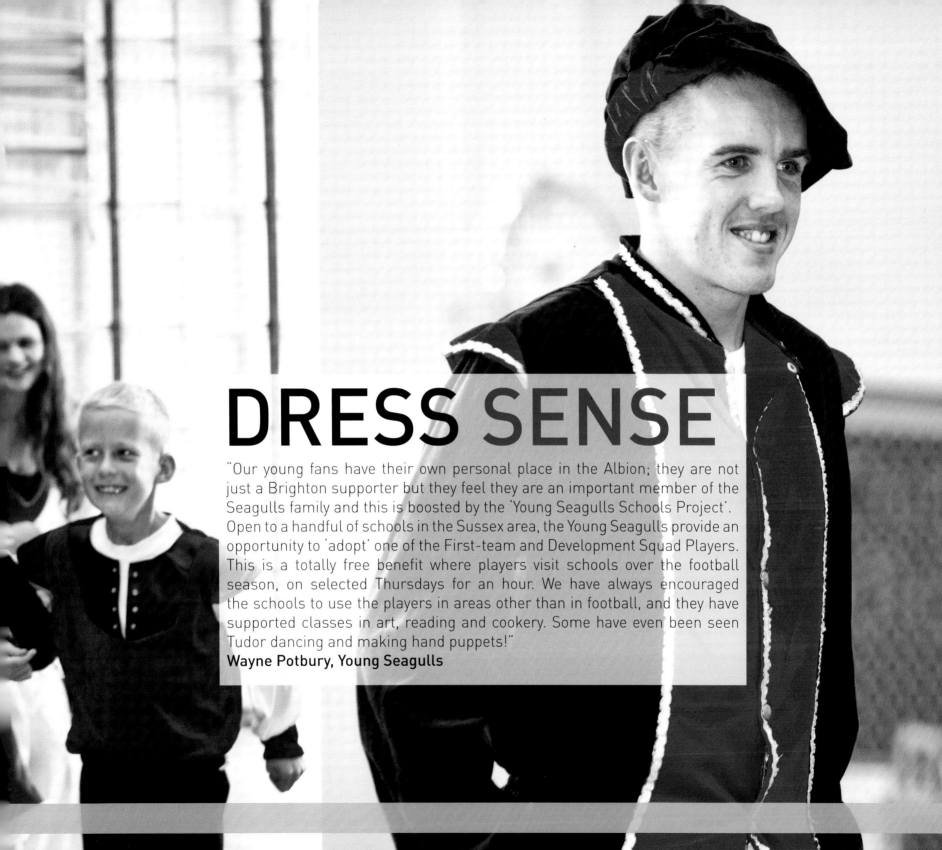

DRESS SENSE

"Our young fans have their own personal place in the Albion; they are not just a Brighton supporter but they feel they are an important member of the Seagulls family and this is boosted by the 'Young Seagulls Schools Project'. Open to a handful of schools in the Sussex area, the Young Seagulls provide an opportunity to 'adopt' one of the First-team and Development Squad Players. This is a totally free benefit where players visit schools over the football season, on selected Thursdays for an hour. We have always encouraged the schools to use the players in areas other than in football, and they have supported classes in art, reading and cookery. Some have even been seen Tudor dancing and making hand puppets!"

Wayne Potbury, Young Seagulls

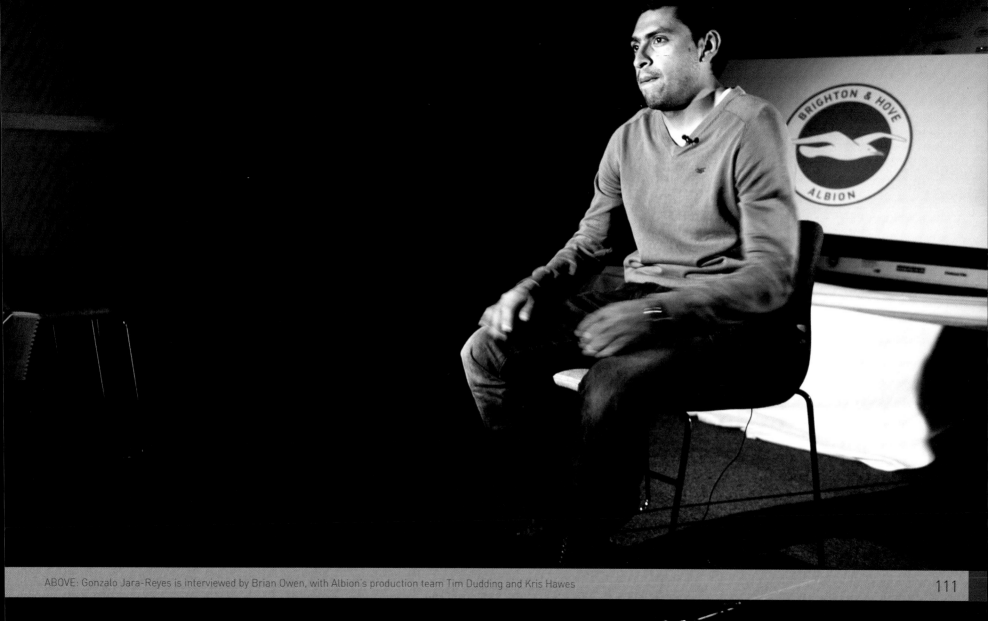

ABOVE: Gonzalo Jara-Reyes is interviewed by Brian Owen, with Albion's production team Tim Dudding and Kris Hawes

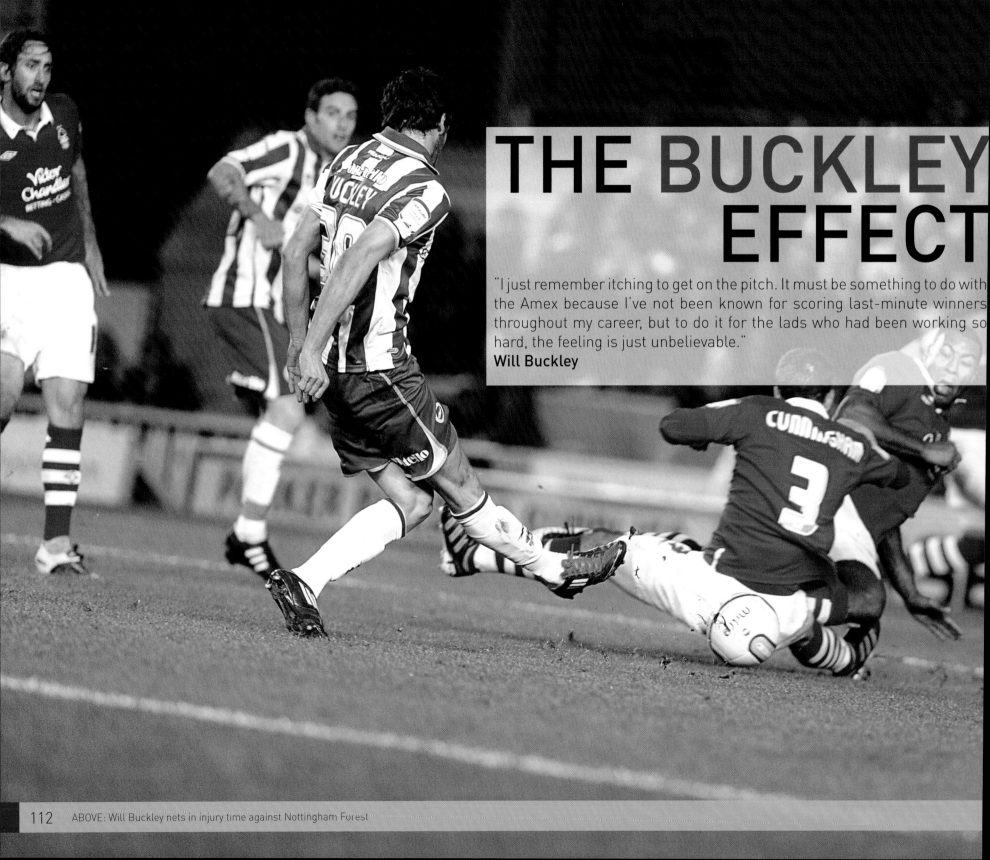

THE BUCKLEY EFFECT

"I just remember itching to get on the pitch. It must be something to do with the Amex because I've not been known for scoring last-minute winners throughout my career, but to do it for the lads who had been working so hard, the feeling is just unbelievable."

Will Buckley

ABOVE: Will Buckley nets in injury time against Nottingham Forest

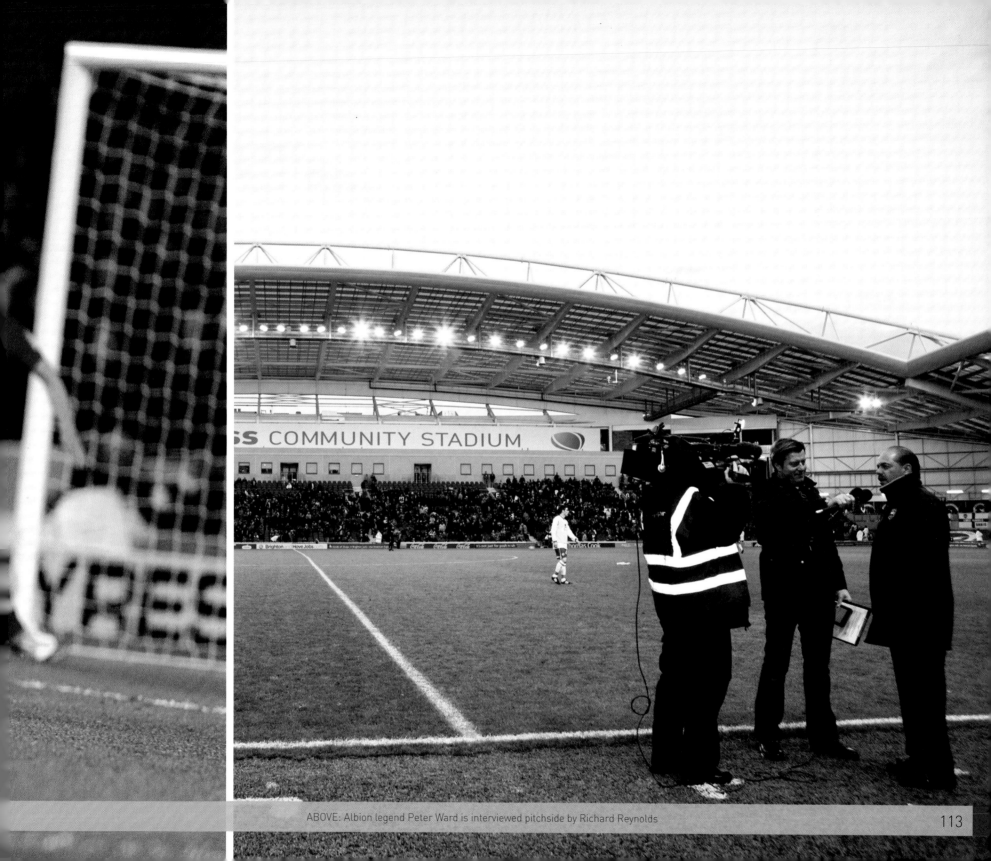

ABOVE: Albion legend Peter Ward is interviewed pitchside by Richard Reynolds

ABOVE: Concourse lights are installed in the West Stand

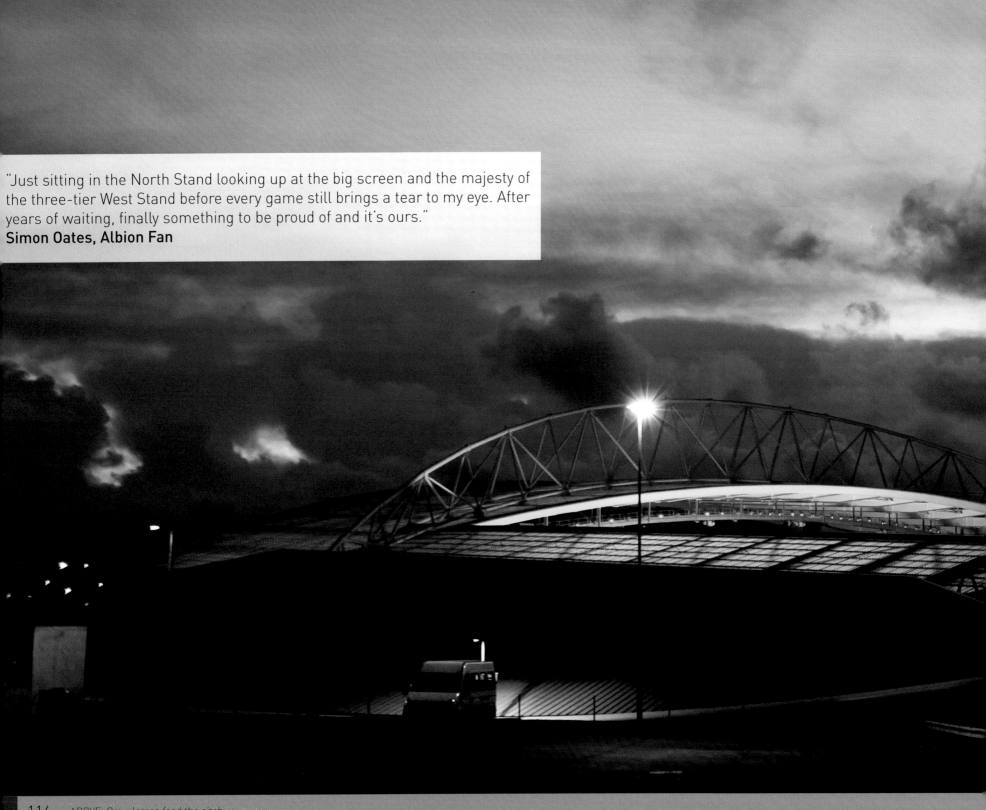

"Just sitting in the North Stand looking up at the big screen and the majesty of the three-tier West Stand before every game still brings a tear to my eye. After years of waiting, finally something to be proud of and it's ours."
Simon Oates, Albion Fan

ABOVE: Grow lamps feed the pitch

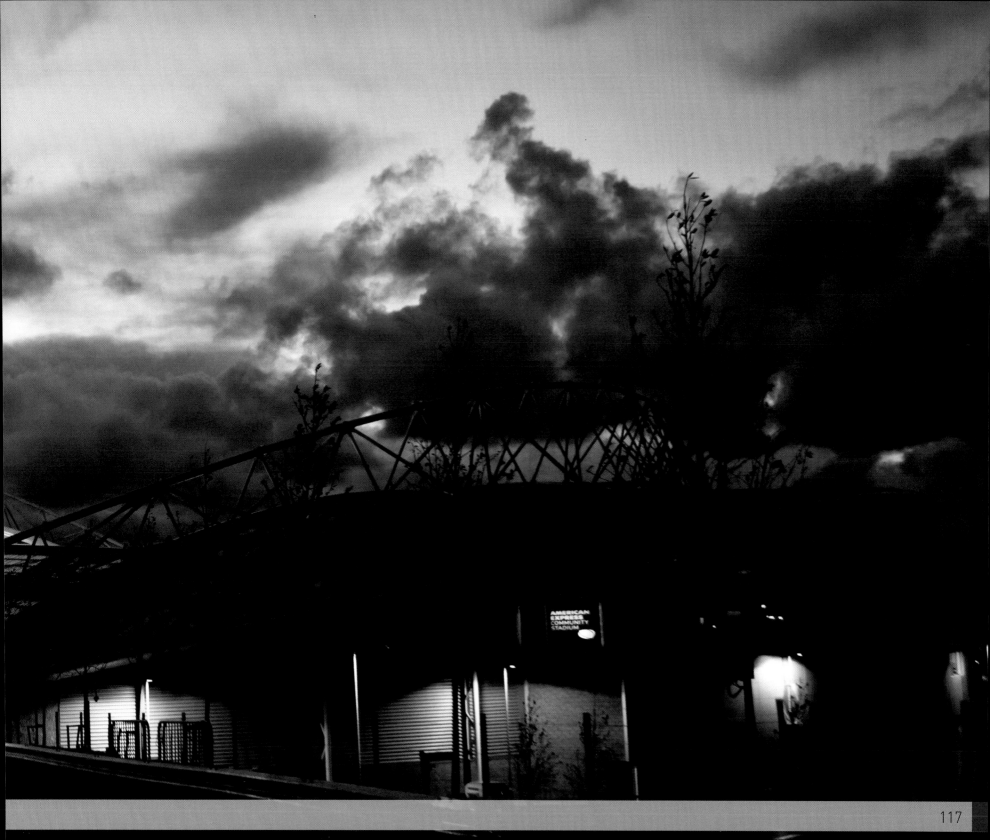

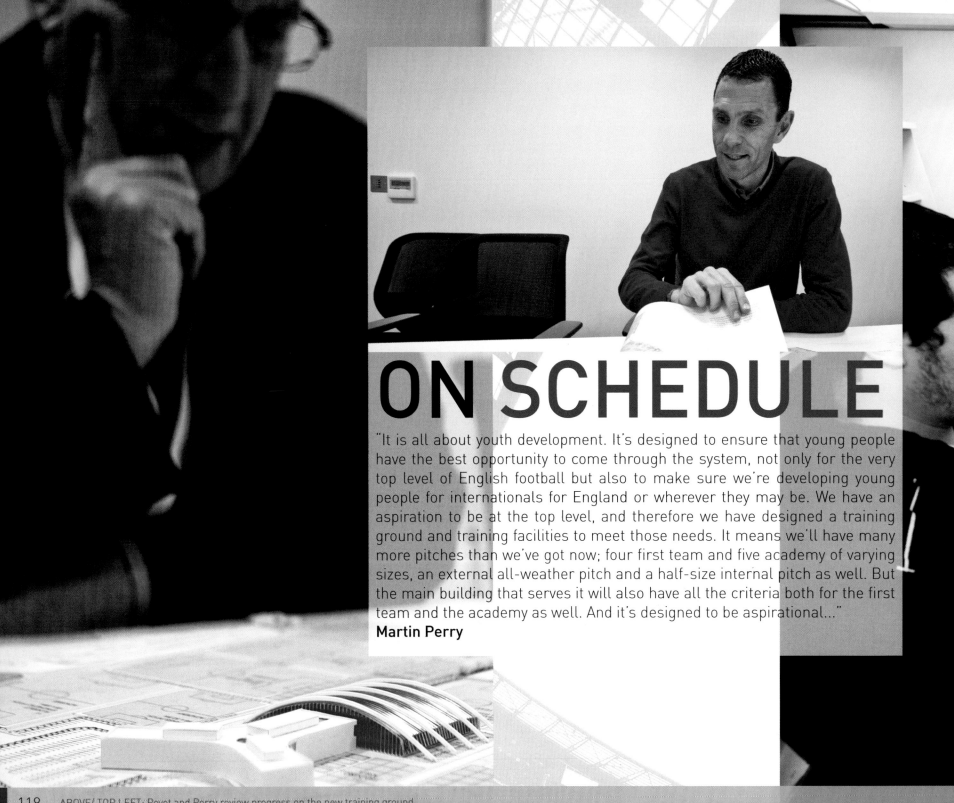

ON SCHEDULE

"It is all about youth development. It's designed to ensure that young people have the best opportunity to come through the system, not only for the very top level of English football but also to make sure we're developing young people for internationals for England or wherever they may be. We have an aspiration to be at the top level, and therefore we have designed a training ground and training facilities to meet those needs. It means we'll have many more pitches than we've got now; four first team and five academy of varying sizes, an external all-weather pitch and a half-size internal pitch as well. But the main building that serves it will also have all the criteria both for the first team and the academy as well. And it's designed to be aspirational..."
Martin Perry

ABOVE/ TOP LEFT: Poyet and Perry review progress on the new training ground

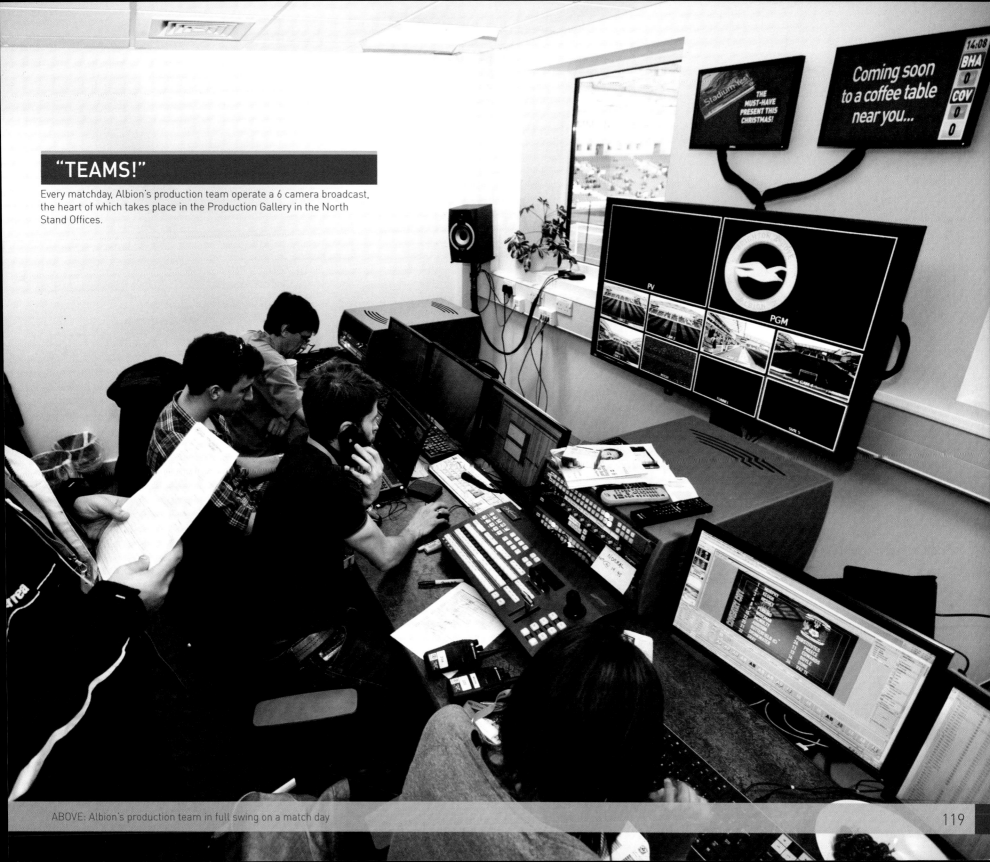

"TEAMS!"

Every matchday, Albion's production team operate a 6 camera broadcast, the heart of which takes place in the Production Gallery in the North Stand Offices.

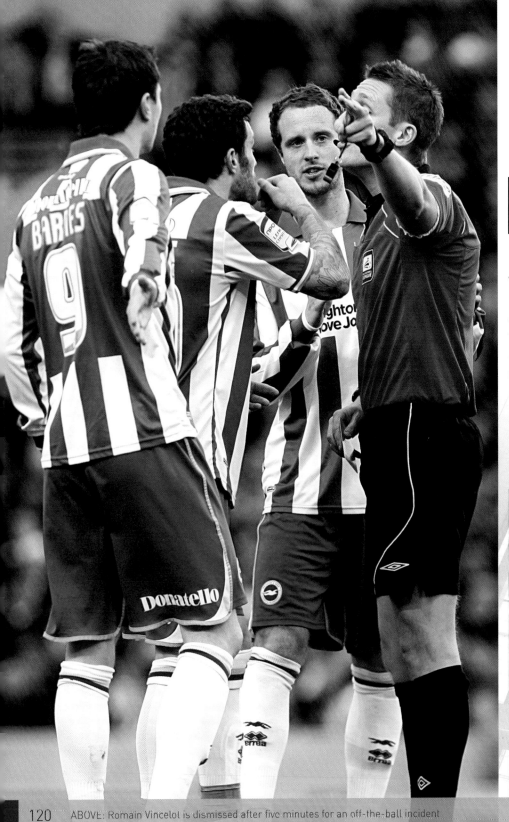

RED ALERT

"I was just shocked. I think when he sent Romain off no-one knew what was going on. I heard the fourth official got hold of the referee which I've never seen before. Then Ash's incident I thought was a foul on him and then he got sent off as well! So, suddenly, after ten minutes you're thinking, wow, we've got to dig deep and just make sure we don't get embarrassed here."
Craig Mackail-Smith

"The atmosphere of that game became overwhelming. That's where 'The Great Escape' started with the flags and the scarves going round heads, it was just a fantastic evening. And we came so close..."
Richard Reynolds

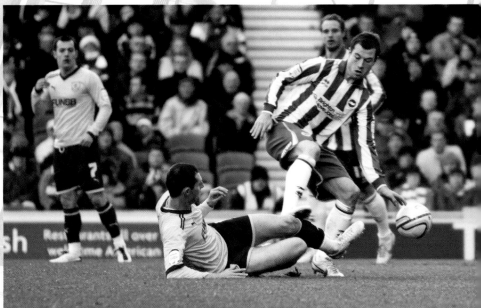

ABOVE: Romain Vincelot is dismissed after five minutes for an off-the-ball incident

ABOVE: Ashley Barnes sees red less than seven minutes later

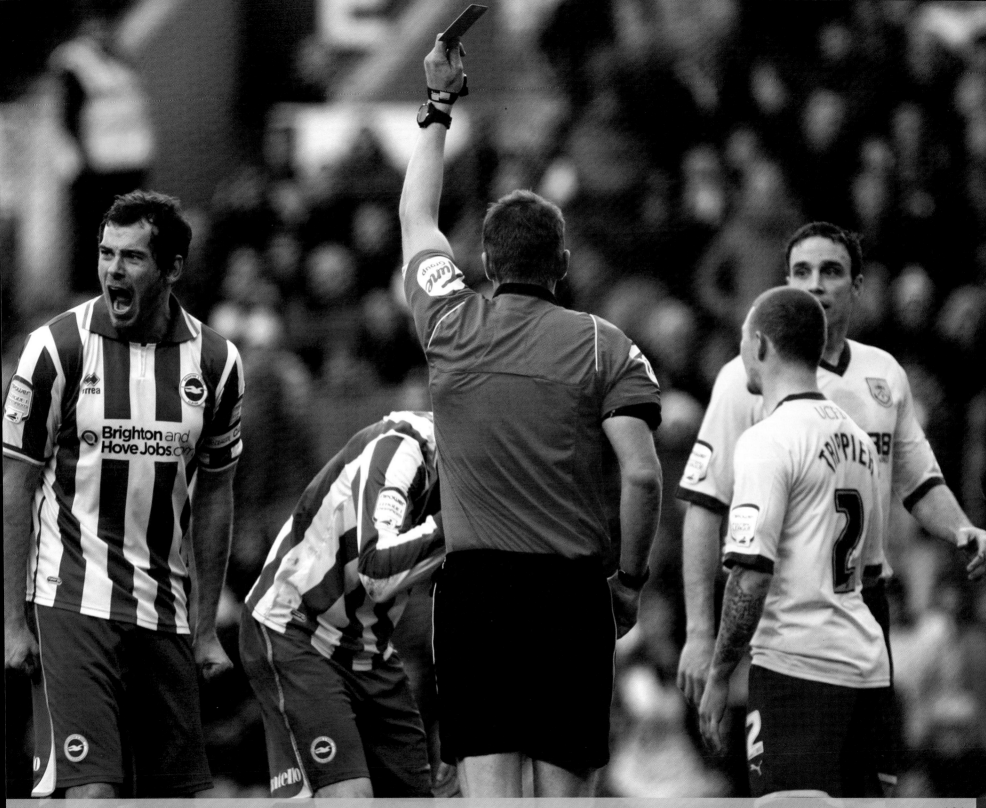

ABOVE: Albion are reduced to nine men after only twelve minutes

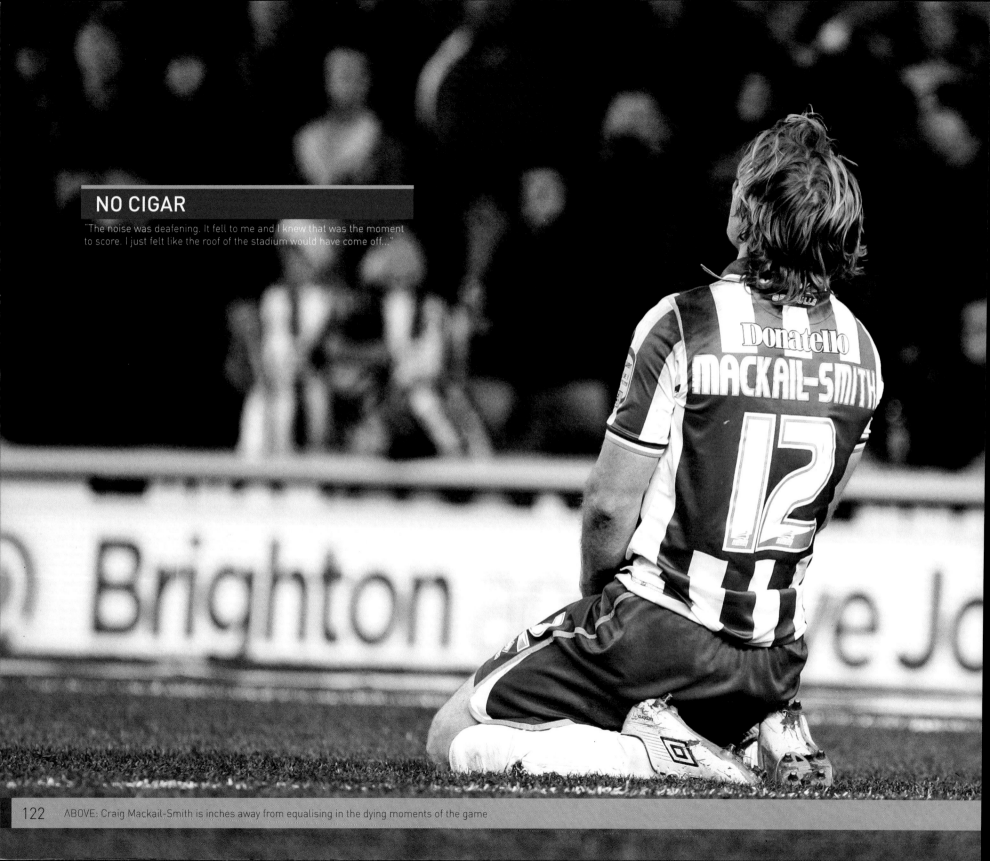

NO CIGAR

"The noise was deafening. It fell to me and I knew that was the moment to score. I just felt like the roof of the stadium would have come off..."

ABOVE: Craig Mackail-Smith is inches away from equalising in the dying moments of the game

FULL VOICE

"My favourite footballing moment would be when we were reduced to nine men within ten minutes at home to Burnley, and one nil down. Somebody started singing 'The Great Escape' in the original spirit it was sung i.e. 'how the hell do we get out of this?' We kept singing it over and over until it spread through the whole of the ground, except in the away end of course. It was the loudest I've heard us sing at the Amex and it spread a feeling of togetherness in adversity which warmed our hearts and spurred the team on to give a good account of themselves for the rest of the game. We had so much to celebrate at the beginning of the season, we almost forget it's when the going gets tough that the true spirit and soul of a team, its supporters and stadium comes through."

Norman Cook

ABOVE: Fans create an incredible atmosphere in an attempt to spur the team on

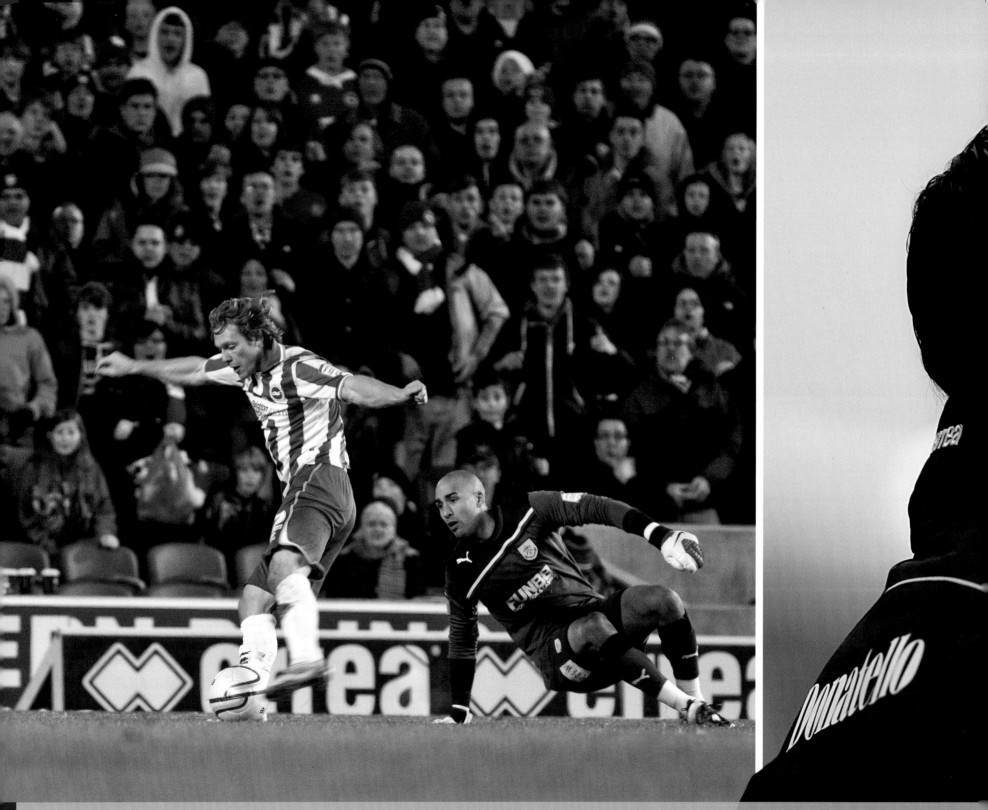

ABOVE: Craig Mackail-Smith rounds the keeper but can't quite find the net

BIGGEST MOMENT AS MANAGER

"It's in my top three games of the season, and normally you pick the ones you win. I think it was the best decision I made as a manager this year, the way we played with nine. The way the players understood what I wanted, what we needed, and the effort and understanding in what they put on the pitch. It's my biggest moment as a manager this year in terms of personal decision making. You don't find yourself after twelve minutes, 9 vs 11 and needing to make two changes, and those decisions are going to live with you in either a positive way or a negative way."

Gus Poyet

"The mighty Brighton army; all three stands united as one! The wall of noise and encouragement was deafening and constant, only increasing in volume as we became the victim of a wonder strike. The effort from the team mirrored that of the fans, and we were oh-so-close to a miracle. Alas, it wasn't to be, but I will never forget being at the Albion's loudest and proudest defeat."

Graeme Rolf, Albion Fan

ABOVE/ TOP: Gus Poyet watches his eight outfield players compete for 80 minutes

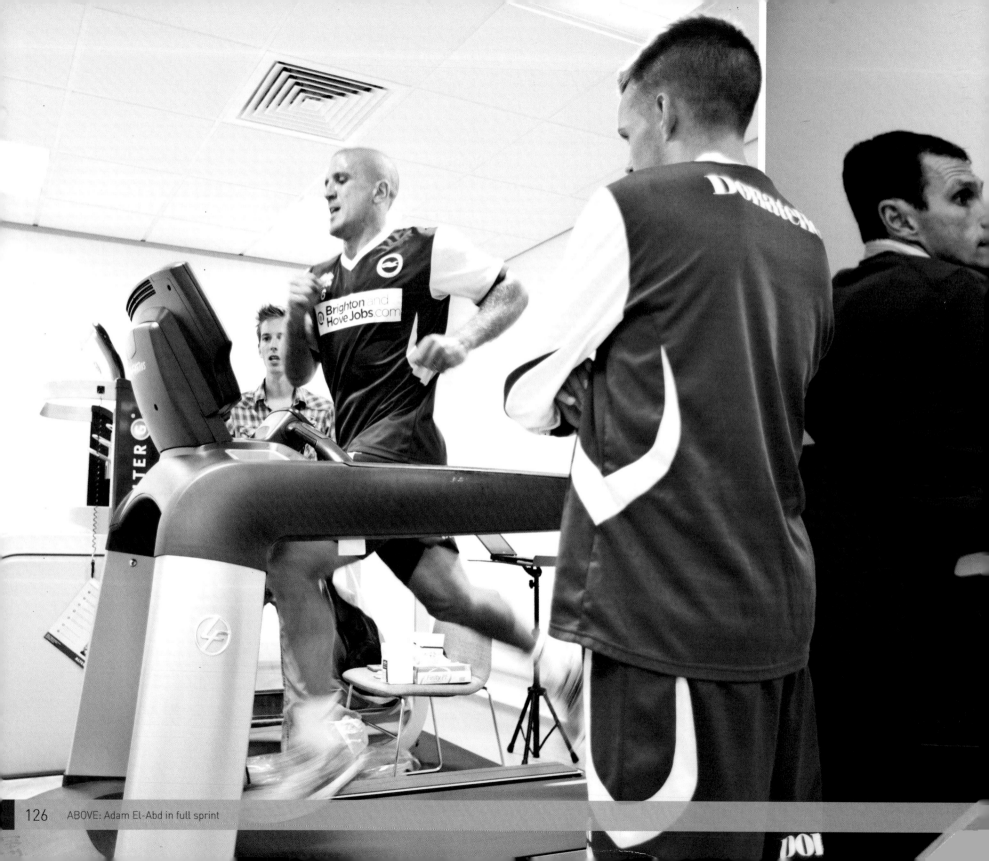

ABOVE: Adam El-Abd in full sprint

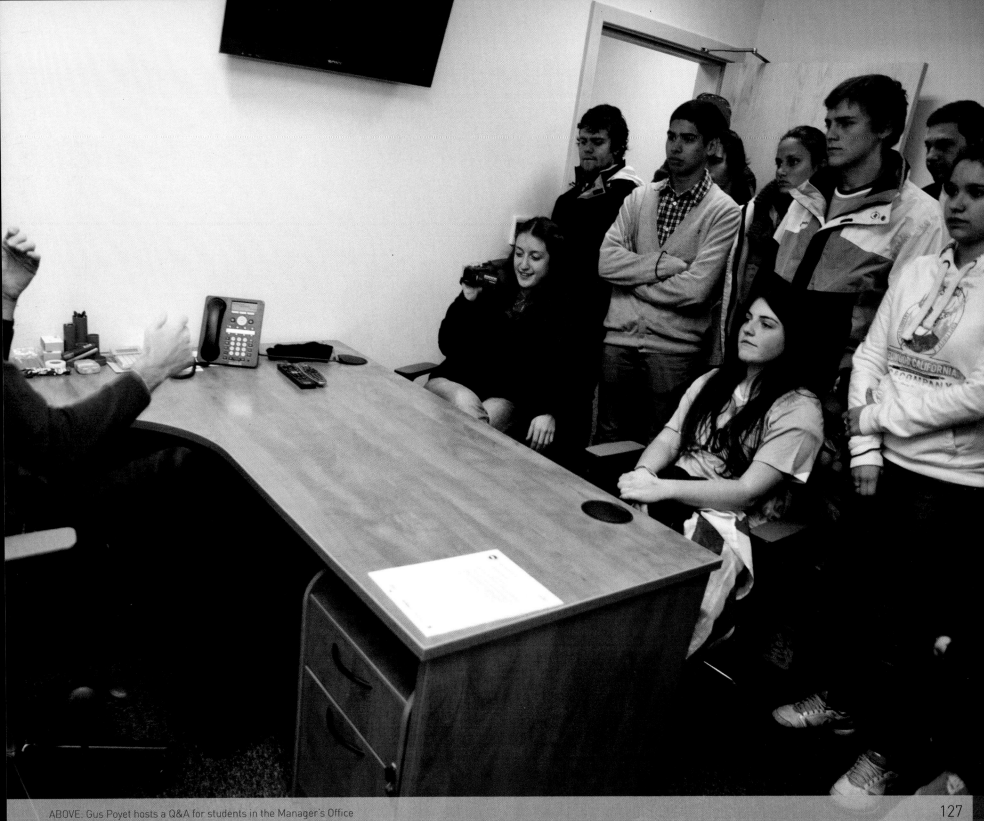

ABOVE: Gus Poyet hosts a Q&A for students in the Manager's Office

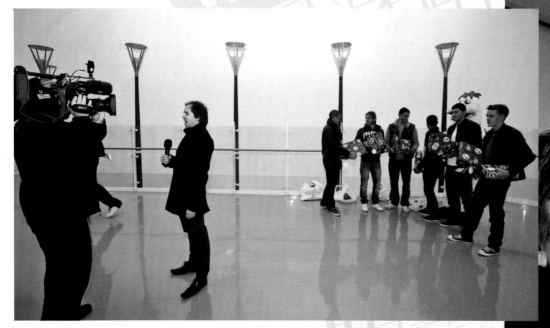

KNIGHTHOOD

In 2011 Albion in the Community benefitted over 47,000 in Sussex and across the world.

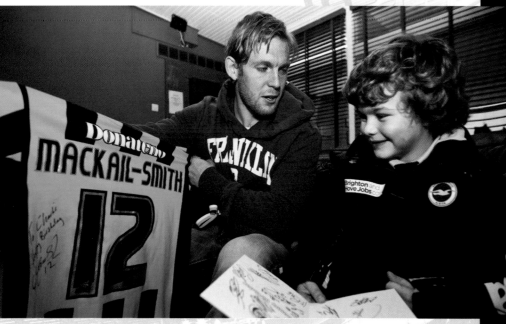

ABOVE/ TOP: Albion's first team pays a visit to Royal Alexandra Children's hospital

ABOVE: Dick Knight prepares to play Santa in AITC's Disability Christmas Party

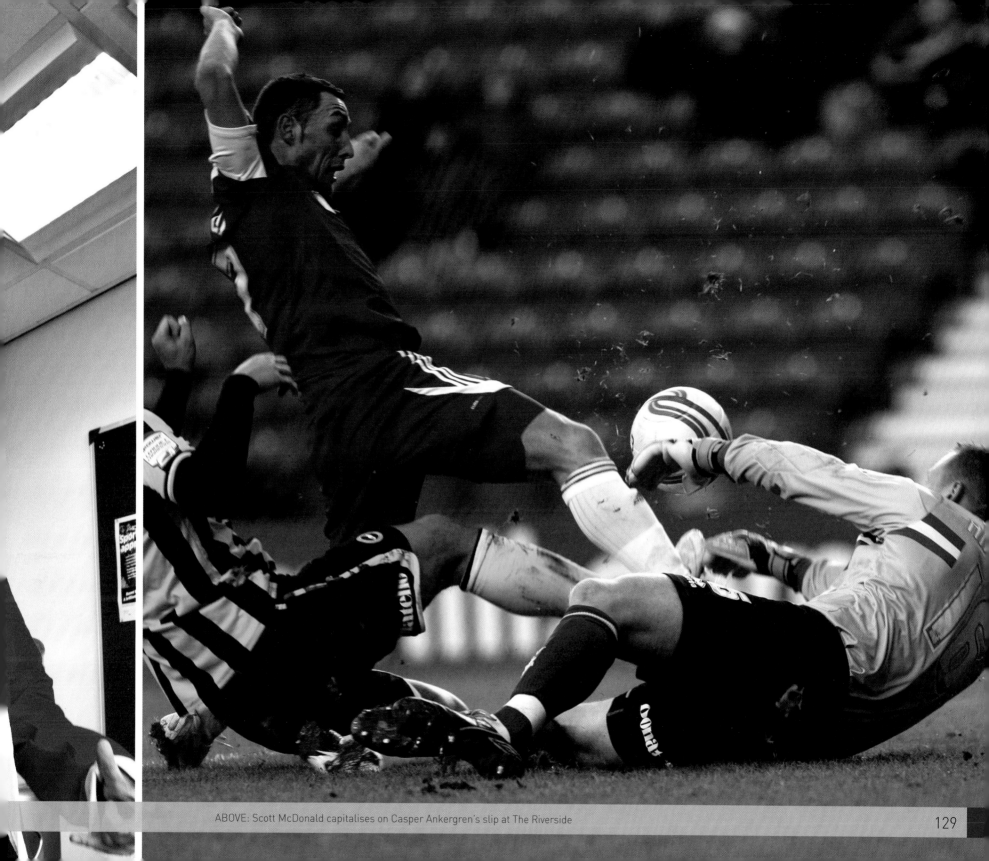

ABOVE: Scott McDonald capitalises on Casper Ankergren's slip at The Riverside

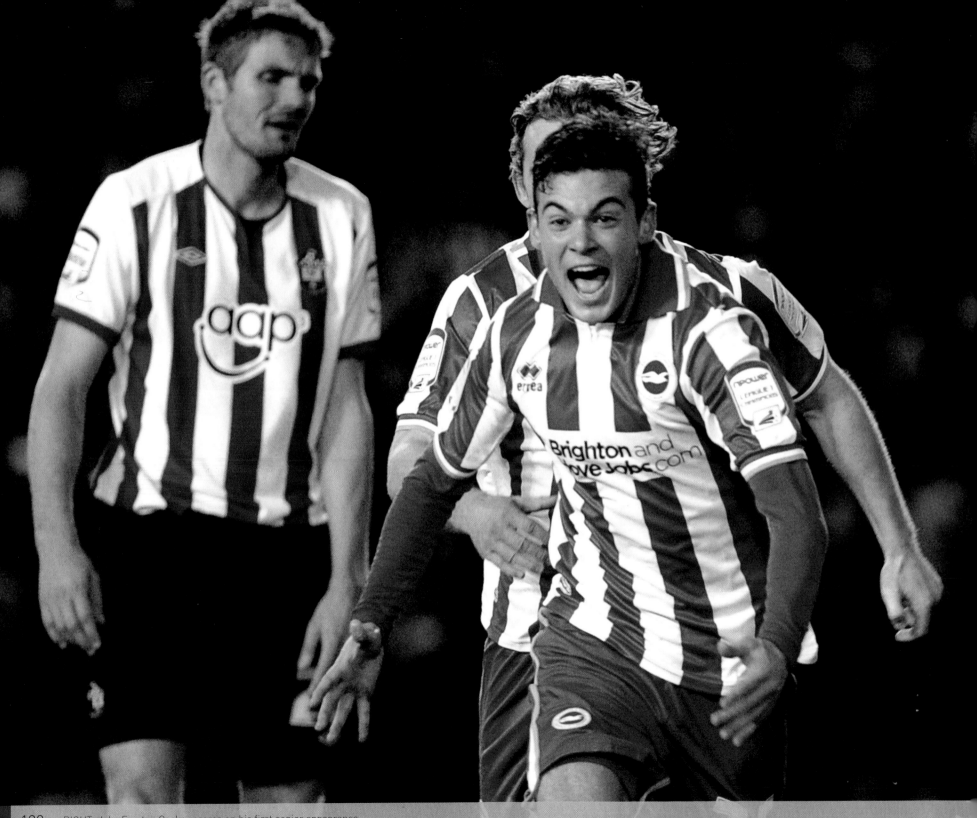

RIGHT: Jake Forster-Caskey scores on his first senior appearance.

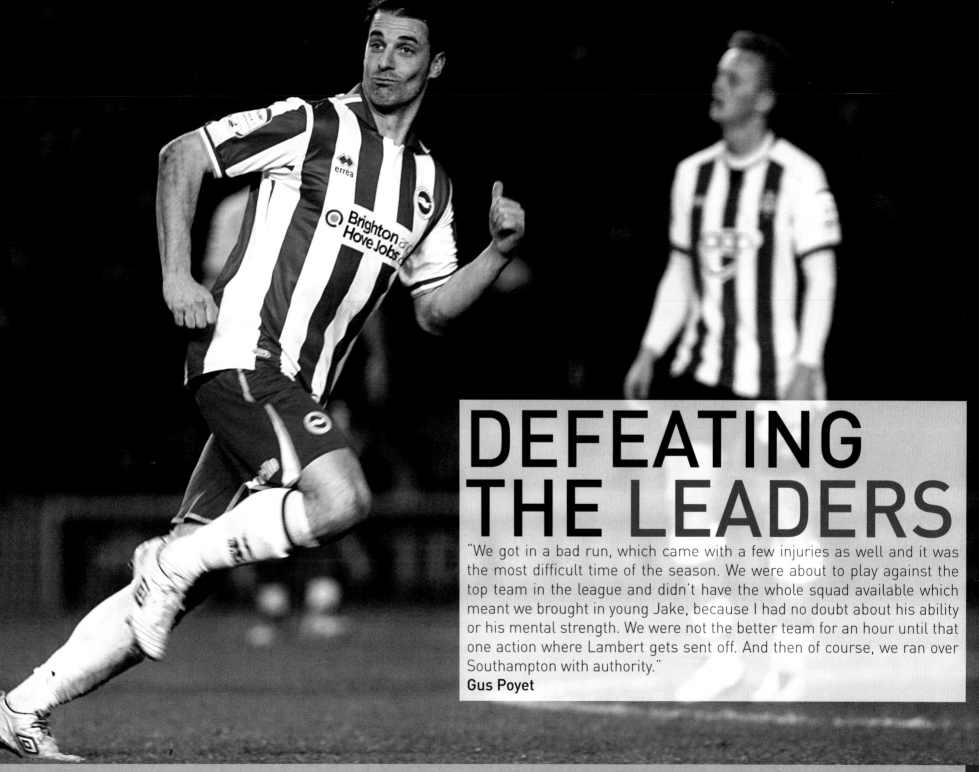

DEFEATING THE LEADERS

"We got in a bad run, which came with a few injuries as well and it was the most difficult time of the season. We were about to play against the top team in the league and didn't have the whole squad available which meant we brought in young Jake, because I had no doubt about his ability or his mental strength. We were not the better team for an hour until that one action where Lambert gets sent off. And then of course, we ran over Southampton with authority."

Gus Poyet

ABOVE: Sparrow nets from well outside the penalty area against Southampton

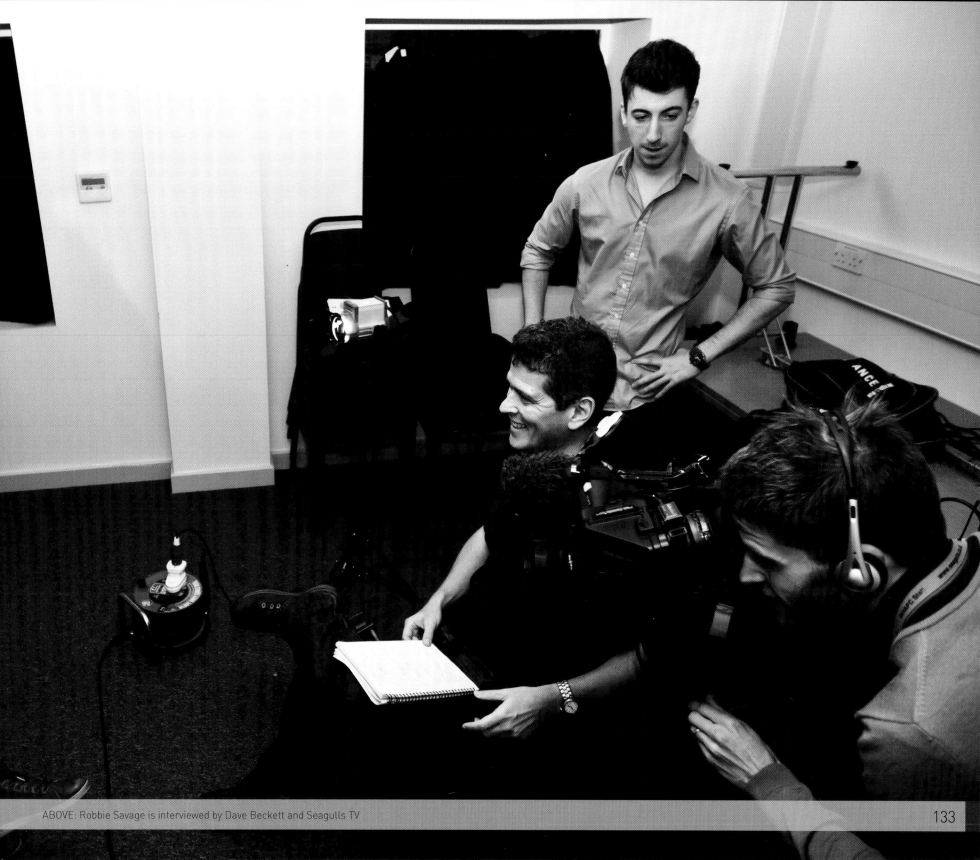

ABOVE: Robbie Savage is interviewed by Dave Beckett and Seagulls TV

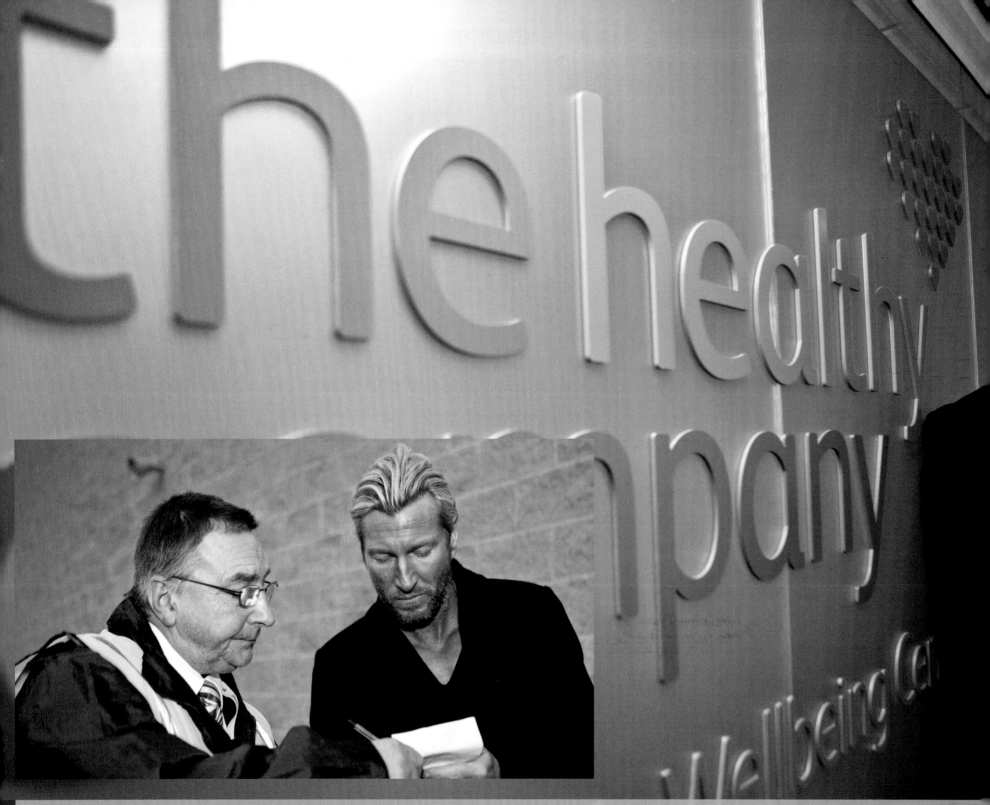

BOTTOM: Savage signs

ABOVE: The Healthy Company is unveiled in the East Stand

THE HEALTHY COMPANY

"I was a bit of a hypochondriac when I came here so the club doctor, Tim Stevenson, and I got close. He's a lovely guy and I think anyone you speak to in Brighton will have a huge amount of respect for him. I'm not even registered with a doctor where I live, so if I have any niggles, coughs or colds, I phone Tim!"
Robbie Savage

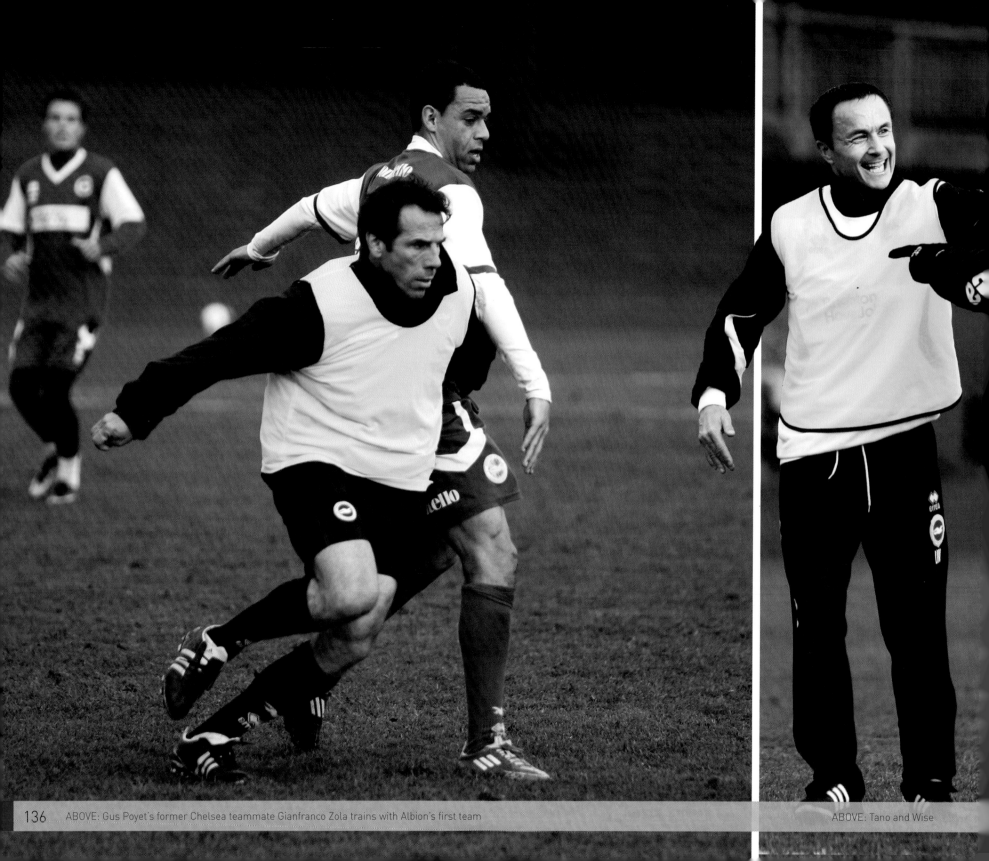

ABOVE: Gus Poyet's former Chelsea teammate Gianfranco Zola trains with Albion's first team

ABOVE: Tano and Wise

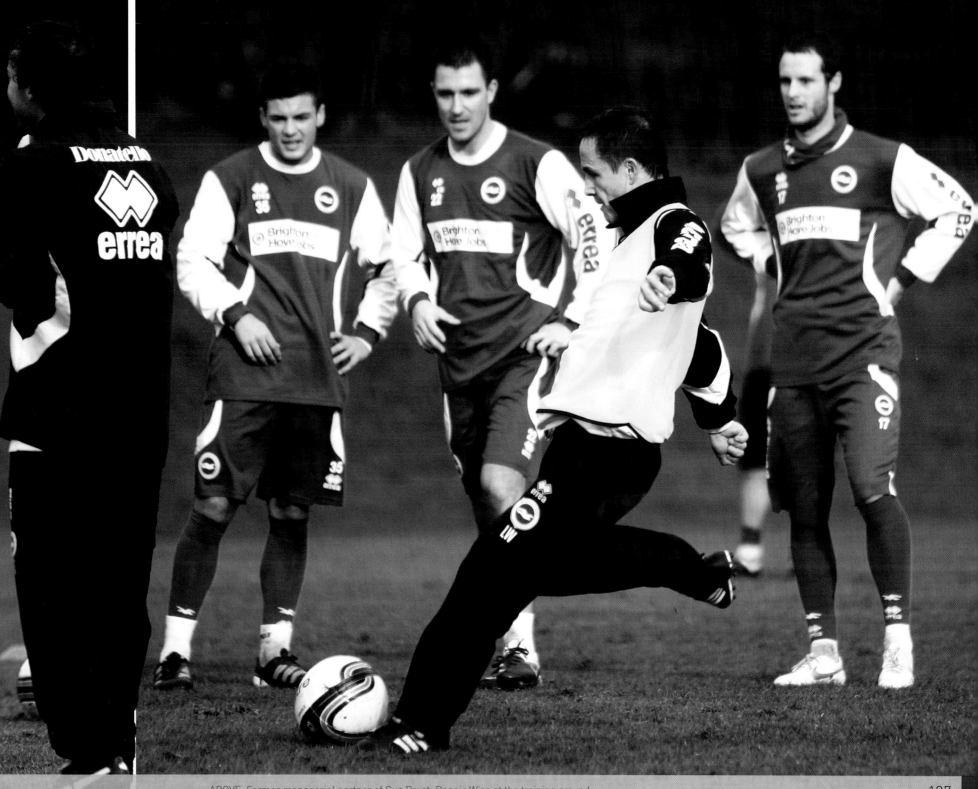

ABOVE: Former managerial partner of Gus Poyet, Dennis Wise at the training ground

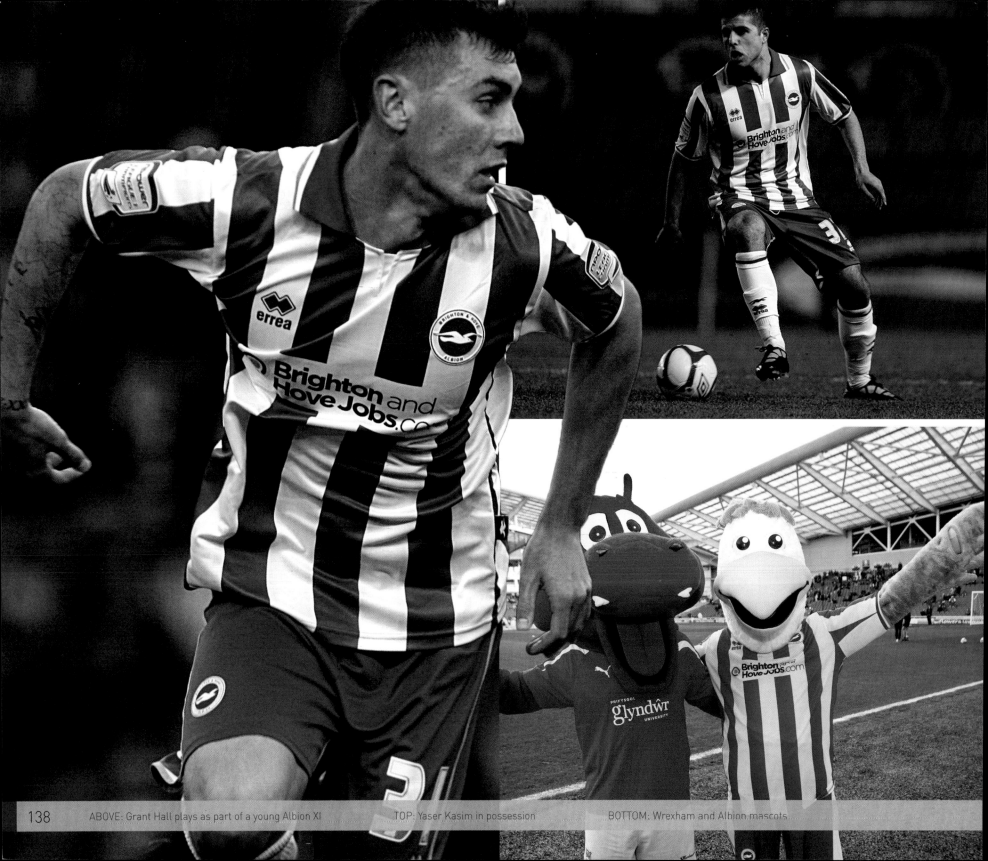

ABOVE: Grant Hall plays as part of a young Albion XI TOP: Yaser Kasim in possession BOTTOM: Wrexham and Albion mascots

THE FA CUP

"We knew how good they were, we knew they were top of the Conference at the time, and they've got some great young players who I think have since gone on to bigger things. They're a solid side, we went 1–0 up and then I think we took our foot off the gas a little bit and they responded with a good equaliser. So we went down there, and that was a long old night in Wales, it got called off the night before and we had to stay over there. I think we just thought, 'We're not coming all this way and not coming away with a glamour tie against Newcastle!'"

Will Buckley

ABOVE: Mid-week hero Caskey makes the cover of the programme

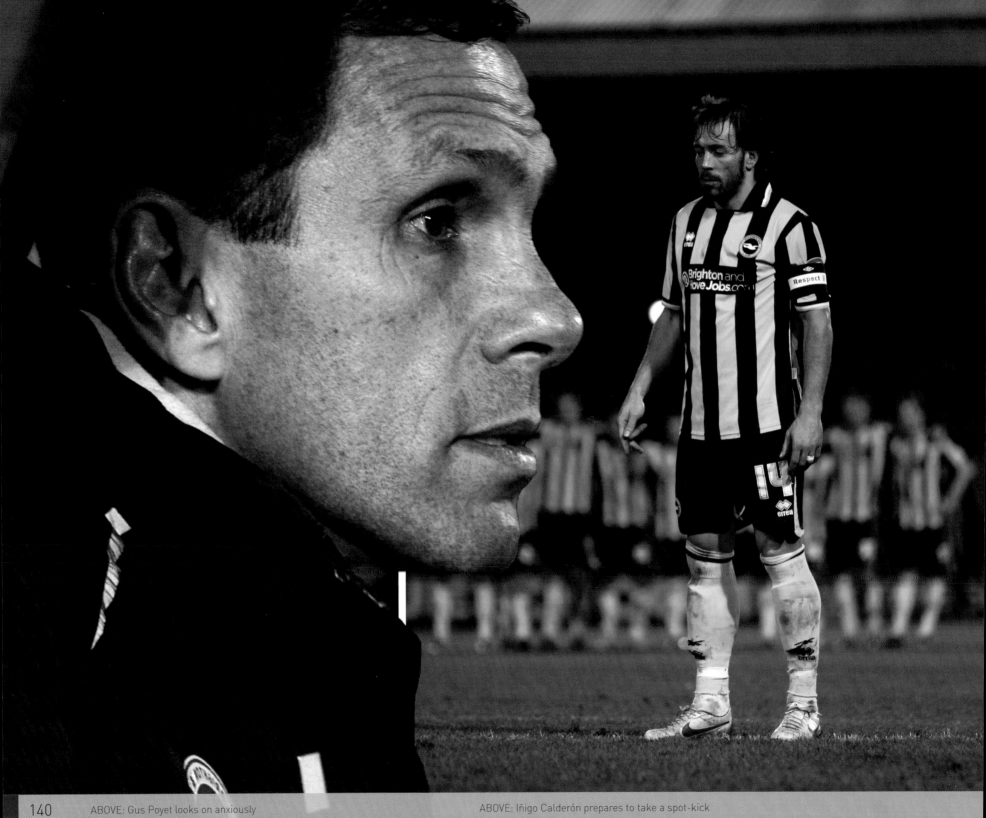

ABOVE: Gus Poyet looks on anxiously ABOVE: Iñigo Calderón prepares to take a spot-kick

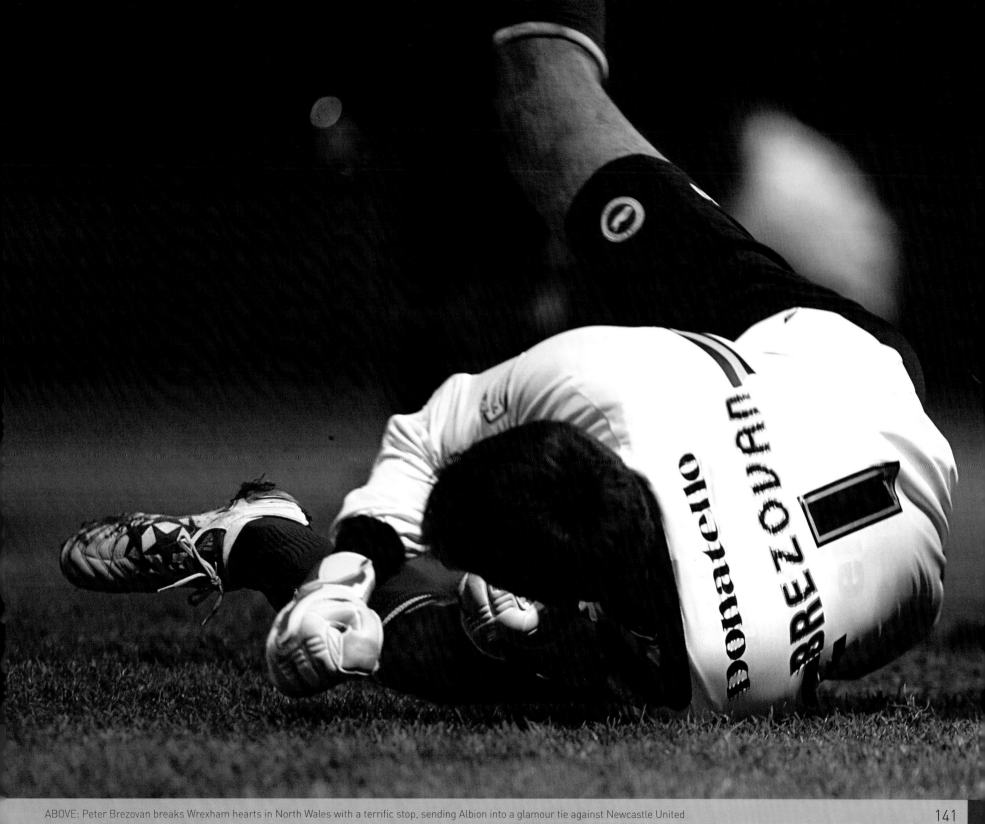

ABOVE: Peter Brezovan breaks Wrexham hearts in North Wales with a terrific stop, sending Albion into a glamour tie against Newcastle United

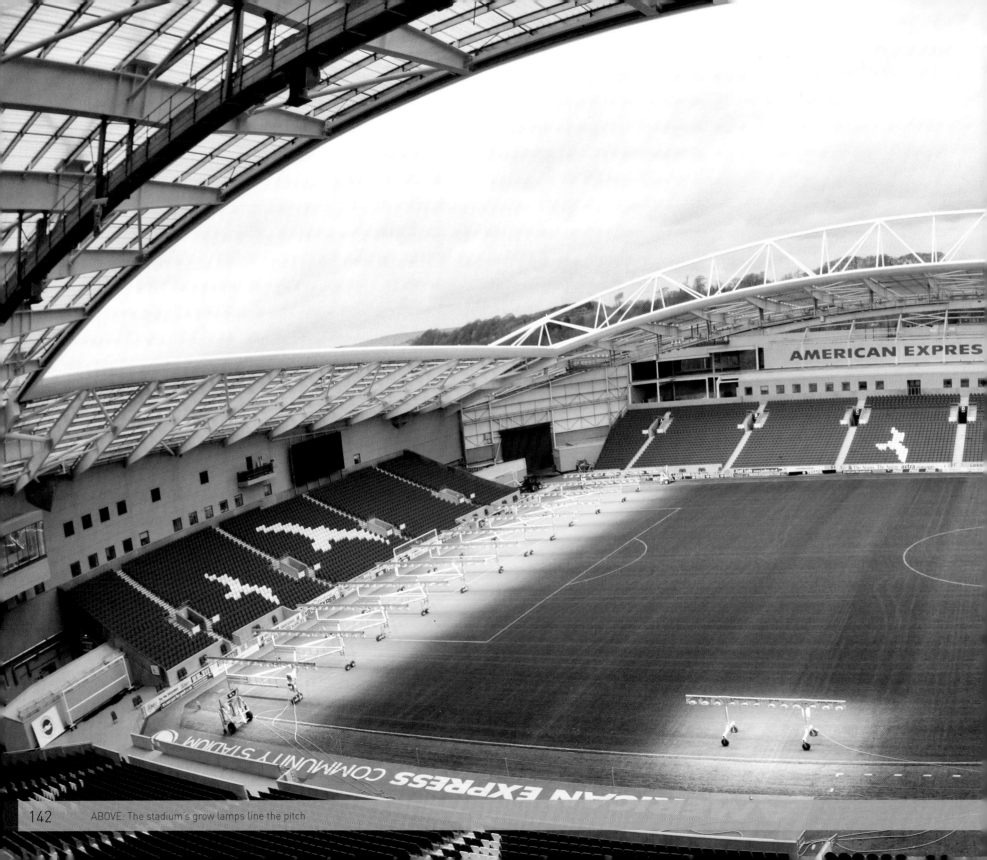

ABOVE: The stadium's grow lamps line the pitch

AMEX IN NUMBERS

In the Stadium Storage area, there are 4 lighting rigs, each containing 96 lamps.

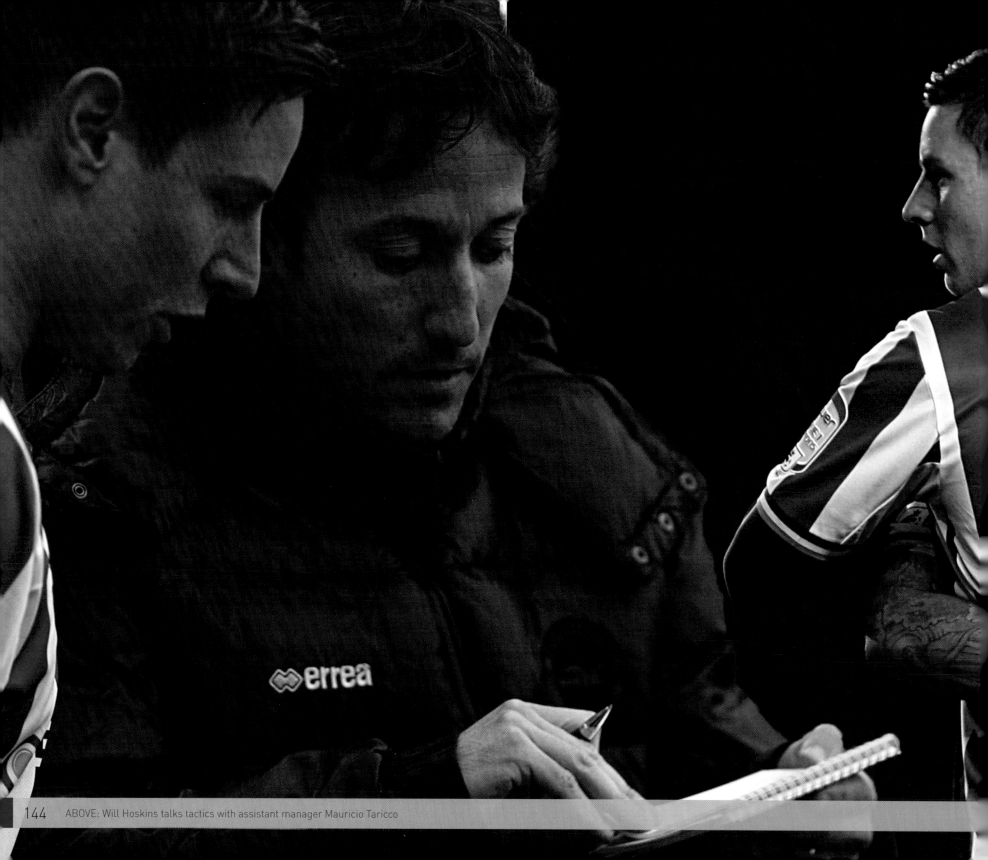

ABOVE: Will Hoskins talks tactics with assistant manager Mauricio Taricco

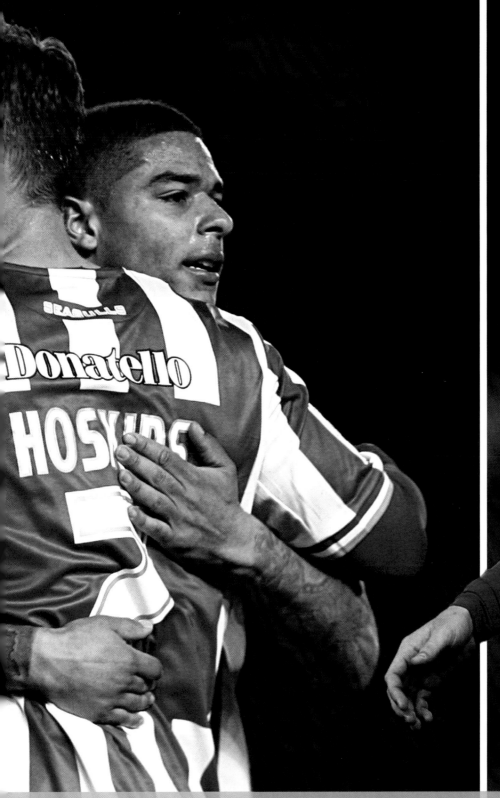

ABOVE: Will Hoskins and Liam Bridcutt against Bristol City

ABOVE: Will Hoskins in action against Bristol City

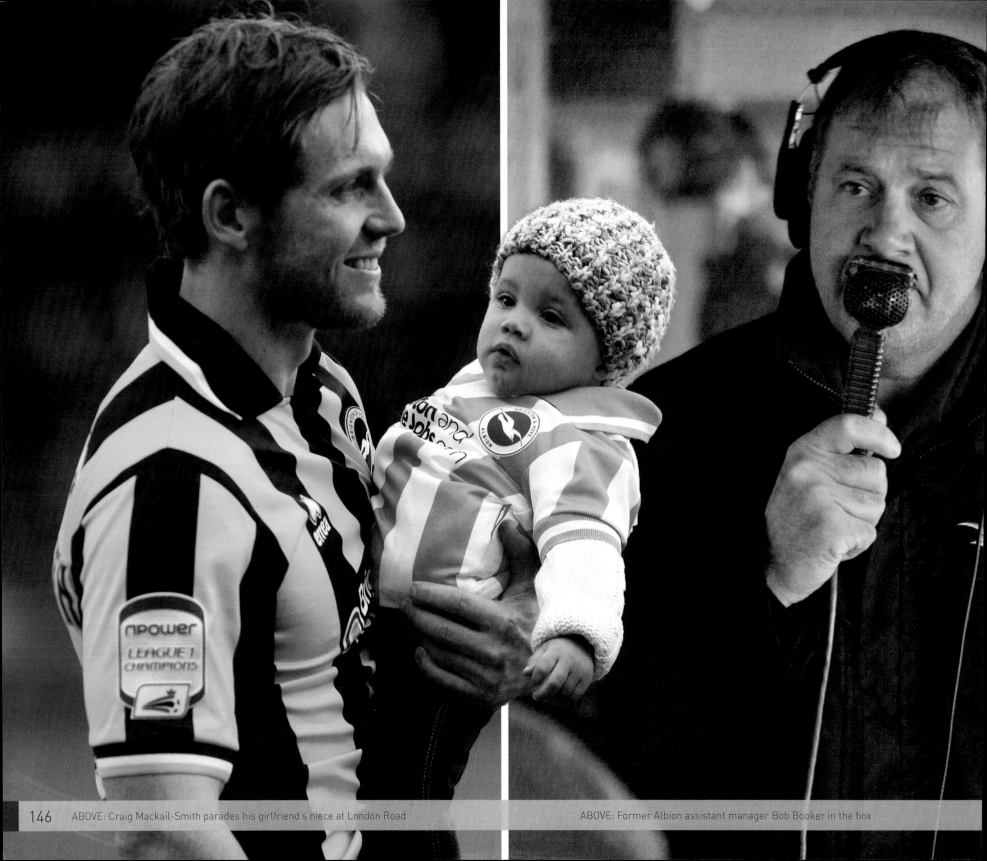

ABOVE: Craig Mackail-Smith parades his girlfriend's niece at London Road

ABOVE: Former Albion assistant manager Bob Booker in the box

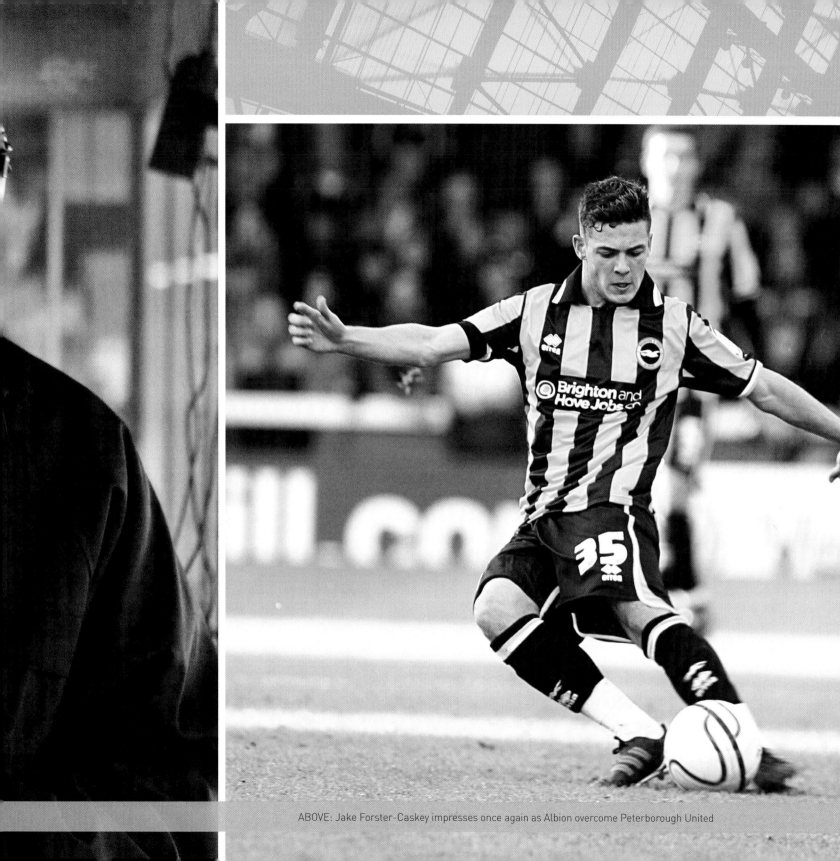

ABOVE: Jake Forster-Caskey impresses once again as Albion overcome Peterborough United

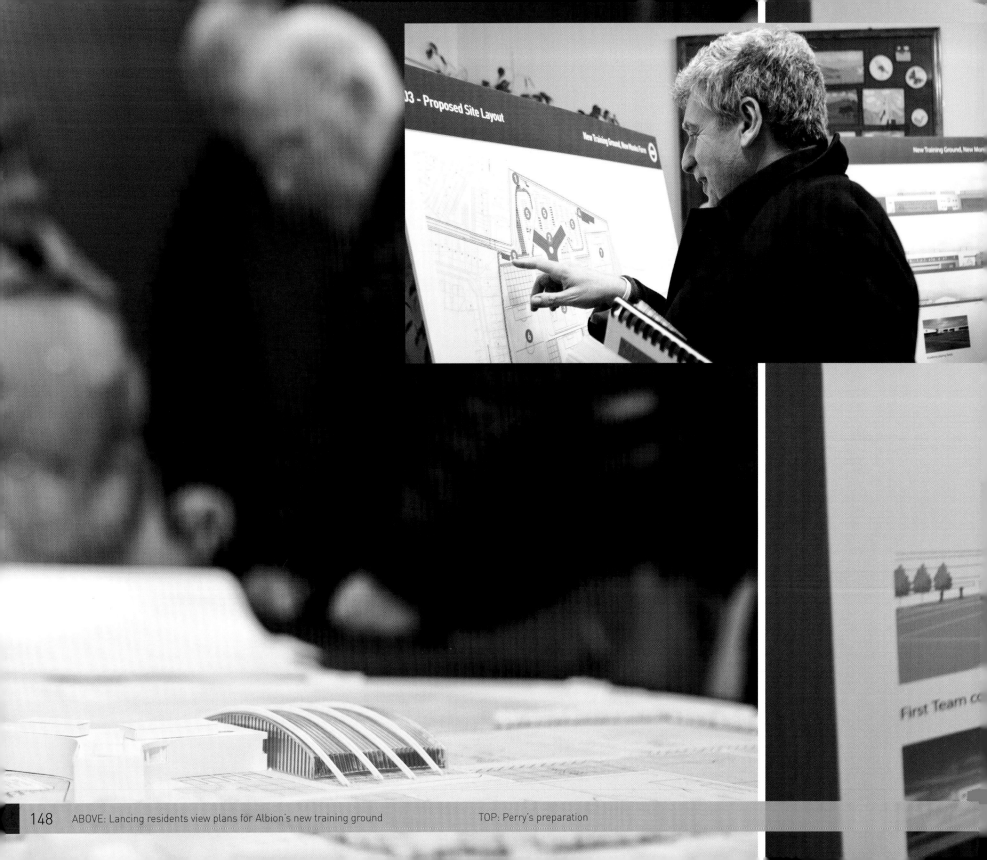

ABOVE: Lancing residents view plans for Albion's new training ground TOP: Perry's preparation

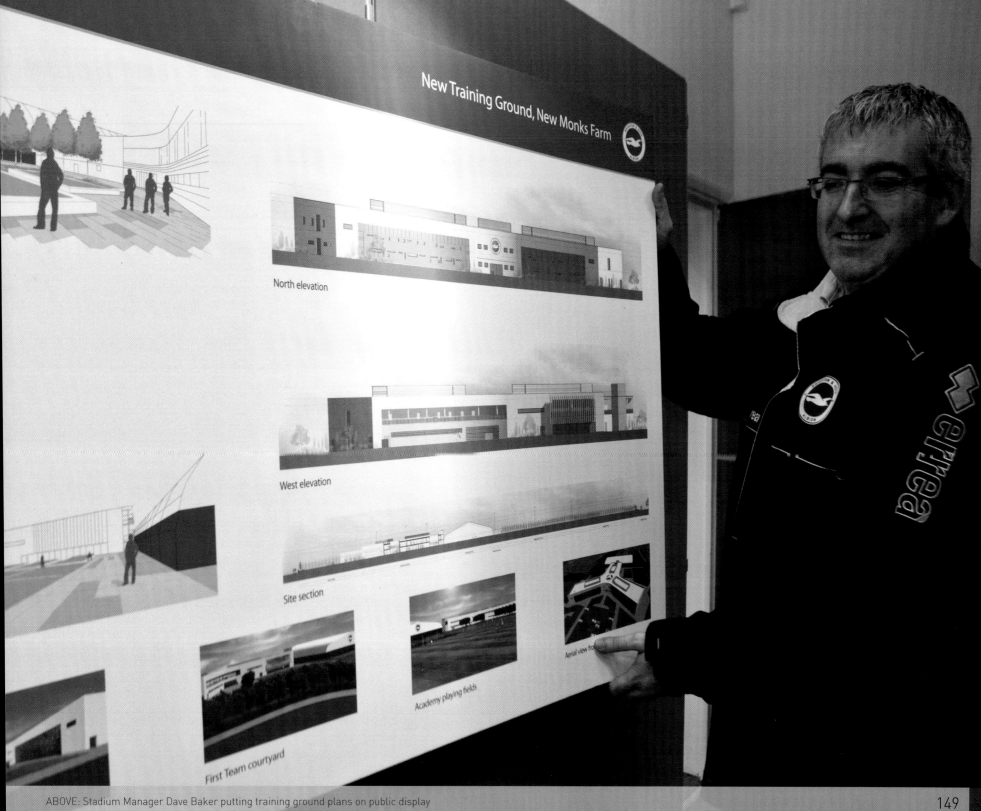

New Training Ground, New Monks Farm

North elevation

West elevation

Site section

First Team courtyard

Academy playing fields

Aerial view fro

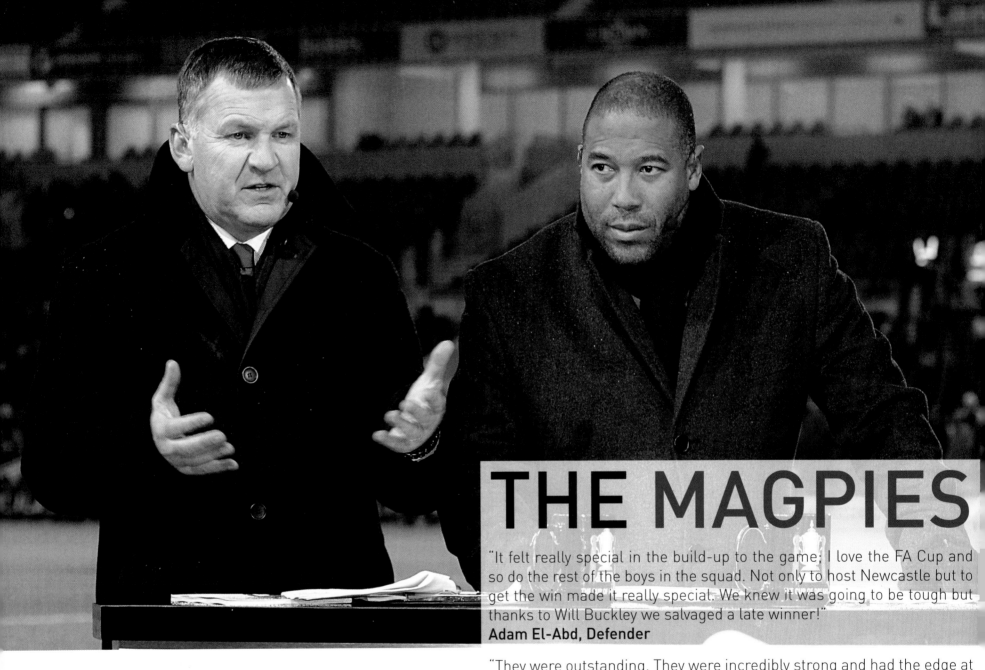

THE MAGPIES

"It felt really special in the build-up to the game; I love the FA Cup and so do the rest of the boys in the squad. Not only to host Newcastle but to get the win made it really special. We knew it was going to be tough but thanks to Will Buckley we salvaged a late winner!"

Adam El-Abd, Defender

"They were outstanding. They were incredibly strong and had the edge at times. The more we defended, the more we needed to stand up, and Brez was there for us at one end and Bucka the other."

Gus Poyet

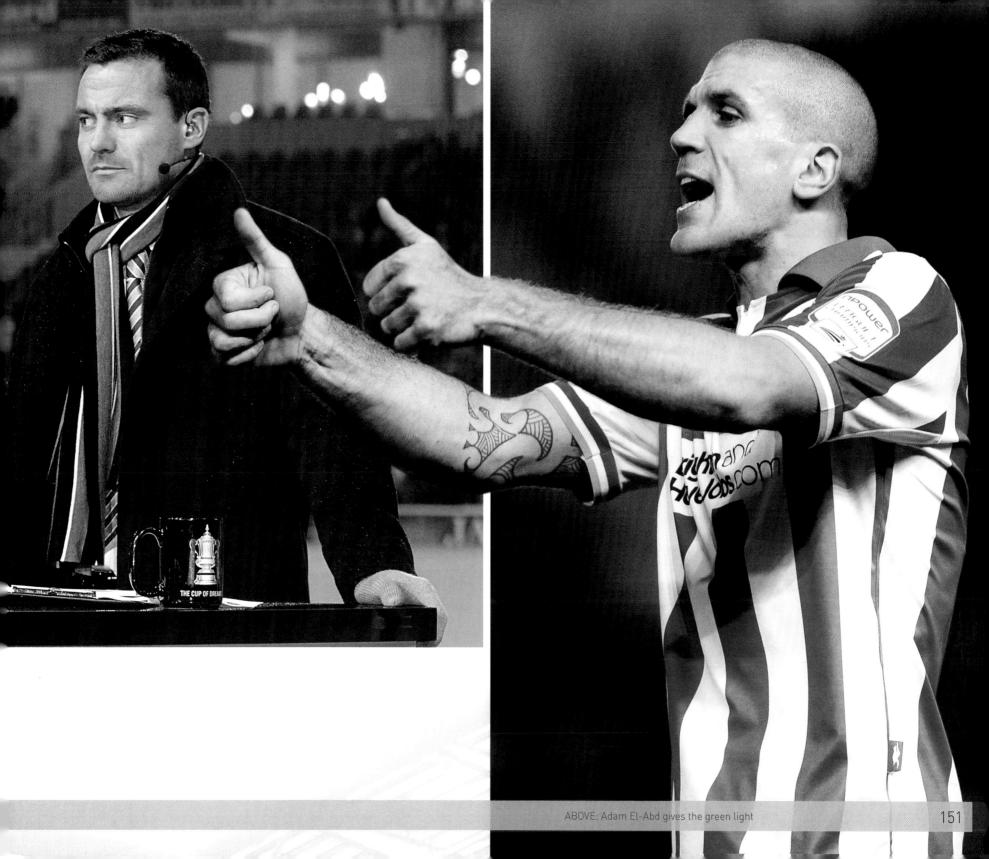

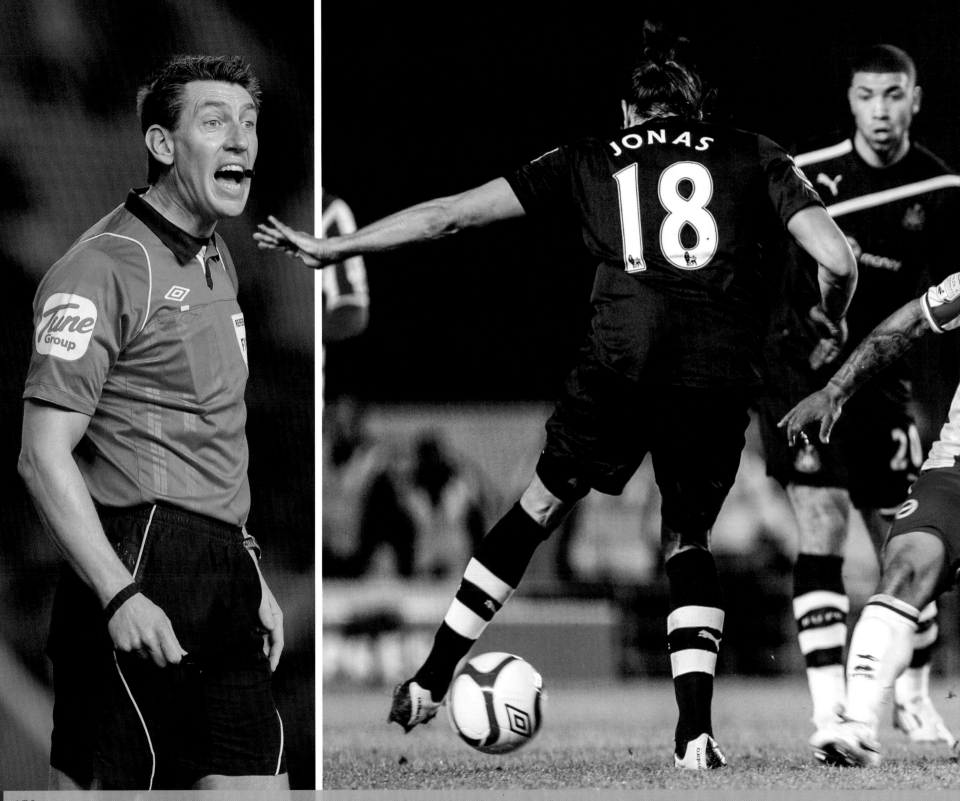

ABOVE: Referee Lee Probert officiates

ABOVE: Jonás Gutiérrez and Liam Bridcutt battle for possession

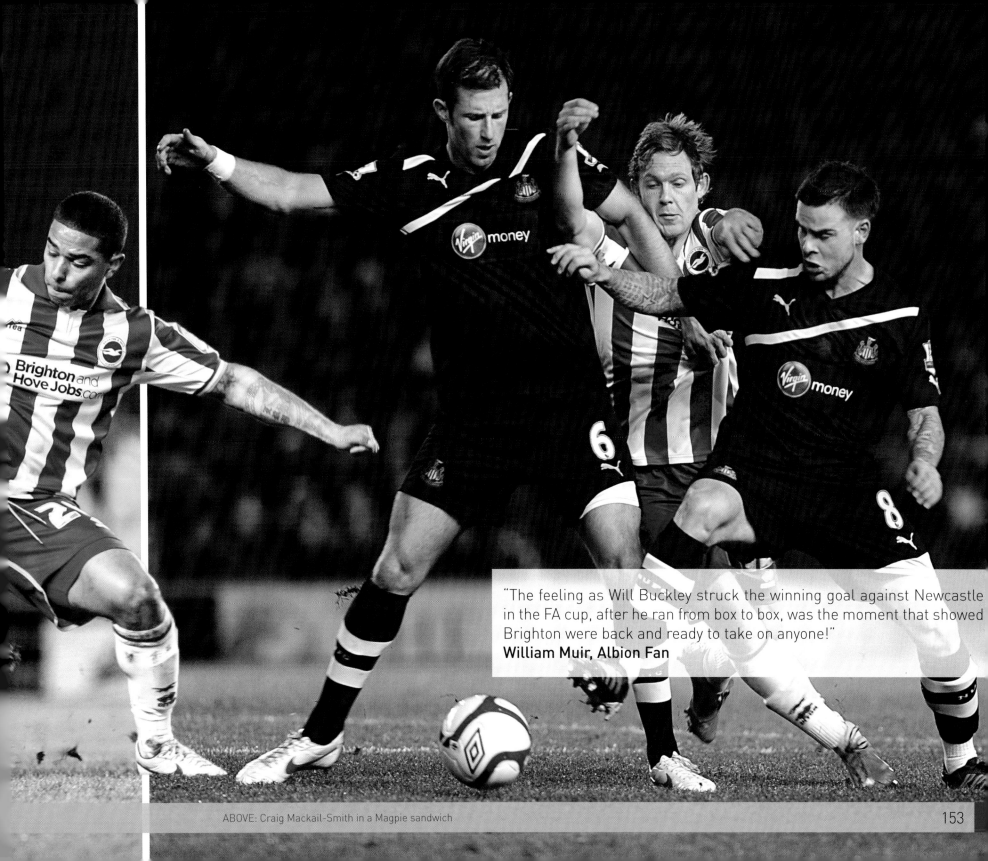

"The feeling as Will Buckley struck the winning goal against Newcastle in the FA cup, after he ran from box to box, was the moment that showed Brighton were back and ready to take on anyone!"
William Muir, Albion Fan

ABOVE: Craig Mackail-Smith in a Magpie sandwich

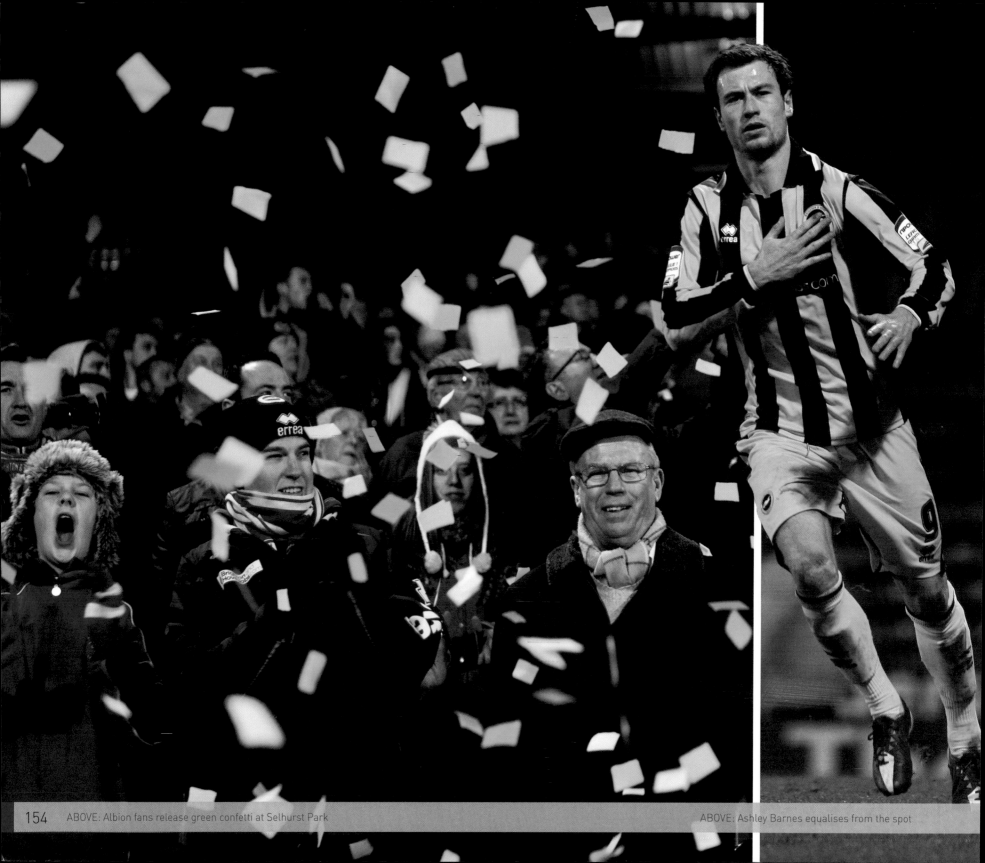

ABOVE: Albion fans release green confetti at Selhurst Park

ABOVE: Ashley Barnes equalises from the spot

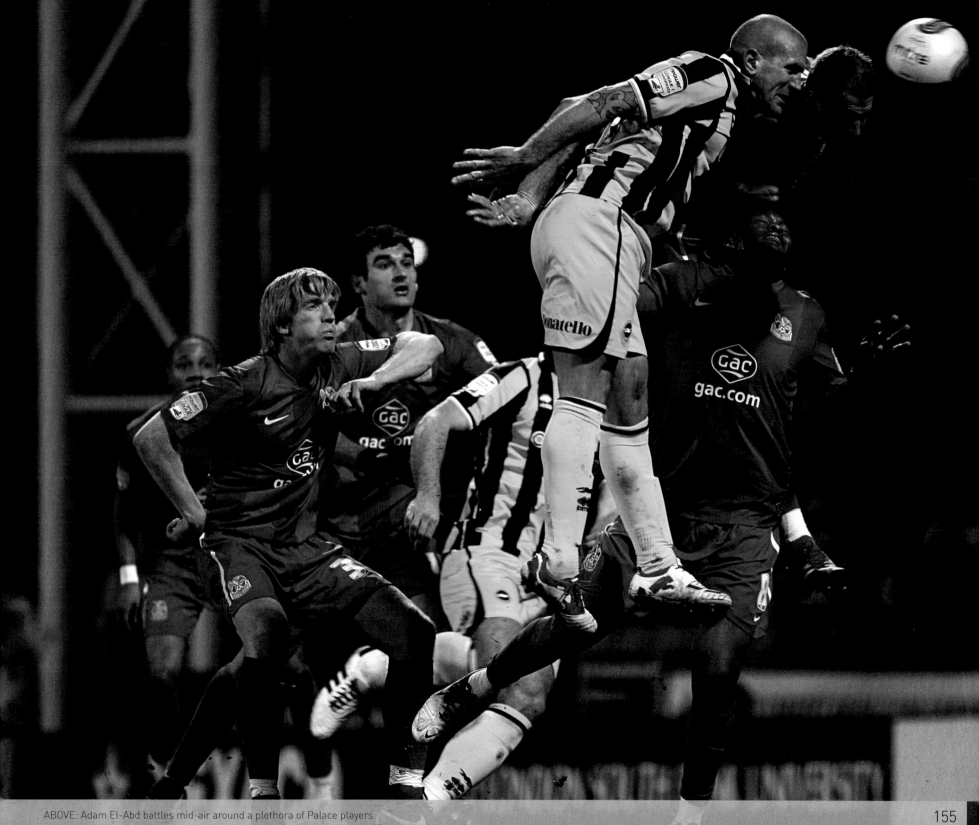

ABOVE: Adam El-Abd battles mid-air around a plethora of Palace players

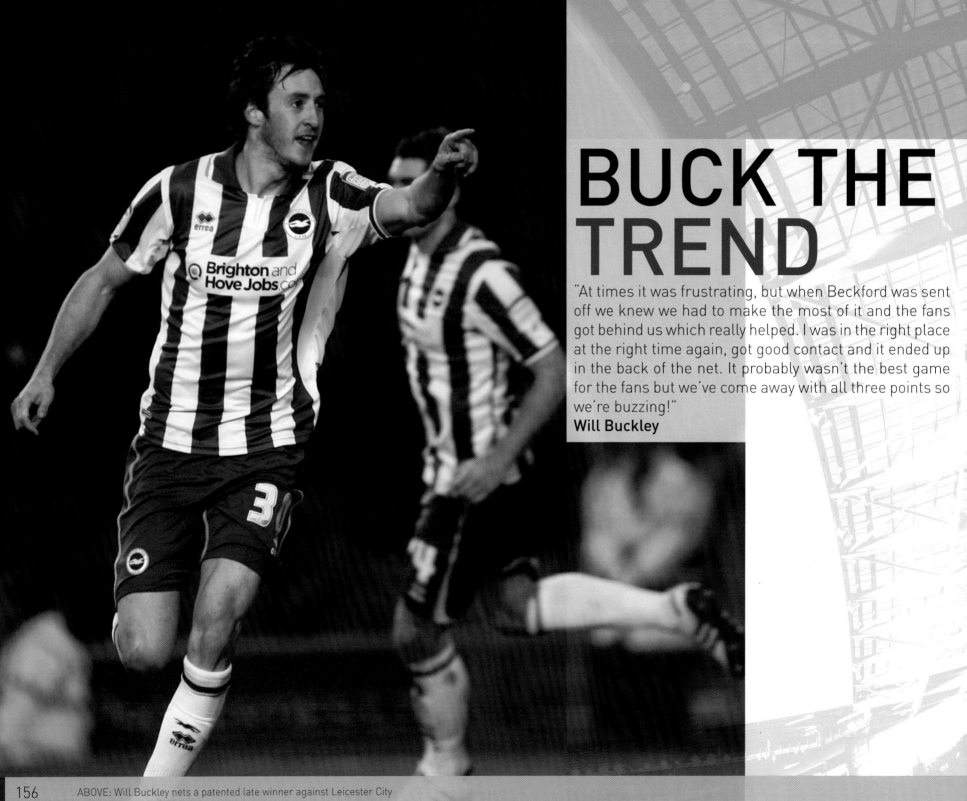

BUCK THE TREND

"At times it was frustrating, but when Beckford was sent off we knew we had to make the most of it and the fans got behind us which really helped. I was in the right place at the right time again, got good contact and it ended up in the back of the net. It probably wasn't the best game for the fans but we've come away with all three points so we're buzzing!"
Will Buckley

ABOVE: Will Buckley nets a patented late winner against Leicester City

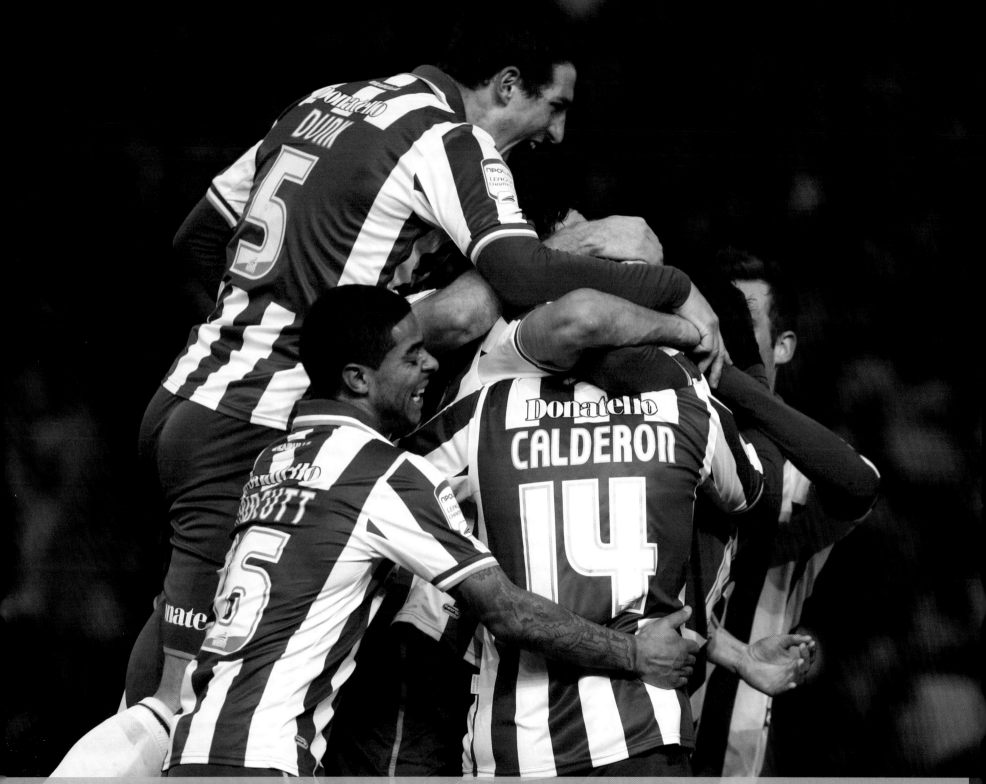

ABOVE: Players celebrate as Albion continue their new year's momentum

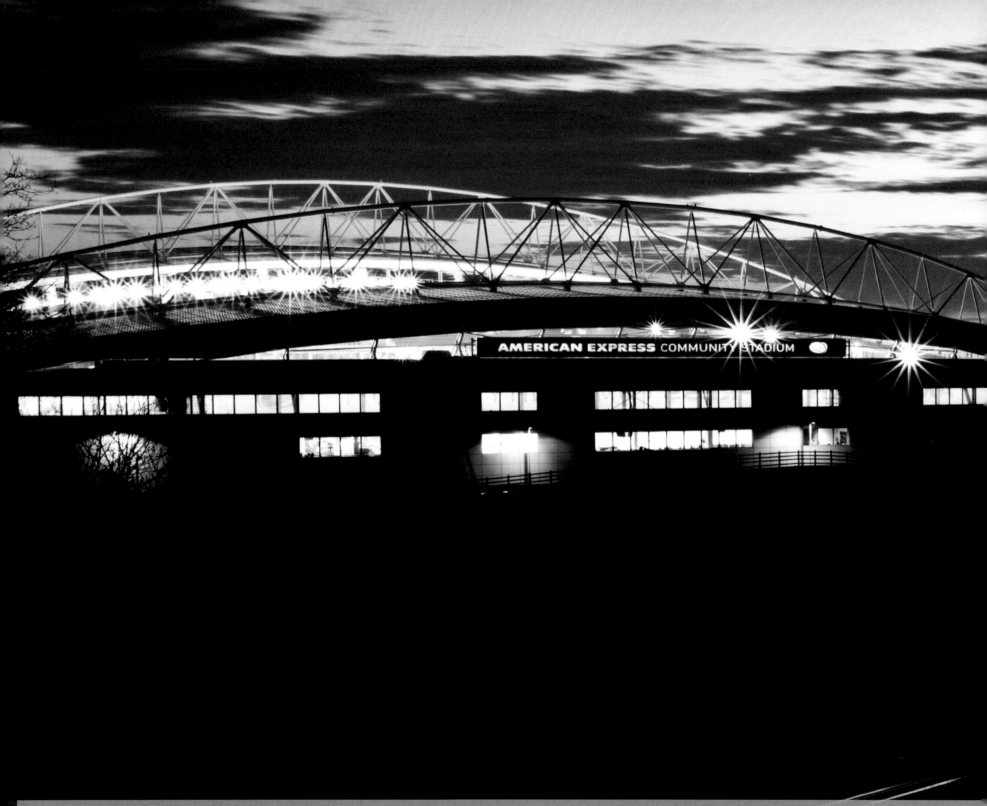

ABOVE: The neighbouring road bustles

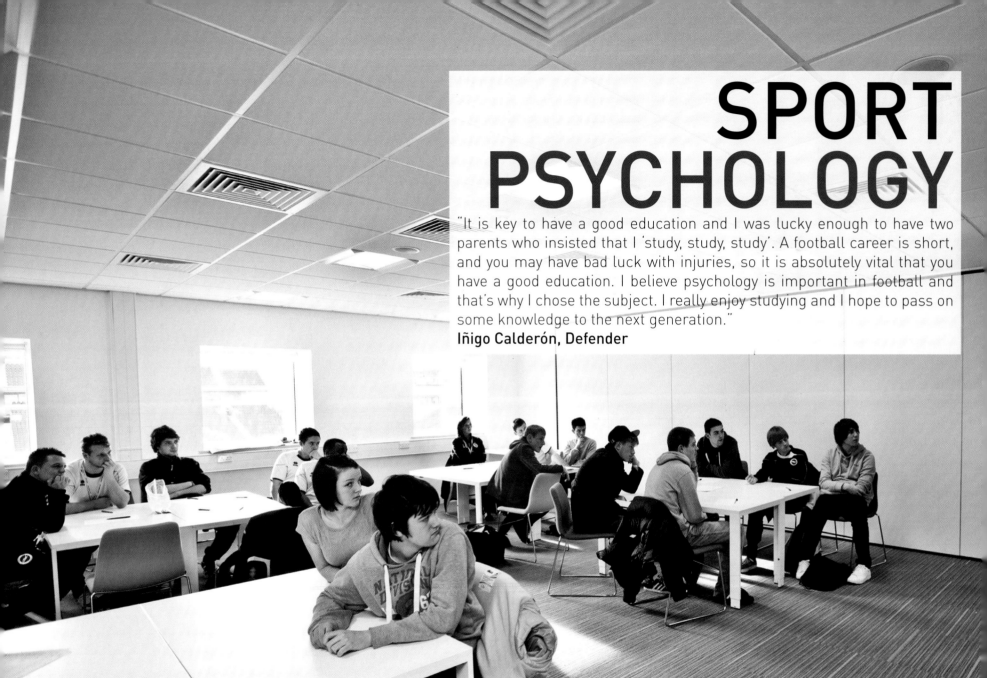

SPORT PSYCHOLOGY

"It is key to have a good education and I was lucky enough to have two parents who insisted that I 'study, study, study'. A football career is short, and you may have bad luck with injuries, so it is absolutely vital that you have a good education. I believe psychology is important in football and that's why I chose the subject. I really enjoy studying and I hope to pass on some knowledge to the next generation."

Iñigo Calderón, Defender

ABOVE: Albion in the Community scholars listen intently

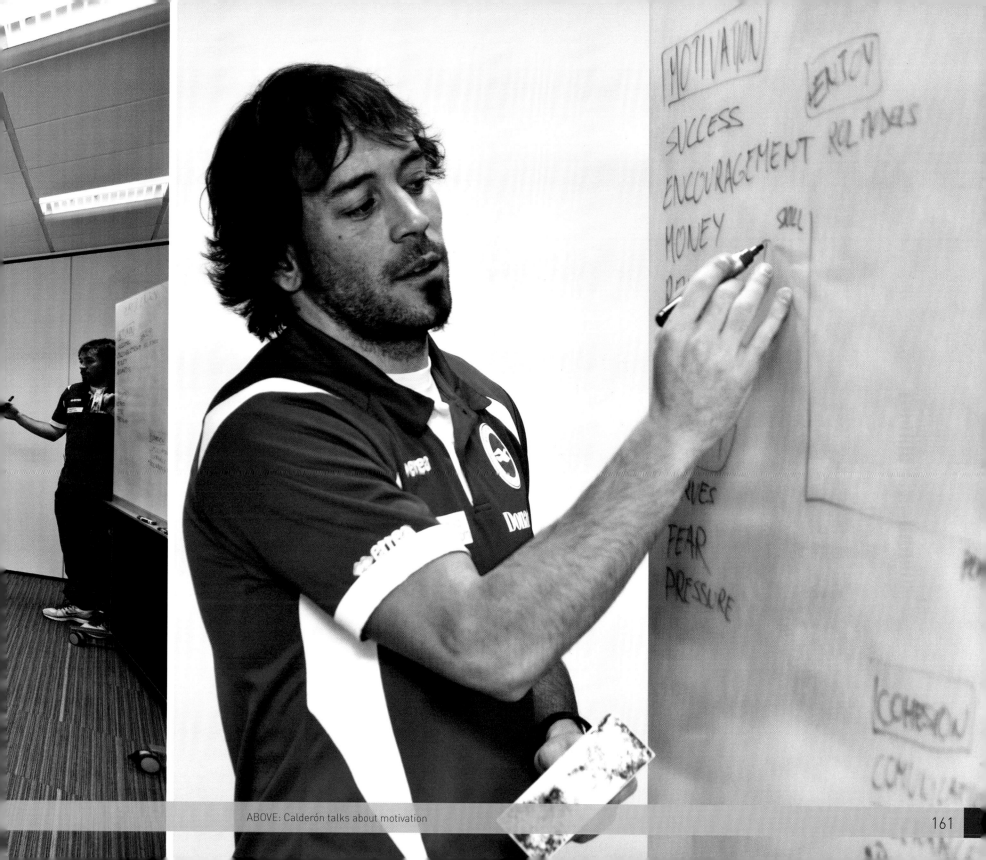

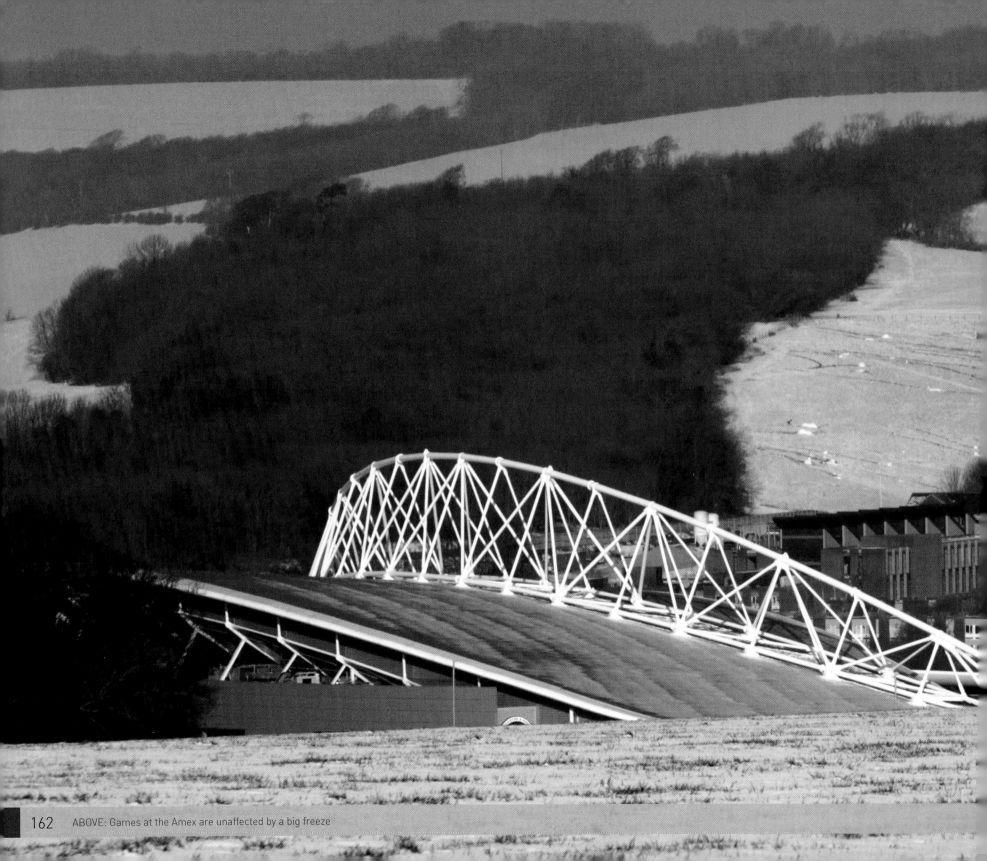

ABOVE: Games at the Amex are unaffected by a big freeze

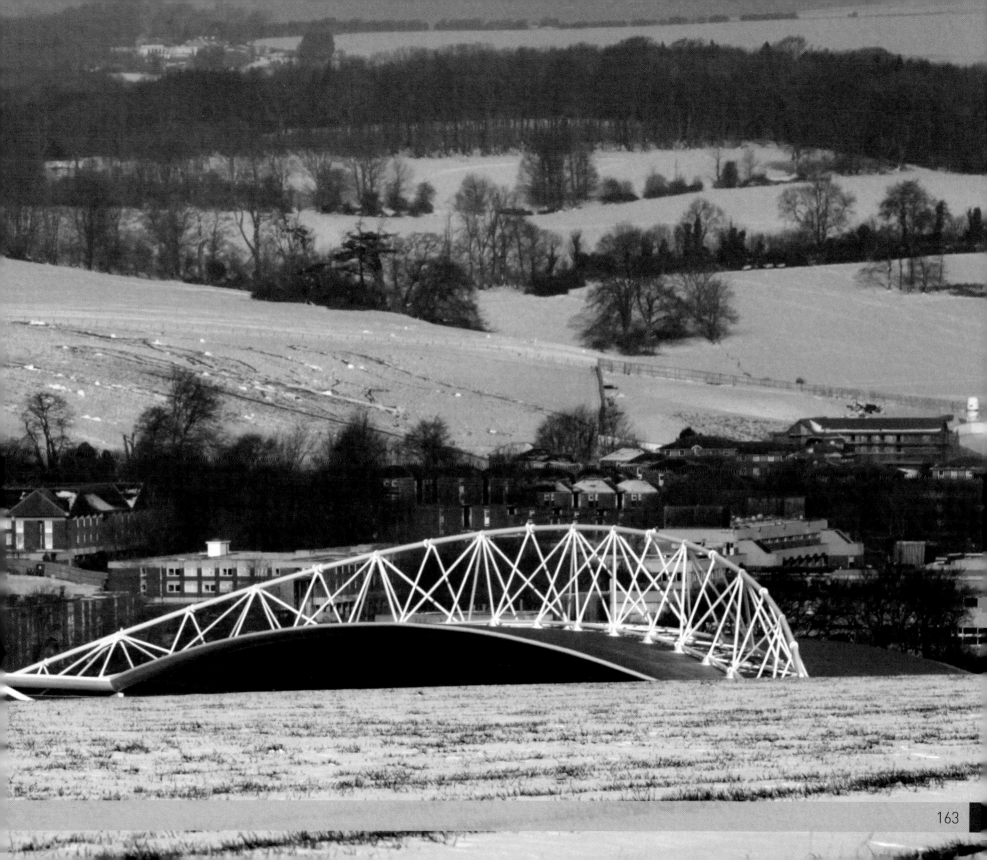

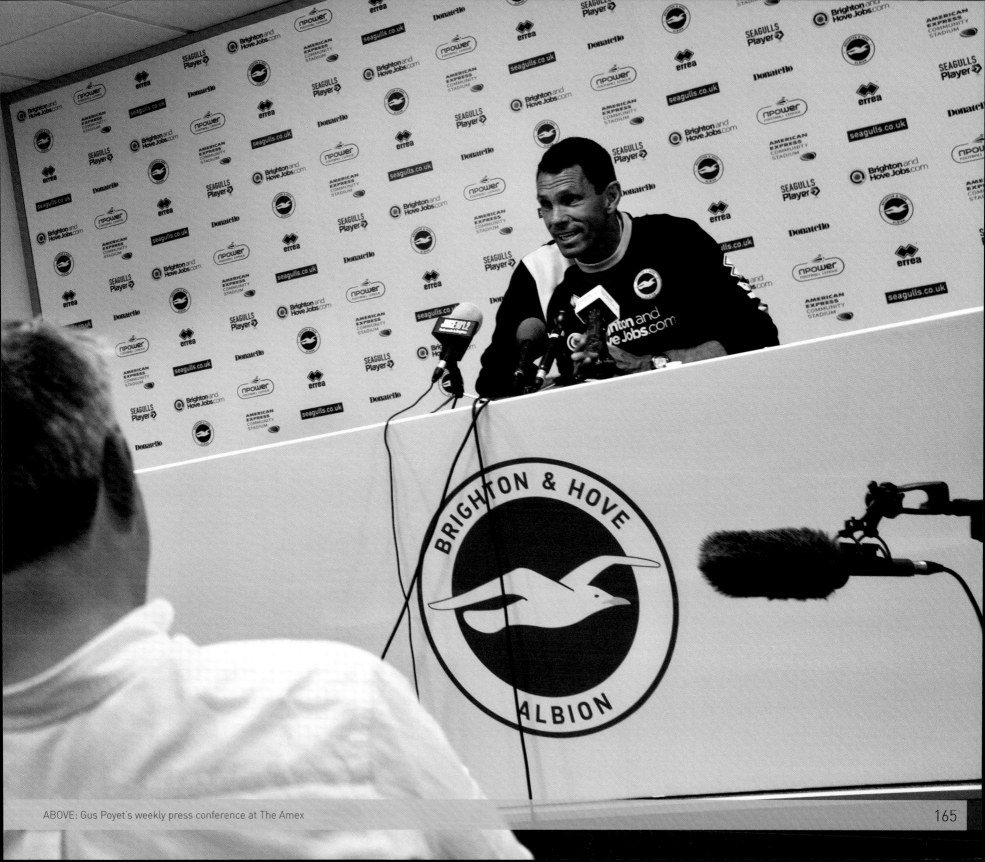

ABOVE: Gus Poyet's weekly press conference at The Amex

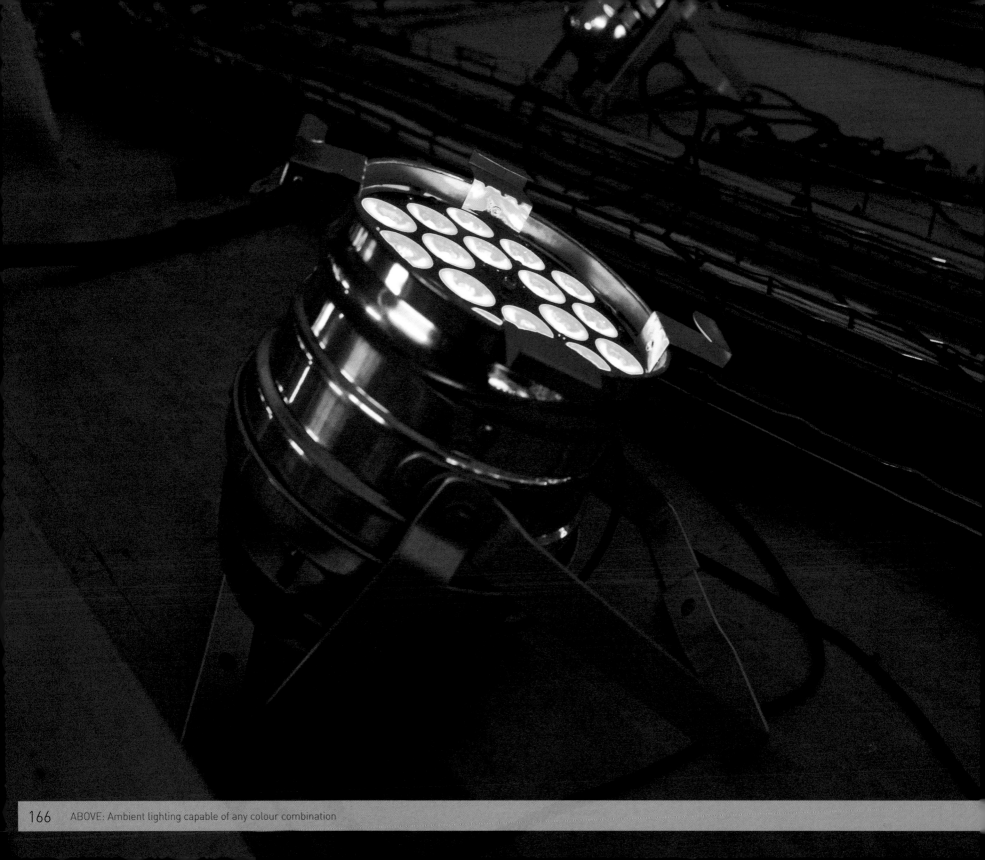

ABOVE: Ambient lighting capable of any colour combination

ILLUMINATION

"The lighting of the visiting teams' club colours within the away stand area, is one of many ways we're trying to revolutionise the 'away fan experience'. This is one of the first things the away fans will see to welcome them to the American Express Community Stadium. The next thing they tend to see is guest beers and ales we also provide from the visitors' home city or town!"

Mark Hooper, Maintenance Manager

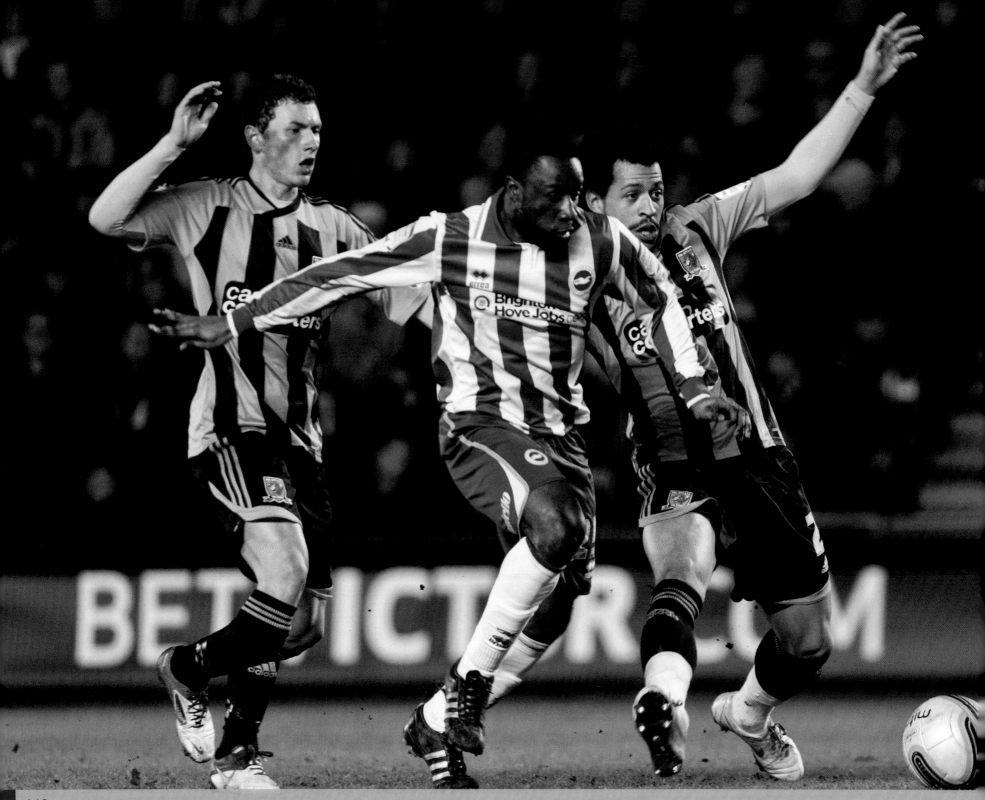

ABOVE: Kazenga LuaLua in action against Hull City at the KC Stadium

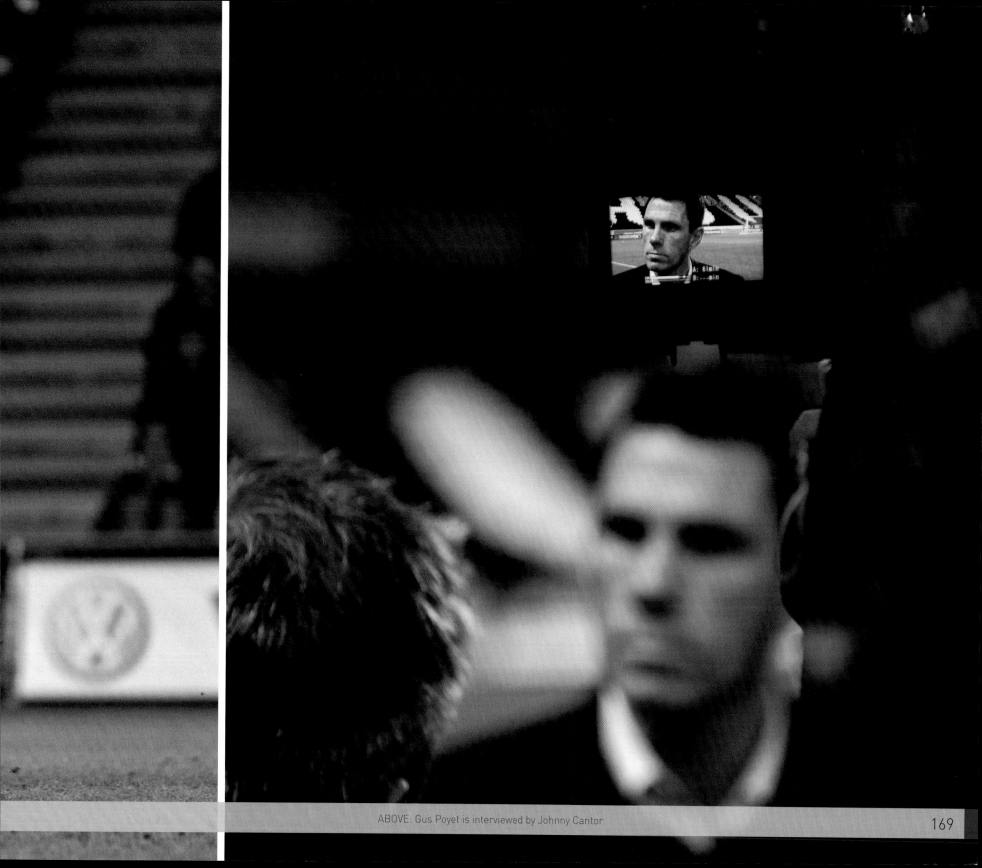

ABOVE: Gus Poyet is interviewed by Johnny Cantor

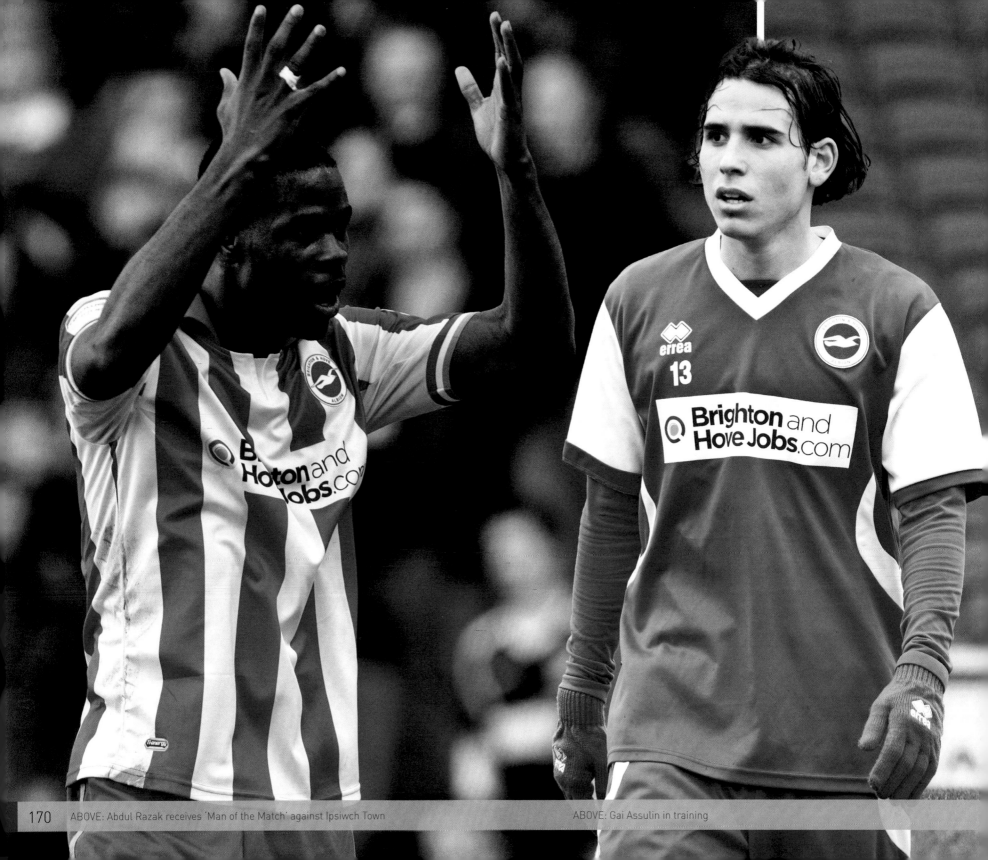

ABOVE: Abdul Razak receives 'Man of the Match' against Ipsiwch Town

ABOVE: Gai Assulin in training

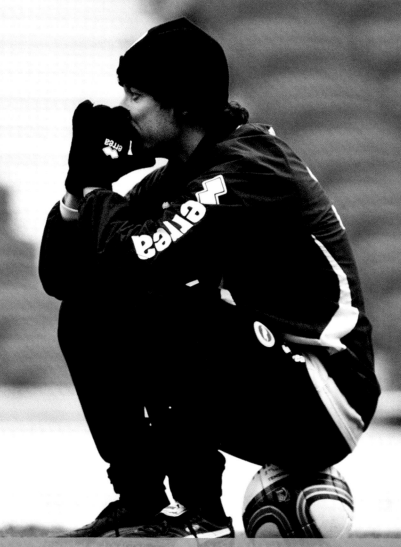

LOAN WATCH

"I'm really enjoying it. The manager gives me confidence and I like the way they play football. The first two games I played were away from home and the pitches were no good. It's difficult when you're used to nice pitches because you can't really play your own football. The Ipswich game was the first home game I played and I got Man of the Match! The supporters were great to me, and I really felt the emotion of the crowd. It was difficult because I hadn't been playing first team games for City so in a way it feels like my season starts now..."

Abdul Razak, Manchester City loanee

ABOVE: Mauricio Taricco deep in thought during an Amex training session

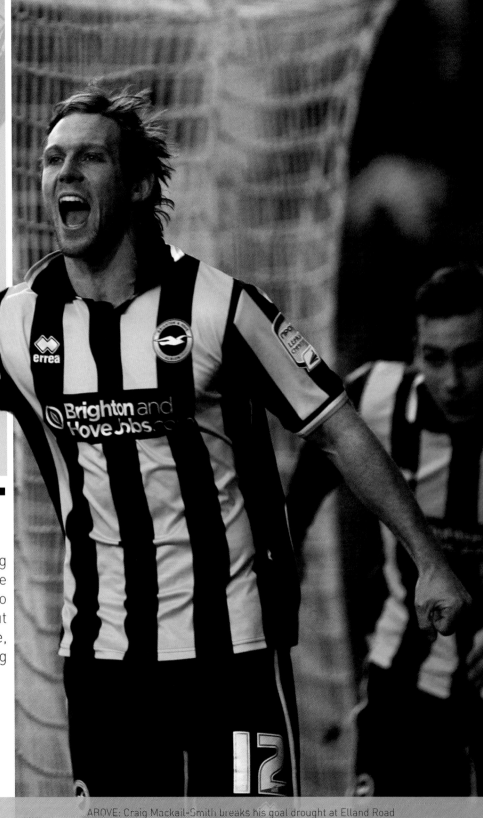

LIMELIGHT

"A few of the boys were giving me a bit of stick for the shots that were flying over the bar or going miles wide in recent games. To actually get one in the back of the net was a great feeling; I hadn't scored for a couple of years so when I saw that go in I was delighted, not only to get the winning goal but to keep that run going. It was a great feeling personally, I'm not going to lie, and the boys were all buzzing for me as well because they knew how long it had been for me."
Alan Navarro

ABOVE: Craig Mackail-Smith breaks his goal drought at Elland Road

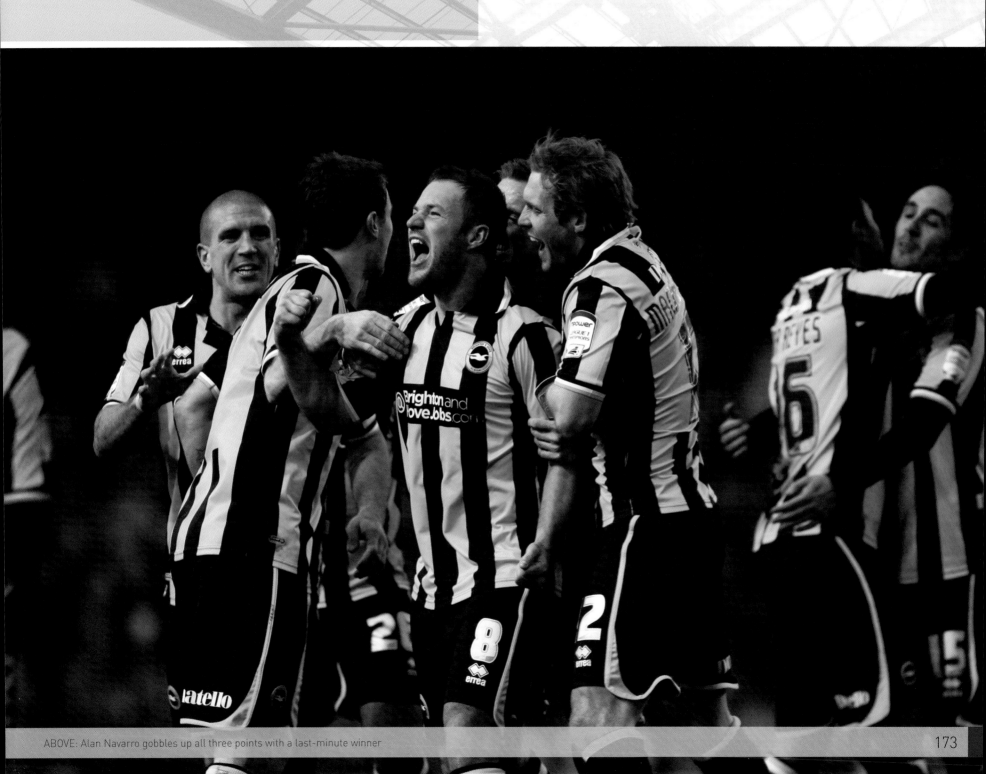

ABOVE: Alan Navarro gobbles up all three points with a last-minute winner

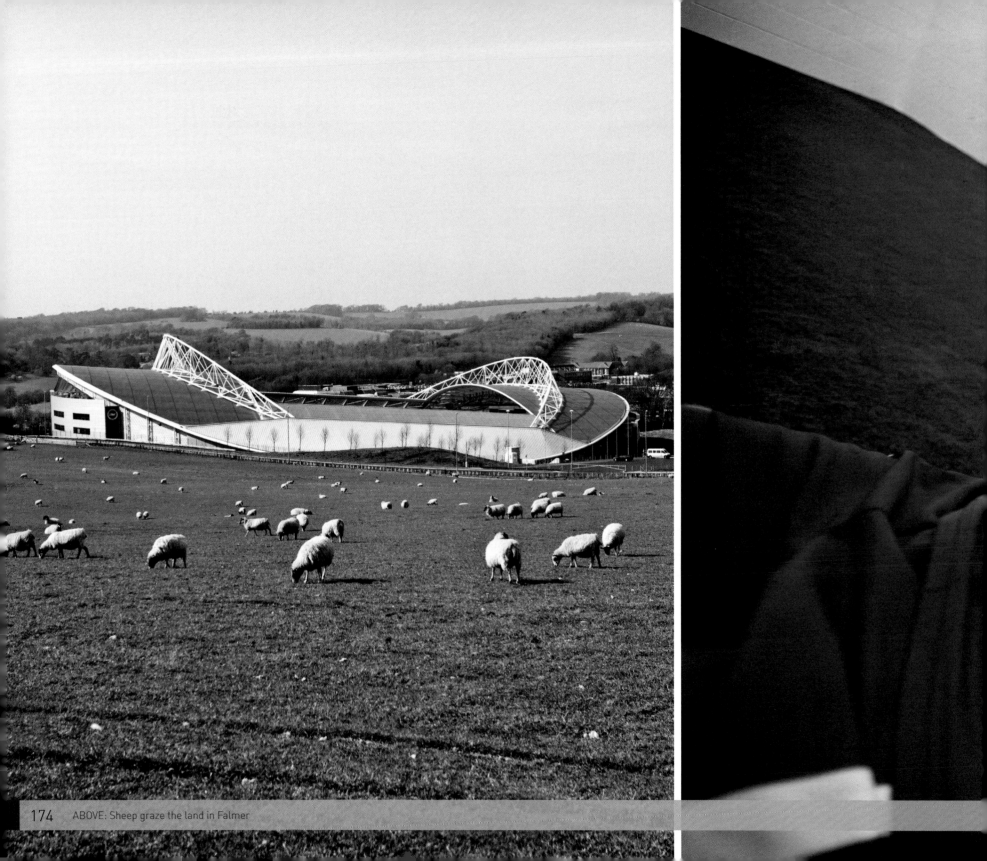

ABOVE: Sheep graze the land in Falmer

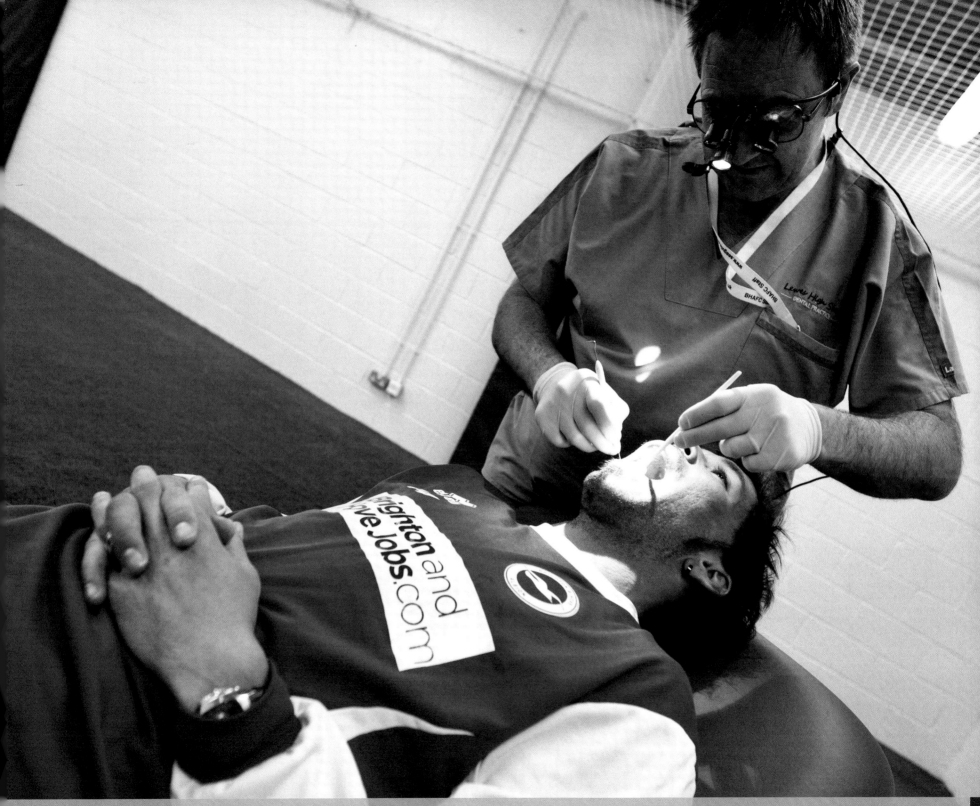

ABOVE: Iñigo Calderón has his teeth examined in the home warm-up room

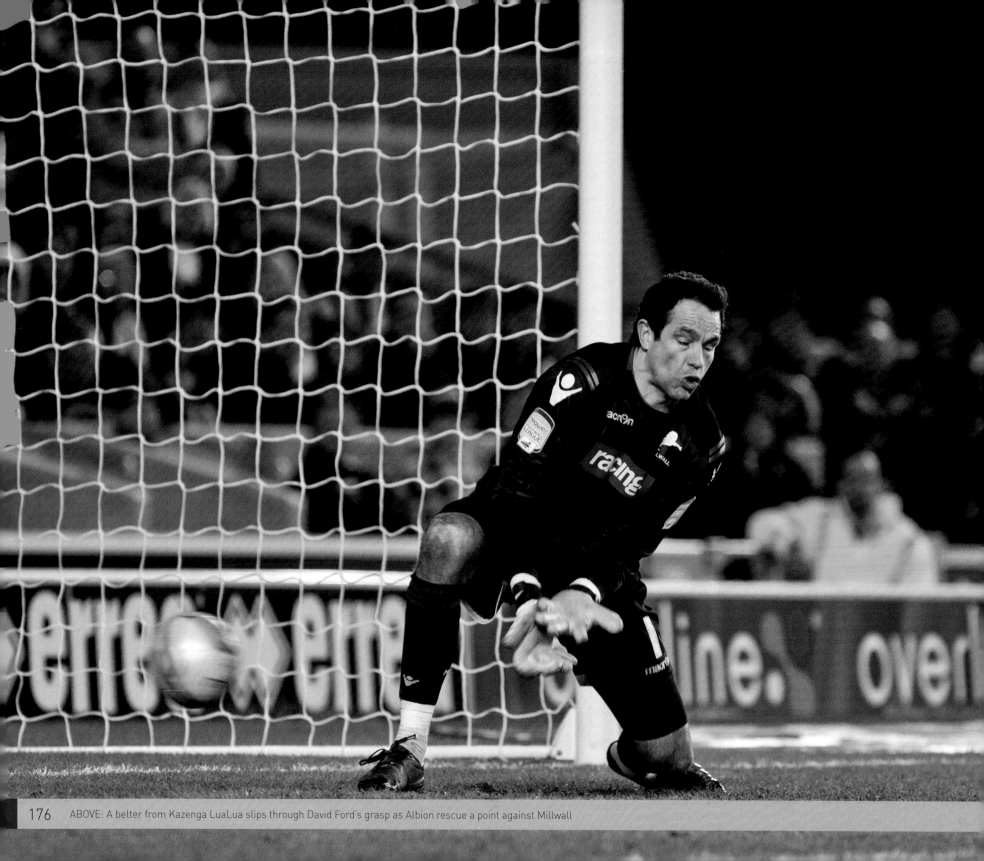

ABOVE: A belter from Kazenga LuaLua slips through David Ford's grasp as Albion rescue a point against Millwall

UNDEFEATED

"Sometimes I just celebrate on my own! I think when Bucka scored the late winner against Forest, I don't know, it just came into my head to do something stupid. Then I did it, then when Jake scored against Southampton I thought I'd celebrate by myself again. The lads kept asking me what I was doing and I'd say, 'Look, I've got my own celebration...'. When I score I always do the backflip though, I don't do those silly things I do on my own."

Kazenga LuaLua

BOTTOM: Big screen interview with the former Magpie

ABOVE: LuaLua celebrates with Craig Noone and Alan Navarro

177

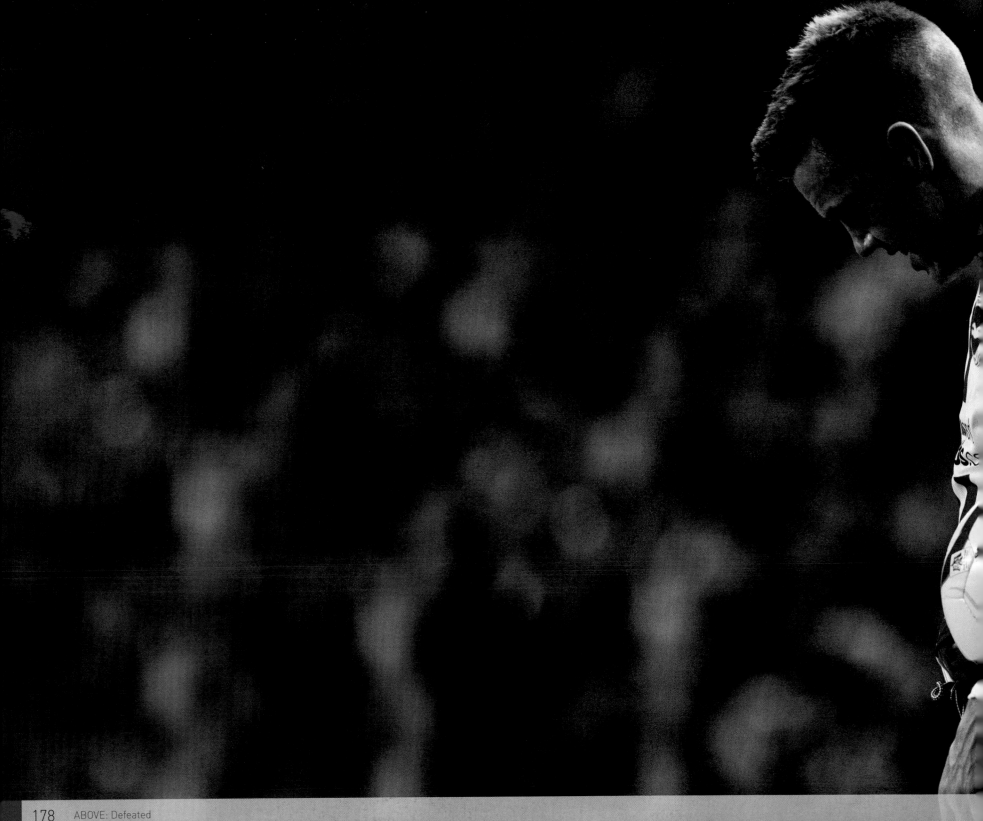

ABOVE: Defeated

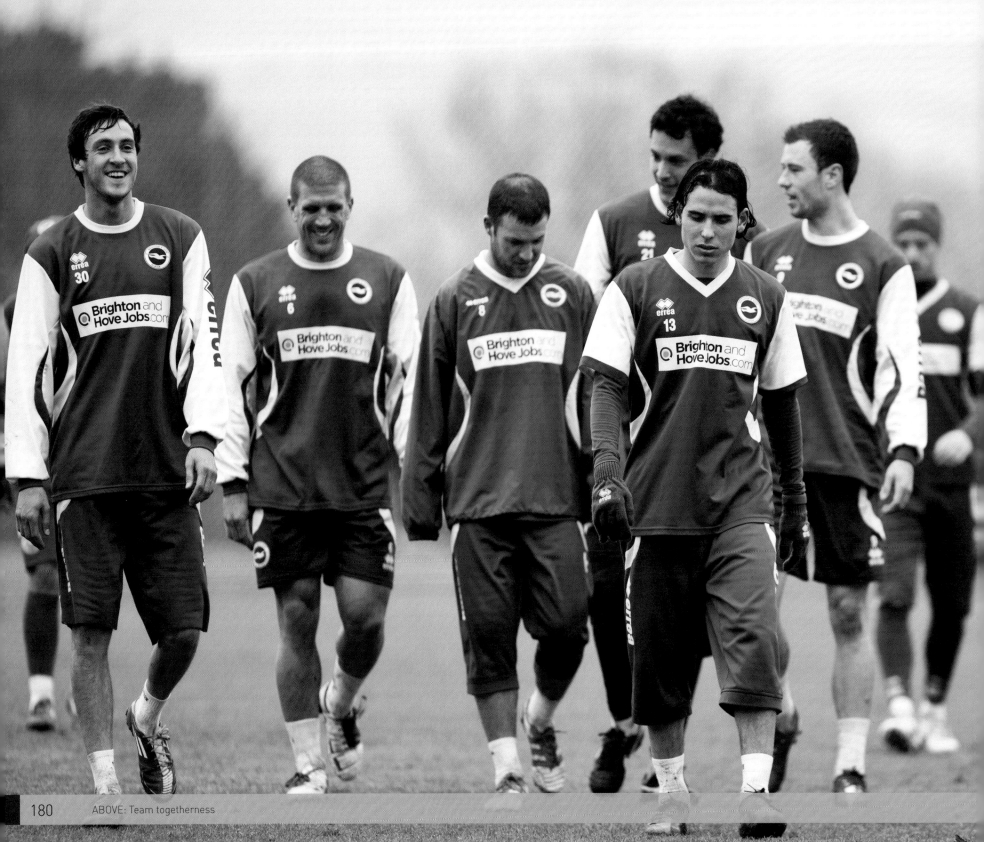

ABOVE: Team togetherness

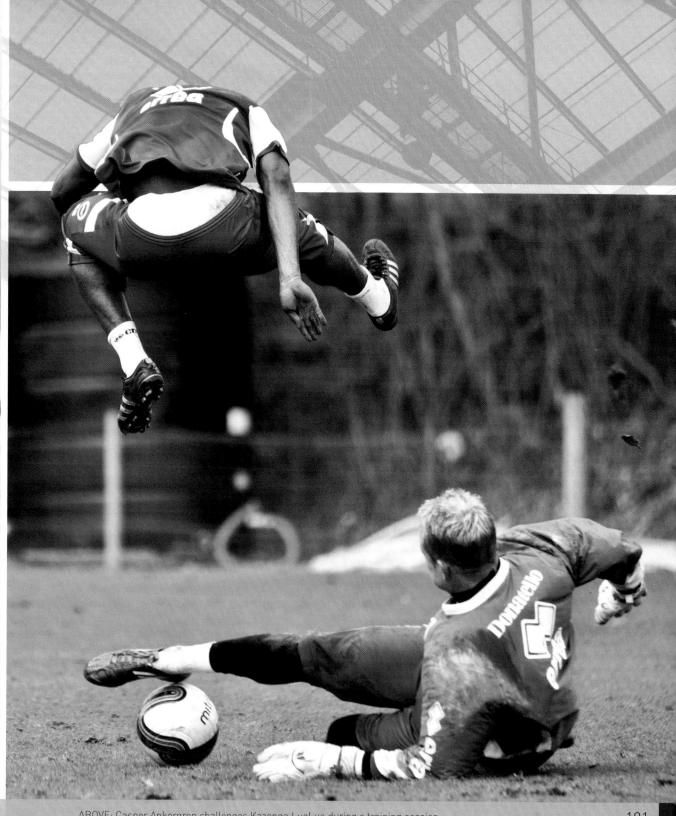

ABOVE: Casper Ankergren challenges Kazenga LuaLua during a training session

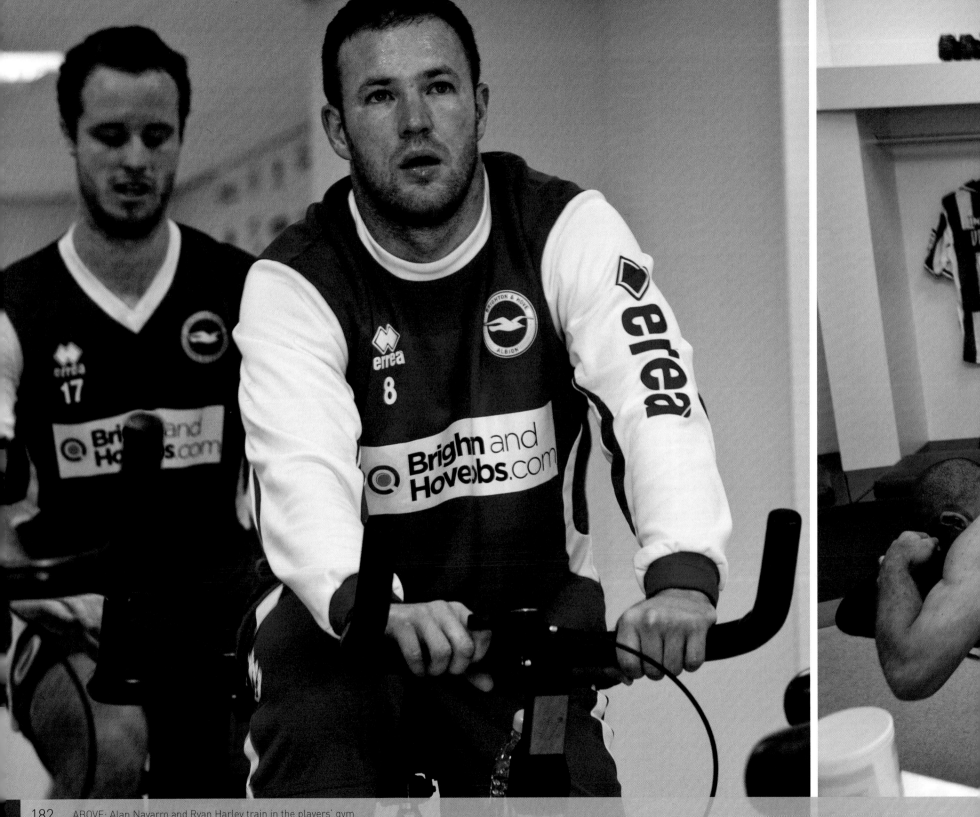

ABOVE: Alan Navarro and Ryan Harley train in the players' gym

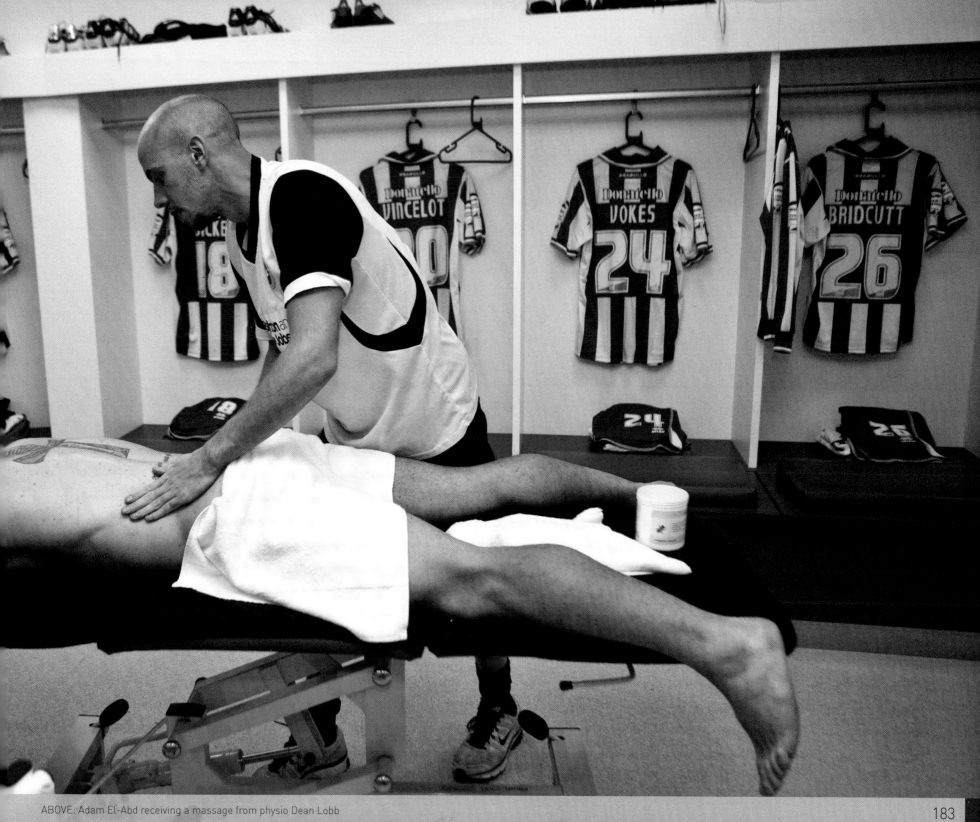

ABOVE: Adam El-Abd receiving a massage from physio Dean Lobb

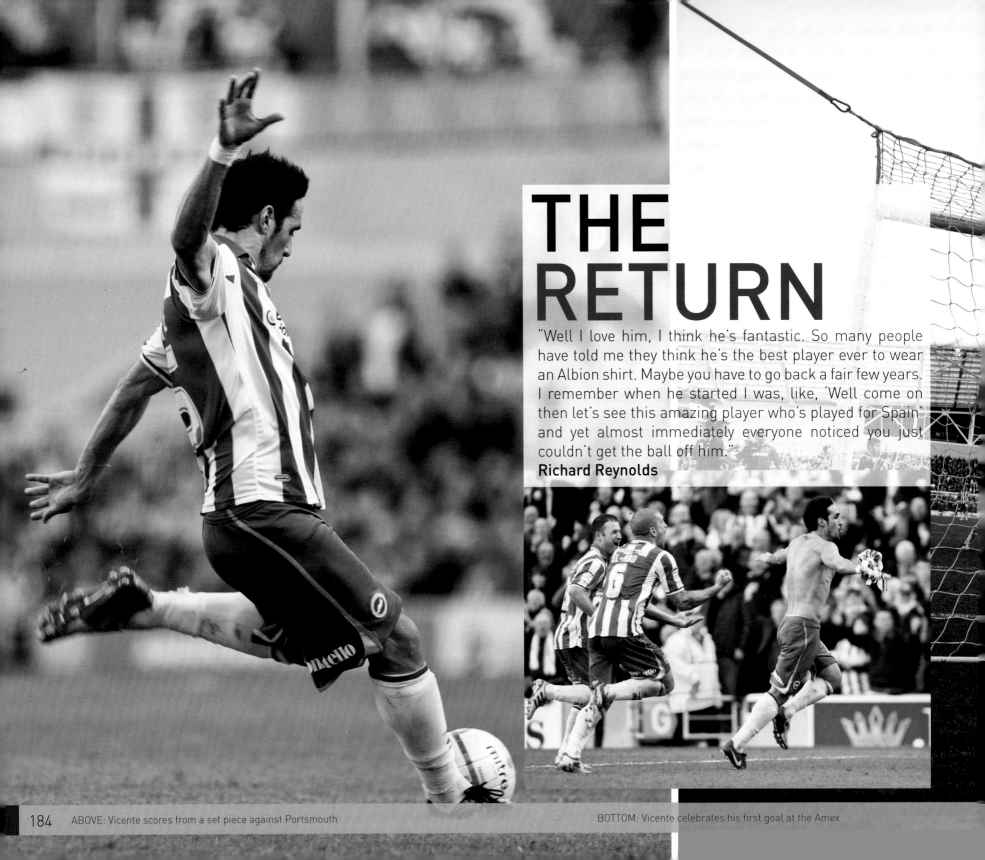

THE RETURN

"Well I love him, I think he's fantastic. So many people have told me they think he's the best player ever to wear an Albion shirt. Maybe you have to go back a fair few years. I remember when he started I was, like, 'Well come on then let's see this amazing player who's played for Spain' and yet almost immediately everyone noticed you just couldn't get the ball off him."

Richard Reynolds

ABOVE: Vicente scores from a set piece against Portsmouth

BOTTOM: Vicente celebrates his first goal at the Amex

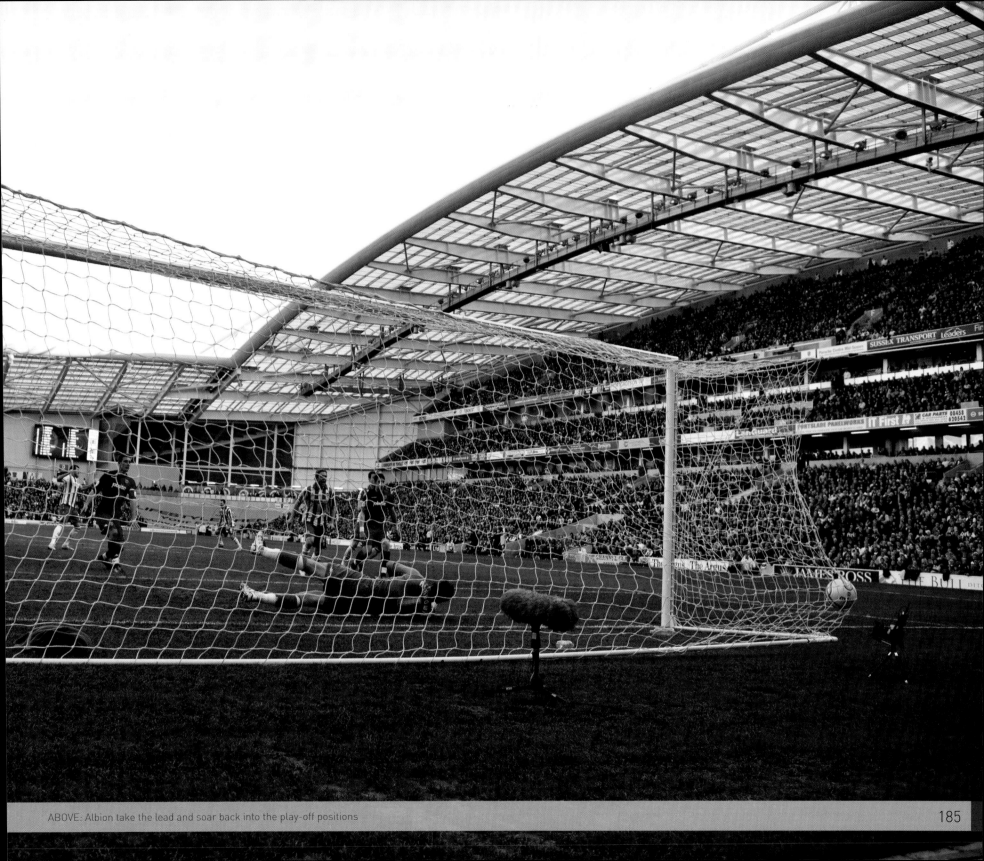

ABOVE: Albion take the lead and soar back into the play-off positions

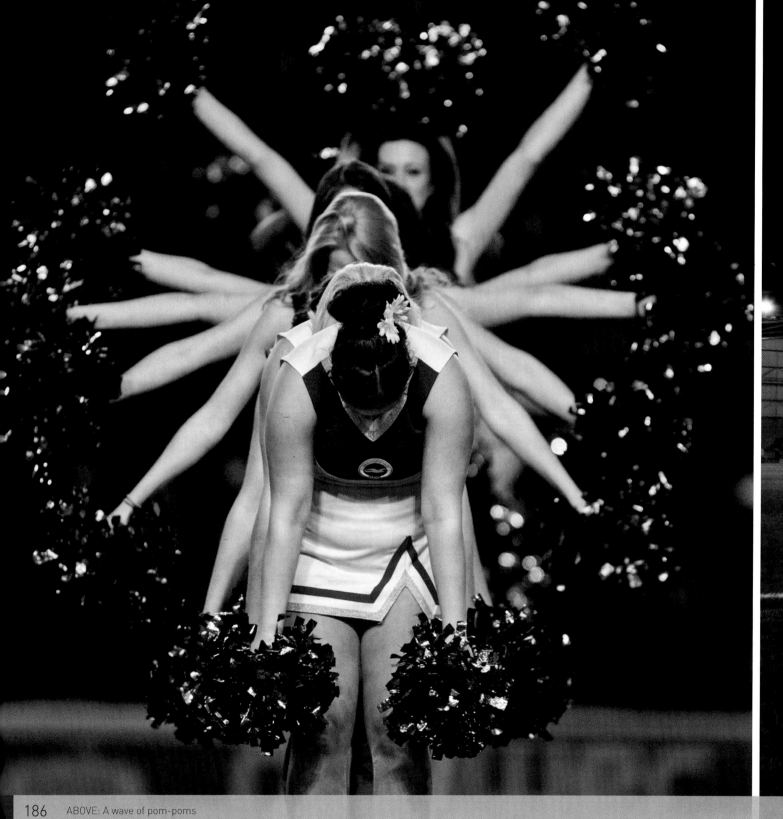

ABOVE: A wave of pom-poms

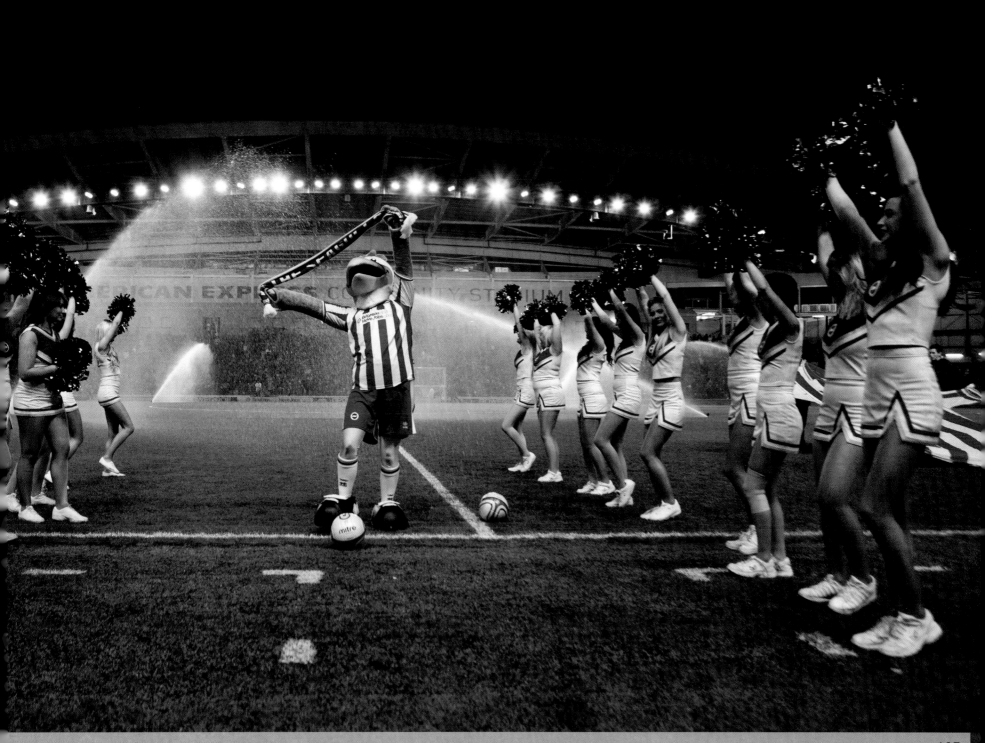

THE PUSH

"We went through a stage where playing teams at home we were actually dominating games, and we really felt comfortable on the pitch. It was a battle out there, don't get me wrong, but we always felt like we were in control of the game at hand. When you're playing those type of games you do feel good about yourself and that helps as well. When you're playing well and the team's playing well and you think you're doing little things right, it gives you that extra bit of confidence to take into the next game."
Alan Navarro

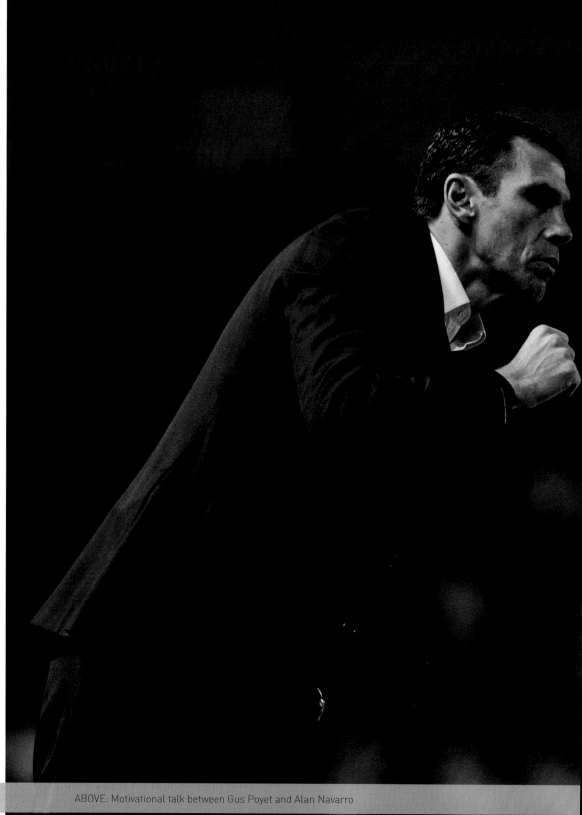

ABOVE: Motivational talk between Gus Poyet and Alan Navarro

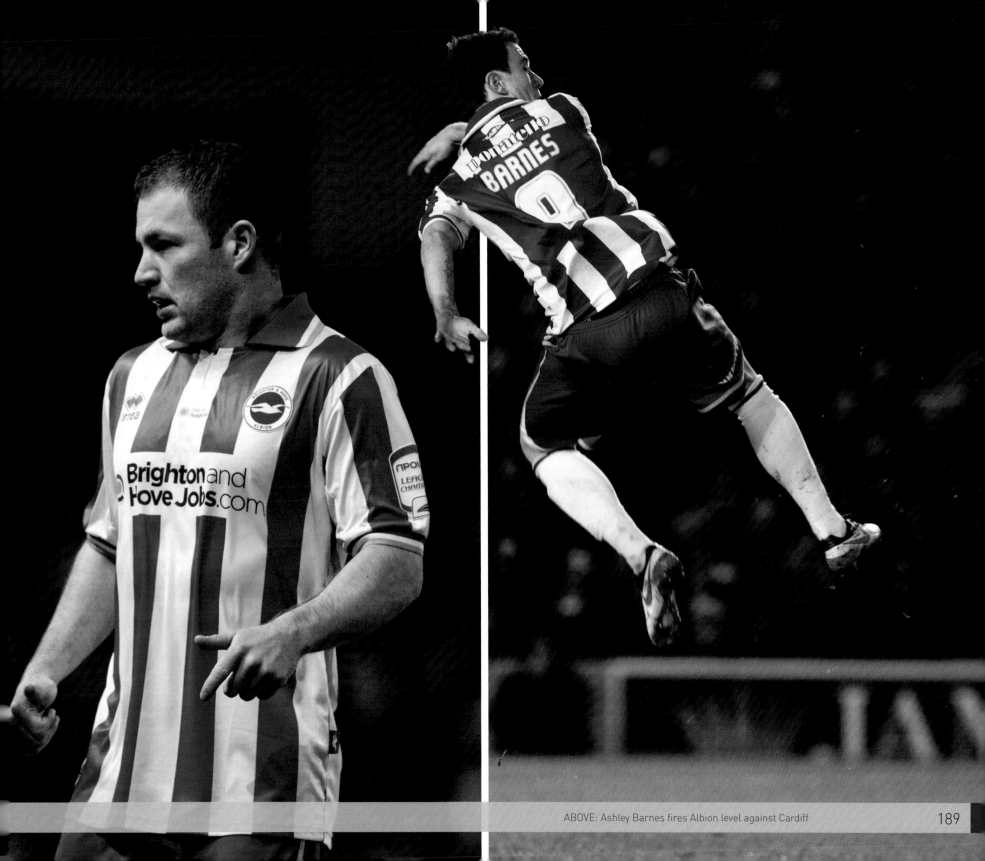

ABOVE: Ashley Barnes celebrates after an acrobatic finish

ON THE WIRE

"I tell you what, come down the Amex... come and see the late, late shows we have down here, on a regular basis!" **Bob Booker, Seagulls TV**

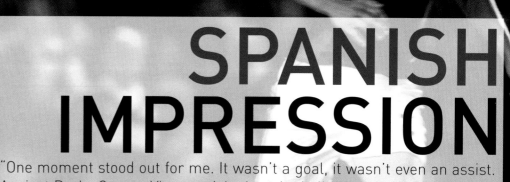

SPANISH IMPRESSION

"One moment stood out for me. It wasn't a goal, it wasn't even an assist. Against Derby County, Vicente picked up the ball in our half. It looked like absolutely nothing was on. But he just looked up, and he had the ball as if it was sellotaped to his boot – no-one was getting anywhere near him. He's not the biggest of players, but he has the ability to run with the ball and excite the fans, and he dazzled the Amex that night. He just breezed past three players and fired from well outside the penalty area, and the crossbar was left reverberating."
Johnny Cantor

ABOVE: Vicente cruises through the Derby defence and sees his shot ricochet off the crossbar OPPOSITE: Symbolic celebration

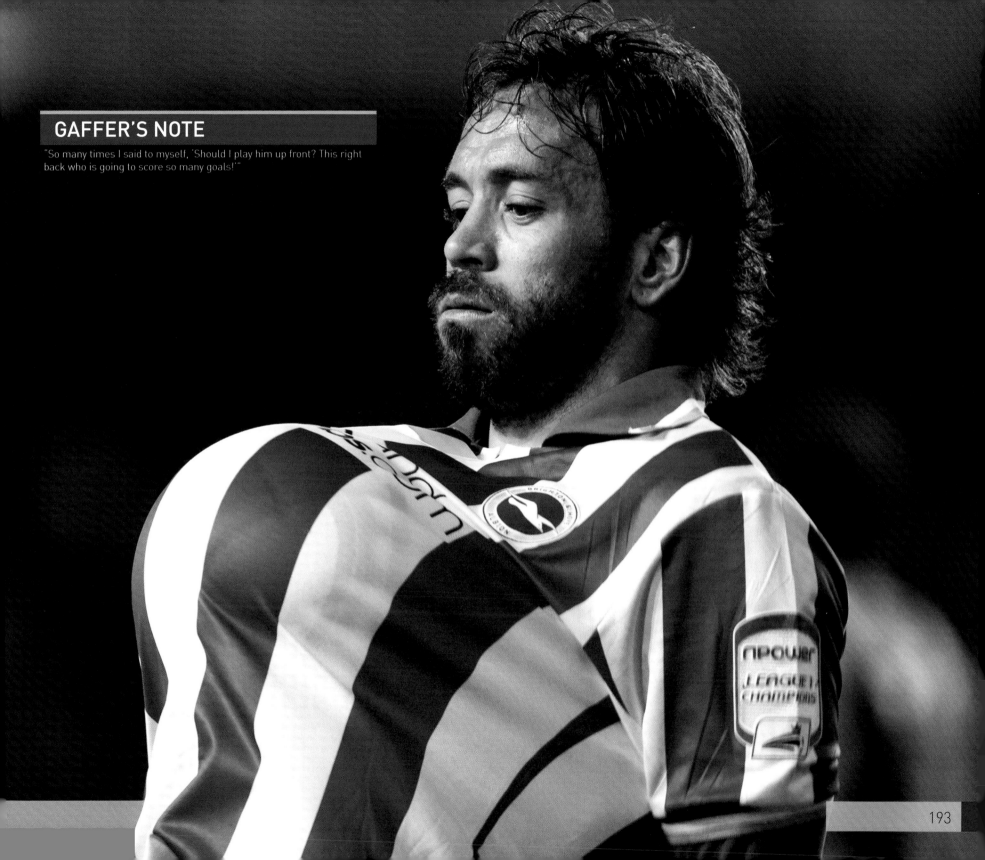

GAFFER'S NOTE

"So many times I said to myself, 'Should I play him up front? This right back who is going to score so many goals!'"

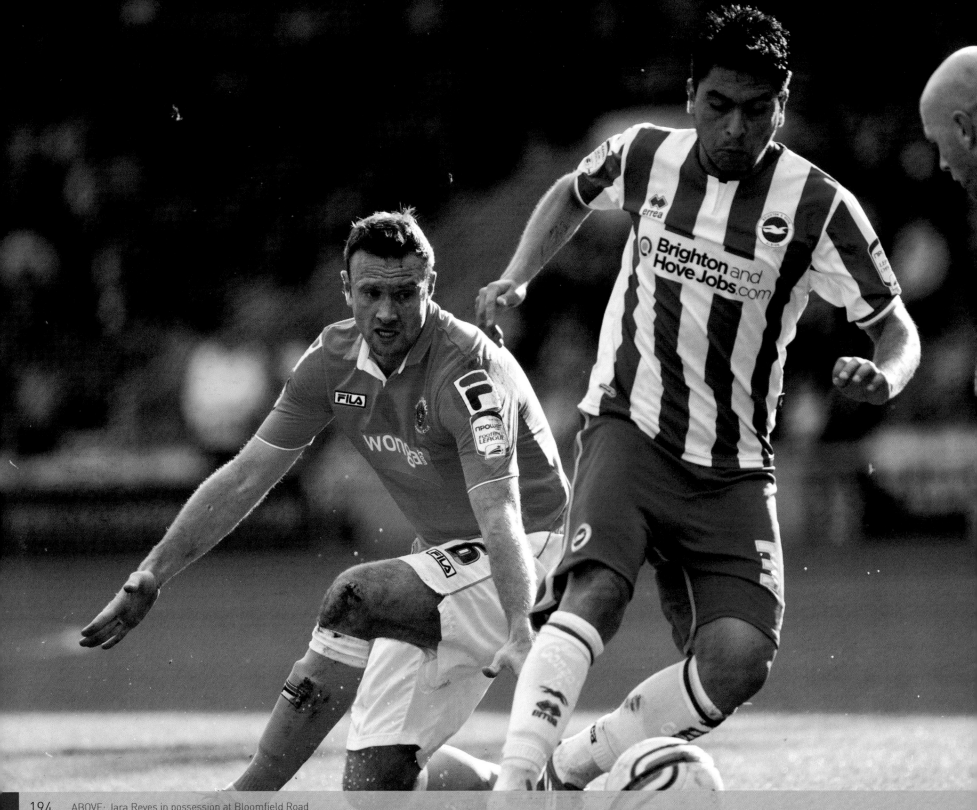

ABOVE: Jara Reyes in possession at Bloomfield Road

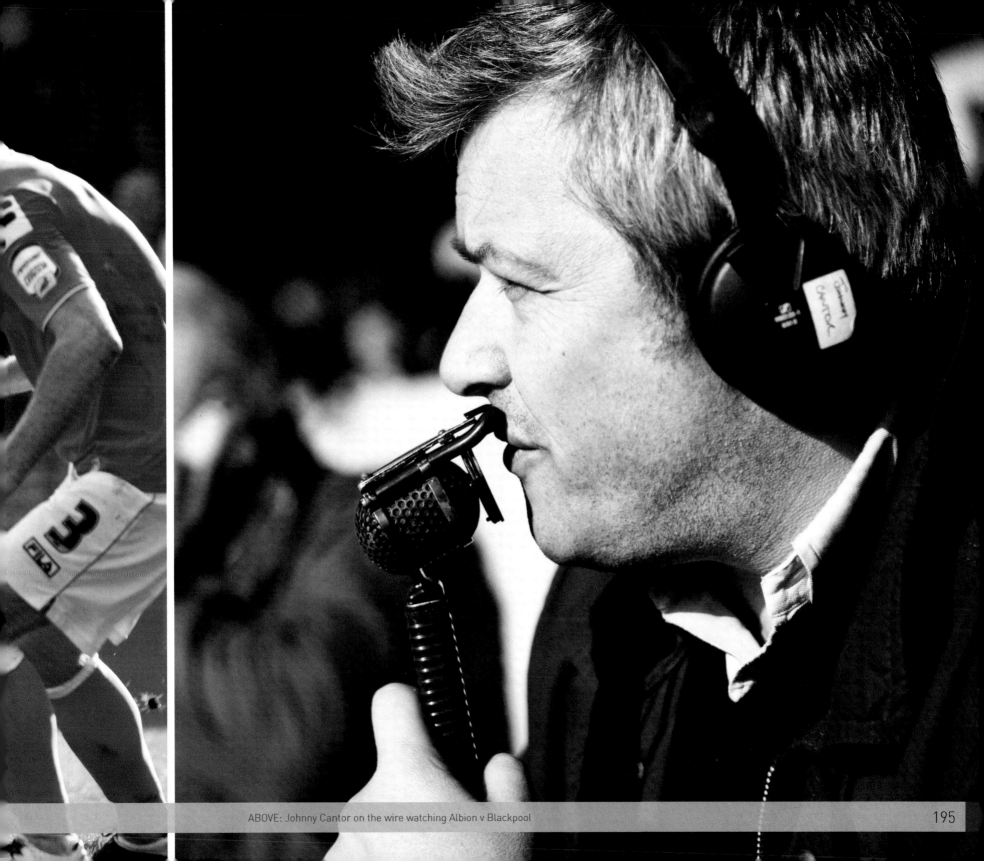

ABOVE: Johnny Cantor on the wire watching Albion v Blackpool

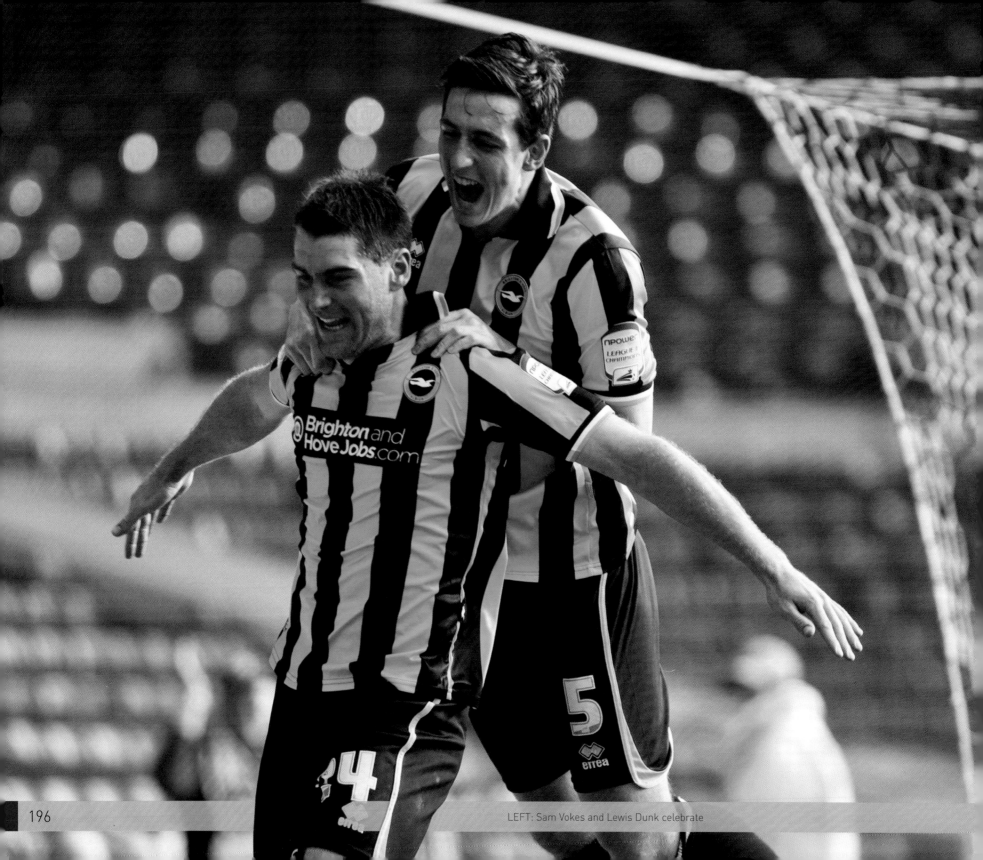

LEFT: Sam Vokes and Lewis Dunk celebrate

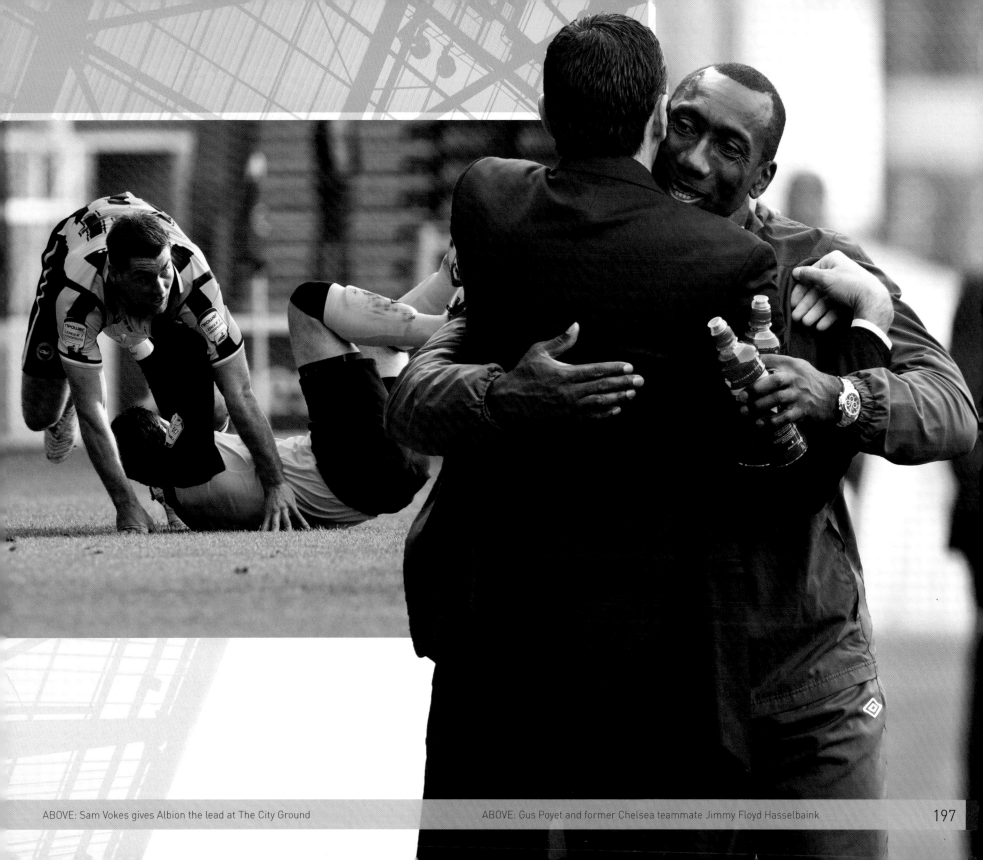

ABOVE: Sam Vokes gives Albion the lead at The City Ground

ABOVE: Gus Poyet and former Chelsea teammate Jimmy Floyd Hasselbaink

IT'S ALL POLITICAL

"Sports grounds now are about regeneration of the areas they're in, they're abou jobs, they're about training and this is magnificent. It's fantastic; the home of th Seagulls. Everyone used to come up to me and say, 'What about that ground?' and I'd say, 'Are you a Seagull?', they'd say, 'Yes', I'd say, 'Don't worry, we'll get thi done, because we must get a good football stadium in Brighton', and you did i Congratulations."

John Prescott

ABOVE: Sam Vokes features in a competitive tie against Middlesbrough ABOVE: John Prescott is interviewed by Richard Reynolds

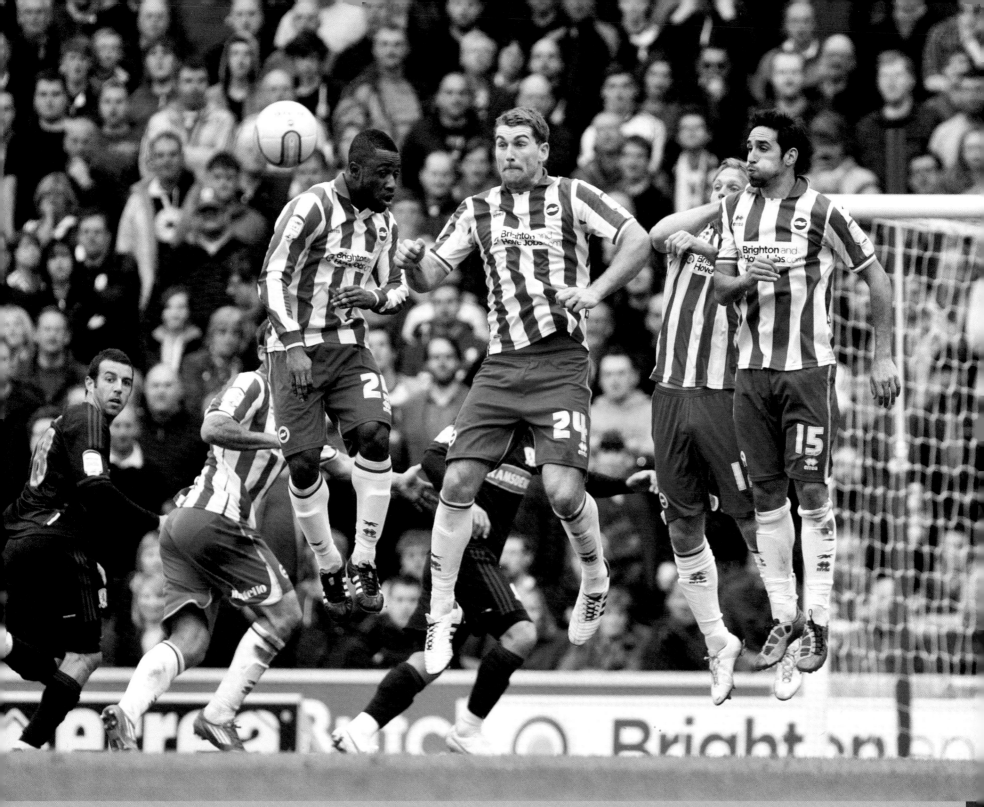

ABOVE: Albion's defensive line in action against Middlesbrough

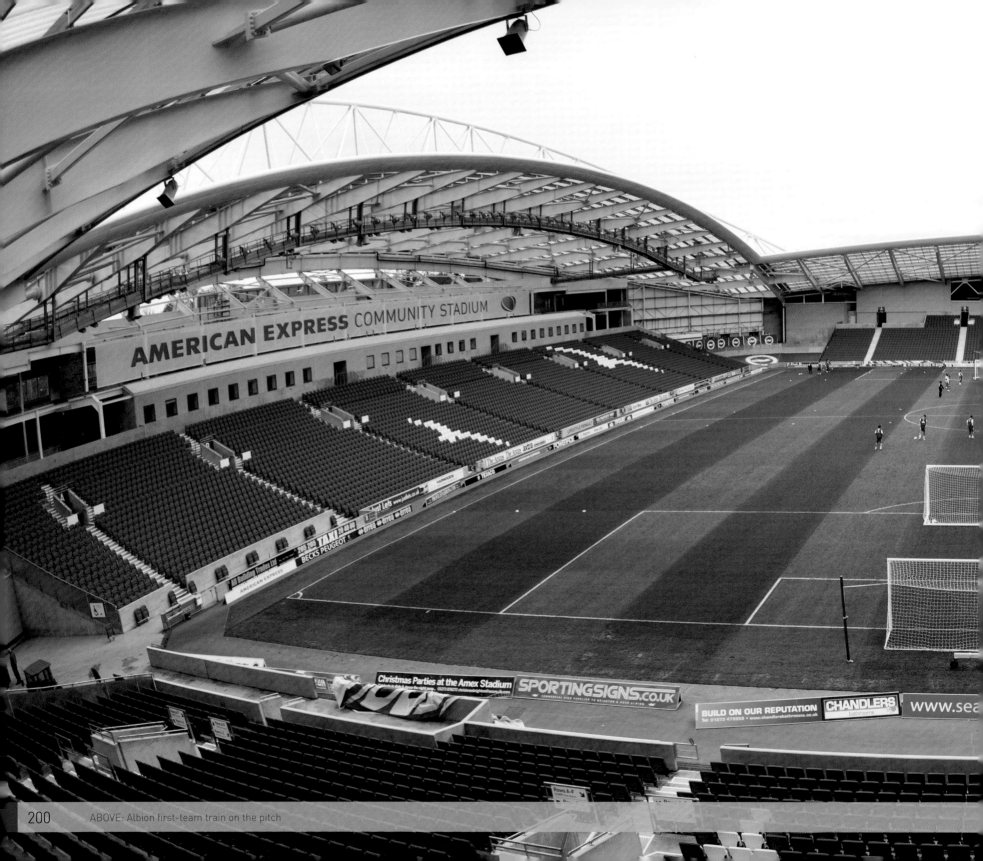

ABOVE: Albion first-team train on the pitch

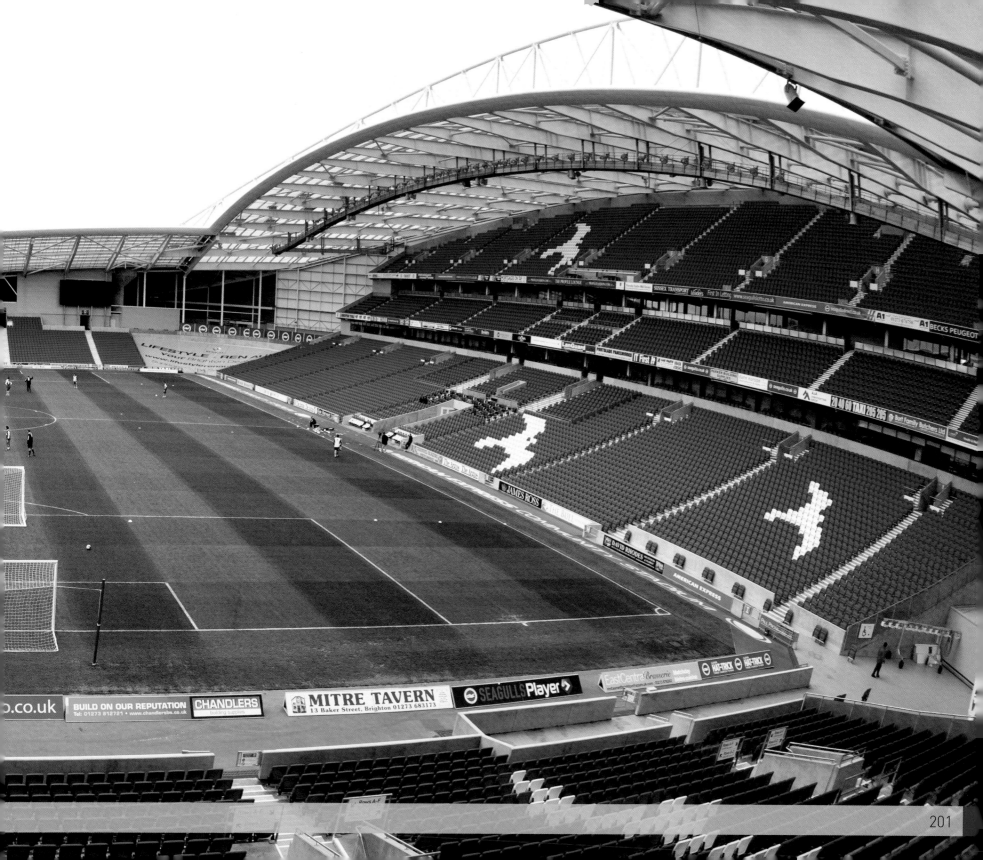

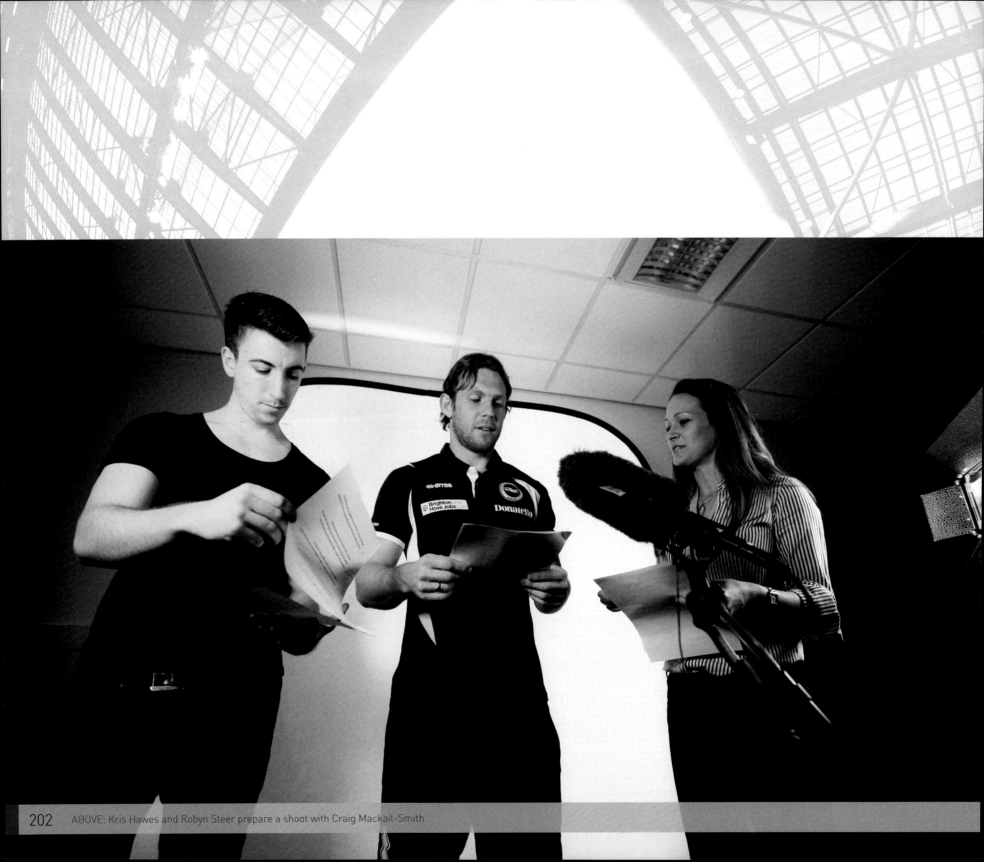

ABOVE: Kris Hawes and Robyn Steer prepare a shoot with Craig Mackail-Smith

RESPEC-T

"In April 2012, I created Respec-T, an interactive, community arts project that used the power of football to actively promote respect. Over 1,400 young people from thirty schools across Sussex took part. Everyone watched a video of Albion players backing Respec-T's key messages about fairness and equality, respect and dignity. The video was a catalyst for discussion and debate that inspired their designs of Respec-T logos. The logos, of which there were over 1,400, captured their voice and through unique design and colour represented issues such as racism, homophobia and sexism. Only one logo could be selected from each school and those thirty logos were featured on the Respec-T: a giant 6m by 9m t-shirt shaped canvas that was exhibited in front of a stadium-filled audience."

Robyn Steer, Albion in the Community

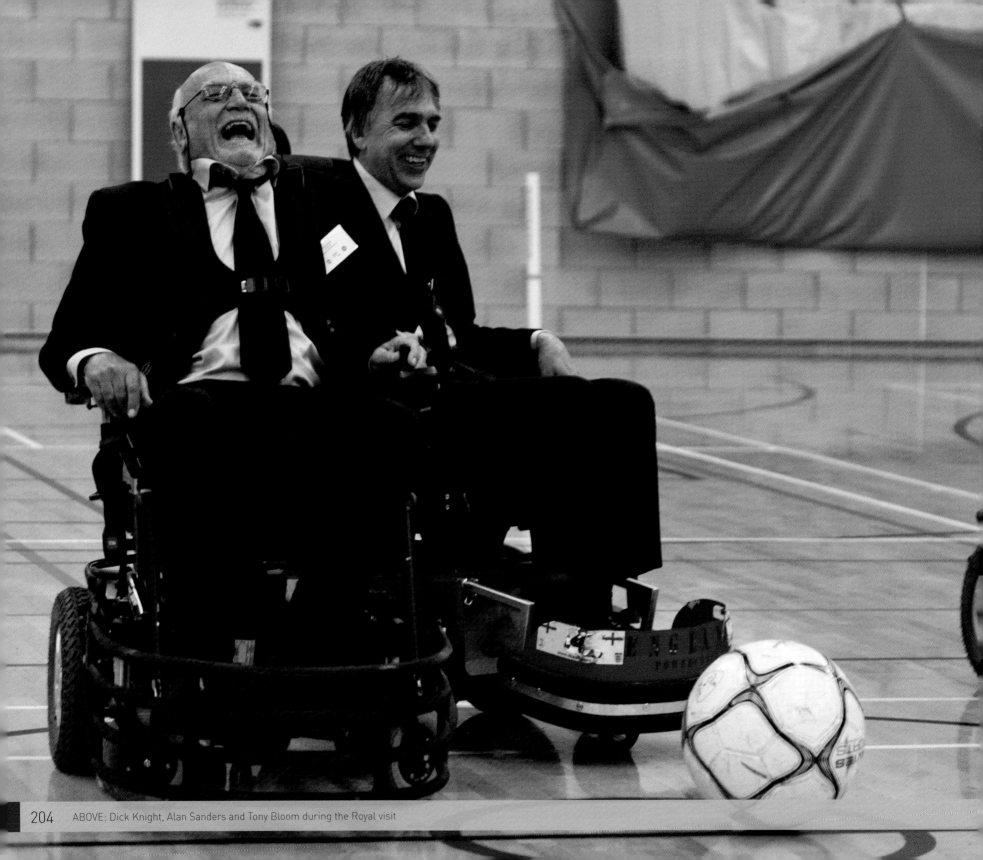

ABOVE: Dick Knight, Alan Sanders and Tony Bloom during the Royal visit

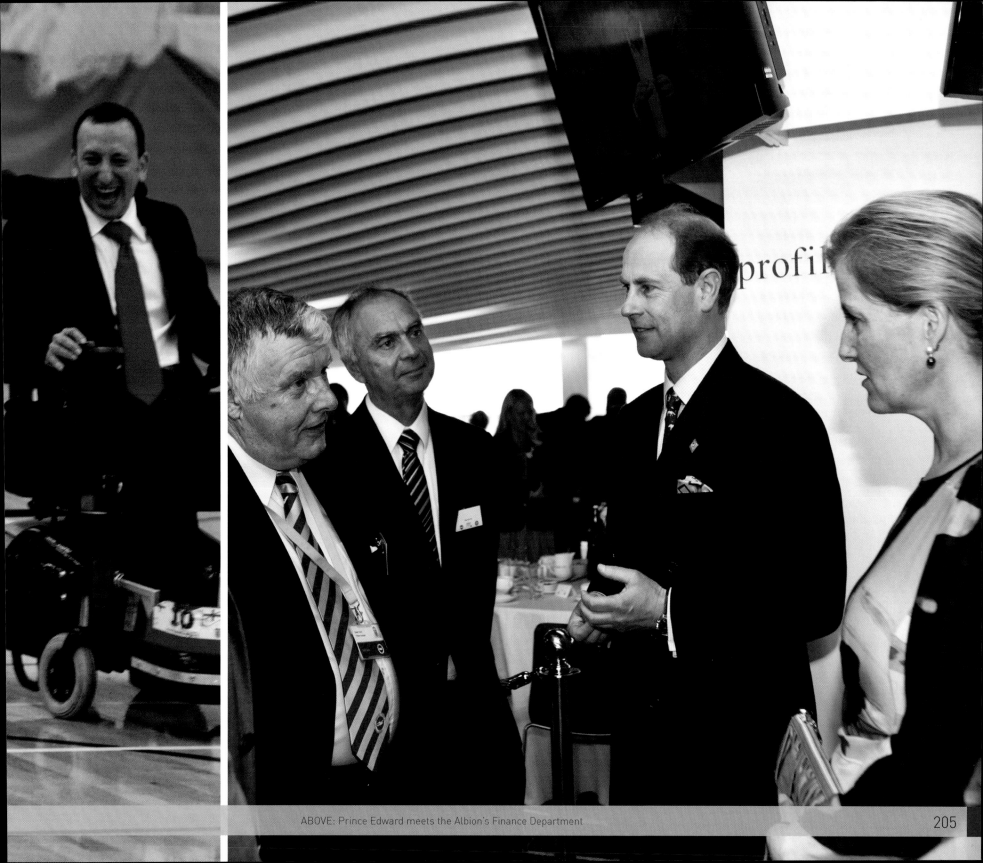

ABOVE: Prince Edward meets the Albion's Finance Department

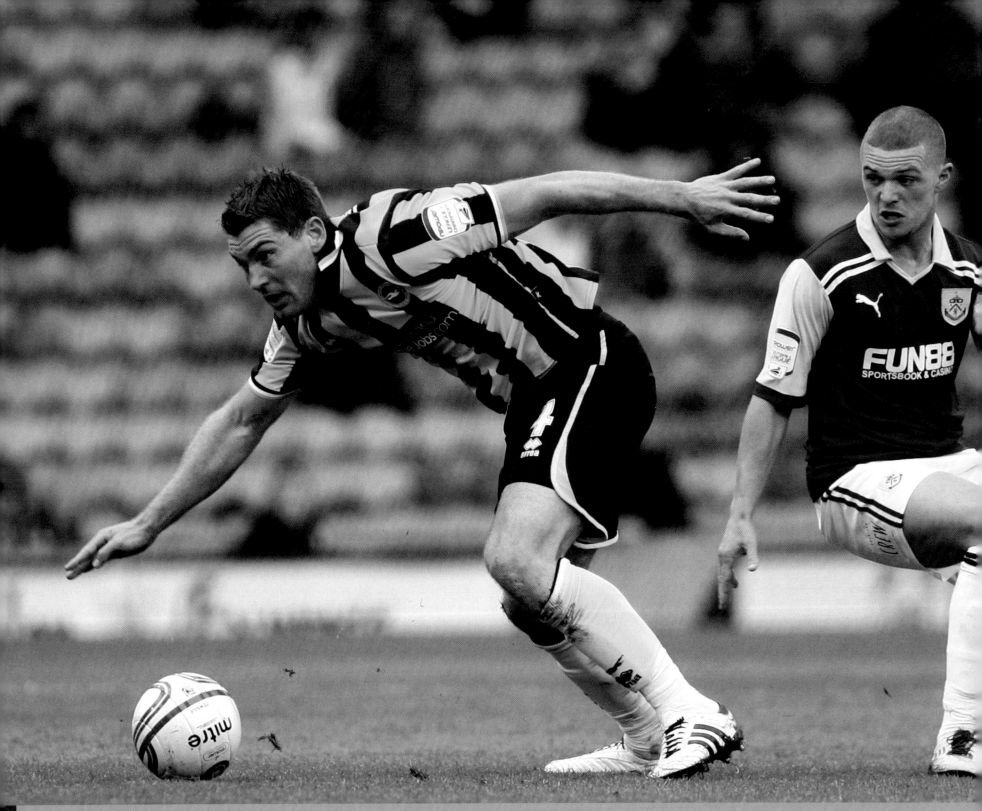

ABOVE: Sam Vokes in action against his former club

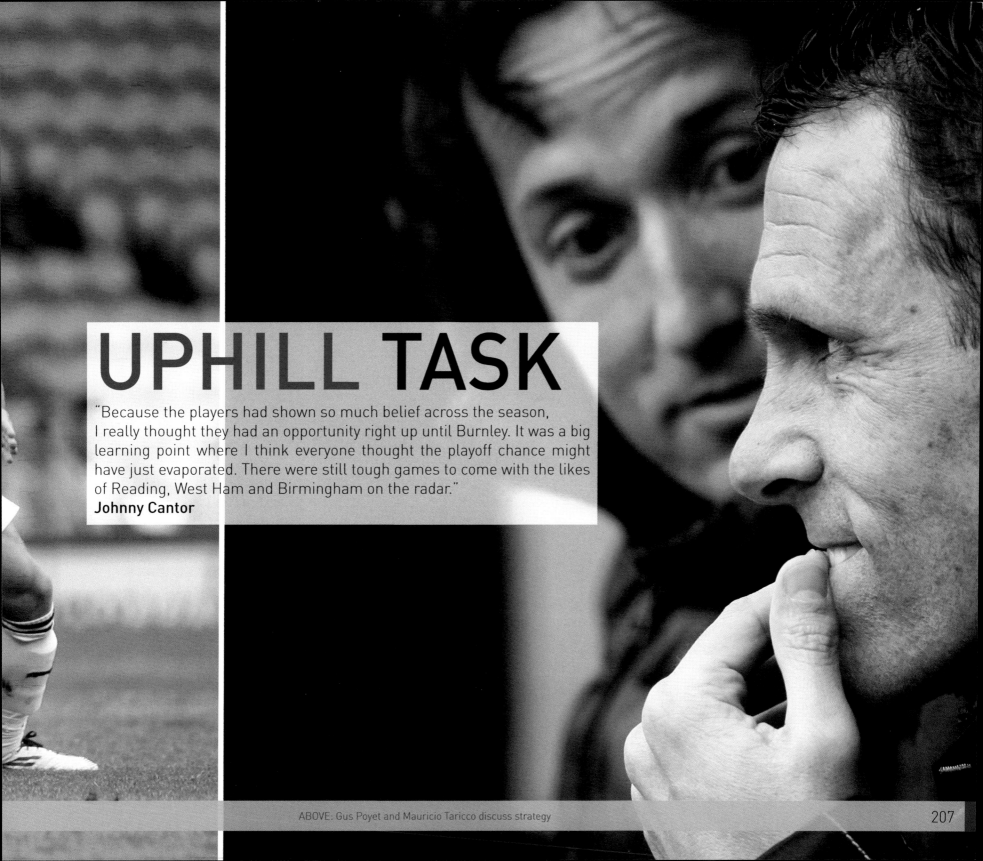

UPHILL TASK

"Because the players had shown so much belief across the season, I really thought they had an opportunity right up until Burnley. It was a big learning point where I think everyone thought the playoff chance might have just evaporated. There were still tough games to come with the likes of Reading, West Ham and Birmingham on the radar."
Johnny Cantor

ABOVE: Gus Poyet and Mauricio Taricco discuss strategy

ABOVE: Personalised shirts are printed in the Seagulls Store

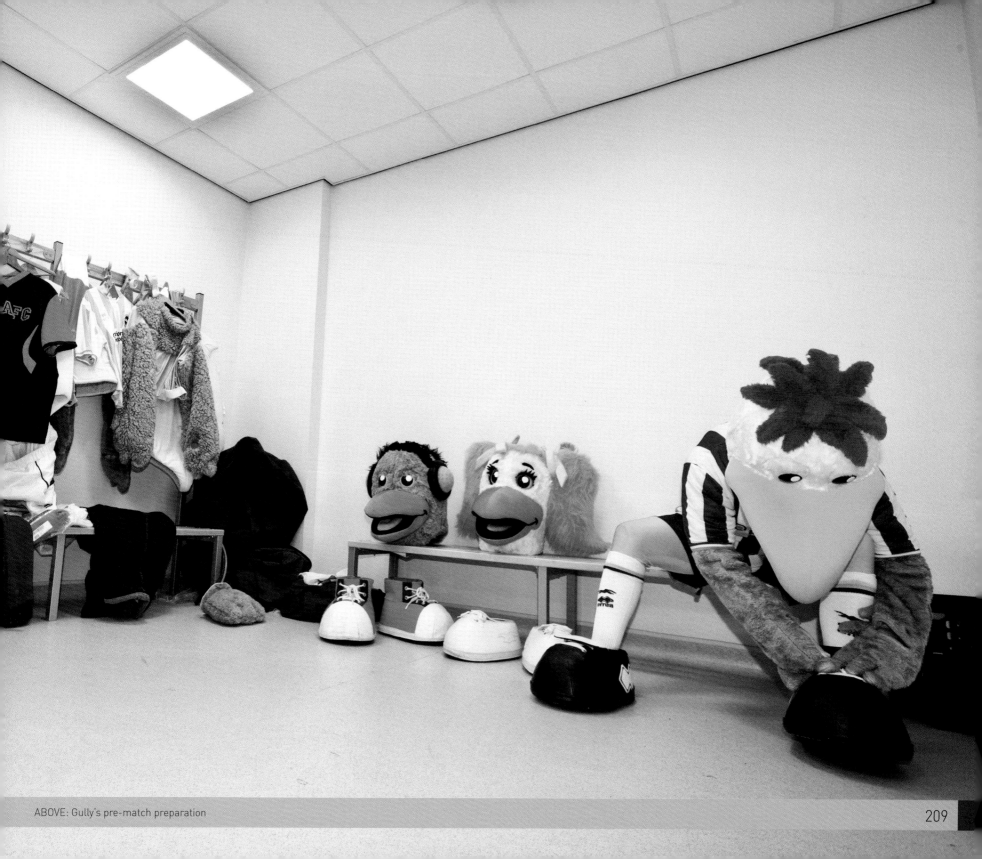

ABOVE: Gully's pre-match preparation

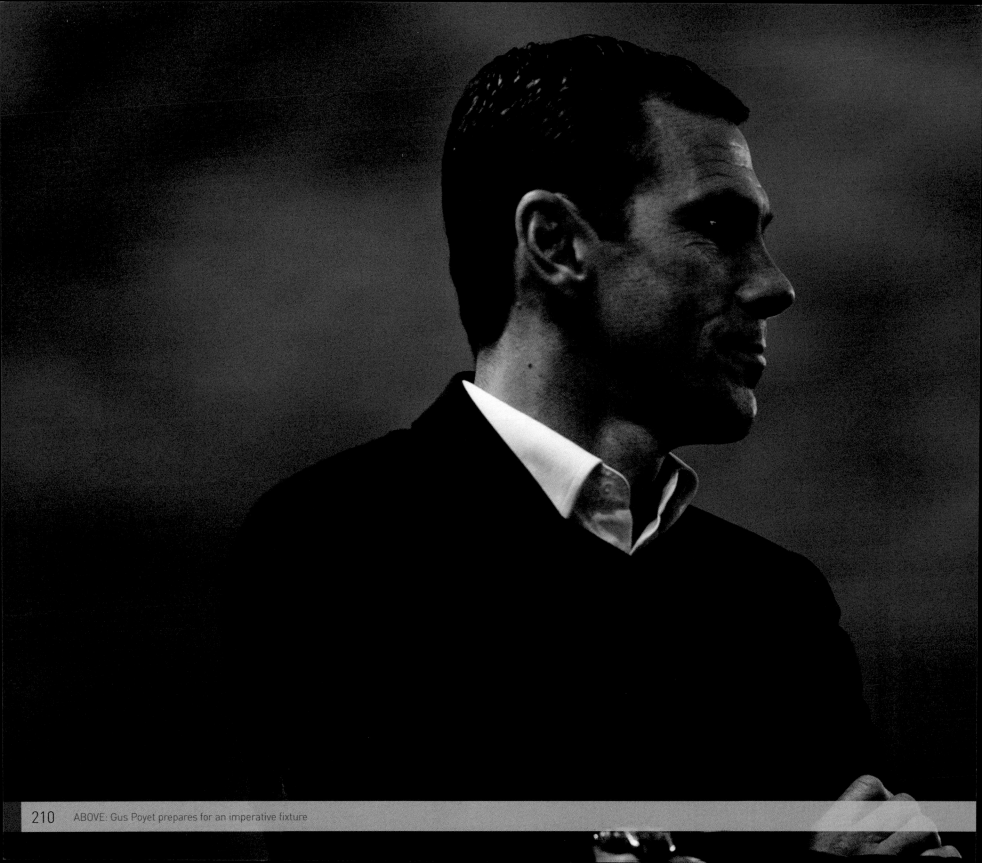

ABOVE: Gus Poyet prepares for an imperative fixture

IMPERATIVE

"Pressure. Pressure. The kind people don't see: Now it's in our hands, now it's up to what we do. 'If we win the games we need to win, we'll be in the top six'. Now the opposition is different, especially against the teams at the top. They were very good games of football but were very difficult games to win, and we saw things we hadn't seen previously. We heard words we hadn't heard even the season before, when we were at the top and close to achieving promotion. Things like, 'It's our last opportunity', things like, 'It's now or never...'"

Gus Poyet

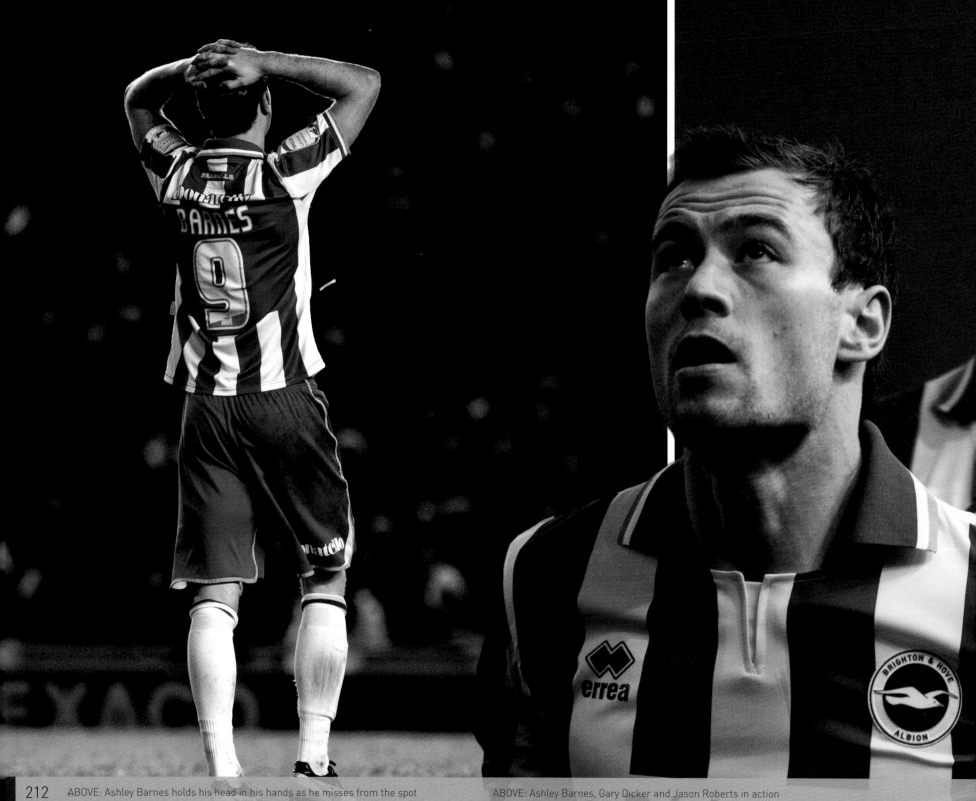

ABOVE: Ashley Barnes holds his head in his hands as he misses from the spot ABOVE: Ashley Barnes, Gary Dicker and Jason Roberts in action

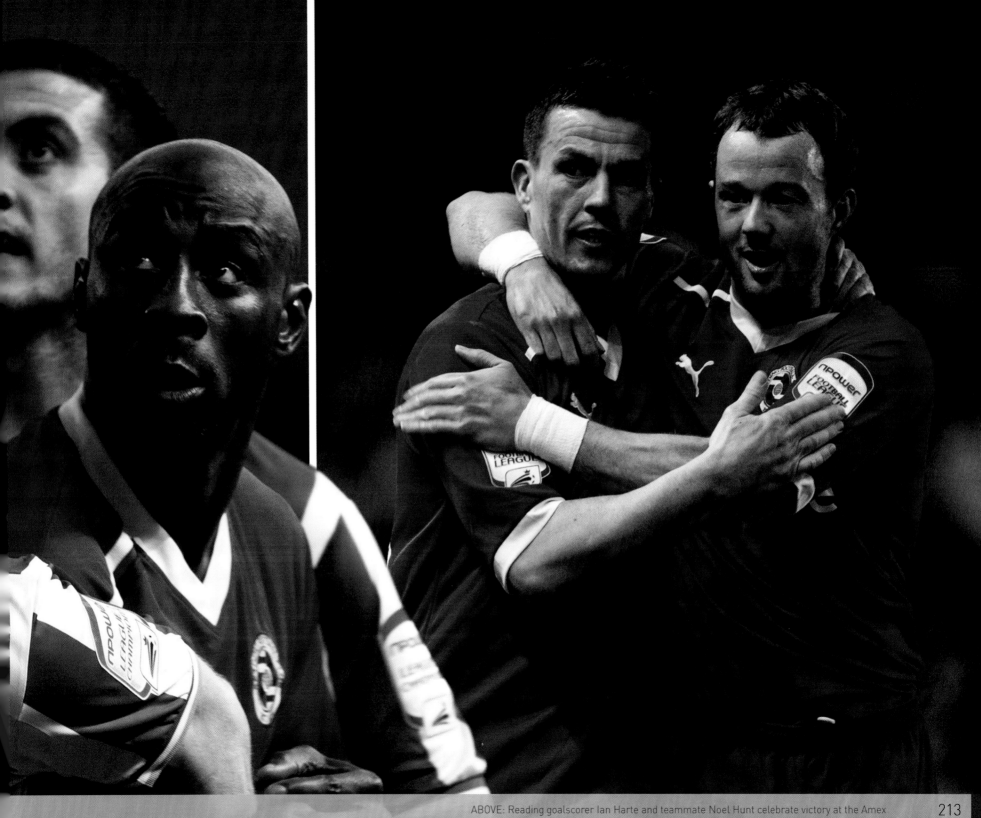

ABOVE: Reading goalscorer Ian Harte and teammate Noel Hunt celebrate victory at the Amex

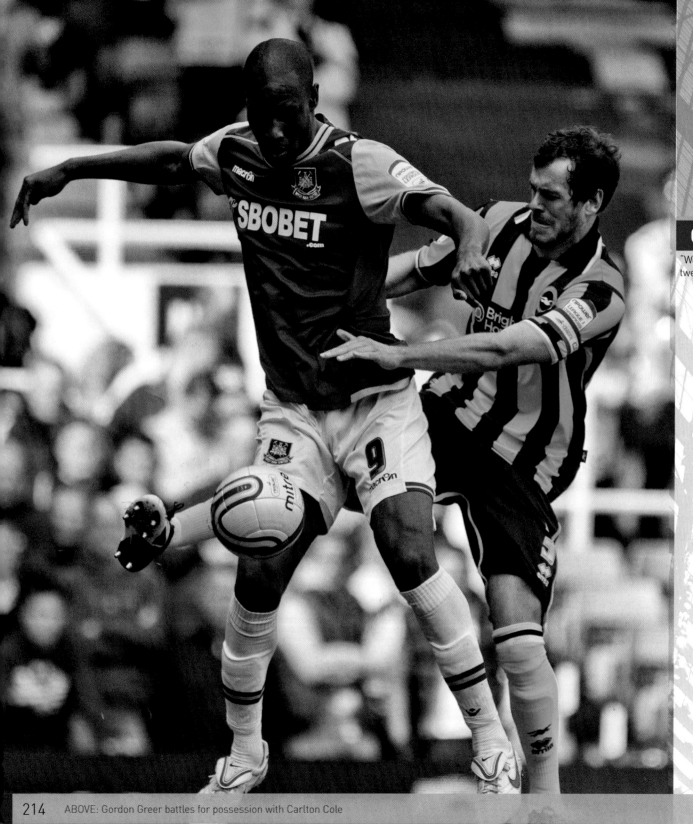

ABOVE: Gordon Greer battles for possession with Carlton Cole

GAFFER'S NOTE

"We knew how West Ham would play. We knew how important the twenty minutes would be. And we didn't do it."

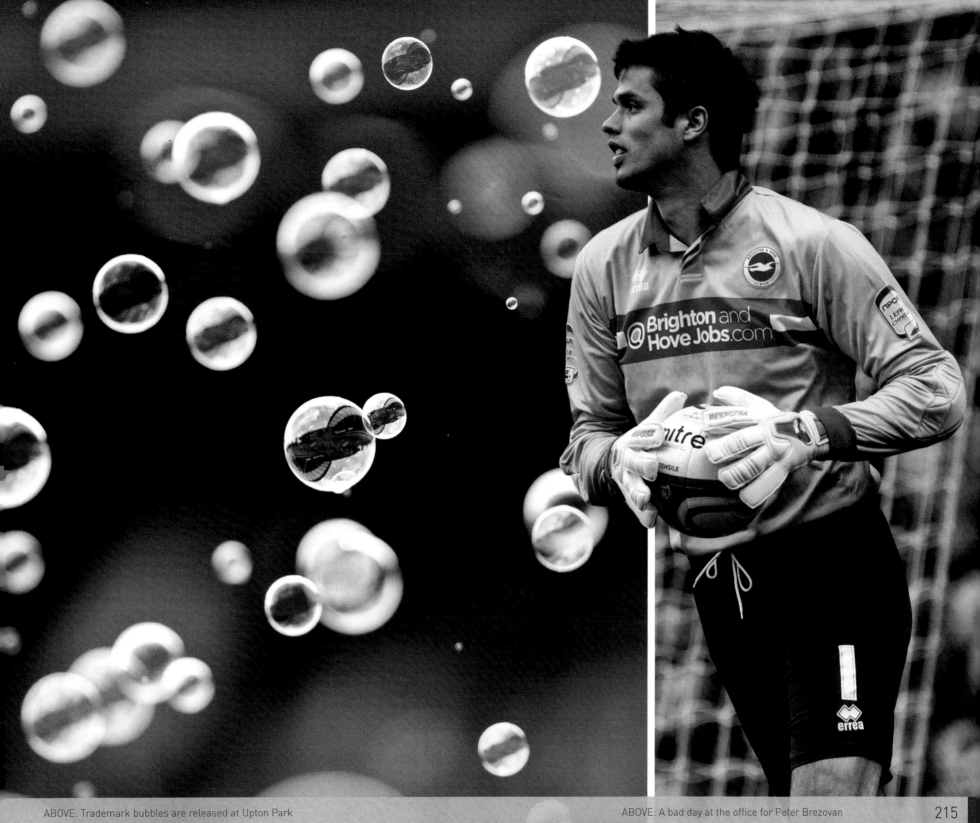

ABOVE: Trademark bubbles are released at Upton Park

ABOVE: A bad day at the office for Peter Brezovan

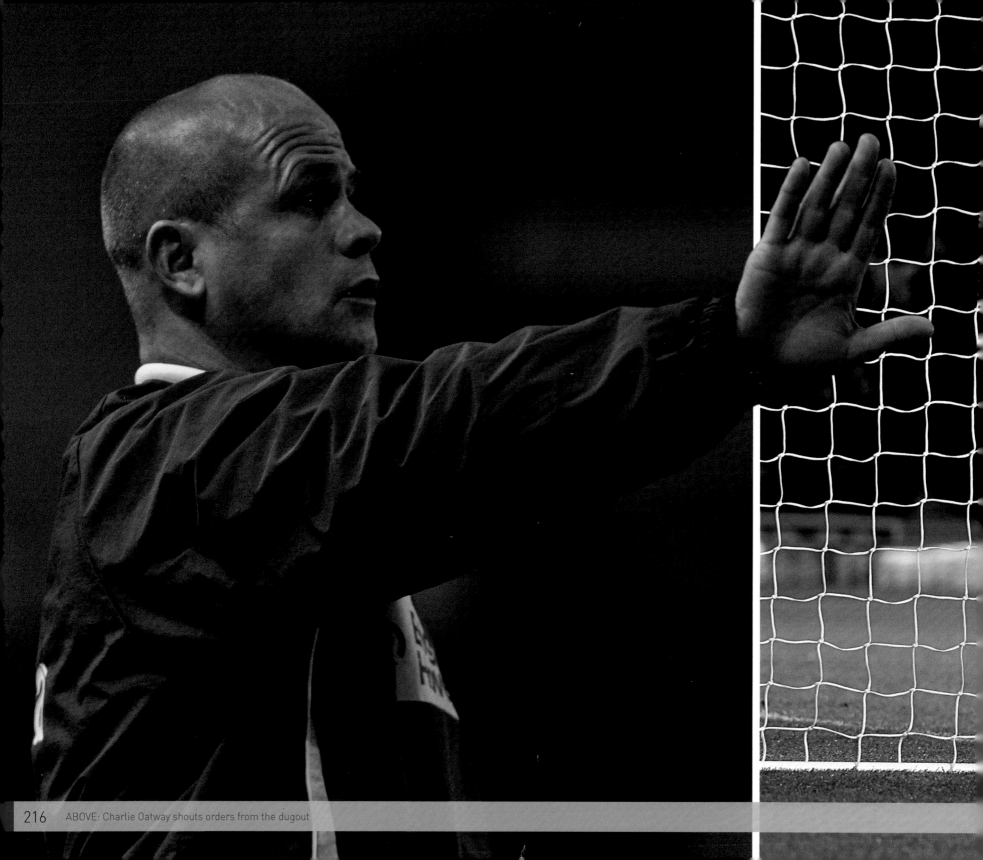

ABOVE: Charlie Oatway shouts orders from the dugout

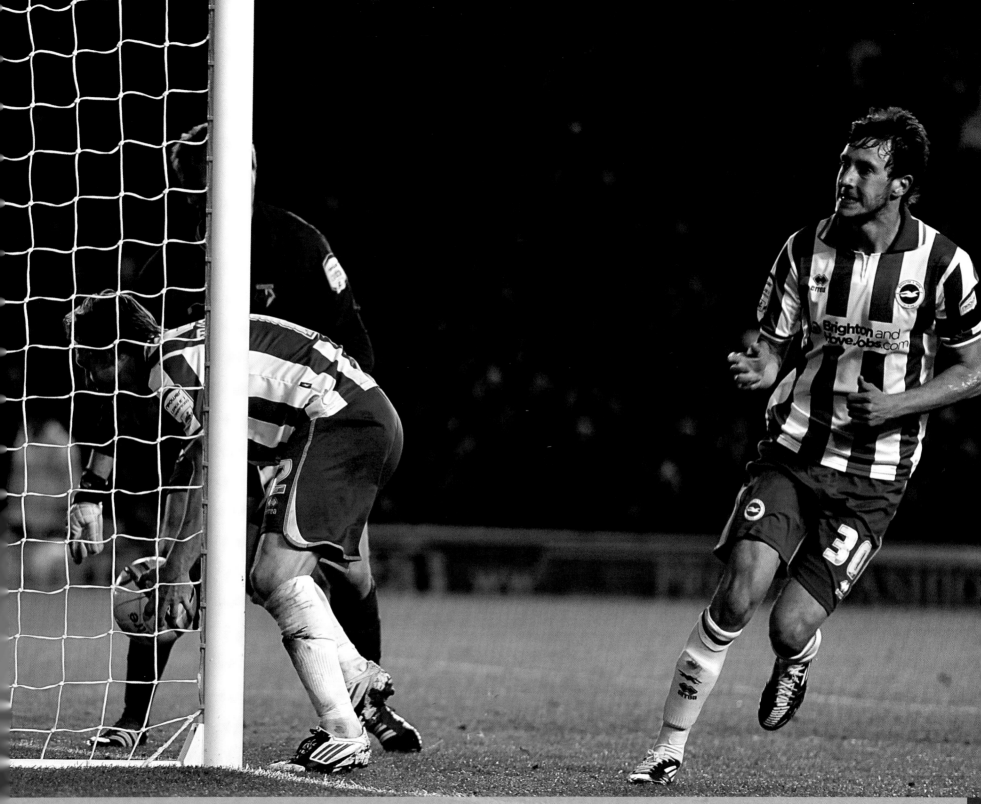

ABOVE: Will Buckley gives Albion a glimmer of play-off hope as he equalises against Watford

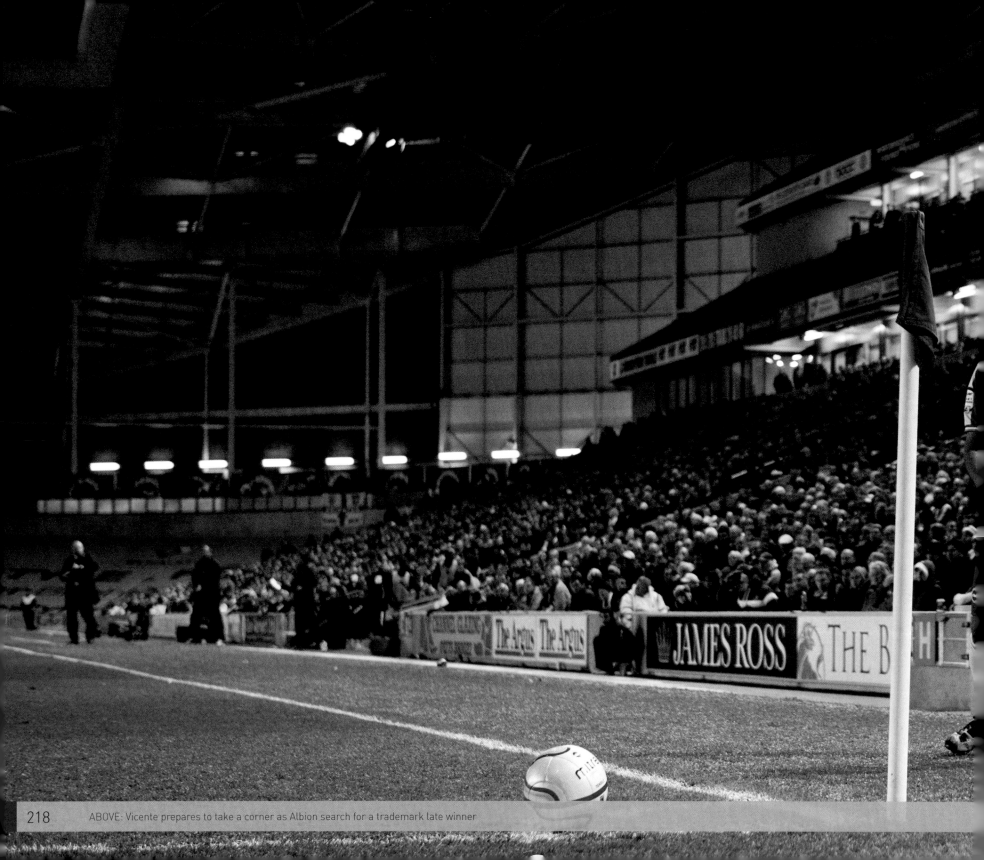

ABOVE: Vicente prepares to take a corner as Albion search for a trademark late winner

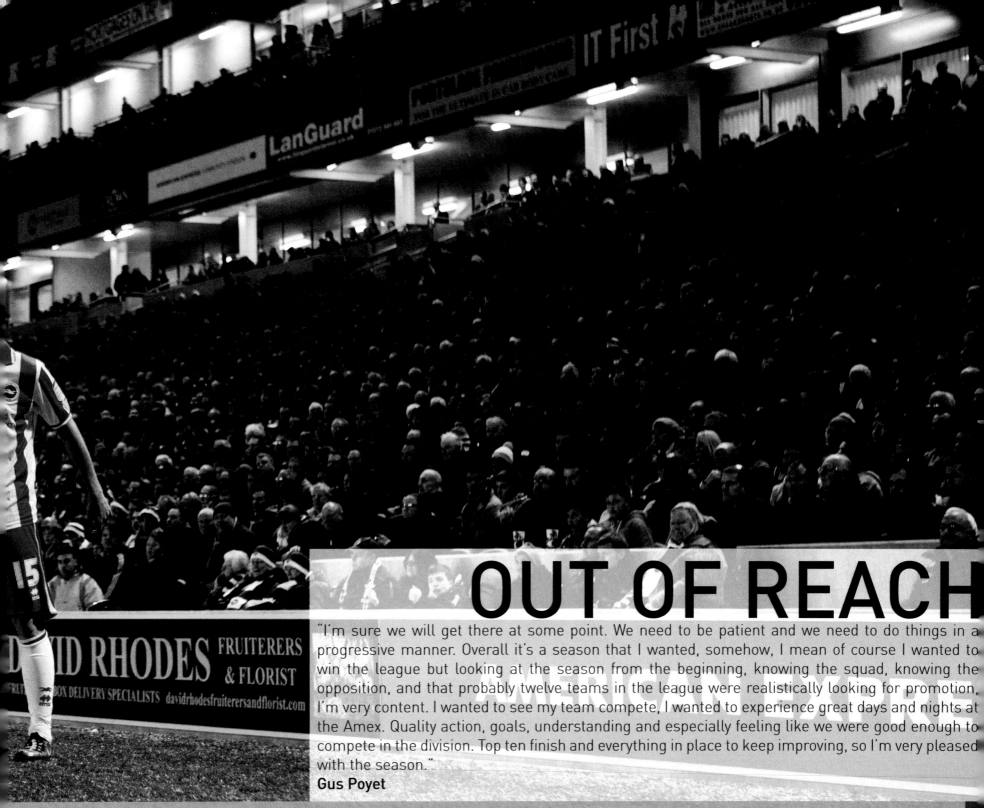

OUT OF REACH

"I'm sure we will get there at some point. We need to be patient and we need to do things in a progressive manner. Overall it's a season that I wanted, somehow, I mean of course I wanted to win the league but looking at the season from the beginning, knowing the squad, knowing the opposition, and that probably twelve teams in the league were realistically looking for promotion, I'm very content. I wanted to see my team compete, I wanted to experience great days and nights at the Amex. Quality action, goals, understanding and especially feeling like we were good enough to compete in the division. Top ten finish and everything in place to keep improving, so I'm very pleased with the season."

Gus Poyet

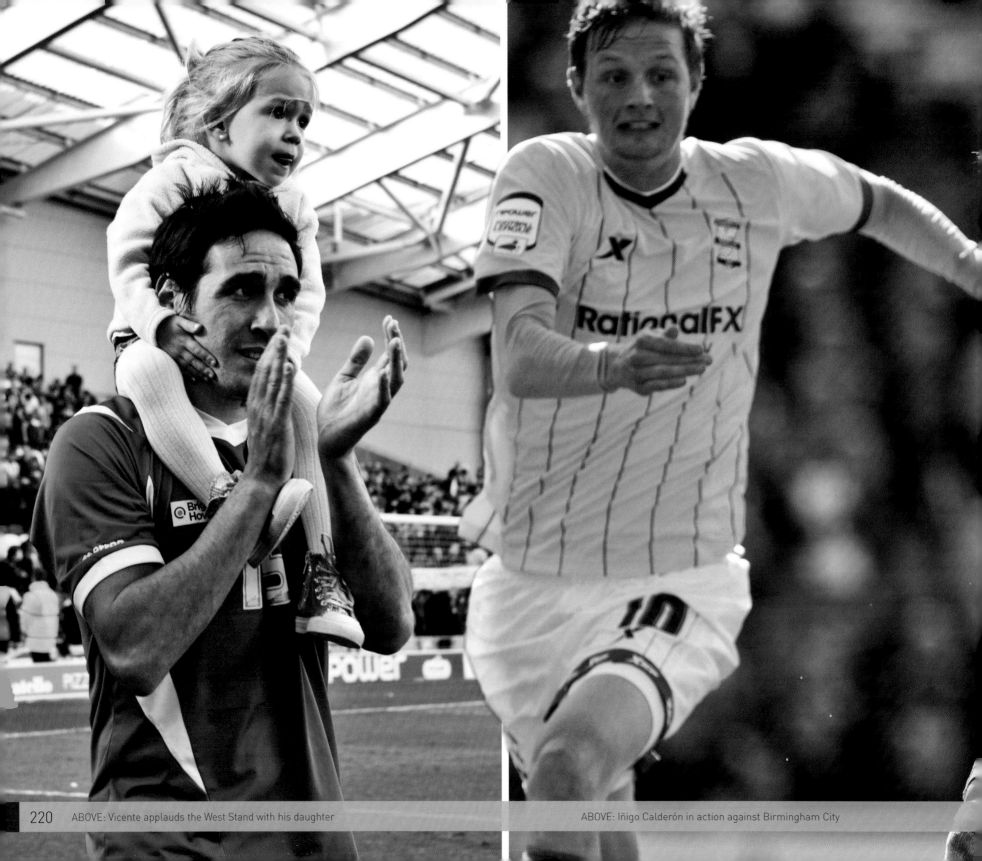

ABOVE: Vicente applauds the West Stand with his daughter

ABOVE: Iñigo Calderón in action against Birmingham City

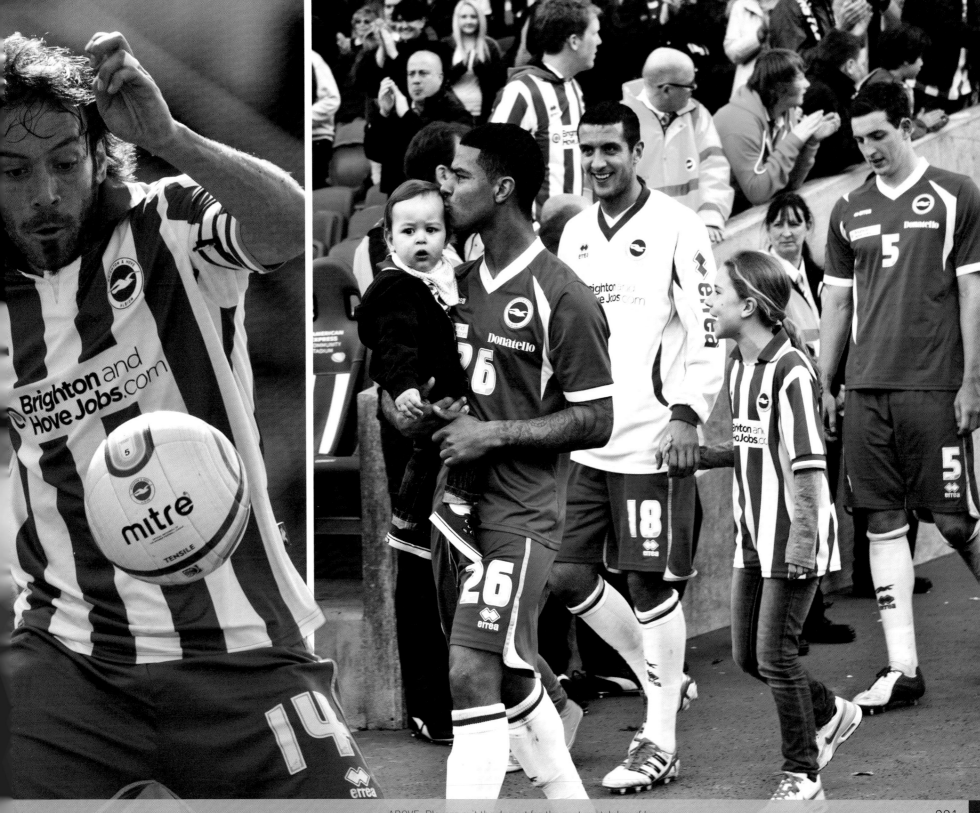

ABOVE: Players exit the dugout for the post-match lap of honour

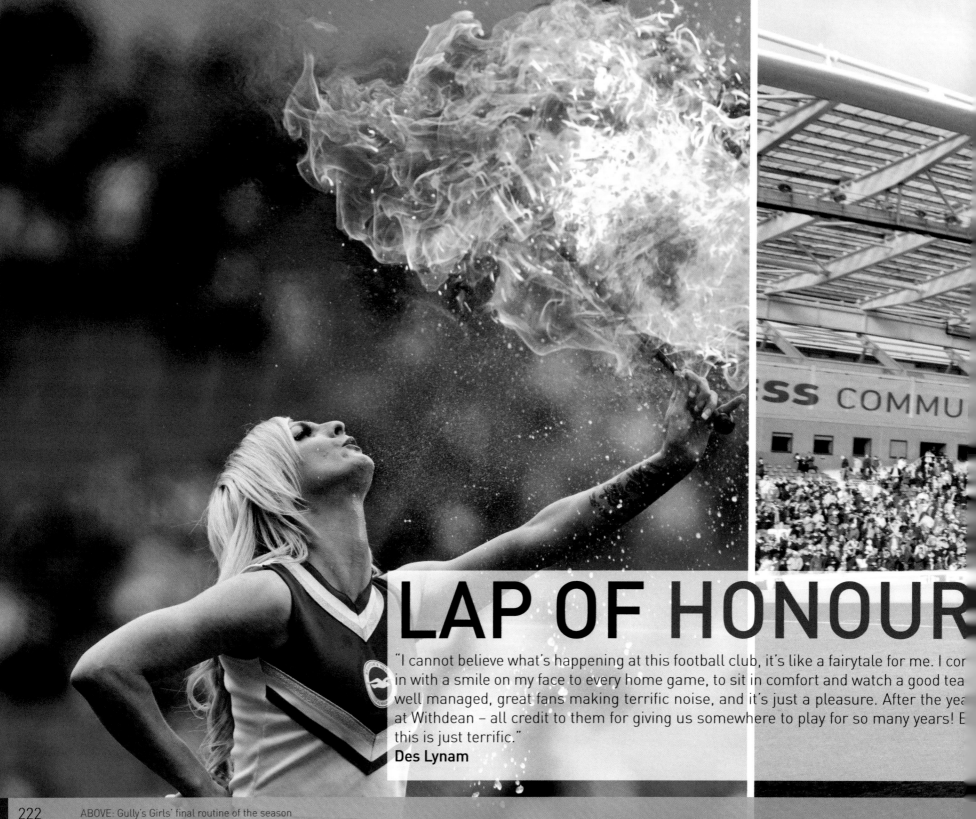

LAP OF HONOUR

"I cannot believe what's happening at this football club, it's like a fairytale for me. I cor
in with a smile on my face to every home game, to sit in comfort and watch a good tea
well managed, great fans making terrific noise, and it's just a pleasure. After the yea
at Withdean – all credit to them for giving us somewhere to play for so many years! E
this is just terrific."
Des Lynam

ABOVE: Gully's Girls' final routine of the season

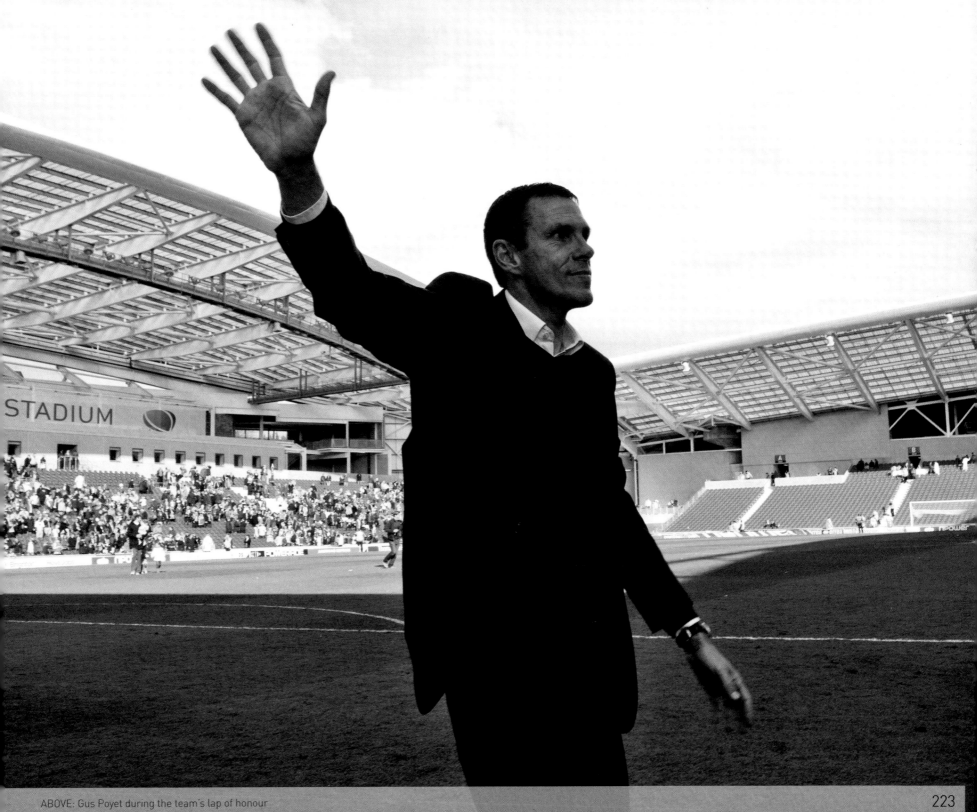

ABOVE: Gus Poyet during the team's lap of honour

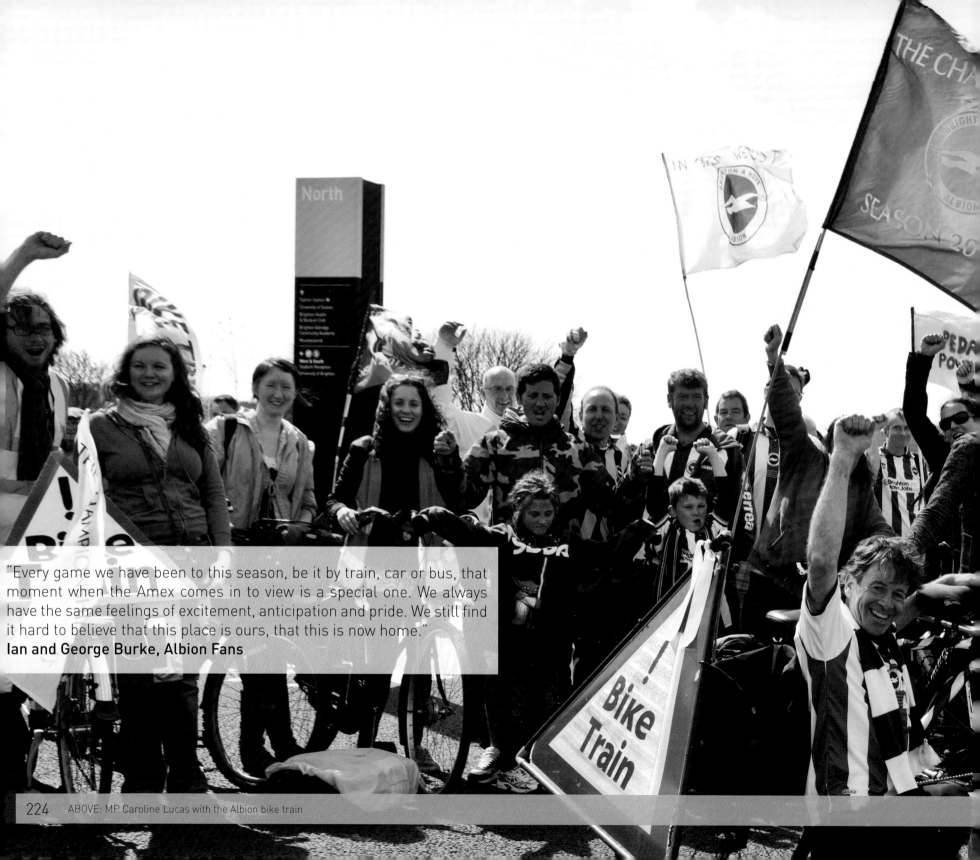

"Every game we have been to this season, be it by train, car or bus, that moment when the Amex comes in to view is a special one. We always have the same feelings of excitement, anticipation and pride. We still find it hard to believe that this place is ours, that this is now home."
Ian and George Burke, Albion Fans

ABOVE: MP Caroline Lucas with the Albion bike train

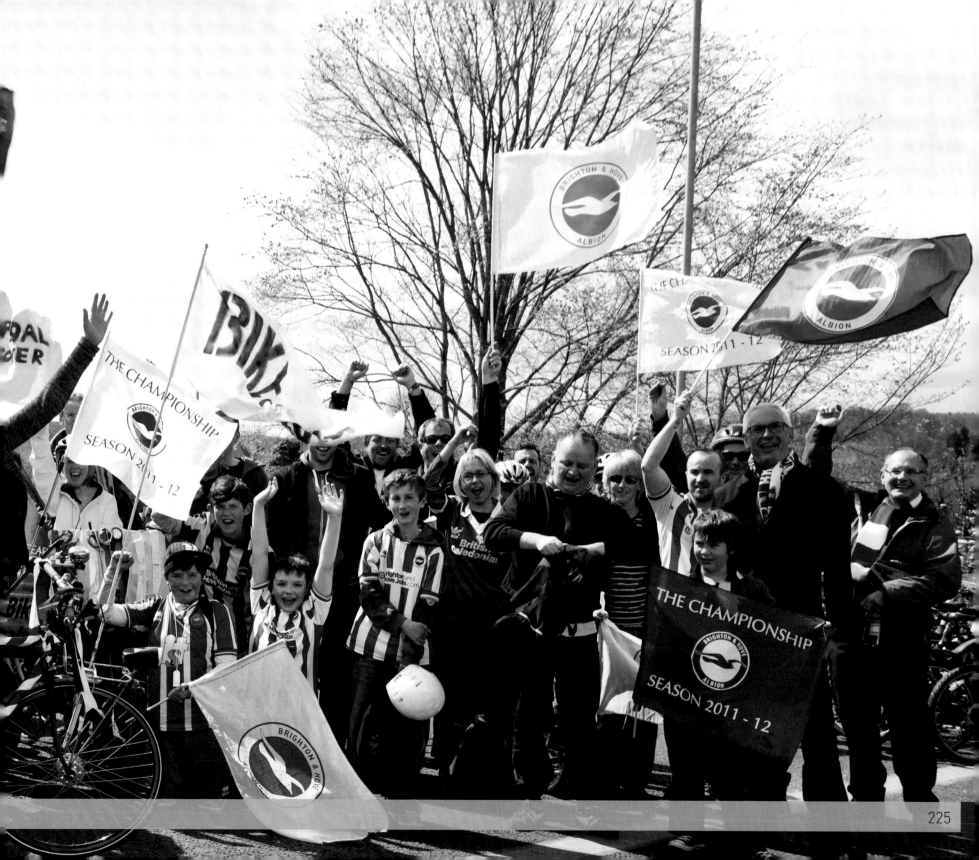

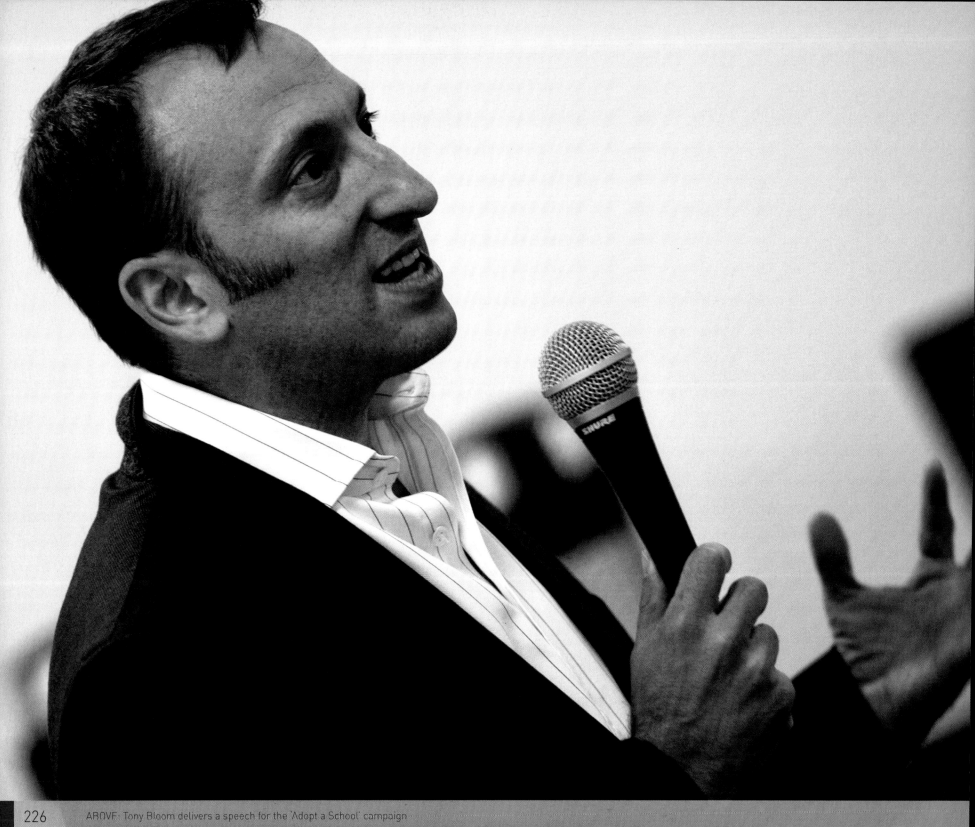

ABOVE: Tony Bloom delivers a speech for the 'Adopt a School' campaign

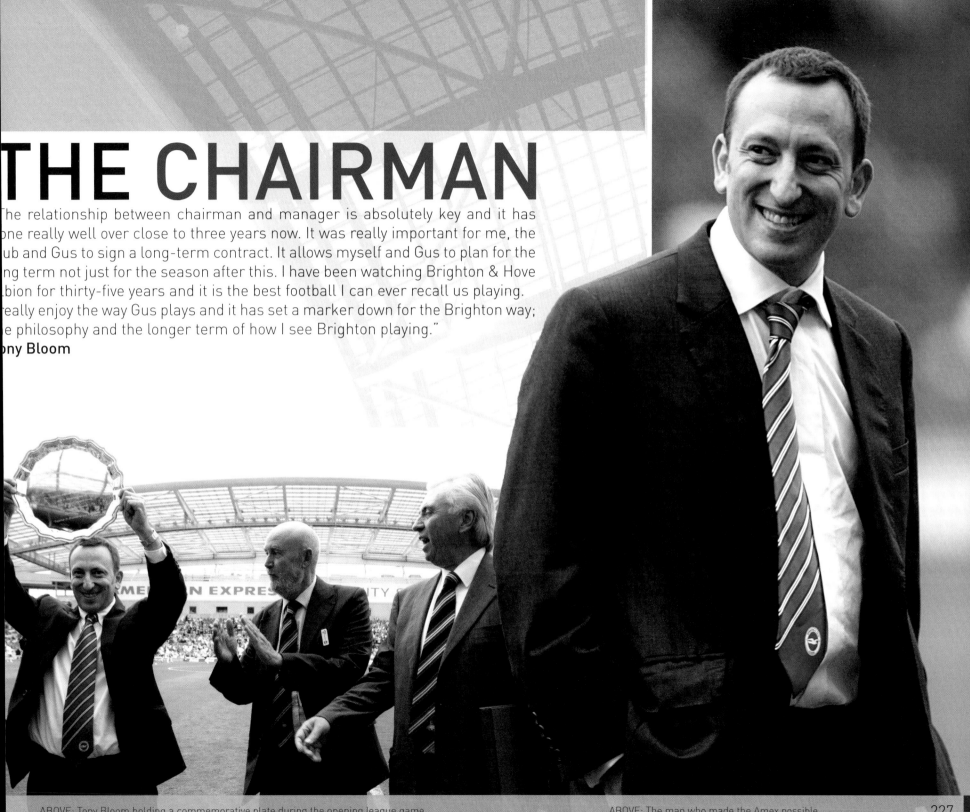

THE CHAIRMAN

The relationship between chairman and manager is absolutely key and it has gone really well over close to three years now. It was really important for me, the club and Gus to sign a long-term contract. It allows myself and Gus to plan for the long term not just for the season after this. I have been watching Brighton & Hove Albion for thirty-five years and it is the best football I can ever recall us playing. I really enjoy the way Gus plays and it has set a marker down for the Brighton way; the philosophy and the longer term of how I see Brighton playing."

Tony Bloom

ABOVE: Tony Bloom holding a commemorative plate during the opening league game

ABOVE: The man who made the Amex possible

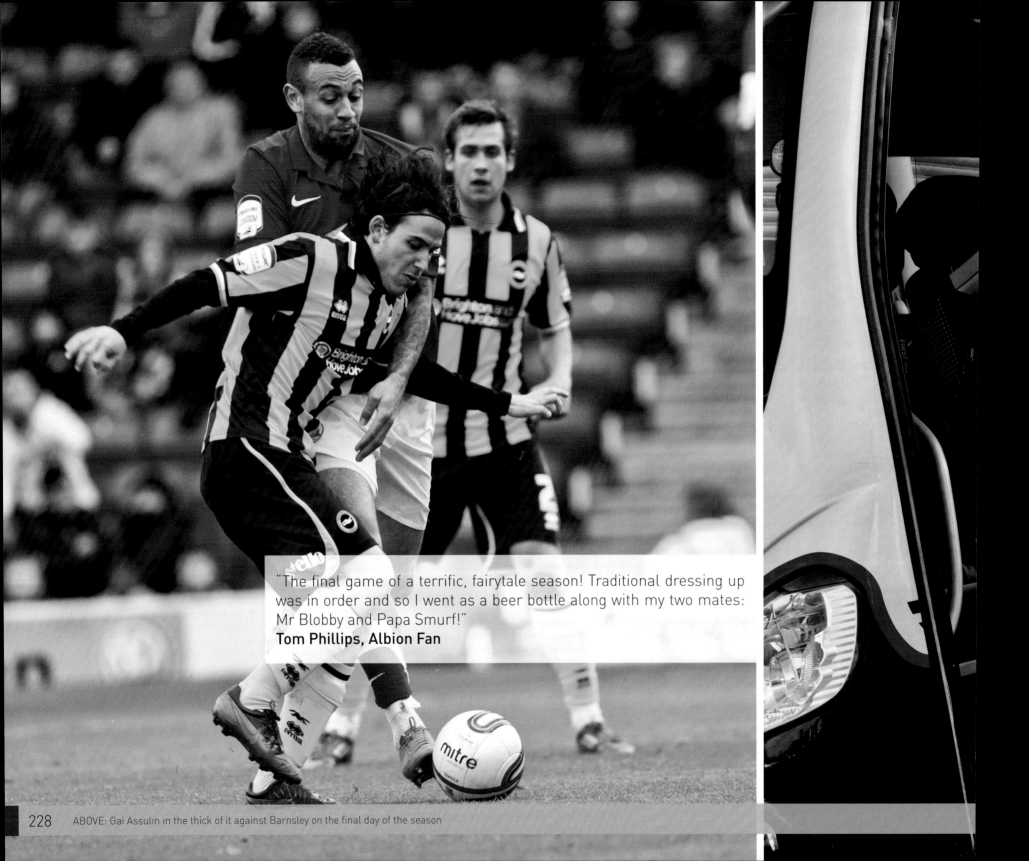

"The final game of a terrific, fairytale season! Traditional dressing up was in order and so I went as a beer bottle along with my two mates: Mr Blobby and Papa Smurf!"
Tom Phillips, Albion Fan

ABOVE: Gai Assulin in the thick of it against Barnsley on the final day of the season

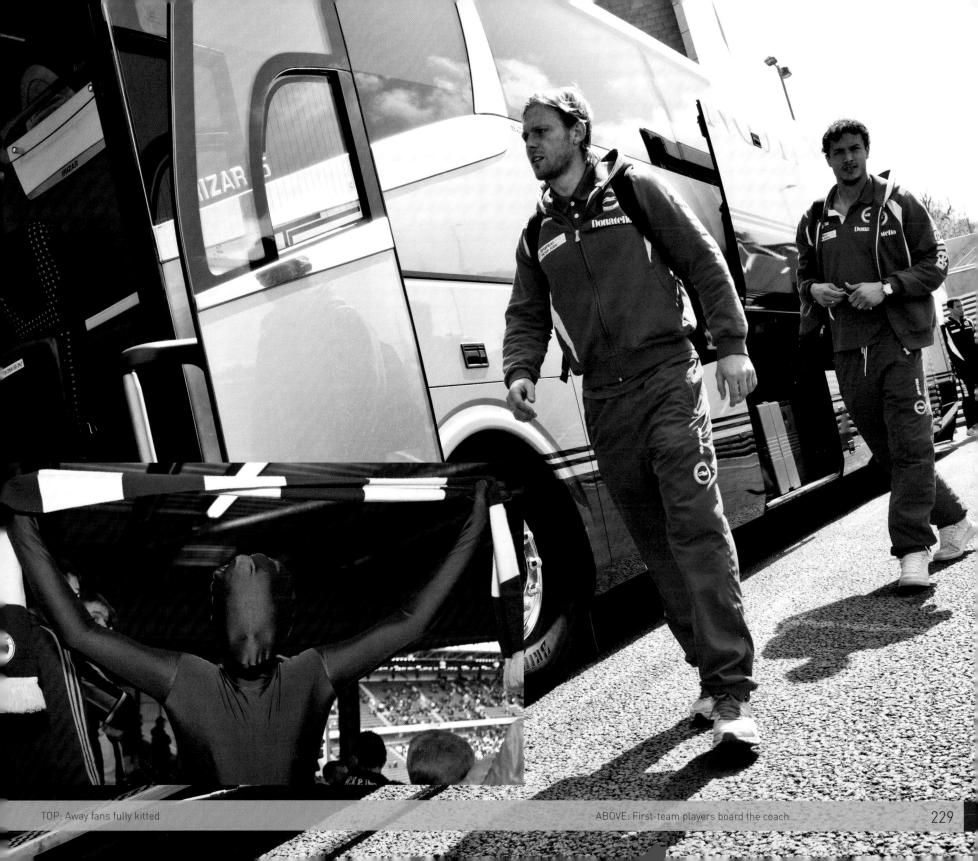

ABOVE: First-team players board the coach

THE REVIEW

"I've reported from grounds all over Europe and while plenty are bigger, I think very few are better. Interviewing Will in the centre circle seconds after the Newcastle upset with the songs cascading down from the stands really brought home how exciting the future looks. Usually I'm at Albion matches purely as a fan and that experience has moved to a whole new level too. I'll never forget the Goldstone but there'll be amazing memories created at the Amex."

Dave Beckett, Presenter

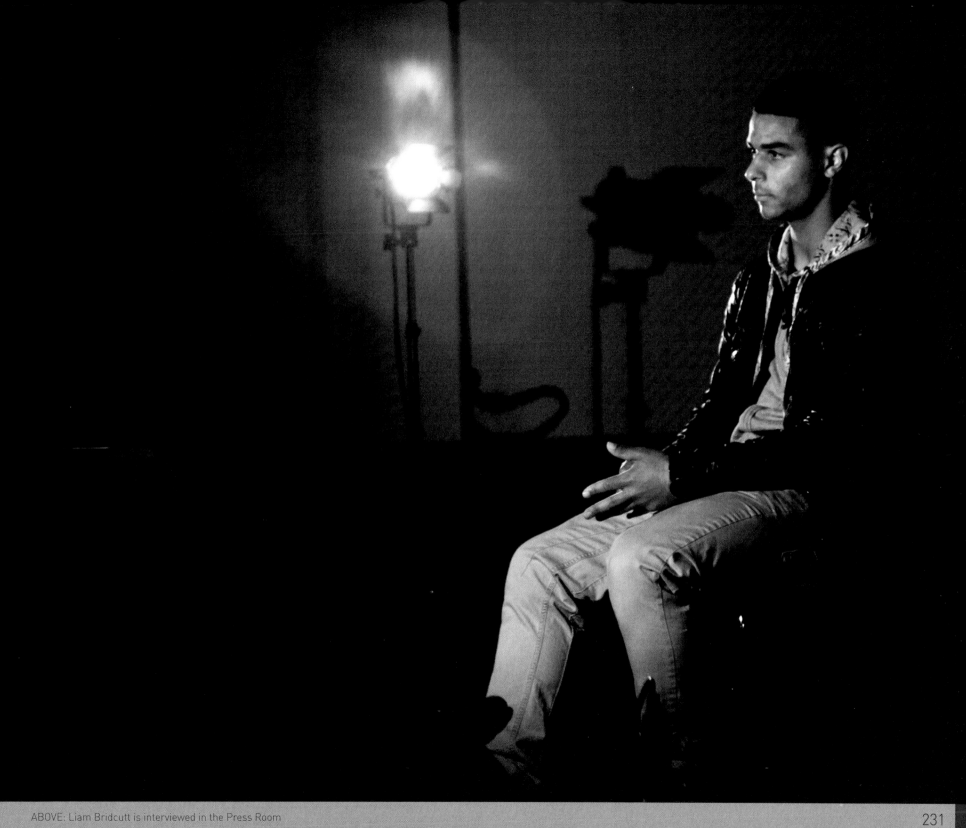

ABOVE: Liam Bridcutt is interviewed in the Press Room

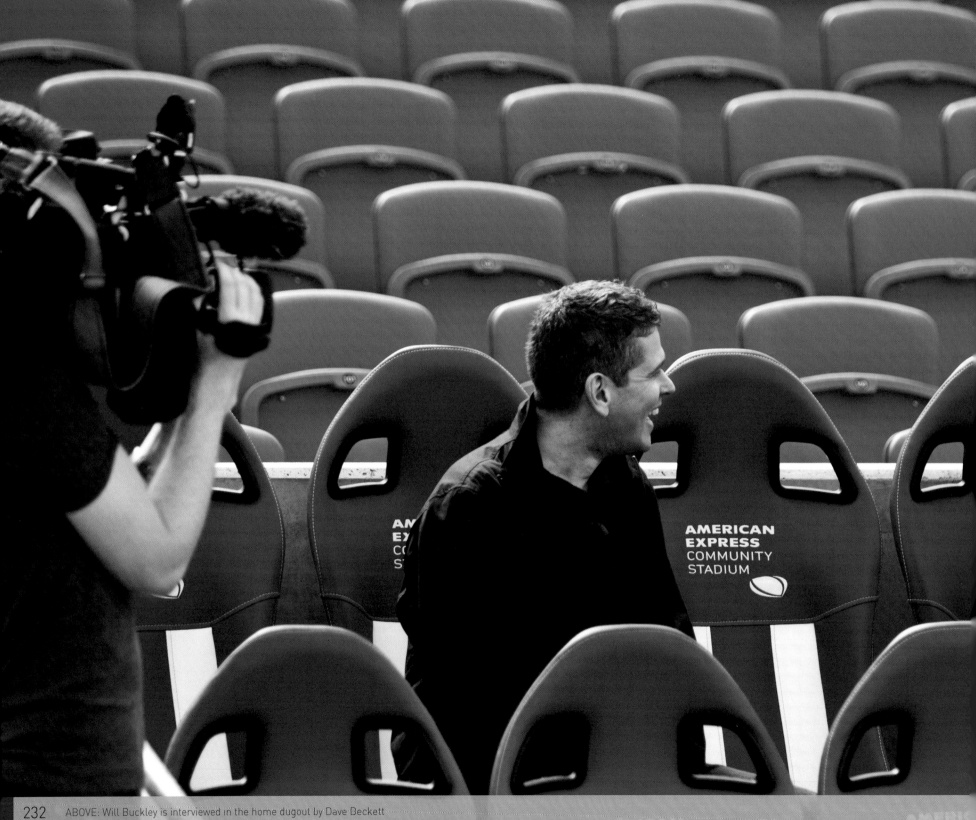

ABOVE: Will Buckley is interviewed in the home dugout by Dave Beckett

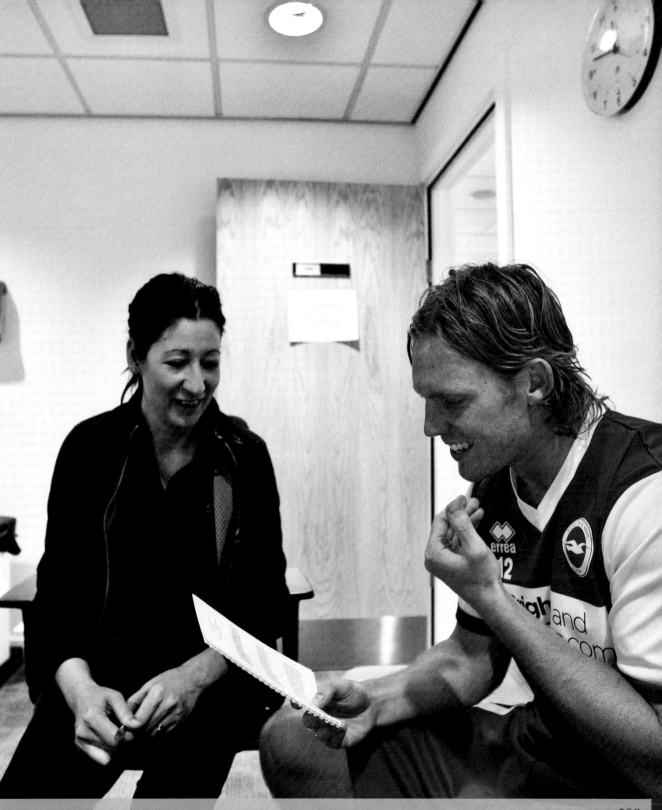

ABOVE: Regular eye testing carried out at The Healthy Company

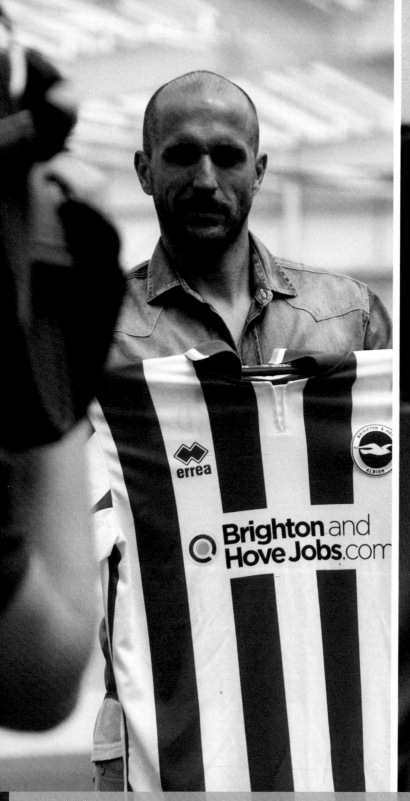

ABOVE: Bruno Saltor joins the Albion ranks

ABOVE: Wayne Bridge is interviewed by Paul Camillin

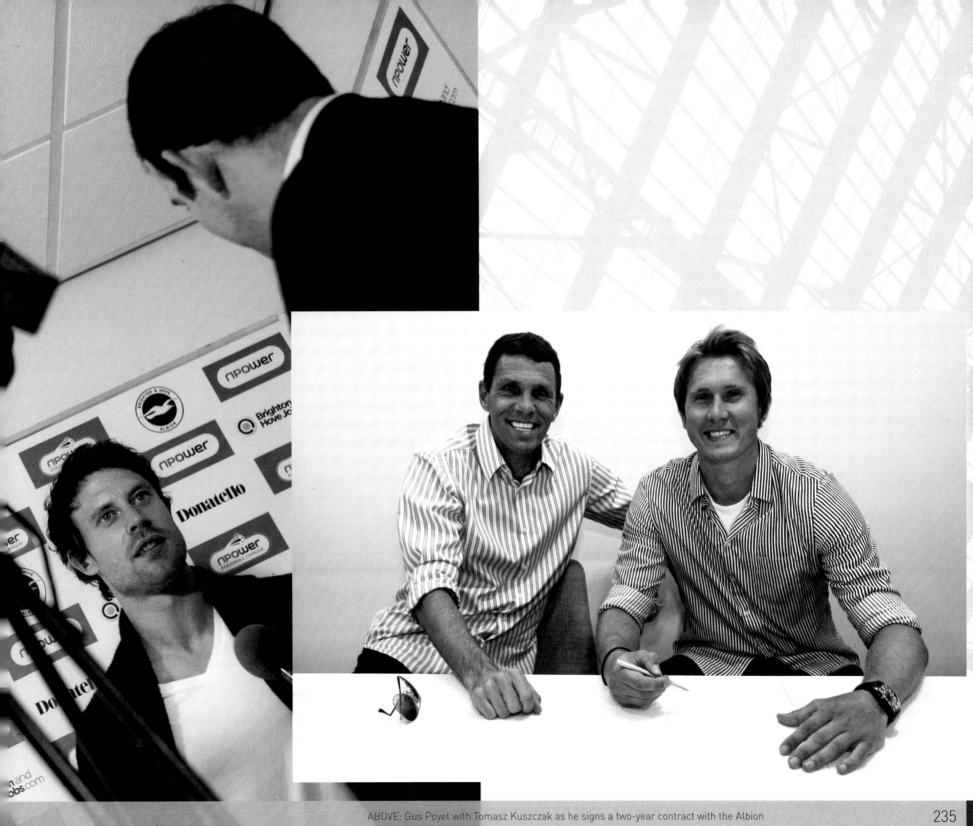

ABOVE: Gus Poyet with Tomasz Kuszczak as he signs a two-year contract with the Albion

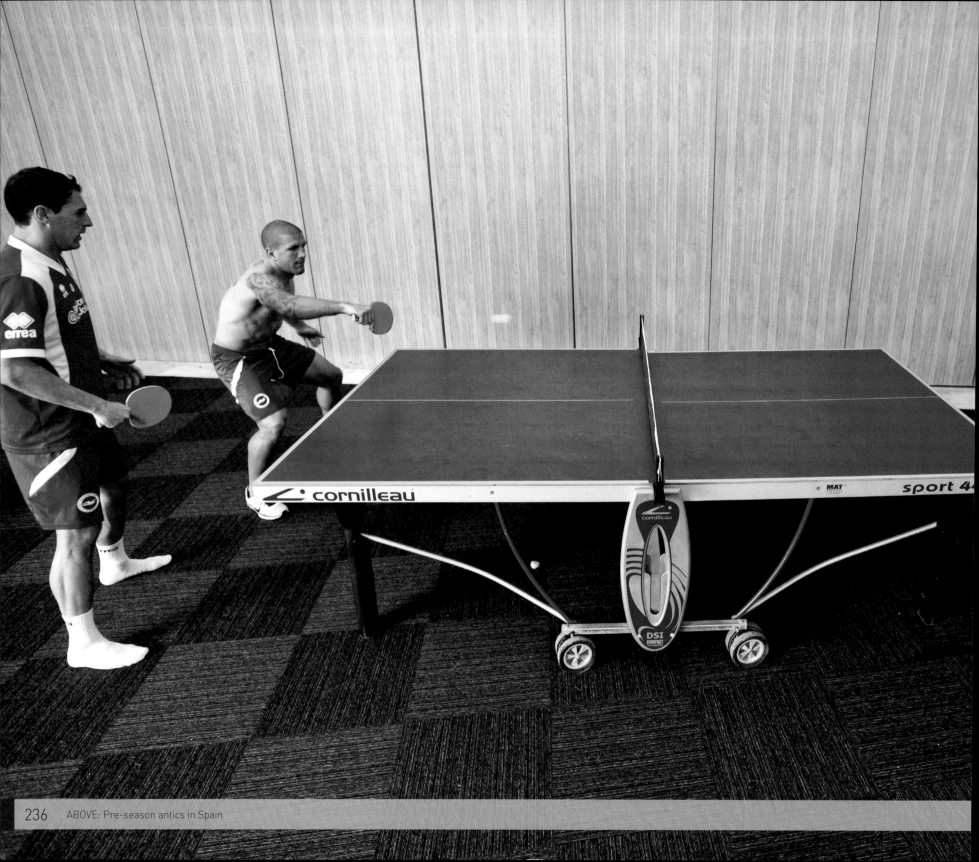

ABOVE: Pre-season antics in Spain

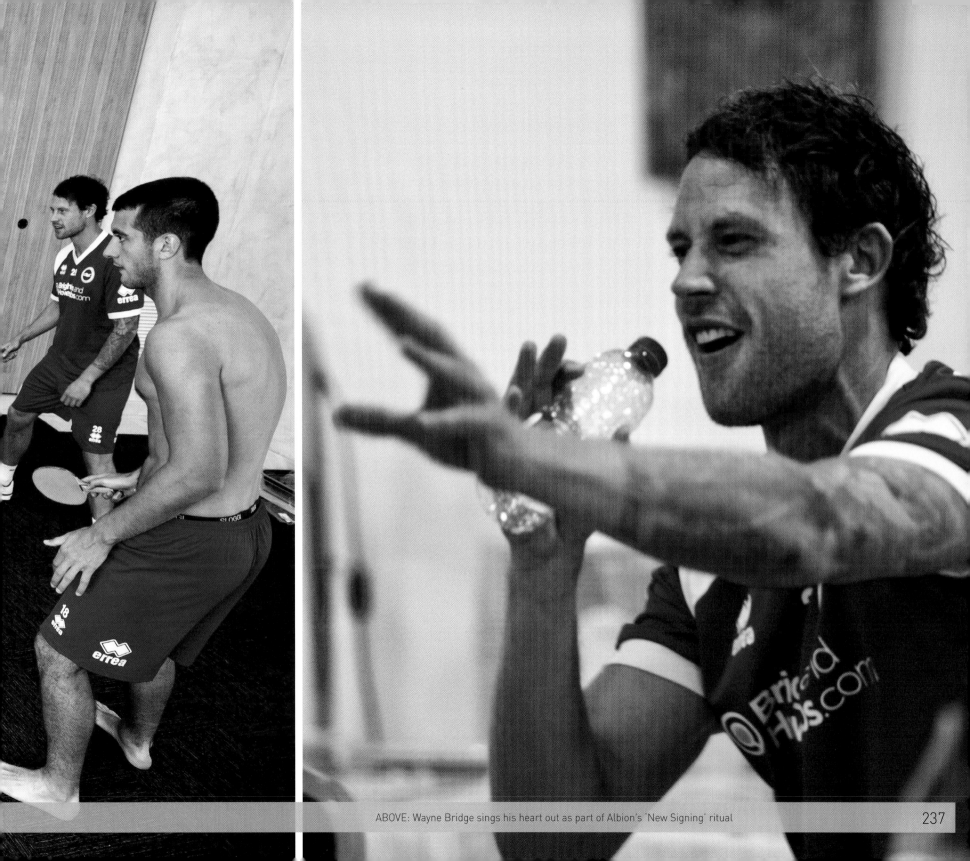

ABOVE: Wayne Bridge sings his heart out as part of Albion's 'New Signing' ritual

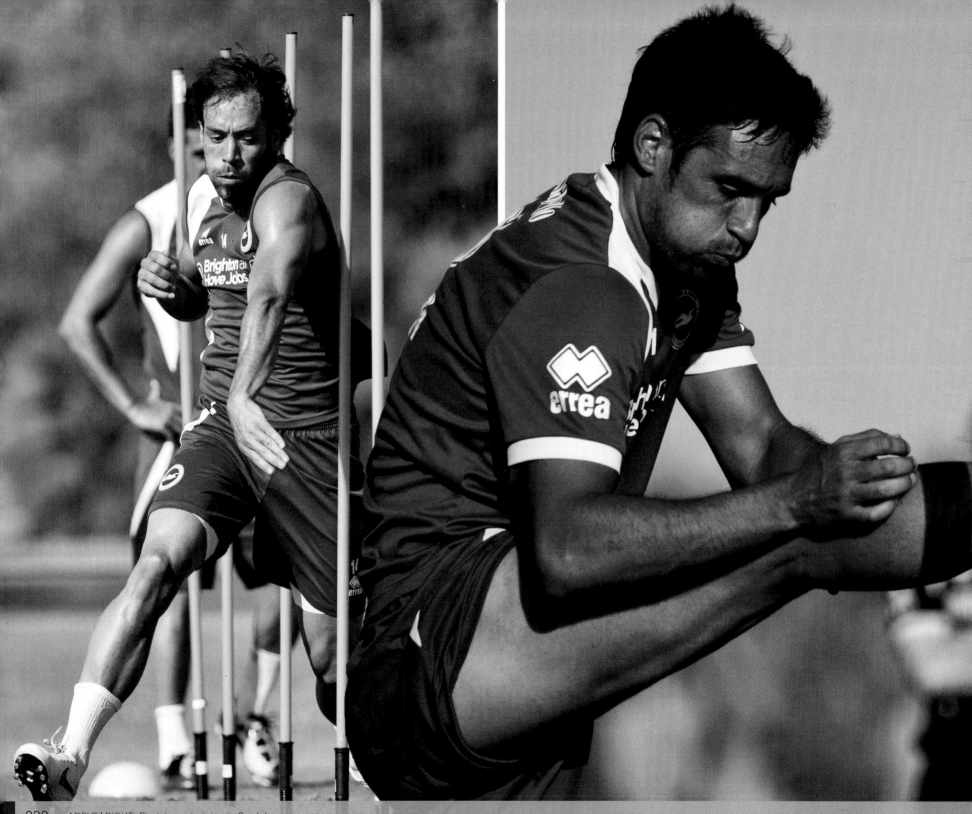

ABOVE/ RIGHT: First-team training in Cordoba

ROUND TWO

"My agent had told me about Brighton before because he's close friends with Gus: he told me they played football, that they played out from the back and the players see a lot of the ball. I'm looking forward to playing in the Championship, there are a great bunch of lads here and the club have made some excellent signings – hopefully, I'm one of them! I've heard the Brighton fans are great fans so I can't wait for the first home game."
Wayne Bridge, Defender

ABOVE: Tomasz Kuszczak stretches